THE HUMAN FIGURE AND JEWISH CULTURE

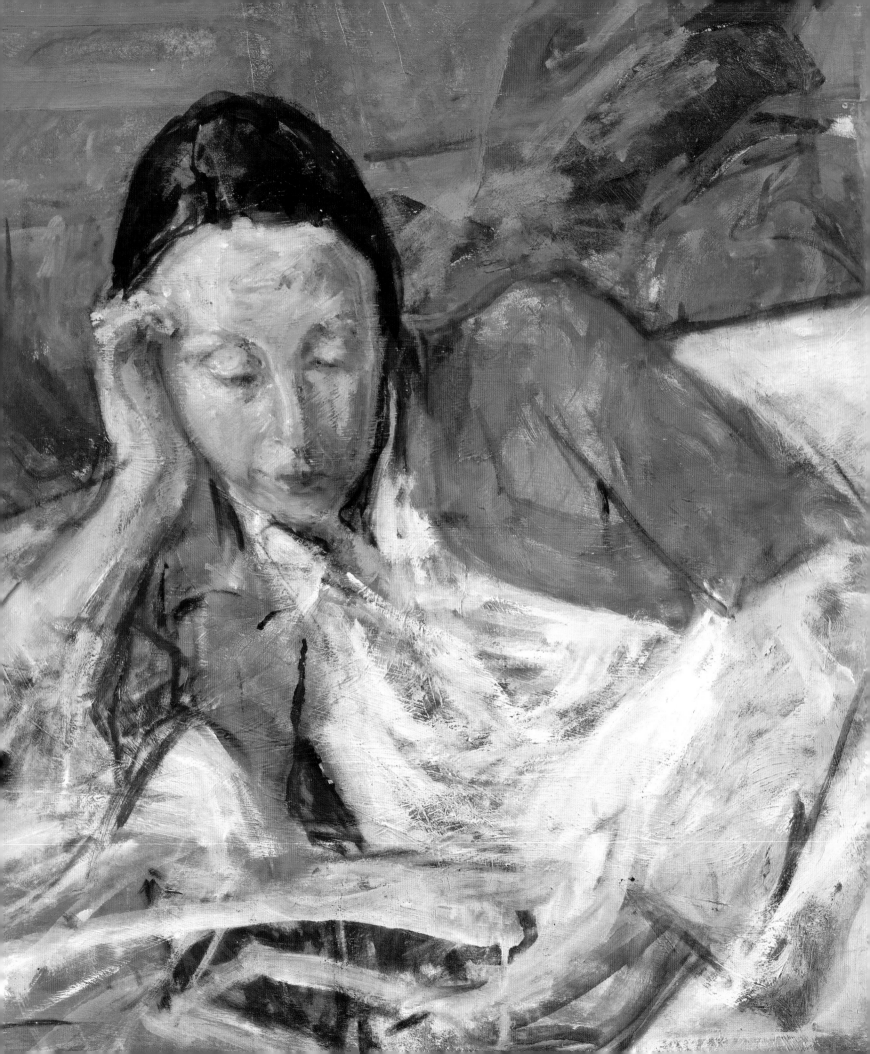

The Human Figure and Jewish Culture

ELIANE STROSBERG

FOREWORD BY JULIA WEINER

ABBEVILLE PRESS PUBLISHERS
New York London

FRONT COVER
Camille Pissarro (1830–1903)
Self-portrait with Beret and Spectacles, c. 1896
Detail of plate 10

BACK COVER
Amedeo Modigliani (1884–1920)
Portrait of Hanka Zborowska, 1917
Detail of plate 74

1 *(page 2, frontispiece)*
Isaac Dobrinsky (1891–1973)
The Reader (The Artist's Wife), c. 1940
Detail of plate 62

2 *(opposite)*
Chaim Soutine (1893–1943)
The Floor Waiter, c. 1927–28
Detail of plate 75

3 *(page 6, opposite dedication)*
Marc Chagall (1887–1985)
The Wandering Jew, 1923
Detail of plate 36

4 *(page 8, opposite contents)*
Leon Zack (1892–1980)
Double Portrait of Men (on the reverse:
Double Portrait of Women), 1931
Oil on canvas, 23⅝ × 31½ in. (60 × 80 cm)
Galerie Gimpel & Müller, Paris

5 *(pages 10–11)*
Ben Shahn (1898–1969)
Albert Einstein among other immigrants,
from the *Roosevelt Mural,* 1937–38
Detail of plate 96

6 *(page 12)*
Georges Kars (1882–1945)
Young Woman with a Rose, 1920
Detail of plate 68

7 *(page 13)*
Leon Kossoff (b. 1926)
Philip II (portrait of the artist's brother), 1962
Detail of plate 90

8 *(page 14)*
Max Weber (1881–1961)
The Talmudists, 1934
Detail of plate 92

9 *(page 15)*
William Gropper (1897–1977)
Art Opening, c. 1959
Detail of plate 98

The author and publisher wish to thank the following individuals and institutions for their invaluable assistance in the preparation of this volume: Christophe Duvivier, director of the Musées de Pontoise; Claude Ghez, president of the Musée du Petit Palais, Geneva; Inge Jaehner, director of the Felix-Nussbaum-Haus, Osnabruck, Germany; The Norton Museum of Art, West Palm Beach; the Von der Heydt Museum, Wuppertal, Germany; Serge Trigano, Galerie Trigano; Berthold Müller, Galerie Gimpel & Müller; Galerie Daniel Templon; Galerie Thaddaeus Ropac; Sandrine Pissarro; Nicolas Feuillie, MAHJ-Paris; Herve-Francois Lancelin; Nicolas and Sophie Lefevre; Ofer Lellouche; the Leuwenkroon family; Ra'anan Levy; Philip Pearlstein; Serge Strosberg; Isabelle Pleskoff, director of the MAHJ library; Eric Riedl, Ludwig Meidner–Archiv, Frankfurt; Zippi Rosenne, director, Visual Documentation Center, Beth Hatefutsoth, The Nahum Goldmann Museum of the Jewish Diaspora, Tel Aviv; Hans-Walter Stork, Staats- und Universitätsbibliothek, Hamburg; The Hebrew University Library of Jerusalem; and several anonymous lenders of pictorial material.

Editor: David Fabricant
Copy editor: Ashley Benning
Production manager: Louise Kurtz
Designer: Louise Dudis
Jacket Designer: Misha Beletsky

A previous edition of this book was published in Paris in 2008 by Éditions d'Art Somogy, under the title *Human Expressionism: The Human Figure and the Jewish Experience.*

First Abbeville Press edition
10 9 8 7 6 5 4 3 2 1

Library of Congress Cataloging-in-Publication Data
Strosberg, Eliane.
[Humanisme et expressionnisme. English]
The human figure and Jewish culture / Eliane Strosberg.
 p. cm.
Translation and revision of: Humanisme et expressionnisme : la representation de la figure humaine et l'expirience juive.
Includes bibliographical references and index.
ISBN 978-0-7892-1054-8 (hardcover : alk. paper)
ISBN 978-0-7892-1056-2 (pbk. : alk. paper)
1. Human beings in art. 2. Judaism and art. 3. Art, Jewish. 4. Art, Modern—20th century. I. Title.
N7625.5.S7713 2010
704.9'42—dc22
 2009030790

For bulk and premium sales and for text adoption procedures, write to Customer Service Manager, Abbeville Press, 137 Varick Street, New York, NY 10013, or call 1-800-ARTBOOK.

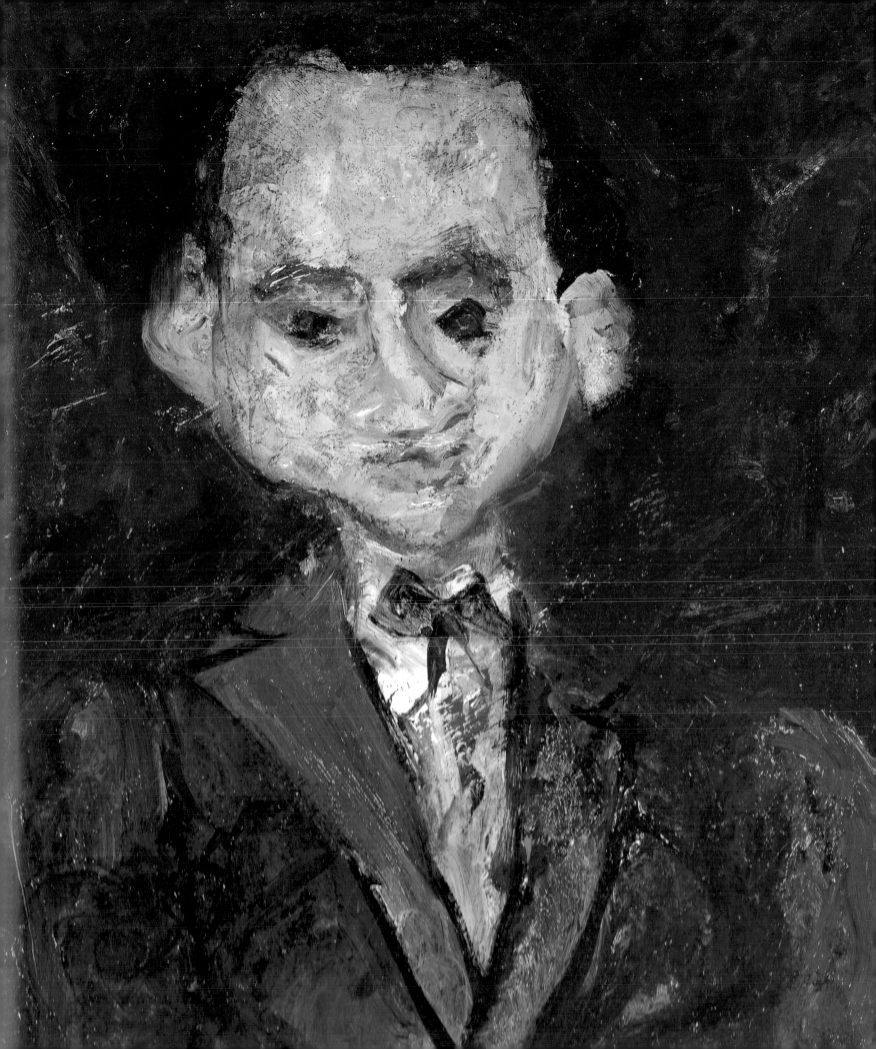

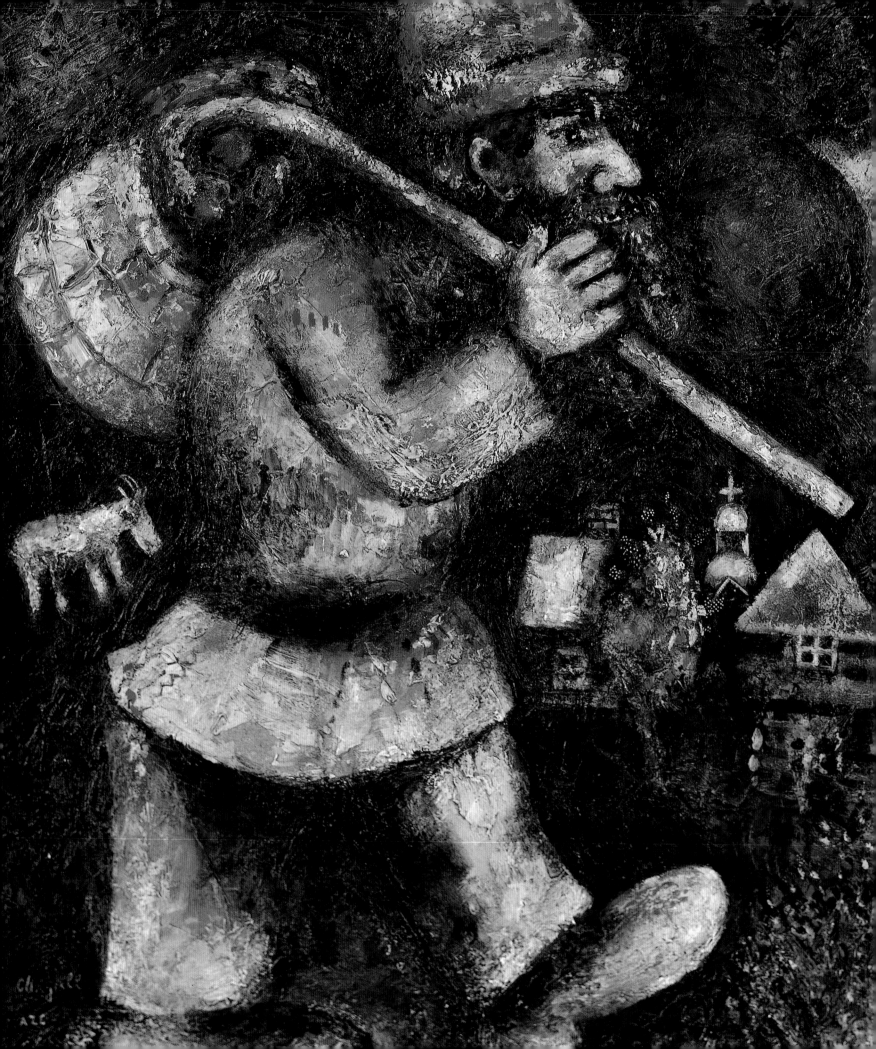

In memory of Baruch Brenig, my maternal grandfather, and
Reizl Levenkron, my paternal great-grandmother, who raised my
orphaned father, Isaac. Baruch and Reizl were deported to the
Mechelen camp, like the painter Felix Nussbaum, and murdered
in Auschwitz.

In memory of Max Lopes Cardozo, who passed away at age
seven in Theresienstadt; his ancestor Jacob is represented in the
painting by Edouard Brandon on page 76. And to Max's cousin,
Raymond-Alexandre, who died at a few weeks of age in the refu-
gee camp in Switzerland where his brother Donny, my husband,
was born.

And to all the others.

Words will not suffice to thank Donny for his uncondi-
tional support, Muriel and Josh for their pertinent critique
and their contagious enthusiasm, and especially Serge, who
truly initiated me to the human figure.

I am extremely grateful to the following experts for
their numerous constructive remarks: Professor Emeritus
Matthew Baigell, specialist on Jewish American artists;
Mark Rosenthal, independent curator and author of several
books on contemporary art; Sarah McFadden, editor for *Art
in America* and the *Bulletin*; Sophie Krebs, chief curator at
the Musée d'Art Moderne de la Ville de Paris; and Nadine
Nieszawer, expert on the École de Paris.

It has been a great pleasure to have David Fabricant
and Ashley Benning as my editors. I would like to thank
Misha Beletsky and Louise Dudis for their beautiful design,
and production director Louise Kurtz. I also admire Bob
Abrams for continuing to publish art books that are works
of art in themselves.

Eliane Strosberg

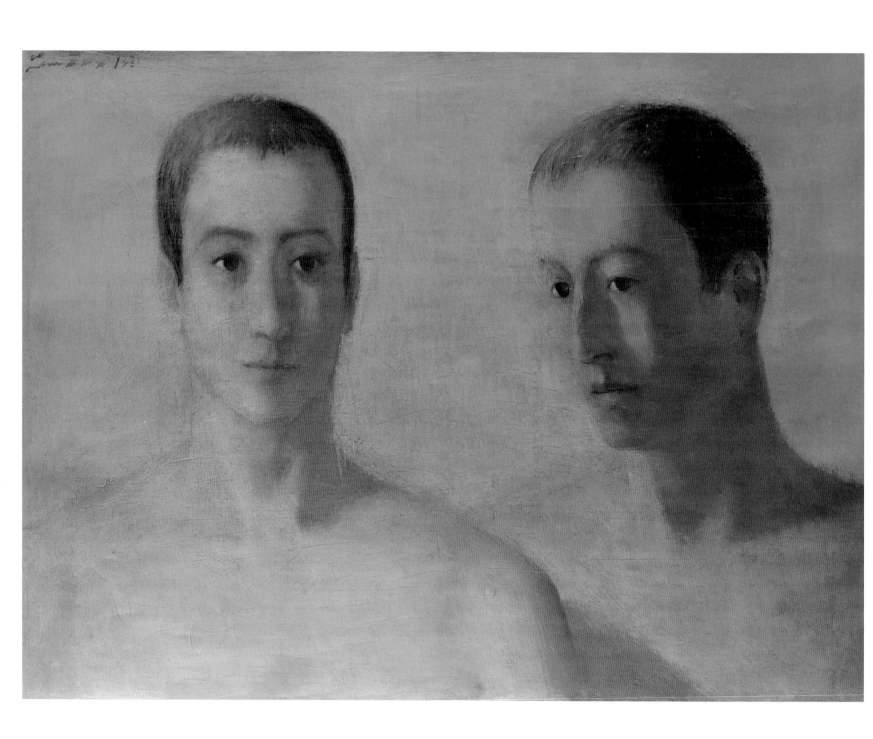

Contents

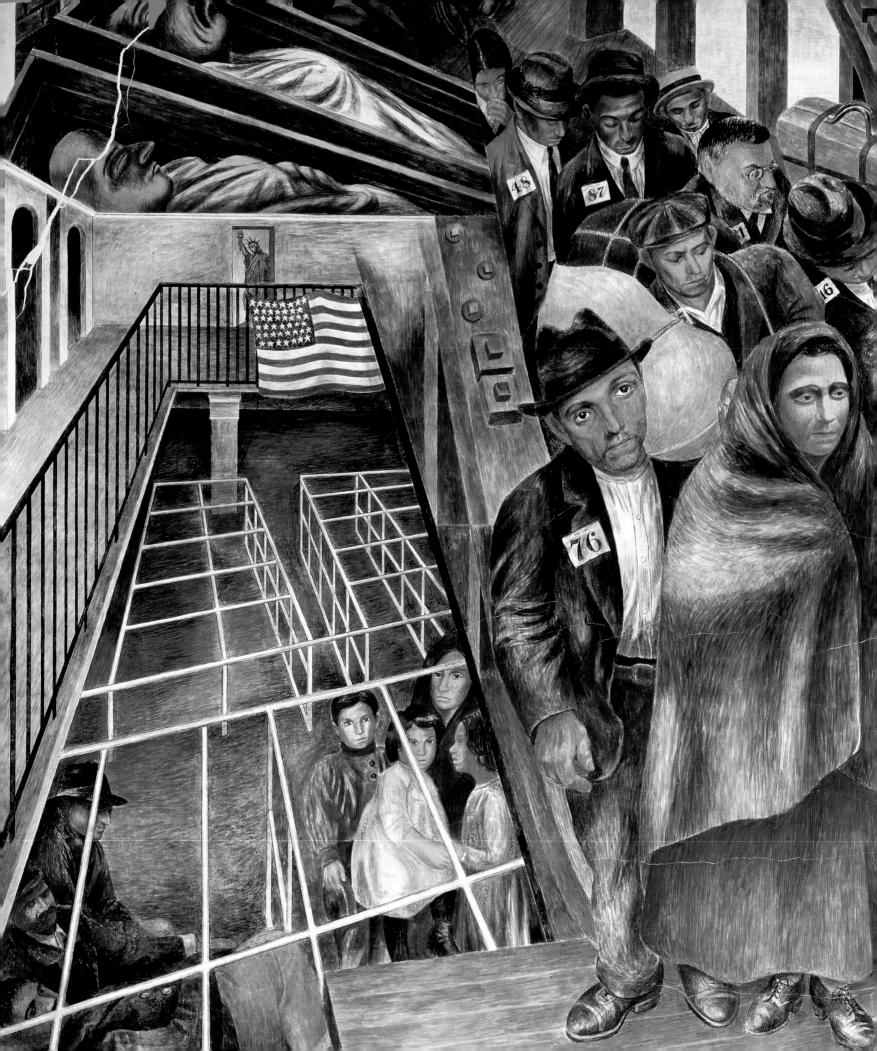

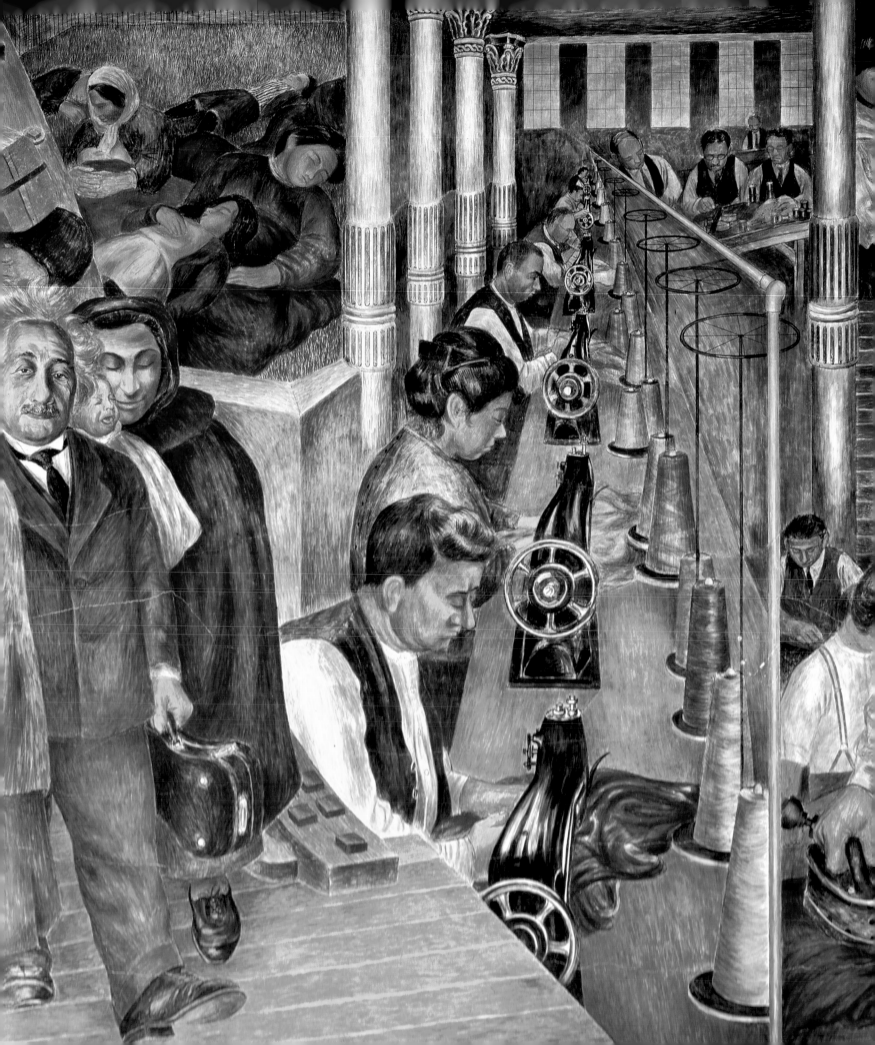

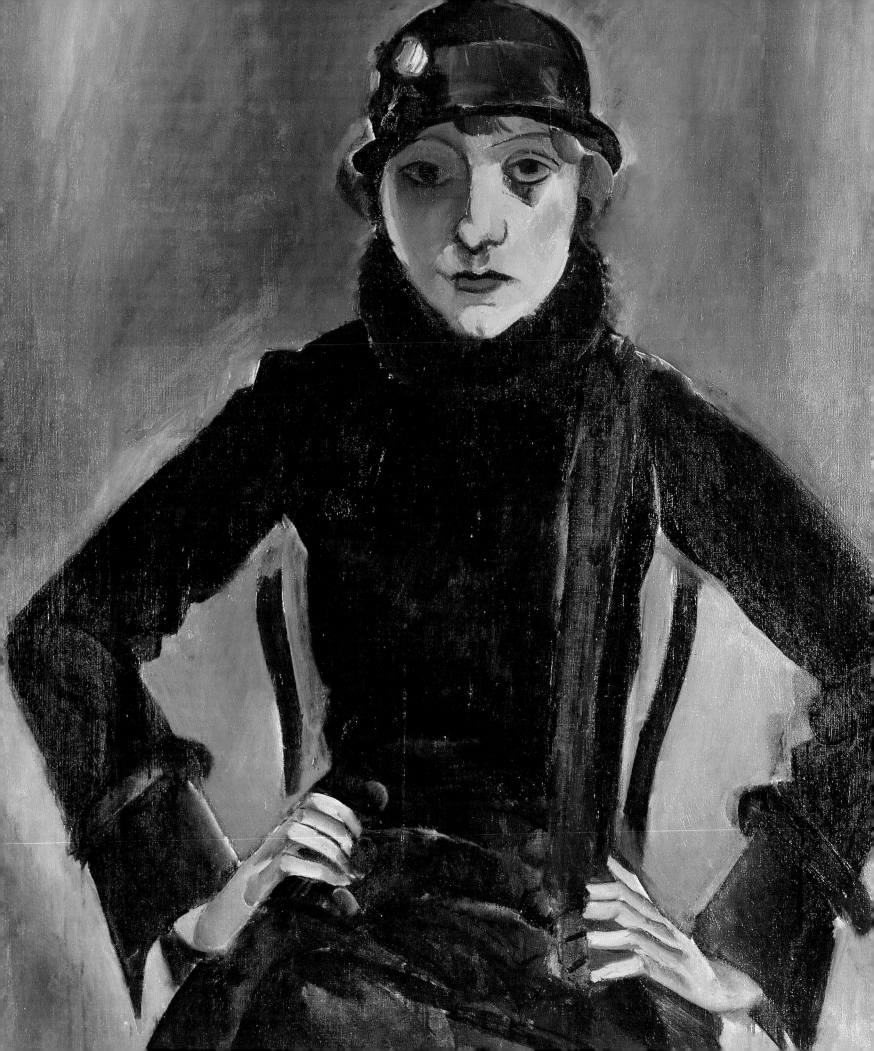

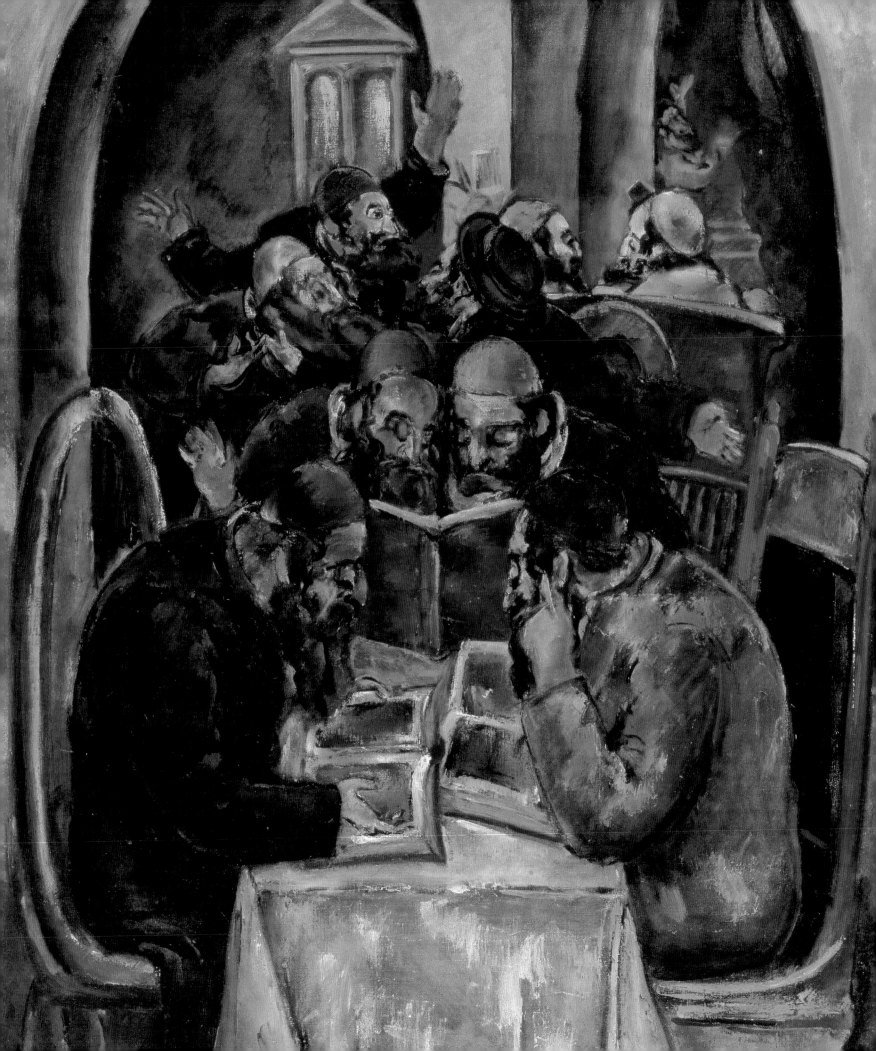

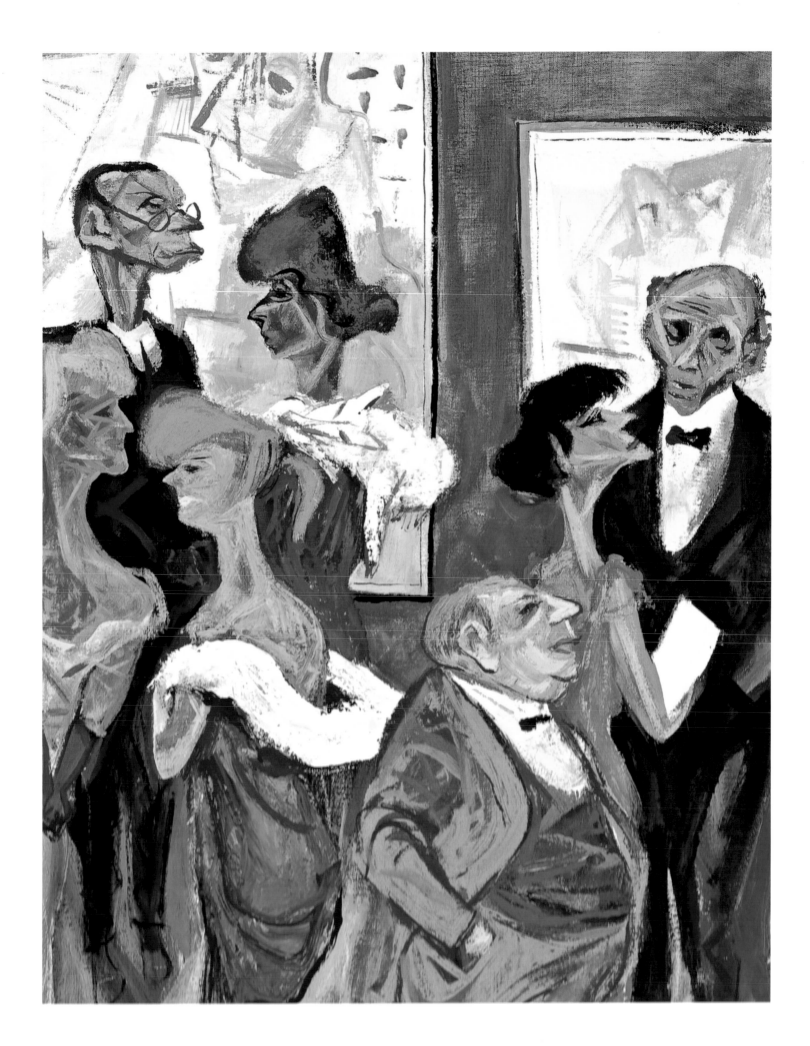

Foreword

In October 2008, I traveled to Kazimierz Dolny, a charming little artist's town on the Vistula, to give a paper at the First Congress of Jewish Art in Poland. The venue was well chosen. A number of Jewish artists had worked in Kazimierz Dolny in the years before the war, and it had also been the location for the celebrated Yiddish films *Yidl Mitn Fidl* and *The Dybbuk*, both of which were screened during the congress.

It was there that I first met Eliane Strosberg and found out about her recent publication *Human Expressionism: The Human Figure and the Jewish Experience* (the first edition of this book) and the accompanying exhibition. Over the three days of the congress, we had many conversations, and so of course I was in the front row to hear her paper on the subject of her book. The congress itself was a won-derful opportunity to see scholars from all over Europe, Israel, and America present papers on many aspects of Jewish art, and I had made copious notes on many subjects, but it was Strosberg's lecture that had me scribbling in my notebook the most. As she demonstrated that in the twentieth century, Jewish artists had almost exclusively painted the human figure and introduced arguments as to why this was, I excitedly thought of new articles and lectures that I could write based on her ideas. I lecture regularly on the work of Jewish artists, but my talks tend to explore the lives and works of artists from similar backgrounds working in the same country. Suddenly I saw myself giving a new series of lectures based on subject matter instead: the Jewish self-portrait, and portraits of Jewish mothers, the family, or artist colleagues. There would also be room for a lecture

on Jewish artists who, inspired by their sense of social justice, painted works highlighting the plight of the poor.

Our conversations continued back in London, where Strosberg was one of a panel of speakers discussing issues of Jewish identity in art at Jewish Book Week in February 2009. I duly purchased my ticket for the event, but ended up on the panel when my fellow art critic Jackie Wullschlager, who writes for the *Financial Times* and had recently published a biography of Marc Chagall, was prevented from taking part due to illness. The debate with art critic Andrew Renton and writer Monica Bohm-Duchen was fascinating, and the audience wanted to continue the discussion well beyond the one hour stipulated for the talk.

One of Strosberg's main arguments is that Jewish artists continued to paint the figure throughout the twentieth century, when so many other artists were turning away from figuration to abstraction. Through our discussions, we realized that although some Jewish artists were major proponents of abstraction (Mark Rothko and Barnett Newman being the foremost examples), many others had experimented with abstraction only to return to figurative painting. These artists include such luminaries as Avigdor Arikha, who did not paint for eight years after seeing a Caravaggio exhibition in Paris and since then has only painted directly from the subject. There was also Max Weber: although he was one of the artists responsible for introducing Cubism to the United States, after the death of his father he began painting Jewish subjects, including *The Talmudists* featured in this volume (plate 92). Perhaps the best known example, however, was Philip Guston, a close friend of Jackson Pollock who, despite inviting scorn from some of his contemporaries for his decision, turned his back on Abstract Expressionism in order to return to telling stories through art.

In the meantime, I had received a copy of Strosberg's original book, which I reviewed for the *Jewish Chronicle*, where I have been a contributor for over fifteen years. I was amazed at the scope of the book: though it concen-

trated on the twentieth century, it also explored the history of Jewish art over two thousand years, refuting the idea that the Second Commandment's injunction against graven images had prevented Jews from producing figurative art.

I learned a great deal from the book and in my review, my only criticism was that in places, Strosberg attempted to fit in too many artists; I preferred the passages in which she was able to analyze the lives and works of her subjects in greater detail. Of course, the first edition was published to coincide with an exhibition held at the Musée Tavet-Delacour in Pontoise, so the choice of artists to be included was partly dictated by the works that were available for the exhibition. I am therefore so delighted that the book is being reprinted in this extended format, which has allowed Strosberg the opportunity to expand on many of her ideas and add a number of new artists and illustrations. Since the aforementioned exhibition was held in France, the artists of the École de Paris do somewhat dominate the text of the first edition. Here, Strosberg has managed to redress the balance and focus more on the situation in the United States, finding room to include some of my favorite artists, such as Ben Shahn and Jack Levine. She has also developed her discussion of the School of London, and I am flattered that my suggestion that she include the work of Frank Auerbach alongside that of his contemporaries and friends Kitaj, Kossoff, and Freud has been taken up. A new section discussing recent work by Jewish artists from Russia has also been added.

I have very much enjoyed reading through Strosberg's revised text and in particular, using her footnotes to further my own reading about artists. I am greatly honored to have been asked to contribute this foreword, and in the same way that I recommended the first edition of this book to the readers of the *Jewish Chronicle*, I now commend this new edition to you.

Julia Weiner, August 2009

Preface

Because the history of art is studied in terms of nation-states, the strength of Jewish art, which is not bound by borders, has been overlooked. The artistic representation of the human figure is already mentioned in the Bible, and Jewish art can be found throughout antiquity and the Middle Ages, although little is known about its creators, who may or may not have been Jewish themselves.

In modern times, numerous Jewish artists have sought to reconcile their traditions with the social and artistic utopias presented by society at large. This book focuses on how the Jewish background of these artists has fed into their creation of works centered on the human figure. It does not discuss the aesthetic aspects of their art, which have been dealt with in other studies.

The majority of the artists considered here stayed away from, or only briefly participated in, radical art movements such as Cubism or Surrealism. In fact, the term "École de Paris" was invented to describe the multinational community of artists in that city who did not subscribe to the avant-gardes. Their work, which often revealed expressionistic tendencies, has been described as "independent art, without the convenient repetitions of a school, [which] must recreate everything for itself. . . . It is led into making a much closer contact with the past."[1] Similar comments

10
Camille Pissarro (1830–1903)
Self-portrait with Beret and Spectacles, c. 1896
Oil on canvas, 14 × 12⅝ in. (35.5 × 32 cm)
Private collection

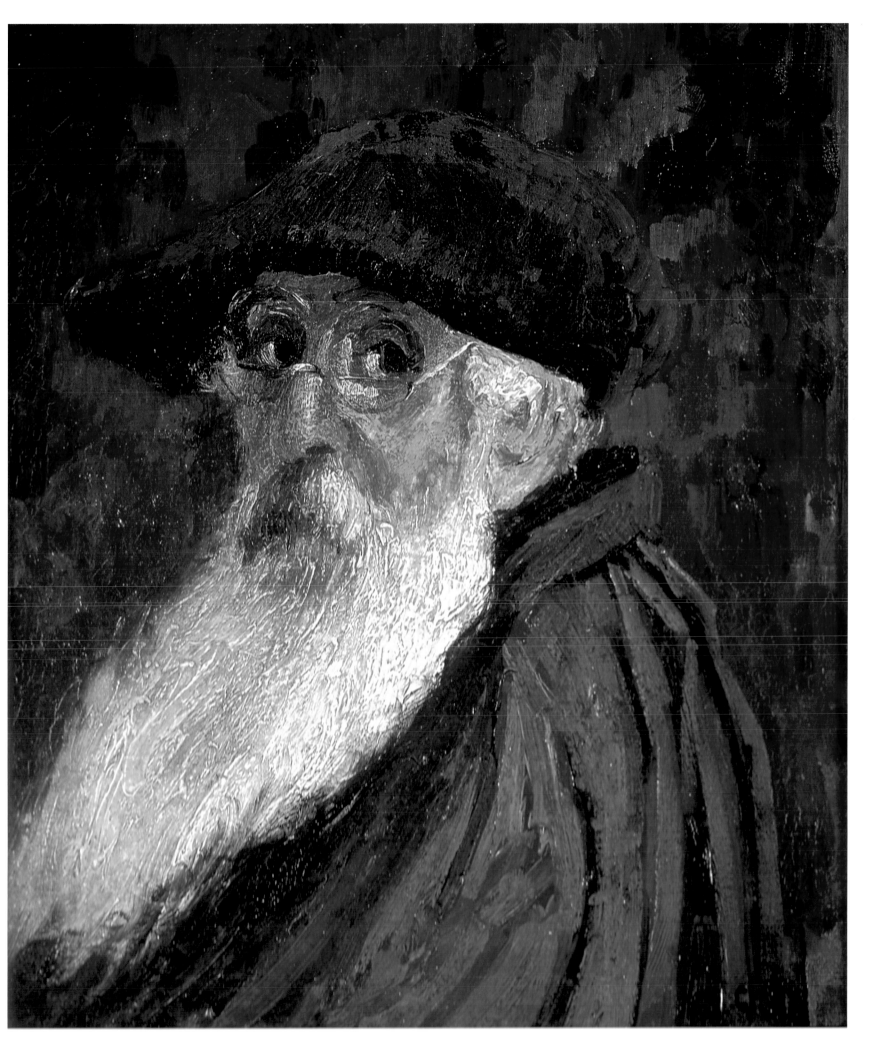

have been made about the artists of the School of London and the American Social Realists.[2]

But what, beyond this independence, did Jewish artists in Paris, London, and New York have in common? They were immigrants who shared more with one another, initially, than they did with their host culture. As their deep-seated loyalties were gradually transferred, Talmudic erudition was transformed into humanistic concerns.

A further perspective is provided by the artist Saul Raskin, who wrote in Yiddish in 1911, "It is very difficult to find a common core, and to predict the main road which Jewish artists will take. They are too diverse in their technique . . . and in the expression of their artistic ego. It seems that to answer our question we do not need to look at 'how' but at 'what themes' they paint, and, even better, the themes they avoid."[3] Here it is interesting to note that the artists discussed in this book rarely employed Jewish motifs, if at all.

The first part of our study is a summary of the Jewish experience, describing the artists' mind-set, and the second is an overview of Jewish art before the Enlightenment. The third and fourth parts survey the treatment of the human figure by modern Jewish artists, beginning with Camille Pissarro, who for a long time believed in making only "a disinterested art of sensation" but was forced to confront "a matter of race" in the wake of the Dreyfus affair (plate 10). Some major artists we will discuss only in passing, in order to devote more attention to several figurative painters who were successful in their own time but were later pushed aside by modernism: David Bomberg and Mark Gertler in the United Kingdom, Max Liebermann in Germany, Jules Pascin and Moïse Kisling in France, and Raphael Soyer in the United States. Recent monographs have shed light on these artists, while many others still await recognition.

The artists discussed herein rarely explained the part that the Jewish experience played in their multilayered creativity. However, philosophers, critics, and other cultural figures provide essential clues in their descriptions of the context in which these artists worked, which was mostly anti-Semitic. To properly interpret their writings, we must keep in mind that there are two ways of looking at the history of the Jews. Viewed from an external perspective—that is, as a record of how they fared over time—their history is certainly marked by its share of grief. But from an intrinsic perspective it appears quite different, even joyful at times. This is because the true home of the Jews is the timeless system of values designed to make their exile meaningful, animated by the belief that one has been elected by God (or by one's mother).

Education and social solidarity ensured the survival of the community, and family bonds were strong, with the mother being the matrix of life and the child symbolizing hope. In nearly every biography of a Jewish artist, at least one parent is shown to have supported his or her child's wish to study art, despite difficult circumstances.[4]

The Jewish tradition of education also produced a deep sense of responsibility toward fellow artists: Pissarro and Modigliani in Paris or Frank Auerbach and R. B. Kitaj in London behaved as role models, treating their colleagues like members of the family.

Surely the passion for social justice shared by many Jewish artists relates directly to the lessons of the Bible, just as the cult of freedom expressed in the Sabbath, Hanukkah, Purim, and Passover rituals played a role in their independent artistic choices. But can their distance from modern-art movements be linked to their heritage of exile and alienation? Does their passion for books explain why they could never abandon narrative in their art? Does the fact that they had only recently gained access to classical literature relate to their preference for classical painting? Each of these questions deserves a study of its own.

As if to capture the unpredictability of their surroundings, many of these artists established a routine of drawing. In a century in which art did away with the human figure altogether, they painted from live models as a way

to hold on to humanity. This book explores how Jewish artists used the human figure to express love, hope, grief, alienation, and, above all, an aversion to the nihilism favored by most avant-gardes.

Their initial attraction to figurative art may have been a reaction against its prohibition in the shtetl. At the same time, the urge to paint their mothers, children, friends, and social milieu, or to endlessly explore human nature through self-portraits, stems mostly from their Jewish experience and values. Furthermore, family members were cheap models, and portraiture was not under gallery contract. (But then, who would buy such sad and unflattering portraits?)

The fascination that Jewish artists displayed for their host city, whether it was Paris, London, or New York, complemented their attachment to the human figure as a means of self-expression: the city was where they built their new identity.

Although their frequent conjunction among the Jewish artists of the last century is noteworthy, obviously none of the traits mentioned above were restricted to Jews alone. Nor were the lessons of the Hebrew scriptures exclusive to Jewish artists, whose heroes, like Rembrandt, Van Gogh, or Giacometti, though not Jewish themselves, had also been raised on the Bible.

A first version of this study was published in France in 2008, accompanying the exhibition *Human Expressionism* at the Musée Tavet-Delacour in Pontoise. The exhibition was curated by Christophe Duvivier, director of the Musées de Pontoise.

Introduction

Thou *shalt* make a graven image

The briefest survey of Jewish art reveals that the taboo against the "graven image" found in the Second Commandment signified far less over the centuries than is generally imagined.[5] Jews decorated their sanctuaries, embellished their ceremonial objects, and illustrated their texts with the intent to glorify God, who is never himself depicted. What the Bible forbids is idolatry, but not the making of images generally suited to religious purposes.

Art has a prescribed place: ornamentation is expressly sanctioned by the scriptures in the verse, "This is my God and I will adorn him." The Bible further describes the ornate Tabernacle built by Bezalel, who is praised for his wisdom and his piety, as well as for his skills "in all manner of workmanship."[6] King Solomon himself ignored the Second Commandment when he built the Temple, installing therein an imposing bronze fountain resting on twelve sculpted oxen.

During the periods of the First and Second Temples (the tenth century BCE and first century CE, respectively), the graves of Kohens, the priestly class, already bore a carving of a pair of hands raised in the act of delivering a benediction. A washbasin or musical instrument marked the graves of Levites, because they washed the priests' hands before prayers and accompanied the ritual with songs.[7] Some Jewish sarcophagi found in Roman catacombs were lavishly decorated: one bears three-dimensional putti, angels, and other figures in high relief alongside Jewish symbols.[8]

Whether we consider antique mosaics, medieval

illuminations, or Renaissance candelabra, the function of these objects was largely the same: they were artworks made for worship, and as such played an integral part in Jewish life. Traditionally, the Passover Haggadah and the *Ketubah*, or wedding certificate, were lavishly illustrated. Within the religious context, even nudity could be represented, as is indicated by a rare image in a medieval Hebrew manuscript showing a naked woman taking a ritual bath, or *mikvah*, while her husband waits in bed (plate 11).

In the twelfth century, pious Jews in Germany requested that animals be used to represent humans. On first entering the sixteenth-century Mohilev synagogue, El Lissitzky (Eliezer Markowitz Lissik) wrote, "The walls were painted [with] . . . fish hunted by birds; the fox carrying a bird in his mouth; birds carrying snakes in their beaks; a bear climbing a tree in search of honey; and all intertwined with acanthus plants that bloom and move on the walls of the wooden synagogue. Behind the masks of four-legged animals and winged birds, there are the eyes of human beings."[9] (Legend has it that the Chaim Segal who painted these walls was an ancestor of Marc Chagall [Mark Segal].)[10]

The graves of Polish Hasidic masters were protected by a hutlike edifice, and in the wake of the mid-seventeenth-century massacres, one observes a rush toward baroque ornamentation.[11] Around the same time, in the Netherlands, wild artistic license was taken, as is shown by the tomb statues of Portuguese Jews at Ouderkerk (plate 12).[12] Less elaborate are the distinctly anthropomorphic tombstones found in the Jewish cemeteries of the coastal cities of Morocco. In Jewish art, as in that of every monotheistic religion, iconoclastic periods alternated over the centuries with periods of great openness.

In the nineteenth century, Jewish painters became active in significant numbers in England, France, and Germany. Culture was among the major criteria by which people were classified into nations: in Germany, where art history took shape, it was deeply intertwined with nationalism. Writers pointed out the perceived contrast between the

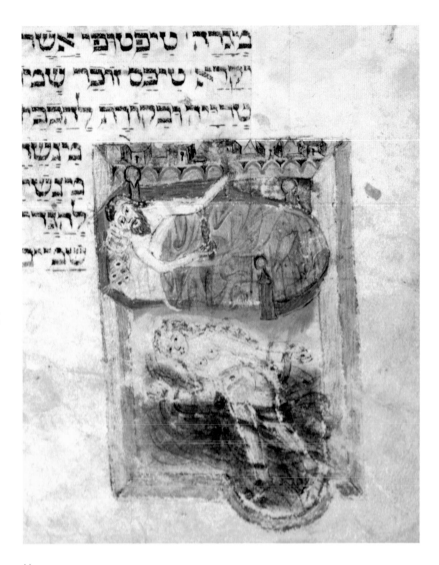

11
Ritual Bath
Hebrew manuscript, 1427
Staats- und Universitätsbibliothek, Hamburg

races: "Understandably the Orient, crippled by anti-artistic Semites, ultimately succumbed to the Great Germanic artistic flowering in the North."[13]

Philosophers of the time viewed the Jews as a people against art. When it came to Judaism, the otherwise enlightened Immanuel Kant called for euthanasia.[14] Hegel consid-

12
Mordekhai Riding a Horse
Tombstone relief, eighteenth century
Cemetery of the Jewish Portuguese Community, Ouderkerk,
Netherlands

ered that "the spiritual emptiness of the Jews was reflected
in the emptiness of their creations. . . . They despise the
image because its beauty brings them no pleasure. . . ."[15]

The Jewish writer Heinrich (Hayim) Heine, who under-
went a lukewarm conversion, poignantly addressed the
theme of Jewish aniconism. Two years before his death,
he acknowledged that Judaism was not without an art of
its own: "Moses, despite all his hostility to art, was him-
self a great artist and possessed the true artistic spirit. In
his case, as in that of his Egyptian countrymen, it was di-
rected solely toward the colossal and the indestructible.
But unlike the Egyptians, he did not fashion his works
from baked brick and granite. He built human pyramids
[*Menschenpyramiden*]; he carved human obelisks; he took a
poor shepherd tribe and from it, he created a people that
. . . could serve as a prototype of humanity. . . ."[16]

Sigmund Freud considered aniconism, far from a
symptom of deficiency, to be a sign of Jewish virtue: "The
prohibition against making images of God was bound

to exercise a profound influence, for it signified subordinat-
ing sense perception to an abstract idea. . . . Through the
Mosaic prohibition, God was raised to a higher level
of spirituality."[17]

In the twentieth century, some artists and historians
started to reclaim the Jewish aspects of their work. In his
essay on Chagall's *Illustrations for the Bible*, Meyer Schapiro
wrote that it was "because of Chagall's Jewishness that
the artist surmounted the limits of his own and perhaps
all modern art. . . . Jewishness kept him in touch with the
full range of his emotions, unlike other modern painters,
whose enthusiasm for new and revolutionary possibilities
of form . . . led them to exclude large regions of experience
from their work" (plate 13).

According to Donald Kuspit, for Schapiro "the creative
artist is also a survivor, that is, a person who can establish
an identity and sense of self and individuality against great
odds. . . . This way, the Jewish Paradox is the root Paradox
of art" and "the best art is a sign of searching conscience."[18]

Is there a Jewish art?

Chagall once said, "[If] I were not a Jew . . . I would not
be an artist at all, or I would be someone else altogether.
I know quite well what this small people can accom-
plish. When it wished, it brought forth Christ and Chris-
tendom. When it wanted, it produced Marx and socialism.
Can it be, then, that it would not show the world some
sort of art? Kill me, if not."[19] Having earlier denied the
prospect of Jewish art, Chagall came to affirm it.

Gabrielle Sed-Rajna has described how Jewish art has
been profoundly susceptible to the host culture's influence.

13
Marc Chagall (1887–1985)
Blue Landscape, 1949
Gouache on paper, 31⅛ × 22⅜ in. (79 × 57 cm)
Von der Heydt Museum, Wuppertal, Germany

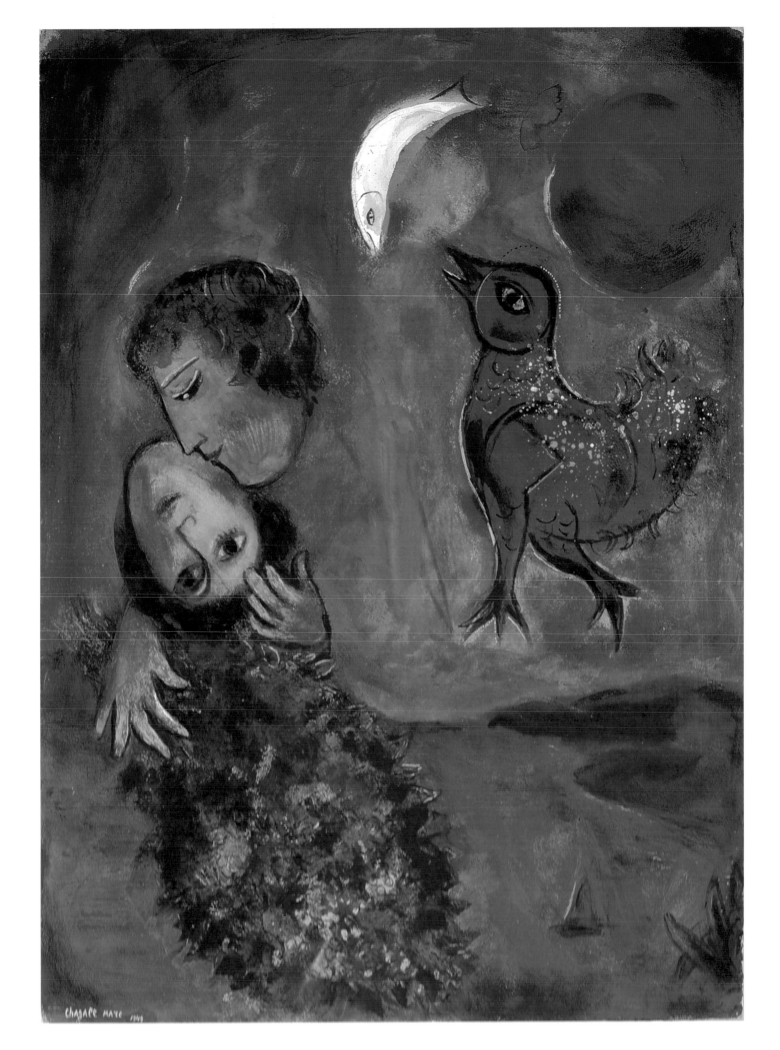

14
Amedeo Modigliani (1884–1920)
Portrait of Diego Rivera, 1914
Pencil on paper, 13⅜ × 10⅜ in. (34 × 26.5 cm)
Private collection

until the eighteenth century, Jewish art was composed of two main elements: narrative iconography and the representation of symbols destined to preserve the unity of the Jewish people. The Enlightenment, which brought Jews out of isolation, encouraged them to broaden their choice of themes. The father of the Enlightenment, Moses Mendelssohn, said that it was advisable "to be a Jew on the inside and a man on the outside."

Susan Tumarkin Goodman describes how widespread migration to cities, where Western culture flourished, coincided with a quest for new forms of expression.[22] As they intersected with the broader society, artists transmitted aspects of their Jewish life combined with their secular experience. Moritz Oppenheim, the painter of the Rothschilds and "the Rothschild of painters," was a perfect example. His *Bilder aus dem altjuedischen Familienleben* (Family Scenes of Jewish Life from the Past, 1865), was the most popular book in Jewish homes for half a century.

In England, Solomon Alexander Hart, the first Jewish member of the Royal Academy, alternated between Jewish themes and scenes from European history. In France, Edouard Moyse and Edouard Brandon were the earliest artists to treat Jewish life in their paintings.

Artists in the East became increasingly familiar with Western art through the work of their own masters: Lovis Corinth in Berlin, Josef Pankiewicz in Krakow, Ilya Repin in St. Petersburg, and such Jewish painters as Yehuda Pen in Vitebsk, Adolf Fenyes in Budapest, and Boris Schatz in Sofia. With massive immigration, artists turned to the predicament of the homeless. Samuel Hirszenberg's *Wandering Jew* won a bronze medal at the 1900 World's Fair in Paris.[23]

At the turn of the twentieth century, Jewish artists started to address the question of acculturation. Throughout their work shines a deep sympathy for the disadvantaged: to be meaningful, art had to provoke thought about social issues, and eventually national issues as well. In 1901, at the Fifth Zionist Congress in Basel, Martin Buber asked,

Since Roman times, Jews had been dispersed in isolated congregations, dependent on the material conditions of their environment. Jews held on to their motifs, but adopted and adapted local techniques and styles.[20] They sometimes borrowed non-Jewish motifs, too.[21]

The same observation holds for medieval art, in which a continuity of themes contrasts with a diversity of styles;

15
Lasar Segall (1891–1957)
Lucy VI, 1936
Oil on canvas
23 × 15¾ in. (58.5 × 40 cm)
Centre Georges Pompidou, Paris

"Is Jewish art possible today? No . . . A national art needs a soil from which to spring and a sky toward which to rise."[24] In this vein, the Bezalel Art School, founded in 1906 in Jerusalem, encouraged artists to paint idyllic landscapes in an Orientalist and modernist style.[25]

Meanwhile, exhibitions featuring Jewish artists were mounted in London (1906), Berlin (1907), Warsaw (1911), and Moscow (1918).[26] As the artists who participated in these shows did not focus on Jewish subjects, none of them can be seen as strictly "Jewish artists," but neither can their roots be ignored.[27]

Human expressions

A dozen Jewish painters were known in Europe at the end of the nineteenth century; a decade later, this number had increased by a factor of ten. In the École de Paris, most embraced a figurative style; the art critic Waldemar George (Jarocinski) referred to their art as a form of Neo-Humanism.

Sophie Krebs, curator of the 2001 exhibition L'École de Paris, 1914–1929, considers this school to be almost synonymous with humanistic figuration.[28] She attributes the prevalence of expressionism among its artists to Chaim Soutine's influence. It is noteworthy that Soutine, whose oeuvre is considered the embodiment of Jewish angst, never once painted a traditional Jewish subject.

Critics fell into the trap of ethnicization, labeling the artists who flooded Montparnasse as expressionists, a term then synonymous with "Hunlike barbarians." Conspicuous among their so-called Jewish features were a nervous handling of line and paint, suggesting an ignorance of academic tradition; an emphasis on social conscience and

16
Ra'anan Levy (b. 1954)
Essential Self-portrait, 2007
Oil on canvas, 47 3/4 × 41 3/4 in. (121.5 × 106 cm)
Private collection

moral seriousness; and a reluctance, if not inability, to accept the idea of "art for art's sake," the modern equivalent of the biblical fear of idolatry.

But long after this anti-Semitic stigmatization vanished, Jewish artists were still described as expressionists. For example, art historian Michel Hoog wrote in 1988 that "the search for expression dominates their stylistic concerns; freedom of personal expression supersedes theoretical speculation—such were the common intentions of these artists, many of whom escaped oppressive regimes."[29]

In the catalogue of the 2004 New York exhibition *Beyond the Myth*, one reads that "Amedeo Modigliani searched for an ideal form that melded classicism with an expressionist or modernist sensibility. . . . One need only look at the study for the portrait of Mexican Muralist Diego Rivera (1914), with its circularity both exploding outward and drawing the viewer into the center, or at any number of his large caryatid drawings to see these basic instincts wedded" (plate 14).[30] Another recent exhibition on Russian Jewish artists still underlines "many similarities with mostly dark moods and colors with dramatic expressivity."[31]

Although the term "expressionism" is protean, it usually refers to German painters, whom the cultural historian Bram Dijkstra characterizes in this way: "Their message . . . is profoundly anti-humanist: it is driven by hatred of, rather than compassion for humanity. There are of course numerous exceptions, best of all the intense and always moving Käthe Kollwitz. . . . The same could be said for Paula Modersohn-Becker. There is also the subdued, yet festive color and form of Gabriele Münter and Marianne von Werefkin, and the incipient social humanism of other figures of the 'second generation' of expressionists, such as Ludwig Meidner and Felix Nussbaum. . . ."[32] It is of remarkable interest that the mentioned exceptions are either female or Jewish.

Yet expressionism clearly cannot be restricted to German art. Describing how American expressionism differs most dramatically from its German counterpart, Dijkstra

quotes the critic John I. H. Baur: "Doubtless, the fate of man is the most thoughtful theme." According to Baur, the work of many American artists is linked by a "specifically humanistic expressionism," recognizable through its "deep preoccupation with spiritual and psychological values and its use of organic rather than angular distortions."[33]

Social Realism reflected on the New Deal in the United States, as Socialist Realism did on the Soviet regime. In France, the Front Populaire was represented by the art of Fernand Léger. Italy had a variety of expressionist painters, most notably Renato Guttuso. After World War II, the human figure gained an added resonance from the ideas of the French existentialists, which were addressed by artists such as Giacometti. He, along with another major figurative painter, Balthus (Balthazar Klossowski), would significantly influence young artists across the Channel.

The School of London was put on the map by the 1976 exhibition *The Human Clay*. In its catalogue, the painter R. B. Kitaj wrote, "There will always be pictures whose complexity, difficulty, mystery will be ambitious enough to resemble the patterns of human existence." In Britain, the human figure continued to challenge the transience of life.[34]

And even when the American art scene was fully dominated by abstract painting, Social Realists like Raphael Soyer persisted in their disdain for abstraction: "My art is representational by choice. In my opinion, if the art of painting is to survive, it must describe and express people, their lives and times. It must communicate. Non-objective art does not do all that. It is a kind of decoration, a personalized decoration at its best. . . . [Art] must communicate. It can do this only by showing figures."[35]

Rembrandt, the prototype

Human expression has been at the core of Western art, as can be seen in the works of El Greco, Velázquez, or Van Gogh. German sociologist Georg Simmel explained the role of the human face: "There is no other figure which provides such multiplicity of form: this extreme individualization allowed for the development of the figurative to form the basis of western art."[36] European Jews started to commission their portraits in significant numbers in the nineteenth century. Max Liebermann in Germany, Solomon J. Solomon in England, Ernst Josephson in Sweden, and Jacob Meyer de Haan in the Netherlands emphasized the seriousness of their profession through numerous self-portraits.

The traditional view of the fully integrated person was then compromised by a perceived decline of Western values.[37] Torn between their variegated identities, Jewish artists became particularly overrepresented in portraiture and self-portraiture.[38] The catalogue of the 1993 exhibition *Kikoïne et ses amis de l'École de Paris* states that "the conquest of the human figure was one of their main achievements. This is why portraiture was so important to many of them. Rembrandt, before them, constantly interrogated his own image through self-portraits."[39] He became the referential painter for these Jewish artists.

Soutine, Modigliani, Kitaj, and others often produced "type" portraits as if to better capture the essence of humanity.[40] Still, these prototypes always retain something of the sitter. Just as Jews struggle with the tension between the universal and the particular in their faith, their art has oscillated between art object and human subject.

17
Serge Strosberg (b. 1966)
Tenderness, 2007
Oil and tempera on linen, 38¼ × 51¼ in. (97 × 130 cm)
Collection of the artist

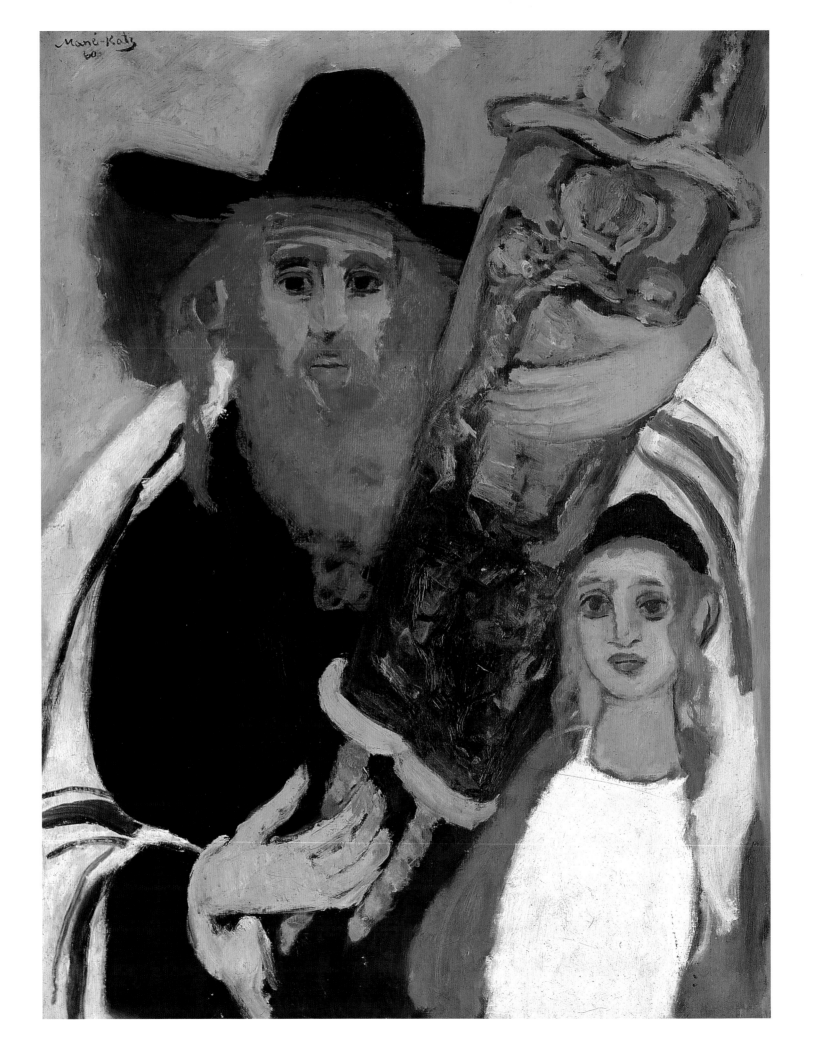

1.
The Jewish Experience

Who is Jewish?

While a thousand books would not suffice to explain what a Jew is, we know for sure that we are not a race, as history reveals countless additions to our number through marriage and conversion.[41] Further problems of identification emerge because there are infinite types of Jews—Israeli versus Diaspora, Ashkenazic versus Sephardic, orthodox versus liberal or reformed—who share only the kernel of Judaism: monotheism, reason, ethics, and universalism. Ethiopian Jews, who lived in isolation in the mountains, were surprised when they discovered that they were not the only Jews: there were others, and they were white!

According to the Jewish religion, anyone born from a Jewish mother is Jewish; another definition might be that a Jew is one who accepts the faith of Judaism. What about the nonreligious Jew, then? A saying tells us that there are two types of Jewish atheists: those who simply do not believe, and those who disbelieve with an almost religious fervor. Of the latter kind, we have a disproportionate number, including Spinoza, Marx, and Freud.[42] In a classic joke, the atheist Jewish father explains religion to his son as follows: "I'm going to tell you something now and I want you never to forget it. There is only one God—and we don't believe in him!"

A century and a half ago, assimilated Jews converted because they recognized that adherence to Judaism, whose rituals they had forgotten, led to a social disability. Heinrich Heine called baptism the "entry ticket to European

19
Emmanuel Mané-Katz (1894–1962)
The Dreamer, n.d.
Oil on canvas, 7⅞ × 6 in. (20 × 15 cm)
Private collection

Incognito ergo sum (I am invisible, therefore I am)[45]—becoming "the non-Jewish Jew" who, according to Marxist historian Isaac Deutscher, does not relate to anything Jewish, yet does not accept being denied his Jewishness, either. Still, the traces of a Jewish childhood could not be erased, even though, with some exceptions—such as Marc Chagall, Emmanuel Mané-Katz (plates 18, 19, 23), or Ben Shahn—the majority of twentieth-century artists born into practicing families did not produce art directly inspired by religion.

A wake-up call

Assimilated Jews were regularly reminded of their origins by each new strain of constantly mutating anti-Semitism, whether theological, racial, social, or economic. When Alfred Dreyfus lost his stripes in Paris in 1895, a young Hungarian journalist, Theodor Herzl, horrified by the cries of *mort aux Juifs* (death to the Jews), was driven to become the founder of Zionism. Camille Pissarro was forced at the same time to ask himself whether anti-Semites were right, and if his race was in some way impeding his search for an "art of sensation." His initial response was to distance himself from his coreligionists.[46]

On the other hand, the German Expressionist Ludwig Meidner returned to Jewish sources by painting the prophets. Events would also catch up with Max Liebermann, "the Manet of the Germans," when his work was associated with "degenerate art." In reply to an invitation to immigrate to Palestine, he wrote, "I always stood far from Zionism. Today, I think otherwise. I have awakened from my dream, which I dreamt my entire life. Next month I will be eighty-six years old, and since I am unfortunately such an old tree, it is impossible to transplant me."[47] R. B. Kitaj insisted that even an agnostic Jew like himself was defined by the past: "Jews and what happens to them fascinate me more than Judaism. The phenomenal history of anti-Semitism tantalizes me more than a faith I never knew."[48]

20
Louis Marcoussis (1878–1941)
Self-portrait, 1940
Etching, 7⅞ × 7¾ in. (20 × 19.7 cm)
Musée de Pontoise, Pontoise, France

culture." Jews converted in massive numbers: for example, Arnold Schoenberg, Max Jacob, Mela Muter (Mutermilch née Klingsland), Eugène Zak, and Louis Marcoussis (Markus) (plate 20), just to name a few artists. Some changed their names, and others, like Balthus, denied their Jewishness by inventing a new persona.

Marx provided vicious arguments for leftist anti-Semitic propaganda.[43] The art critic Clement Greenberg went so far as to express *Selbsthass*, "self-hate."[44] Others kept the lowest possible profile—as Sidney Morgenbesser put it,

Victim and host

At the time of the destruction of the Second Temple in the first century CE, the Jews numbered some eight million people, and represented up to 20 percent of the population in some cities of the Roman Empire.[49] Today's thirteen million Jews account for less than 0.25 percent of the world population. From the experience of the Babylonian and Roman exiles, the Crusades, the Inquisition, pogroms, and jihads, one can assume that "every Jew has a Holocaust within him; in his innermost heart he has gone up in smoke or been starved to death, after being castrated by society."[50]

The Passover ritual says, "It was not one man alone who rose against us to destroy us. In every generation there are those who rise against us to destroy us." The twentieth-century painter Philip Guston wrote, "Our whole lives . . . are made up of the most extreme cruelties of holocausts. We are the witnesses of hell. When I think of the victims, it is unbearable. To paint, to write, to teach, in the most sincere way, is the most intimate affirmation of creative life in these despairing years."[51]

Jews survived in the face of relentless persecution because there was always an enlightened ruler who found them to be of use. In Roman times, Julius Caesar and Augustus protected the Jews, as did Charlemagne in the Middle Ages; Casimir the Great attracted the Jews to Poland after the German massacres; Bayazid II and Süleyman the Magnificent hosted the Jews in Turkey; likewise, the Medici invited those who fled the Roman Inquisition to establish commercial activities in Livorno. In Prague, Rudolf II granted protection to the Jews and authorized them to enter into the trades; Cromwell brought them back to England; and in France, Abbé Grégoire was instrumental in their emancipation.

Enlightened philosophers also supported the Jews. Blaise Pascal wrote, "In certain parts of the world we can see a peculiar people, separated from the other peoples of the world, the Jewish people. . . . For whereas the people

of Greece and Italy, of Sparta, Athens and Rome, and others who came so much later have perished long ago, these still exist, despite the efforts of so many powerful kings who have tried a hundred times to wipe them out. Their preservation was foretold. My encounter with this people amazes me. . . ."[52] Denis Diderot, too, admired the industriousness of the Jews, viewing it as a positive link among the European nations.[53]

The multifaceted Jewish experience, drawn from the centuries passed in so many different countries, includes that of Greek philosophers, Arab scientists, Spanish poets, Polish legalists, Italian mystics, German philosophers, and American entrepreneurs whose wisdom is still at work.

Memory of a chosen people

The real meaning of "chosenness" in the Jewish tradition is perhaps best expressed in one biblical verse: "You only, have I known of all the families on the earth, therefore will I visit upon you all your iniquities."[54] Jews are well represented in all forms of criminal activity—smuggling, theft, and the slave trade, even though they were slaves themselves. "Each Jew knows how thoroughly ordinary he is; yet taken together, we seem caught up in things great and inexplicable. We remain bigger than our numbers."[55]

To understand Judaism, one must examine the broad philosophy that underlies its faith; Jewish beliefs are organized undogmatically: there is no catechism.[56] Judaism is primarily concerned with what God wants us to do, not what God wants us to believe; we talk about behavior, not doctrine. Seeing Moses at the shore of the Red Sea, praying for deliverance from the pursuing Egyptian army, God might well say, "Stop praying. . . . Do something!"[57] With that, one brave man jumps into the raging sea, and only because a human dares to act do the waters split apart.

Jewish decision making is practical; rabbis are not supposed to establish rules that people cannot obey. The adjustments in ritual over the centuries are of little

consequence compared to the values that have kept Judaism alive. Jews feel that they are a vertical people, linked to both their ancestors and their descendants through a covenant, dedicated to ideas; they see each other as "letters in the scroll."

Jews have seen history as a journey and have never stopped searching. Over the course of two thousand years, they remained a kind of nation without any of the prerequisites of nationhood: no land, no sovereignty, no power, no organized political structures, not even a shared culture. They were front-row spectators at the rise and fall of Egypt, Assyria, Babylon, Persia, Greece, and Rome, yet historical works written by Jews were few in number. The authors of the Book "were indifferent to chronology and regarded all Jewish experience as contemporary: past and present are one," Yosef Yerushalmi, an American scholar, wrote about Jewish collective memory. "We are struck by the primacy of liturgy and ritual over historical narrative, and by the power of commemorative observance to preserve the essential memory of an event, without necessarily preserving its historical details."

The word *zakhor*, "remember," is used throughout the Hebrew Bible.[58] These admonitions to remember would have been of no avail if the narratives had not been canonized as the Torah (literally, "teaching"), or Pentateuch, the first five books of the Bible.[59] While the historical works of gentile nations are generally chronicles of wars,[60] the invocation of memory in the Bible is rarely actuated by the desire to preserve heroic deeds. Ironically, many of the narratives seem almost calculated to deflate pride.[61]

One finds a key to understanding the melding of the personal and the universal experience in the words of Ben Shahn: "At that time I went to school for nine hours a day, and all nine hours were devoted to learning the true history of things, which was the Bible. . . . Time was to me, in some curious way, timeless. All the events of the Bible were, relatively, part of the present. Abraham, Isaac, and Jacob were 'our' parents, certainly my mother's and fa-

ther's, my grandmother's and grandfather's, but mine as well. I had no sense of imminent time and time's passing."[62]

The language of exile

The condition of being in exile means that you "schlep," dragging yourself from one day to the next, painfully aware that any episode of prosperity is likely to be brief. R. B. Kitaj treats the subject of exile as a "way of life and death" in defining his Diasporist art, of which Modigliani's work may be seen as a precursor.[63] Kitaj wrote, "Painting is a great idea I carry from place to place. It is an idea full of ideas, like a refugee's suitcase, a portable Ark of the Covenant. . . ."[64] An essay on Kitaj's work notes that "while the exile looks back nostalgically, the Diasporist is not torn between past and present. His burden is not that things were once better, but that things are always as they were."[65]

The psychoanalyst Julia Kristeva gives a generic profile of the exile, Jew or non-Jew:[66] "to live in a foreign environment confronts the exile with the possibility of being another (*alienus*), not simply to accept the other but to be in his shoes. Exile can be transformed into a creative project."[67] The assimilation of a landscape or a city weaves itself into the process through which the artist reconstructs his life, as a link between the inner self and the outside world. Painters, photographers, and writers in exile have described special ties with their host city, with one of their earliest experiences being the fabric of the new language. Exploring its sounds and logic allows for a reinvention of the meaning of words.[68] The acquired language provides a cultural resurrection.

Not by chance did James Joyce choose a Dublin Jew as the protagonist of *Ulysses*, or Marcel Proust a French Jew, Swann, as the central character of *Remembrance of Things Past*. Woody Allen and Paul Auster found in their city not just a physical home: the center of their life and their work is less a background than a character in its own right.[69] Many writers of Jewish descent have expressed alienation:

the authors of the medieval chronicles of Spain as well as Cervantes, Montaigne in Bordeaux, Heine in Germany, Proust in France, or Pasternak in Russia.

Yiddish, Talmud *in utero*

At the turn of the twentieth century, whether one discussed friendship in Russian, Zionism in Hebrew, or culture in German, at home nearly eleven million Ashkenazim spoke Yiddish (out of a total of seventeen million Jews). Bernard Berenson (Valvrojenski), the connoisseur of Italian art and Oriental languages, was born a Lithuanian Jew but later converted (and at times even sounded anti-Semitic). At eighty-nine years of age, he at last openly expressed his Jewishness: "How easy and warm the atmosphere [is] between born Jews like Isaiah Berlin, Lewis Namier [Namierowsky], myself, Béla Horowitz, when we drop the mask of being *goyim* [gentiles] and return to Yiddish reminiscences, and Yiddish stories and witticisms! After all, it has been an effort . . . to act as if one was a mere Englishman or Frenchman or American, and it is something like homecooking, returning to 'Mother's cooking.'"[70]

The matrix of Yiddish is a Talmudic way of thought; its components are Hebrew, Aramaic, Romanic, Slavic, and German. Yiddish, written in Hebrew characters, flourished as the main language of a whole society from the First Crusade to the end of World War II. "It is entirely fair to say that this language and culture were born in one massacre and died in another."[71] Yiddish, which developed in an environment of terrible deprivation, is the language of *kvetch*—of complaint and protest. "'The vocabulary of the East European Jews' heart," wrote scholar Abraham Heschel, "has only one sound—Oy!" This cry, a mixture of joy, sadness, and enthusiasm, emanates from all of Soutine's paintings. The flow of passion seems to overwhelm form, calling to mind an analogy with Yiddish literature, in which an outpouring of feelings submerges structure.[72]

This "argot of the unredeemed" is a form of German

21
Lasar Segall (1891–1957)
Abba Segall (Pai Segall), 1929
Portrait of the artist's father on his deathbed
Wood engraving, 8⁵⁄₈ × 11 in. (22 × 28 cm)
Musée d'Art et d'Histoire du Judaïsme, Paris; gift of Mrs. Lucy Citti Ferreira

to spite the Germans. Elaborate curses, delivered as a Talmudic singsong, are a form of recreation that lets thoughts run wild, as a mirror of *goles*, exile. No matter how much you seem to have, there is always something wrong.[73] The inversion of expectations is a major strategy in Yiddish cursing: *Zolst krenken in nakhes* (You should suffer in the midst of pleasure). Inversion is also a basic element of Jewish humor, in which no phase of human life is taken seriously, not even pregnancy.

An old sage stroking his beard looks up from his Talmud and says, "Thank God, things are good." Then he pauses and adds, "But tell me . . . if things are so good, how come they're so bad?"[74] Judaism begins not in wonder that the world is, but in protest that the world is not what it ought to be. Its position is, "Whatever it is, it's not good enough." In the Yiddish language, beauty and ethics are linked to expressions of longing, rooted in the interminable wait for a Messiah who is in no hurry to come.

From words to images

Religious imagery translates directly into the art of Chagall, made of Yiddish expressions, puns, and songs.[75] The *luftmensch*, the "air man," is full of ideas that never fly and has no visible means of support.[76] He is a satire of the verse "Man does not live by bread alone, but by everything that proceeds out of the mouth of the Lord does a man live."[77] Words may be found in images by Modigliani (plate 73), El Lissitzky (plate 50), Lasar Segall (plate 21) or Ben Shahn (plate 22).[78] The paramount role of words derives from the popular notion that every human being has a finite quota of them assigned at birth. When they are expended, the person dies. Words are more than a means of communication: a word is a force in itself. In the biblical tales, there are no descriptions of the landscape or physical portraits of heroes, but psychological allusions are very elaborate. The Torah doesn't say, "See, O Israel," but rather, "Hear."

An "evil eye" was blamed for any common ailment, and speech was considered a powerful antidote to visually caused problems—there was even a professional *oyssprecher*, a "talker-away of badness."[79] A pregnant woman was taught to fear "mislooking" and to avoid focusing on anything that might harm her unborn child. The act of looking and seeing was believed to have a terrible power—hence the orthodox Jew adopts a furtive glance.[80] The importance of verbal communication implied a suspicion of visual expression; therefore drawing and painting were considered sinful.[81] Modigliani's use of the African-inspired asymmetrical "non-gaze," a form of suppressed expressionism, may be related to Jewish superstition.[82] Soutine's manner was frequently remarked upon, and it is recalled that as a boy, when the praying congregation was asked by the rabbi to lower their heads, Soutine defiantly raised his.[83]

The passion of prayer, with the body incessantly rocking back and forth, matches Soutine's immersion in the act of painting.[84] The movement in his work echoes the recitation: Hebrew characters undulate and loosely follow one another; detached, without a base, they seem to float. Nadine Nieszawer explains that while reading the Bible, one can follow the characters' rhythm; likewise, in a painting one feels the artist's brushstroke. In Chagall's early Cubist paintings, even the straight lines seem curved, and in Soutine's work as well an apprenticeship in the Hebrew script can be perceived.[85]

Torah and life

When Jews toast, they raise their glass and say *L'Chaim* (to life). Life is so important that with only three exceptions—idolatry, murder, and sexual immorality like incest or rape—every Jewish law may be disobeyed in life-threatening situations. The Torah is analogous to a human life.[86] It begins with Genesis, which recounts the birth of the world and continues with the problems of raising a family. Cain kills Abel; Abraham nearly kills Isaac; Sarah and Rebekah nearly fail to bear children; Rebekah finally has twins, who fight *in utero*; Rachel's children, Joseph and Benjamin, are favored over Leah's. Genesis ends with Jacob blessing his children and predicting their destiny as the twelve tribes of Israel.

Exodus features adults at work in the world. The fully grown tribes are enslaved in Egypt, and then are freed by God and brought to Mount Sinai in order to establish a covenant, as consenting adults. The end of Exodus and all of Leviticus describe ordinary responsibilities, a lengthy list of things to do and the many rules that a viable society imposes. The fourth book of the Torah is Numbers, the story of forty years of wandering. Then comes the midlife crisis: the people rebel, and try to find themselves in the desert. Finally, Deuteronomy is a retrospective look at history from Exodus to the moment when the Hebrews stand poised to enter the Promised Land. The story stops there: the last act is the death of Moses.

Judaism is the religion of the Book, the text that holds

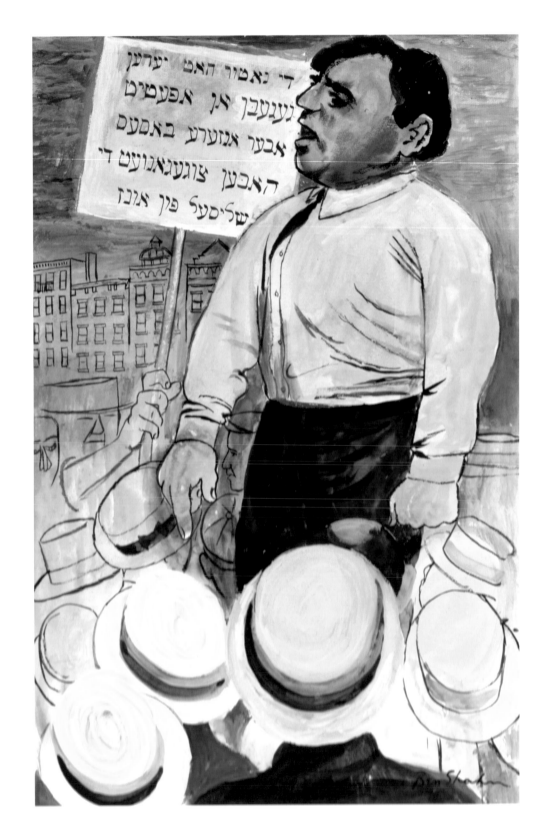

22.

Ben Shahn (1898–1969)

East Side Soap Box, 1936

Preparatory drawing for the Roosevelt Mural, 1936

Gouache on paper, 18½ × 12¼ in. (47 × 31.1 cm)

The Jewish Museum, New York

Purchase: Deana Bezark Fund in memory of
Leslie Bezark, Mrs. Jack N. Berman, Dr. Jack Allen
and Shirley Kapland, Hanni and Peter Kaufmann,
Hyman L. and Joan C. Sall Funds, and Margaret
Goldstein Bequest

together philosophy and literature in Hebrew, Yiddish, German, or English. Heine called the Torah, whose study represents the highest value, the "portable homeland" (plate 23). "We stand when it passes as if it were a king. We dance with it as if it were a bride. If it is desecrated or destroyed, we bury it as if it were a relative or a friend. We study it endlessly, as if it were hiding all the secrets of humanity."[87]

Education, education, education

The Jewish community at its most authentic views itself as a school where young and old commune with God through learning. The circumcision, *Brit Milah*, which is performed on the eighth day of a male child's life to symbolize his alliance with God, is so important that except for health reasons, no postponement is permitted, not even for the Sabbath or Yom Kippur.[88] At the end of the circumcision, the baby is welcomed with the words, "May he grow up into the study of the Torah. . . ."

In most times and places, there has been a knowledge elite; an insightful gesture of Judaism was to overturn this.[89] That God said Israel would be a "kingdom of priests" implies a society in which everyone can read and write and has access to knowledge on equal terms.[90]

The world's oldest surviving evidence of alphabetical instruction has been preserved by chance in southern Israel, where the first five letters of the Hebrew alphabet were scratched by a schoolboy in the plaster of a staircase in the eighth century BCE.[91] The first century CE saw the emergence of three intellectual organizations: the school; the yeshiva, or academy; and the *bet midrash,* or house of exegesis. Paul Johnson described this system as an "ancient and highly efficient social machine to produce intellectuals."[92] There was a marked difference here from Roman education, in which the adolescent was groomed for public office. The young Jew, who earned his living in the family circle, learned to read and write; if talented or wealthy, he pursued higher education, that is, the study of the Talmud with a renowned master.

The education of the poor or orphans was the responsibility of the entire community, and the system was compulsory.[93] Rabbis state that "a bastard scholar takes precedence over an ignorant High Priest."[94] Abelard's disciple, a twelfth-century monk, wrote that "a Jew, no matter how poor, if he had ten sons, would put them all to letters, and not for gain . . . but for the understanding of God's law; and not only his sons but also his daughters."[95]

"When does the obligation to study begin?" asked the Jewish philosopher Maimonides. "As soon as a child can talk. When does it end? On the day of death." The implication is that the Jewish people cannot die so long as they keep studying.[96] On the first day of school, youngsters were fed honey cakes shaped like letters of the alphabet, so that they would associate learning with sweetness. Boys started school at the age of three, going to *heder,* the room where they were taught Hebrew. A boy who left school at ten, well before the norm, had seven solid years of twelve-hour days behind him.

The stories of the Bible remain fresh, millennia after they were recorded. The characters are very concrete; whether they were real or not, what matters are their clues on how to behave. Rabbinic literature is an anthology of "arguments for the sake of heaven."[97] The Bible commentaries are integrated into the traditional method of study. Discussions roam from topic to topic, classifying, comparing, contrasting, and endlessly considering all sides of the issue. Its length of over two million words gives some idea of what the Talmud is like; its compilation took six centuries, from the first to the sixth century CE.[98]

23
Marc Chagall (1887–1985)
Man with Torah in the Snow, 1930
Gouache on paper, 23⅝ × 17¾ in. (60 × 45 cm)
Anouck and Nathalie

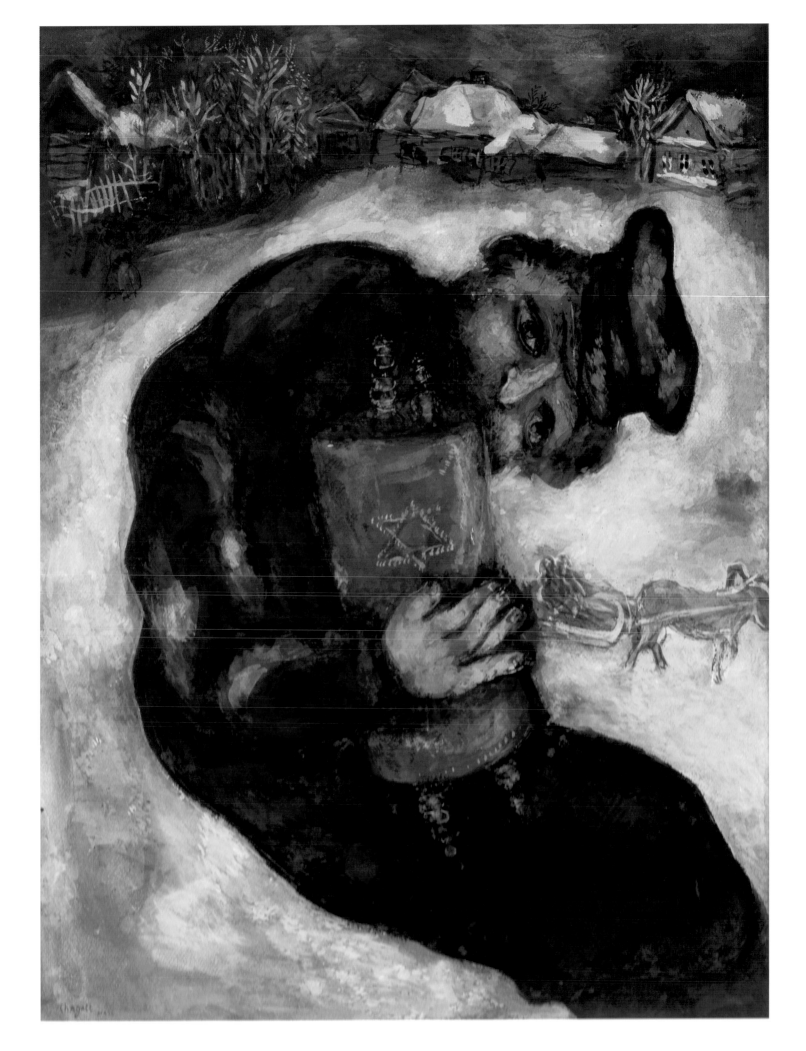

A Talmud page looks like an ornamental carpet, with a distinct physiognomy created by commentaries placed in rectangular shapes surrounding the main text, illustrating conflicting views on the same page. (Writings in the shape of bricks are a subtle reference to slavery in Egypt: words last longer than bricks.)

The Hebrew script has been cultivated in an unbroken tradition through the continuous copying of the Torah scrolls used in synagogues, which are not decorated, although biblical manuscripts in book form may contain images. As a combination of various calligraphic and aesthetic traditions, the art of illumination and illustration provides a good introduction to the story of Jewish art.

Two bodies of literature occupy a major place: *Halakhah* and *Kabbalah*. *Halakhah* perpetuates the antique tradition of adapting the Talmudic lessons to an ever-changing environment. *Kabbalah* is concerned with Jewish mysticism, which was formalized in the eleventh century and became more important with the Hasidic movement in the eighteenth century.

Law and justice

Legal requirements are the core of *Halakhah*, whose name is derived from *halakh*, "to go," because it embodies the Jewish way of walking in the world. To hold on to the Torah is a way of holding on to civilized behavior. The social scientist Howard Bell suggested that "Jews are afraid of mobs, of the nihilistic elements which lie deep in human nature. . . . There is a great sense that man is a raging beast and only a kind of tough-minded law holds him down."[99]

The law was given as a covenant between free people. In the civilizations of the ancient Near East, such as those of the Hittites, Mesopotamians, and Assyrians, the relationship between God and man was often contractual. The logic of the biblical covenant is based on the three minimum requirements of a just society: *mishpat*, "Do not do to your neighbor what is hateful to you"; *tzedek*, "char-

ity to restore dignity," which in biblical times already involved a series of institutions; and *hessed*, "kindness and loyalty."[100]

Justice and integrity are the basis of every great religion, and the covenant is the model for three of Judaism's primary associations: between husband and wife, between fellow citizens, and between humanity and God. When the Jews received the Ten Commandments, God revealed himself to the entire nation, not just to the priests. There is no religious hierarchy, and confessions do not require an intermediary. Rabbis are teachers whose only authority is based on their wisdom.[101] God does not discriminate on the basis of color, gender, or class. He makes covenants with non-Jewish people—such as Noah. All of us, being made in God's image, have an infinite capacity for doing good; therefore the job of society is to bring out the best that is in each of us.

Yiddische ashires iz vi shney in marts, "Jewish wealth is like snow in March"

Among the many parables in the Talmud, a favorite is: "Why is it that we are born into the world with clenched fists and leave with outstretched fingers? To remind us that we take nothing with us."[102] Money is an arbitrary commodity, useless except for enabling us to transfer things of the world through economic exchange. Philanthropy is born out of the belief that all we possess is God's, only passing through our hands. The rabbis insist on "democracy in death" so that no poor family is forced into ostentatious expenditures; funeral arrangements must be as simple as possible and donations to charity are customary instead of flowers.[103]

In Yiddish, a person who is too well-dressed is like a "herring marinated in vinegar and honey"—*ayngemarinirt in esik und honik.* Judaism affirms the concept of property but insists that money does not belong to those who have it. They are temporary holders of capital, charged with

using it in helpful ways: sustaining the community's funds for the poor, making interest-free loans, and encouraging ventures in the marketplace. Lending money to the poor is an obligation, so that they can become independent and attain dignity. Loans are not only permissible but desirable. Modigliani liked to tell his friends, "I'm Jewish, and you know the family bond we have among us. I can say that I have never been destitute; my family has always helped me. . . . They never abandoned me."[104]

Responsibility and a mission

The artists of the École de Paris or the School of London acted as families: not only their work but, in many cases, their lives were interrelated. The Torah commands that equity be provided for those unable to fend adequately for themselves, including the slave, the stranger, the widow, the orphan, the poor, and the animals.

In Judaism, no fate is preordained: man and God are partners in the work of creation. While Christianity sees man as in need of salvation and Islam calls for submission to God's will, Jews must see the world as it is, without despair or the comfort of myth, knowing that evil and injustice are inevitable.

Tikkun olam is a phrase derived from the final section of the prayers recited by observant Jews three times daily—or weekly on the Sabbath by Reform and Conservative Jews. Tikkun, literally "healing, repair, transformation," may be translated here as "setting straight"; olam stands for society. Thus tikkun olam means that Jews are responsible not only for the ethical and material welfare of other Jews, but for society as a whole.[105] This is about making the world a better place.

Every time a mitzvah, a "good deed," is performed, the world moves inexorably forward toward its destiny of complete repair. If one were to look for a single word to catch the spirit of Judaism, it would be mitzvah. It is a "divine command": there are 613 mitzvoth, 248 "thou shalts,"

and 365 "thou shalt nots," one for every day of the year.[106] These mitzvoth regulate every aspect of life—they are Judaism. The ideal life is a string of mitzvoth performed daily.

At circumcision, the baby is welcomed with the words "may he grow up in the study of Torah, into marriage, and the doing of good deeds." Bar mitzvah literally means "a member of the people who live by and for the responsibility of doing a mitzvah." Boys become Bar mitzvah on the Sabbath corresponding to their thirteenth birthday (twelfth birthday for girls): they are then given an honor reserved for adults, that of leading the congregation in prayers.[107]

Mother and child

Jews have built an emotional barrier against the outside world.[108] Whereas states are sustained by governments, armies, police, and so on, Jewish society depends on social institutions, with a gradual unfolding of widening spheres: the family, the tribe, the federation of tribes, the nation, and humanity (plates 24, 29). Family is the most important institution for the Jews, who identify their religiousness more closely with home than with their synagogue. The home is a religious sanctuary, with domestic rituals such as lighting the Sabbath candles every Friday evening and blessing the children—not to mention gifts and games that give rhythm to the joyful festivals.

Jewish homes are decorated with ritual objects; the practice of placing a mezuzah on the doorpost goes back to the Bible. It contains a parchment on which is written the Shema, the most famous of all prayers, a daily invocation as well as the deathbed prayer: "And you shall teach these things repeatedly to your children, speaking of them when you sit at home or go for a walk, when you lie down and when you rise up."[109] The Shema is about transmission.

In addition to strong links between children and parents, the bond between the two sets of parents of a couple is formalized in a relationship that has no counterpart elsewhere. When X marries Y, X's father becomes the

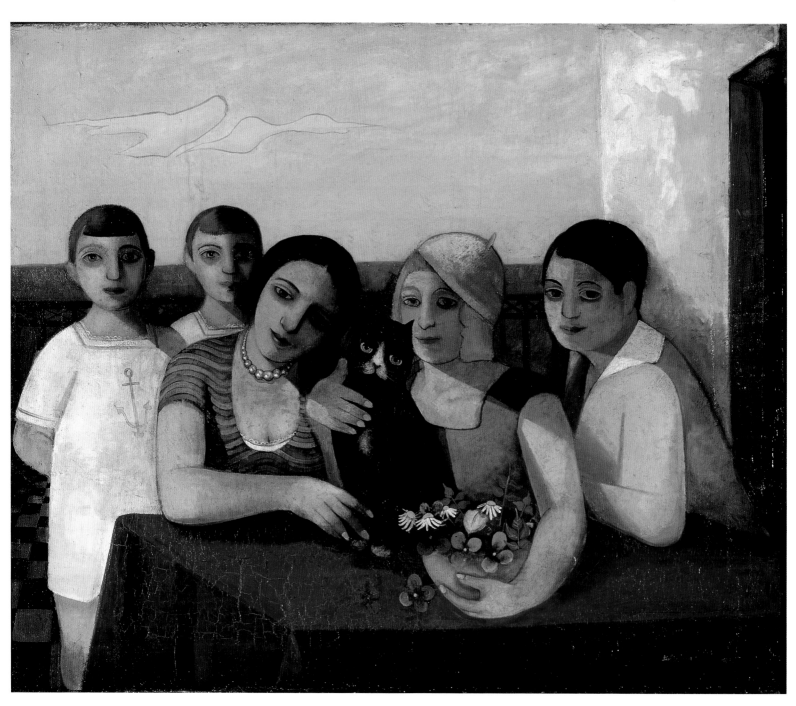

24
Felix Nussbaum (1904–1944)
Group Portrait, 1930
Oil on linen, 28¼ × 34¼ in. (72 × 87 cm)
Felix Nussbaum Haus, Osnabrück, Germany; donation by
the widow of Dr. Sigmund Wasserman, Tel Aviv

25 (above)
Chana Orloff (1888–1968)
Didi, 1919
Bronze, 8⅞ × 6⅛ × 7¼ in. (22.5 × 15.5 × 18.5 cm)
Private collection

26 (right)
Chana Orloff (1888–1968)
My Son and I, 1927
Bronze, 25 × 12 × 9½ in. (63.6 × 30.5 × 24.1 cm)
Private collection

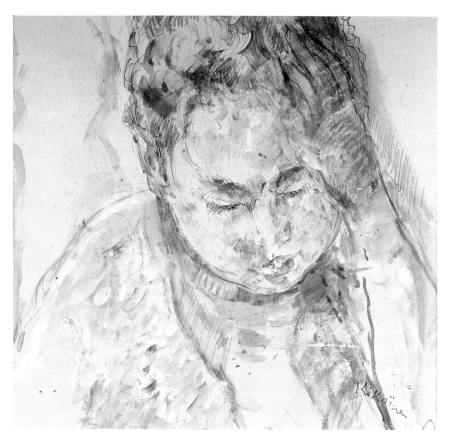

27
Michel Kikoïne (1892–1968)
Portrait of a Child, n.d.
Pastel, 9½ × 10¼ in. (24 × 26 cm)
Private collection

mekhutn of Y's mother and father, while X's mother turns into their *mekhuteneste*—and each of Y's parents stand in a similar relationship to X's: the two sets of parents function as board members of a corporation devoted to the production of grandchildren.

The mother is the keeper of traditions. It is said that since God could not be present everywhere, he invented women. The separation of men and women in the synagogue appeared in medieval times, although some wealthy donors were women.[110] In modern times, to the expression "my son the doctor" has been added "my daughter the professor"; Jewish women have participated in great numbers in all sectors of activity, and especially in the arts. They played a significant role in the Women's Liberation movement.

The role of educator is now entrusted to the father, too, as was already the case for Frida Kahlo, whose father was a German immigrant in Mexico. Yet the mother usually

played the key role: Pauline Einstein, Jeanne Proust, Feiga Chagall, Golda Gertler, to name just a few. Eugénie Modigliani fashioned Amedeo's education. This is perhaps why "he shunned the masculine, avoiding an aggressive approach to painting, especially avoiding the racial and misogynist content of bodily violence."[111] So did most Jewish painters: mothers and children were favorite subjects (plates 25–29).[112]

To be elected by God, or by Amalia Malka Freud, provided a narcissistic feeling of security, and her "Goldener-Sigi" was convinced that this exclusive love was at the heart of his perseverance. Through his father, Sigmund was initiated into the Bible, in which he found heroes with whom he could identify, like Moses or Joseph. He believed that in later life, by working out the Oedipus complex and submitting to paternal authority, the drives of love and hate could be overcome.

His grandson, the artist Lucian Freud, had a proud

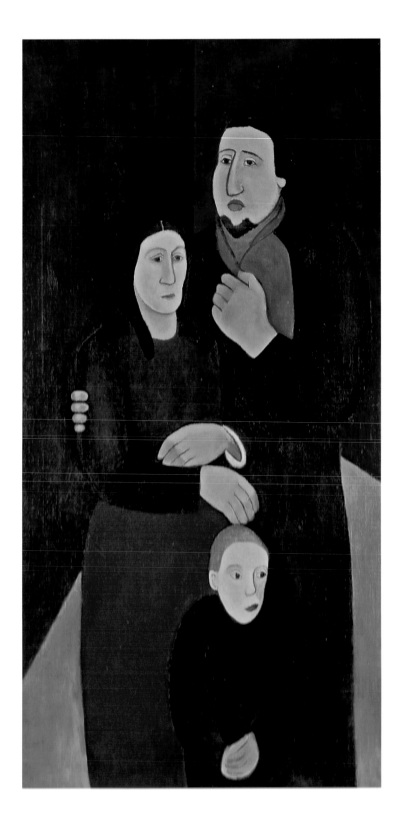

28 (*above*)
André Blondel (1909–1949)
Baby, n.d.
Oil on canvas, 11 × 9 in. (28 × 23 cm)
Private collection

29 (*left*)
Nathalie Kraemer (1891–1943)
The Family, c. 1930
Oil on canvas, 55¹⁄₈ × 27³⁄₈ in. (140 × 70 cm)
Musée du Petit Palais, Geneva

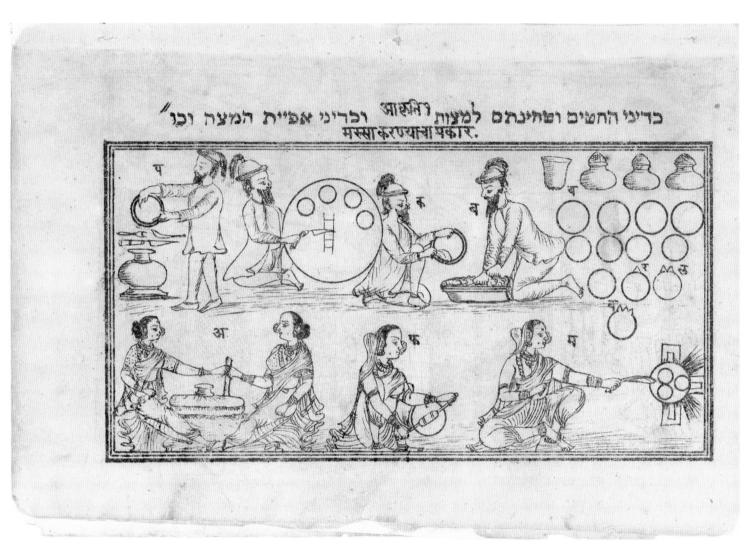

30
Preparation of Matzo
Haggadah in Hebrew and Marathi, Poona, India, 1874
Library of the Hebrew University of Jerusalem

mother as well, who asked the critic Herbert Read to write the introduction for Lucian's first show. (He refused.) Freud made several portraits of his mother (plate 82). "If my father hadn't died I'd never have painted her. I started working from her because she lost interest in me; I couldn't have it. . . . From very early on, she treated me, in a way, as an only child. I resented her interest; I felt it was threat-

ening. She was so intuitive. And she liked forgiving me; she forgave me for things I never even did."[113]

Food, the "Jewish penicillin"

Food remains the touchstone of Jewish identity even as religious observance declines.[114] "I love your cooking

more than your religion," Heine remarked.[115] Food is the link between the sacred and the profane, husband and wife, mother and child; because of its scarcity, it was a special way of expressing love.[116] In the Passover ritual, food remains a tangible medium of recollection. The happiest holidays of the year mean special food; the holiest, denial of food. In the pre–Yom Kippur ritual, a live chicken is gently waved in the air while the following is recited: "This is my stand-in, my substitute, this is my atonement." Why chickens? That is like asking, why Jews?

In Judaism, blood equals life, and its consumption is punished: "[He] who has shed blood shall be cut off from his people,"[117] because God has created man in his image. The all-important dietary concept of "kosher" depends upon killing animals cleanly, quickly, and painlessly, immediately removing all excess blood, and eating the meat as soon as possible. Soutine would extract a fresh pail of blood as soon as the carcass he was painting showed signs of drying out, in order to revive its color.[118] His representations of beef and fowl as primary subjects are most significant, since dietary laws and rituals are of transcending importance (plate 30).[119]

Festivals for freedom

During the festivals, freedom is prized above all.[120] The first words of the Ten Commandments establish God as the Great Liberator: "I am the Eternal your God who brought you out of the land of Egypt."[121] This is repeated weekly in the *Kiddush*, the blessing that initiates the Sabbath, a sanctified twenty-four-hour period during which everyone, master and slave, employer and employee, and even the animals, should enjoy peace. The Sabbath is, undoubtedly, at the heart of a feeling of well-being. It was a new institution—no religion before had a day whose holiness was expressed in the prohibition of work—and the Greeks and Romans ridiculed the Jews for it.[122] But "the Jews kept Sabbath; what is more, Sabbath kept the Jews."

On Passover, Jews tell the story of how the Hebrews left Egypt, ate the bread of affliction, and tasted the bitter herbs of slavery. They drink four cups of wine at specific stages of the ritual, symbolizing the long journey to freedom. "Each generation, Jews must regard themselves as if they had been personally delivered from the hands of the Egyptians."[123]

In his *Haggadah for Passover*, begun in 1931 and finished in 1965, Ben Shahn fuses Jewish tradition with social concerns, using the Exodus story as a metaphor for the strife of the Depression.[124] From the background of one of its illustrations, a hopeful stream of immigrants emerges, with the dream of a land of fruit and flowers, and the Statue of Liberty, hovering above them.

Passover begins with a child's question: "Why is this night different from every other night?" It ends with the Jewish version of "Old MacDonald had a Farm," "Had Gadya" (The Only Kid), in which a little goat is bought for two silver coins and then devoured by a cat, who is gobbled up by a dog, who is beaten by a stick, which is burned by a fire, which is quenched by water, which is drunk by an ox, who is slaughtered by a butcher, who is killed by the angel of death, who is finally slain by God himself. Tradition identifies the kid with the Jewish people, victim of a long line of persecutions, beginning in the distant past and continuing into modern days. Ultimately, God will save his only kid (plate 50).

The merging of historical and liturgical time, linearity and circularity, is inherent to the Jewish festivals.[125] Seven weeks from Passover, on *Shavuot*, Exodus, with its Ten Commandments, is read, symbolizing the gift of the Book. At the end of *Simhat Torah*, the "Feast of Torah," two people are given the honor of reading, respectively, the last verses of the Pentateuch and, immediately thereafter, the first chapter of Genesis—and the cycle starts all over again. The honorees are called bridegrooms, evoking the symbols of marriage and the covenant. The ancient rabbis did not observe Hanukkah, which celebrates the liberation of the Temple by the Maccabees in the second century BCE.

Described in ancient Greek texts, it was revived by the Zionist movement in the late nineteenth century.

As the themes of freedom and equality run throughout their four-thousand-year history, the Jews responded readily to the challenge of the American Declaration of Independence and the Bill of Rights. René Cassin, the Jewish French judge who drafted the Universal Declaration of Human Rights adopted by the United Nations in 1948, was subsequently awarded the Nobel Peace Prize.

Universalism versus diversity

Belief in one, and an only, God is central to Jewish life. Judaism considers him to be the God of all people because the Torah was given in seventy languages.[126] Peace in the Judaic sense will come not when all nations are conquered or converted, but when, under God's sacred canopy, the different nations and faiths make space for one another.[127] "The same law applies to the native-born and to the alien living among you."[128] "Do not mistreat an alien or oppress him, for you were aliens in Egypt."[129]

Abraham is considered to be the first proselyte, and since then Judaism has mostly been open to exogamy. Moses married the daughter of a Midianite priest, Jethro; Esther married the King of Persia, Ahasuerus; King David was the son of Ruth, a Moabite; several rabbis of the Talmudic period were converts; and the most famous one, Rabbi Akiva, who symbolizes resistance to the Romans, came from a converted family.[130] Philo of Alexandria, a renowned Jewish philosopher, practiced proselytism, which was common in that period. It would be prohibited in Christian times.

The German philosopher Ernst Cassirer sums it up: "What the modern Jew had to defend in this combat was not only his physical existence or the preservation of the Jewish race. We had to represent all those ethical ideas that had been brought into being by Judaism and found their way into general human culture, into the life of civilized nations. And here we stand on firm ground. These ideals are not destroyed and cannot be destroyed. They have stood their ground in these critical days. If Judaism has contributed to break the power of the modern political myths, it has done its duty."[131]

What's in a name: solitude?

The four-letter Hebrew name of God, YHWH (or YHVH), uttered as *Adonai* or *Elohim*, the "Creator," is also referred to as *haShem*, "the Name." YHWH (Yahweh) is not pronounced by Jews. The invisible, abstract God requires an effort of the imagination: by not revealing his true name, God conceals his Self. In the Bible, he expresses his will through an angel, a visitor, a warrior, a wrathful tyrant, a gentle provider, or a bestower of life. In Chagall's paintings, the angel becomes a bird, a rabbit, or a fish.[132]

The designation of the Jews has changed often over time. The Egyptians called them *Ivrim* (Hebrews), meaning "nomads, outsiders." Jacob's name was changed to Israel after his victorious fight with the angel.[133] The word "Jew" is derived from the name of Judah, the fourth son of Jacob and Leah and the ancestor of one of the twelve tribes of the *Bnei Israel* (sons of Israel). Leah had named him Judah (Yehudah, or YHVDH) in order to honor YHVH.[134]

In 722 BCE, the northern kingdom of Israel was destroyed, and the only Jews left were the Judeans. In diaspora, the people once known as Hebrews were called Jews. They adopted Hellenistic names in Alexandria, Spanish names in Granada, German names in Worms, English names in London. But a Jew is considered to have only one real name, the *rufnomen*—the Hebrew name by which he or she is summoned to the Torah—which always takes the form of X *ben* (son) or *bat* (daughter) of Y. This is the name that stays with the person in the other world, as part of the soul.[135]

For the outside world, one's name is often adapted: the Dadaist Samuel Rosenstock became Tristan Tzara,

31
Michel Kikoïne (1892–1968)
The Wounded Hunter, 1929
Oil on canvas, 32 × 21¼ in. (81 × 54 cm)
Musée du Petit Palais, Geneva

the Surrealist Emmanuel Radnitsky became Man Ray, the Abstract Expressionist Philip Goldstein became Philip Guston, and Judy Cohen became Judy Chicago.[136]

Specific to Judaism is the idea of a single God with many names, who sets his image on each of us, in its own language and in its own way. The Hebrew God was radically alone, and with that, the birth of the individual made its appearance. The Bible asserts that nations are born of individuals, not individuals of nations. The way in which we order our private lives determines the way in which we build society.[137]

In *Remembrance of Things Past*, Proust theorized that "psychology in space," rooted in the unicity of a person's name and face, had to give way to "psychology in time," with changing aspects as a function of circumstances.[138] Modigliani identified his Jewishness as a marker of difference: "This can be traced in his defiant non-conformity, in his stubborn character, in the idiosyncrasies of his oeuvre, and, especially, in the preponderance of the solitary figure."[139]

Messianism and utopia

The belief in the coming of the Messiah, a descendant of the House of David who will establish peace on earth, has persisted since the days of the prophet Isaiah. "Messiah," from the Hebrew word *moshiach* (anointed), refers to the ceremony by which biblical monarchs were singled out. Legend depicts the Messiah as a gifted human being—not a divine one—with strong leadership, great wisdom, and deep integrity. Although there are different interpretations of when and how he will appear, it is generally believed that the Messiah will rebuild the sanctuary of the Temple and gather all the dispersed of Israel under his dominion. Maimonides discouraged people from hoping for an otherworldly paradise and insisted instead on the idea that "the only difference between the present and the messianic days is a deliverance from servitude to foreign powers."[140]

There was, and still is, a great deal of disagreement as to what the messianic period will involve. Jews believe in redemption, a word preferred over salvation, as the dawn of the age of the reparation of the universe. The rabbis believe that the righteous of all nations shall be resurrected when the Messiah arrives. There is no specific dogma on the afterlife. Jews have always been more concerned with this world than the next, and have concentrated their efforts on building a better place for the living.

Since antiquity, a subversive passion has repeatedly emerged. Cornered between modern anti-Semitism and a promise of assimilation that would never be fulfilled, Jewish intellectuals embraced all the utopian movements.[141] They were active in the Risorgimento, which led to Italian unity as well as the emancipation of the Jews, and which took Verdi's *Nabucco*, in which the Jews are liberated, as a symbol.

Zionists rooted their movement in a return to the land with a kibbutz lifestyle. Marxists saw in Judaism a fossil to be wiped out by universalist ideals. The Bund, the Jewish worker's party in Russia, was founded in 1897 and played a key role in the formation of the "Party of the People" shortly thereafter. Leon Trotsky (Lev Bronstein) orchestrated both revolutions, in 1905 and in 1917; other Jews led social movements across Europe: Béla Kun was active in Hungary, and Ernst Toller, Gustav Landauer, and Leo Jogiches (Tyszka) in Bavaria, while Rosa Luxemburg spearheaded the Spartakusbund in Germany.

Among the International Brigades of the Spanish Civil War (1936–39), seven thousand participants (one-fifth of the total) were Jewish. In the Soviet Union, Jews reached the highest ranks, but Stalin soon turned against them: up to what point did philosophers like Ernst Bloch, Georg Lukács, or Walter Benjamin stick to their illusions? The last utopian explosion was the May 1968 student movement in France: its leaders, Daniel Cohn-Bendit, Alain Krivine, Alain Geismar, and Benny Lévy, were all inspired by the Jewish social critic Herbert Marcuse.

The Bible as the mirror of the psyche

Hitler called "conscience" a Jewish invention. It is the ability to see the world for what it is and still believe that it can be different. For Freud, the formation of the conscience takes place with the development of the superego—a sense of guilt being a major factor of civilization.[142] Freud found in his Jewish experience the capacity to resist his detractors. In an address to the Vienna lodge of B'nai Brith, "Sons of the Covenant" (founded in 1843, the oldest and largest modern Jewish organization), he said, "What bound me to Judaism was not the faith, not even the national pride. . . . Whenever I have inclined toward feelings of national exaltation I have tried to suppress them as harmful and unfair, frightened by the warning example of those people among whom we Jews live." Attracted to Judaism after observing the dark power of rising anti-Semitism, Freud concluded, "I have the clear consciousness of an inner identity, and the familiarity of the same psychological structure."[143]

In the twentieth century, Jews who lost their faith found a wide spectrum of secular surrogates. Some expressed their identity through devotion to a new cultural model based on *die Wissenschaft des Judentums*, "the science of Judaism"; others through philanthropy, fraternal organizations, or nationalism. There are ideological Jews, cultural Jews, culinary Jews, and so on. And many who do not actively define themselves as Jews feel Jewish nonetheless: Philip Rieff describes them best, as psychological Jews.[144]

If, for secular Jews, Judaism has become "Jewishness" of one kind or another, the Jewishness of psychological Jews seems devoid of all but the most vestigial content. They do claim, as quintessentially Jewish, independence of mind and intellectualism, high ethical standards, concern for social justice, and tenacity in the face of persecution.

mejschke Bahelfer. 1928 dessau

2.

The Human Figure before the Enlightenment

42
Moses Bagel (1908–1995)
The Prophets, 1928
Watercolor on paper, 8¼ × 6⅝ in. (21 × 17 cm)
Private collection

The Jewish myth of origins

The Bible incorporates many elements that preceded it: the myth of Creation, the Flood, and the Covenant were drawn from surrounding cultures.[145] Hannah Arendt wrote, however, that the "Jews offer the spectacle of a people who, unique in this respect, started their journey with a quasi-conscious resolution of bringing about a defined project in this world."[146] They did not flourish once and then decline; instead, at each stage, they discovered new modes of spirituality. Commentators, poets, mystics, legalists, and philosophers followed prophets and priests.

The sociologist Max Weber considered Genesis to be original in the sense that, for the first time, a group of humans envisioned the universe without recourse to myth.[147] Jews did not accept the idea that the world is an arena of clashing forces, and they rejected pagan practices. Instead of worshipping idols, they pledged loyalty to one God, creator of heaven and earth. The great shift was the idea of man: "So God made man in His own image; in the image of God He created him; male and female He created them."[148] The Jewish faith was born in these first words.

To Adam's question "Where is God?"[149] God replied with a question of his own: "Where are you?" Adam heard God's voice in the Garden of Eden and went into hiding because he was naked; this was the first act that revealed a consciousness of sin. (A great break from Jewish tradition would occur in the nineteenth century, when the nude was depicted in a nonreligious setting. The religion that began

33
Moïse Kisling (1891–1953)
Young Blond Boy, 1937
Oil on canvas
39⅜ × 28¾ in (100 × 73 cm)
Musée du Petit Palais, Geneva

with the prohibition of making images evolved into sexual restraint but not renunciation; quite the opposite.)[150]

The analogy between the biblical account of the expulsion from Paradise and Freud's theory about sexual restraint is striking.[151] For Freud, the Law brandishes the threat of castration in opposition to a fundamental incestuous desire.[152] Violence, too, as it appears in the Bible, is similar to Freud's analysis of compulsion: human thoughts are bad from their inception. (Because he is not the favorite sibling, Cain kills his brother Abel.) Destruction and violence cannot be redeemed by the sacrifice of one man since these traits are part of the human psyche.[153] While eradicating evil is impossible, God chooses to destroy his work in a Great Flood.

Throughout the Bible there is a pattern of creation followed by destruction and re-creation. Noah, with whom he forges a first alliance, the laws of which will be perfected at Sinai, attenuates God's pessimism.[154] His decree to Abraham to go to the Promised Land marks an end to the phase of Genesis that takes place in Mesopotamia.[155] Abraham starts a new cycle as God gives him the power to create a nation. Abraham's journey is a double one, comprising both an internal spiritual odyssey and an external trek, which together must prepare his lineage to resist slavery and deliver humanity from bondage.[156]

This Hebrew myth of origins, in contrast to others, is one of mobility and exile, perhaps because the patriarchs' nomadic life allowed them to see the moral failings of the surrounding empires. Abraham and Sarah were ordinary people living in a small country, not heroic figures.[157] They set off on a journey that would change the world with the advent of the monotheistic religions. The relationship of Sarah (formerly Sarai) and Abraham (formerly Abram) was between equals. (The name change took place when Abraham was circumcised.)

Abraham and the infertile Sarah did not have a child until she was ninety; after this experience, never again could their descendants take children for granted.[158] The long years of waiting, followed by the near-loss of their son Isaac, burned into their consciousness the notion that generational continuity does not simply happen: Judaism became, and still is, a child-centered faith (plates 18, 33).

Moses and Sigmund

Moses—whose name meant "child" in ancient Egyptian— was found in a basket among the reeds of the Nile by Pharaoh's daughter, who adopted him. As an adult, he came one day upon the mountain of God, who spoke to him from the bush, invoking the names of Abraham, Isaac, and Jacob. Moses promptly hid his face, for he was afraid to look at God, who announced his intention to free the Hebrews and lead them to the land of "milk and honey."

Moses, whom God elects to be their liberator, objects, saying that he is not a great man. But God assures him, "I will be with you." And when the Hebrews ask who sent him, demands Moses, what is he to say?[159] God's elliptical answer is rendered in Hebrew as *ehyeh asher ehyeh.* Translators interpret this response in various ways, as "I am who I am, I shall always be what I have always been" or "I will be there however I will be there. . . . This shall be my name forever. This is my appellation for all eternity."

Moses is called up the mountain again, where he stays for forty days; he then receives elaborate instructions on how to construct the Ark of the Covenant, "a box made of acacia wood, covered with pure gold, and protected by two cherubim with outstretched wings."[160] (Among the Hebrews who left Egypt there were craftsmen "to work in gold, silver, brass, and in the cutting of stones.") The Ark is to be placed inside the Tabernacle, God's residence on earth, a "blue, purple, and crimson tent, made of linen and goat yarn, roughly forty-five feet long and thirty-six feet wide"—about half the size of a tennis court. At the end of these instructions, God gives Moses two stone tablets "inscribed by the finger of God" with the Ten Commandments.

In Egypt, the religion of the pharaoh Akhenaton (r. 1353–1336 BCE) was already characterized by the exclusive belief in one God, the sun disk Aton, but upon his death the Egyptians reverted to their multiple deities. According to Freud, Moses was not a Hebrew but a monotheistic Egyptian who placed himself at the head of an oppressed people and brought them forth from bondage.[161] At Sinai, the Israelites received a written constitution, because a free society must be a moral society. But the former slaves could not bear the severe demands of the new faith. In a revolt, Moses was killed, and the repressed memory of this event was carried over the generations. The transmission of such acquired characteristics, Freud insisted, made possible the transition from individual behavior to group psychology. His *Moses and Monotheism* (1938) was a counter-theology of history in which a chain of unconscious repetition replaced the chain of tradition. Biblical scholars rejected it unanimously, and so did anthropologists.[162]

That Moses may have been Egyptian was the starting point, but not the essential point, for Freud: "It is honor enough for the Jewish people that it has kept alive such a tradition and produced men who have lent it their voice, even if the stimulus had first come from outside from a great stranger."[163] When Freud's book was published, nine months after his arrival in London and six months before his death, he considered it "quite a worthy exit."[164] Despite all the work's failings, it struck the imagination of many intellectuals and artists, among them Frida Kahlo, who painted *The Birth of Moses* (1945).

That monotheism originated in Egypt was argued before Freud by the Egyptologist James Breasted, whose *Geschichte Aegyptens* (1936) became Lucian Freud's pillow book: "It remained the painter's companion, his 'bible' it could almost be said, for sixty years" (plate 34).[165] A photo of Lucian Freud taken by Julia Auerbach in the late 1980s, showing the painter sitting on the bed with this book, is reproduced on the first page of the catalogue of his 2002 retrospective at the Tate Britain.

34
Lucian Freud (b. 1922)
The Egyptian Book, 1994
Etching on T.H.S. Saunders paper, plate: 11¼ × 11¼ in. (30 × 30 cm)
Private collection

The Egyptians were pioneers in many things. Their papyri offer some of the earliest examples of illustrated narratives. As a major power, Egypt had an aura of grandeur — it was where the Israelites strengthened their sense of destiny. Three millennia ago, Egypt and Israel asked themselves the most fundamental question, of how to defeat death. The Egyptians responded by building gigantic monuments that would stand for thousands of years. The Jews gave a different answer.

A saying has it that it took one day to take the Israelites out of Egypt, but forty years to take Egypt out of the Israelites, that is, for them to fully accept the Law and to evolve from a liberated people to a free people.[166]

Their idea that God is on the side of the powerless was a political revolution.

Kings and prophets

The twelve tribes penetrated into the Land of Canaan with Joshua in command. The poet-musician David united the tribes and established Jerusalem as their capital. This unlikely hero, a small shepherd boy, earned his fame with a victory over the Philistine giant Goliath. That story struck a chord with the Jews, a small people able to defeat great adversaries. However, God told the founder of the House of David—expected to rule in messianic times—that he could not build the Temple because "you have shed much blood."[167]

The transition from the Tabernacle to the Temple built by David's son Solomon symbolizes the passage from a tribal stage to a monarchy. Even though he promoted peace and prosperity, Solomon's lavish spending on architecture and his passion for "divine prostitutes" made him a much-criticized figure as well.[168]

The true heroes of Israel are the prophets—Samuel, Isaiah, Ezekiel, Ezra, and Daniel, among others—the teachers of the people (plate 32). To them, the most grievous sin was to remain silent in the face of oppression, especially when the victim was underprivileged. The Jews trust the prophets not so much as foretellers of the future as for their moral courage. Ezekiel tells us that there were Jews who "want to be like the [other] peoples of the earth."[169] When they were exiled to Babylon in the early sixth century BCE, they might have gone the way of the ten tribes of the northern kingdom, who, a century and a half earlier, had been deported and had assimilated. The prophets tirelessly maintained that the Jews should stick to their principles.

The sack of Jerusalem and deportation to Babylon resulted in the Diaspora. Since antiquity, the Jews have prayed in a group of at least ten people—a *minyan*, which is symbolic of the community—and have needed only a Torah scroll to carry out the ritual. The *synagogue*, "congregation" in Greek, symbolizes Jerusalem in exile: a country of the mind where a scattered people are temporarily reunited. In Roman times, it developed into a house of study that sustained the continuity of the Jewish people for two thousand years. The existential saying by Hillel, combining a questioning attitude with a sense of self-esteem and responsibility toward humankind, sums it all up: "If I am not for myself, who is for me? And when I am only for myself, what am I?"[170]

And if not now, when?

Within a few centuries, thriving Jewish communities that displayed the characteristics of modern Judaism spread across the Mediterranean countries, with Jerusalem as their center—and the suspicion of double allegiances arose even then. Under Hellenistic rule, the desecration of the Second Temple in 167 BCE led to a Jewish revolt and the establishment of the Hasmonean dynasty (142–63 BCE). In that period, a transition away from the relative openness to figural art of the biblical and post-biblical periods, and toward aniconism, became part of the nation's rebuilding strategy.[171] After the destruction of the Second Temple by the Romans in 70 CE, a return to the figural would take place.

Jews had arrived in Rome well before the Roman occupation of the Middle East. When Julius Caesar was murdered, they mourned the death of their benefactor, and Augustus confirmed by edict their right to send shekels to the Temple. Around that time, according to Strabo (quoted by the Jewish historian Josephus), they "lived all around the globe and it was hard to find a city where Jews had not settled."[172] Judaism was a fashionable religion to which many converted.

Greco-Roman Jews wove their identity into their host culture. A Greek translation of the Bible was prepared, known as the *Interpretatio septuaginta seniorum* (Translation

of the Seventy Elders), or the Septuagint, because it was supposedly the work of seventy (or seventy-two) scholars. In the first century CE, Philo of Alexandria wrote a wide variety of treatises seeking to reconcile the Torah with philosophy; his work would influence generations of Christian theologians.

The Second Temple was enlarged by Herod. Jewish members of his household commissioned portraits, and his court was composed of Hellenizers. The latter antagonized the traditional Jews, who again revolted. Several uprisings with eschatological overtones ended in disillusion. In Alexandria, anti-Jewish riots took place. The Roman army put an end to the trouble, but the result was disastrous, with the near-total destruction of Alexandrian Jewry and the weakening of many communities along the North African coast.

The Second Temple was destroyed in a crushing defeat in 70 CE. Hadrian later changed the name of Judea to Palestina, in a radical effort to erase any link between the Jewish people and their national roots. Rabbi Akiva, the foremost scholar of his age, responded to the loss of the Temple with a paradoxical sense of hope and hailed Bar Kokhba, the military leader of the revolt of 132 CE, as the Messiah. Akiva chose martyrdom for continuing to teach Jewish law against the Romans' edict. The irony is that it took the end of Israel's independence to bring about the flowering of its religious vision.[171]

From the third century CE onward, Jewish life was centered in the Persian-ruled city of Babylon, and Roman-occupied Jerusalem was overshadowed. In ancient Babylon's open society, the rulers' statues were at times admitted to synagogues frequented by high scholars.

From there, the rabbis' words spread around the globe until modern times. Their voice was heard on all issues that aroused the ancient prophets: integrity in public office, civil rights, education, housing, health standards, and peace among the nations. While the Jews were "outside the Land," as they referred to their situation, they awaited the opportunity to return home to Zion, a sanctified Jerusalem.[174] Three times a day, 365 days a year, for some two thousand years, they prayed for its well-being. That Jerusalem is at the center of the sacred map is clear from the way Orthodox Jews sign letters: not with "Sincerely" or "Send my regards to the family," but "Pray for the welfare of Jerusalem."[175]

Competing religions

Throughout the Middle East, Jews adopted Greco-Roman art and architecture. In 1932, an astonishing ancient synagogue was found in the sands of Dura-Europos, in present-day Syria. Its walls were filled with bright frescoes whose interpretation has occupied historians ever since.[176] A total of twenty-eight panels, depicting fifty-eight biblical episodes, have survived—nearly 60 percent of the original total.

Hellenistic rulers had founded the city of Dura-Europos as a trading post on the Euphrates River at the end of the fourth century BCE. Its spiritual life was marked by the worship of Greek and Eastern deities, sometimes fused. Since Dura-Europos was located on the route that connected Babylon and Jerusalem, it benefited from the traffic between the two centers. After it fell to the Romans in 165 CE, the population consisted of Roman legions in addition to the Semitic, Mesopotamian, and Persian residents. The Persians destroyed Dura-Europos in 256 CE.

Each of the three languages spoken by the locals—Greek, Aramaic, and Persian—may be found in inscriptions in the synagogue. The third-century interior frescoes display some of the most prominent figures from the Torah, including Abraham, Moses, Samuel, David, and Elijah, and some of its most popular stories, such as those of the Ark, the Exodus, and the Temple of Jerusalem.

The artists used techniques based on Roman coins, paintings, mosaics, sculptures, and monuments. In the synagogue frescoes, non-Jews are distinguished from Jews by their nudity. Pharaoh's daughter, for example, rises naked

35
Pharaoh's Daughter Finding the Infant Moses in the Nile River
Fresco, c. 239 CE
Synagogue of Dura-Europos, Syria

out of the river (plate 35), and the Egyptians portrayed in
the Exodus scene are nude as well. One of the ceiling tiles
is decorated with an "eye," symbolizing a superstitious be-
lief. The frescoes suggest a mystical approach to Judaism,
as found in Philo's texts. The Jews were concerned by
the claims of the emerging Christian community; they
sought to solidify their legitimacy by asserting their Jewish
messianic "brand."[177]

An inscription credits one community member, Uzzi,
for the Torah shrine and another, Joseph, for the decora-

tion. The grand patron seems to have been a man called
Samuel: two ceiling tiles with Aramaic inscriptions refer
to him as a priest and celebrate his role as "the builder"
of the synagogue. The architecture, as well as the painted
interior, attests to a syncretism that extends to the niche
that held the Torah scrolls, which resembles the niche that
held the image of the deity in the temples of the region's
other religions.

The Dura-Europos frescoes are the only antique Jewish
paintings that have survived; however, their quality sug-

gests that they belonged to a larger tradition of painting.[178] Throughout the area, mosaics showing biblical scenes with figures are common: for example, the sixth-century floor mosaics at Bet Alfa, created by the craftsman Marianos and his son Hanina.[179] Similar mosaics have been found at Hammath Tiberias, Hurvat Susiya, Sepphoris, Usfiya, Na'aran, and Beth Shean.[180]

The Jews of late antiquity adapted themes and techniques from Roman and early Christian models, using them to create a Jewish response to the Judeo-Christian religious controversy.[181] The pictorial means by which this distinction is conveyed—for example, imperfect symmetry to evoke the destruction of the Temple, or a restricted color palette to suggest the imperfection of the world—may be recognized as symbolic forms that "make their Jewish art Jewish."[182]

The Old and the New Israel

Analogies between Jewish images and early Christian illuminations—as seen, for example, in the sixth-century Vienna Genesis, which is based on a fourth-century model—suggest that Christian images were inspired by Jewish prototypes.[183] After the death of Christ, Saul of Tarsus, later known as the apostle Paul, reinterpreted the Jewish tradition to which he belonged, having studied the Torah in the Jerusalem academies. The death of Jesus (Joshua) became a sacrificial offering that cleansed humanity of the burden of guilt. God was to be found in the soul; the key idea was that Christ ("Messiah" in Greek) was the Savior.

Had the greatest rebellion against Rome, with its mass killings and deportations, not taken place, Paul's theories might have been less successful. But most importantly, Paul removed those elements of the faith that were a barrier against its wider adoption, namely, the stringent Jewish laws, the practice of circumcision, and dietary rituals. Through his model, the relationship between Jews and Christians was decisively established. The New Israel was

born out of the failure of the Old Israel: the "Israel of the flesh," alluding to the circumcision, had to be replaced by the "Israel of the mind."[184]

The scarcity of medieval Jewish works of art, due to their destruction, is an accepted fact of modern research.[185] There is little evidence of Jewish artistic activity in the Byzantine Middle East, but this parallels the Orthodox Christian Iconoclastic movement. Meanwhile, in the Western world, Charlemagne, who was interested in the trade in silk, spices, and other luxury goods, protected the Jews. Ashkenazic Judaism emerged in the post-Carolingian era, when Rashi of Troyes—the capital city of Champagne, on a major trade route—opened a new chapter in Talmudic studies. Highly tolerant, Rashi did not object to the decoration of homes with frescoes of biblical scenes with human figures.[186] He developed Talmudic dialectics: between the exegetic rabbis and the dogmatic Christian church, polemics crystallized around the questions of Deicide, Incarnation, Eucharist, and Resurrection.

Medieval anti-Semitism developed the particular theme of the satanic Jew, perpetrator of ritual murder and occult emissary of evil, who contaminates the community. The Judas legend, derived from the story of Oedipus, arose in twelfth-century monasteries: before killing Christ, Judas killed his father and committed incest with his mother. The abundance of incest-related stories points to the importance of matrimonial questions; the Gregorian reforms of the eleventh century forbade marriage between cousins up to the seventh degree, dealing a severe blow to endogamy, the core of the medieval power structure. Only Jews could continue to practice intermarriage.

The Black Death prompted serial massacres. From 1420 to 1520, nearly one hundred cities expelled the Jews, who were readmitted into Western Europe only toward the end of the sixteenth century. The legend of the Wandering Jew, condemned to roam perpetually for having rejected Christ, emerged around that time as well (plate 36).[187]

Social and material restrictions contributed to the safe

guarding of the educational nature of medieval Jewish art, whose narrative cycles were depicted mostly in the medium of popular crafts. There were no frescoes in medieval synagogues, perhaps because the literate Jews did not need them to remember the scriptures. However, Jewish manuscript illumination blossomed in the thirteenth century. The practice of enriching the Bible with *midrashim*, in the form of written and visual comments, originated in the fourteenth and fifteenth centuries, along with a new literary genre, the "rewritten Bible," which was narrative and dialectic as opposed to exegetic.[188] Jewish art remained dependent on the styles of the surrounding cultures, but this dependence was not one-sided, since biblical iconography is the fundamental contribution of the Jews to Western art.[189]

The dhimmi and the scholar

In the seventh century, the Prophet Muhammad reinterpreted the Bible in his turn, using it as the basis of a new divine text, the Koran. After the Jews, having refused Christianity, rejected Islam as well, Muhammad changed his strategy and reoriented the direction of prayer from Jerusalem to Mecca. The Jews were then systematically deported or eradicated from the Arabian Peninsula.

The Omar Covenant (630 CE) was a set of discriminatory regulations that applied to the *dhimmi*, a term for both Christians and Jews. It codified the relations between the Muslim power and the "people of the book" until the nineteenth century.[190] A series of clauses regulated the lives of the "protected" populations: the height of religious buildings was strictly limited, and it was forbidden to perform religious rites in public. These rules were accompanied by humiliating measures; for example, the dhimmi had to wear distinctive clothing and were forbidden to ride horses.

Nevertheless, a Judeo-Arab culture emerged as early as the seventh century, thanks to the active role played by

Jews in the caravan trade that linked the East to the West. Along the trade routes, several Jewish centers gained intellectual independence from Babylon. In the ninth century, local rabbis started to answer *Halakhah*-related questions raised by their own communities.

The Cairo Geniza is a reflection of the intense activity first along the North Africa–Egypt axis and then along the Egypt-Yemen-India route: more than 50,000 books were produced in a mere 250 years. A *geniza* (from the Hebrew word meaning "to hide") is a place, usually the basement of a synagogue or a cemetery, where old prayer books and disused cult objects are hidden (plate 37). In many communities, the burial of the geniza was a solemn ceremony with music and ritual meals, just as for a human funeral. The practice of concealing these objects and books probably started when mobs assaulted Jewish funerals. The documents found in the geniza, whether in Arabic, Persian, Greek, Spanish, or, later, Yiddish, were written in Hebrew characters.

Literary activity, while preserving Jewish content, increasingly used Muslim frameworks. As a result of Rabbi Saadia ben Joseph's translation of the Bible, Arabic written in Hebrew characters also became common. Jews blazed new paths in philosophy, science, linguistics, and poetry, none of which had precedents in the Talmudic period. Only in historiography, at which Islamic scholars excelled, did a similar interaction fail to take place.

Although he was well-versed in Muslim philosophy, Maimonides considered the reading of profane history a "waste of time." He developed a theory of power based on the distinction between the rational and the narrative: the ruler must be enlightened by wisdom, while biblical

36
Marc Chagall (1887–1985)
The Wandering Jew, 1923
Oil on canvas, 28¼ × 22⅜ in. (72 × 57 cm)
Musée du Petit Palais, Geneva

37
The Cairo Geniza
Ben Ezra Synagogue, Fustat (Old Cairo)
Diorama
Beth Hatefutsoth, The Nahum Goldmann Museum of the Jewish Diaspora, Tel Aviv

stories are for the common people. Under Islam, superb ornamentation appeared in Jewish manuscripts, usually divorced from the actual content of the texts. Obviously, the Jews were no more open than their Muslim hosts as far as the human form was concerned.

Under the Ottomans, the Jewish communities along the North African coast were more exposed to Western culture. The painter Eugène Delacroix wrote in his diary in 1832, "Jewish women are the pearls of Eden. . . . Imagine Jews walking at sunset with white robes like disdainful Roman senators. . . ."[191] Western artists provided romantic accounts of these communities, which had no artists of their own. However, Jewish craftsmen played a key role in the production of jewelry and metalwork.

Despite a plea by London's Jewish sheriff, Sir Moses Montefiore, and the publication of decrees promising the improvement of the Jews' status, the Omar Covenant remained in effect. Montefiore's French friend, the Jewish statesman Adolphe Crémieux, was instrumental in the abolition of slavery; he became president of the Alliance Israélite Universelle, founded in 1865, which helped to emancipate minorities around the world. As the colonial era ended, many Jews chose to move to the West, which can be easily explained by the fact that they were still an underclass in the Muslim world.

Inquisitive masks

Spain enjoyed a golden era until the eleventh century, when a conservative caliphate radically changed the atmosphere. Science and philosophy were no longer tolerated, and many Jews were forced into exile, including Maimonides.

The first Jews had arrived in Spain in Roman times. Carlos Fuentes, who won the Nobel Prize for literature, acknowledged the Hispanophones' enormous debt to the Jews with whom they coexisted for fifteen centuries: "Jewish intellectuals were prominent in the court of King Alfonso X of Castille, Alfonso the Wise, where they wrote down the monumental *summae* of the Spanish Middle Age: the judicial compilation known as *Las Siete Partidas*, the judicial treatise *El Fuero Real*, and the two great histories of Spain and of the world in the thirteenth century. The extraordinary fact is that the Jewish intelligentsia at Alfonso's court demanded that the vast knowledge of the times be written in Spanish and not, as was then the custom, in Latin. It can be said that the Spanish language as we know it and write it now is the great bequest of Spanish Jews of the Middle Ages to us all, the four hundred million men and women who speak and write and dream in Spanish today."[192]

Several Jewish translators and scientists were based in the Iberian Peninsula, including the astronomer Judah Hacohen. The Catalan Atlas, produced in 1376-77 by Abra-

ham Cresques and his son Judah, was a work of art as well as a geographic tool.

Then the Inquisition fabricated a trial in order to prove the existence of a Jewish conspiracy: the removal of the Jews had to be legitimized as self-defense. The sequence of European expulsions had started in England in 1290; France and Germany followed suit during the Crusades. Thus the expulsion from Spain in 1492 was seen as the culmination of a process that shifted the Jewish people globally, from West to East. The "great catastrophe" that put an abrupt end to Jewish life in Spain and the forced mass conversion of Portuguese Jewry only five years later became the primary stimulus to Jewish historiography.[193]

Until the sixteenth century, the Spanish tolerated the *conversos*, expecting their total assimilation. The experience of the so-called *marranos* ("pigs"), who secretly continued to practice Judaism, served as a laboratory for the modern individual split between private and public life.

The Jewish painters Abraham Yom Tov de Salinas, his son Bonastruc, and Moses ibn Forma de Saragossa were mentioned in the early 1400s. Various hypotheses have been formulated about Diego Velázquez: "On the paternal side, it is likely that his family was originally in trade, and it is at least possible, as with so many Portuguese immigrants who settled in Seville, that Jewish blood ran in his veins."[194]

Isaac Abrabanel, a rabbi and former financial adviser to the Catholic kings, insisted that "even if *conversos* would do all in their power to assimilate, they would not succeed. They would still be called Jews against their own will and they would still be accused of Judaizing in secret, and be burnt at the stake for it."[195] The Jews were now spiritually ready for *Kabbalah*, which endowed each one with the mystical power to hasten their messianic deliverance.[196]

In Spain alone, the Inquisition burned 32,000 heretics, and 291,000 were "reconciled." A similar number were expelled under terrible circumstances, and many died on their journey.[197] The *Exodus* tragedy of 1942 — when a ship carrying Holocaust survivors was turned back to Germany

by the British authorities occupying Palestine—was a repetition of the flight of the Sephardic Jews from the Inquisition in 1492, which was recounted by Benjamin Raba of Bordeaux.[198]

Michel de Montaigne, whose mother was of Sephardic origin, was the first to write that every man bore the full form of the human condition.[199] Jews found refuge in the Mediterranean basin, especially in Turkey and in the south of France. In northern Italy, they prospered as physicians, pharmacists, bankers, leather merchants, shoemakers, bookbinders, goldsmiths, artists, and craftsmen. But the Inquisition atmosphere eventually darkened prospects there as well. The Talmud *auto-da-fé* and the establishment of the ghetto of Rome in 1555 inaugurated a process of segregation that lasted until the arrival of Napoleon's troops in 1796.

A Dutch Jerusalem

Toward the end of the sixteenth century, those *marranos* who had settled in the major harbor cities of northern Europe reclaimed their Jewish identity. Romeyn de Hooghe was one of many painters who found a new source of inspiration in Amsterdam's Jews. Govaert Flinck, a former student of Rembrandt's, used Jewish models to represent Jesus, and Rembrandt himself hired Jews as models.[200]

Why were Jews suddenly being represented in an idealized manner? The tiny Netherlands, which had defeated the Spanish Goliath, viewed itself as a "New Jerusalem." In the Hebrew scriptures, the Dutch found examples of the civic virtues of wisdom, courage, fortitude, and justice. Their study of Hebrew was rooted in the belief that the language was essential to a true understanding of the Bible, and that it was imperative to engage Jews in dialogue, because they were to be converted by argument.[201]

In Spain, the *marranos* had not been able to maintain all their Jewish customs: by the end of the sixteenth century, they had given up ordinary blessings, kosher rules, circumcision, and funeral rites.[202] The *marranos* who came to

Amsterdam sought help in these matters from the rabbis of the city's Ashkenazic population, which counted 5,000 members by 1674, outnumbering the Sephardim there two to one. The two communities had different attitudes toward the Second Commandment: the Ashkenazim, who considered relief sculpture of human forms to be a clear violation of God's prohibition, were scandalized by the unprecedented aesthetic liberation experienced by the Sephardim.[203]

Calvinist preachers, too, fulminated against the adornment of churches, which they argued was for idolatrous Catholics, but most Calvinists still bought paintings and commissioned portraits. Rabbi Leone Modena, visiting "the Dutch Venice," said with resignation that "there are many here who have painted portraits in their homes, although avoiding works of sculpture, both in relief and in the round." As the Sephardic rabbis had to keep up with the taste of their congregation, Saul Levi Mortera even conceded that "Jews could own works of art—both two- and three-dimensional—since they were not in themselves idols."[204]

Over 430 paintings turned up in a survey of twenty-two Jewish estate inventories. Raphael's famous portrait of *Baldassare Castiglione*, now in the Louvre, was auctioned off to Alphonso Lopez for 3,500 florins.[205] However, Jews seem not to have gone in for portraits of themselves, which is surprising, given that practically the entire Dutch bourgeoisie had their portraits painted in this period, which marked one of the high points of the genre.[206]

Why did Jewish associations not commission group portraits? The community even had its own artists to do the work, Samuel d'Orta or Jacob Cardoso Ribeyro.[207] There was also Shalom Italia, an accomplished etcher who lived in Amsterdam for a decade: he made portraits of two important rabbis, Menasseh ben Israel and Jacob Judah Leon.[208] Yet apart from these scholars, whose printed portraits were widely distributed, there were few images of Amsterdam Jews.

38
Rembrandt van Rijn (1606–1669)
Menasseh ben Israel, 1636
Etching
Pierpont Morgan Library, New York

Menasseh ben Israel had a printing shop in Amsterdam, which was then one of the centers of Hebrew publishing in Europe. In his logo, he used the image of the Wandering Jew; however, "he changed its malign connotation to a positive peregrination and search of spiritual enlightenment."[209] Menasseh was possibly Rembrandt's adviser on Hebrew scriptures, as they lived just a few houses apart (plate 38). No other painter included in his art as much Hebrew—nor of such quality—as Rembrandt did.[210]

Menasseh believed redemption to be close at hand, "for we see so many prophecies fulfilled." His power of persuasion was behind the readmission of the Jews to England by Cromwell. Aaron de Chaves went to England to paint *Moses and Aaron and the Ten Commandments*, which hung for a time over the ark of the synagogue in London (founded 1656). This synagogue, like many others throughout the Sephardic world, was modeled on the Portuguese synagogue in Amsterdam, the *Esnoga* (plate 41).[211]

Even though there was no generally accepted opinion regarding what might await the soul in the other world, in the Amsterdam Jewish community of the time there was no room for anyone who actually denied its immortality. Uriel da Costa did so, and was excommunicated for his criticism of the faith. His suicide may have later inspired Spinoza's *Critique of Revealed Religion*. The philosopher of rationalism, whose masterwork was his *Ethics*, believed that the scriptures should be studied with the same scientific methods as were used to investigate nature. Spinoza studied with Menasseh ben Israel and Saul Levi Morteira, the latter of whom cosigned his excommunication act.[212]

Less than a quarter century after the foundation of the Amsterdam Portuguese community in 1597, Jewish merchants were among the founders of the West Indies Company. The first official Jewish community in the Americas was established in Recife; when the Portuguese conquered Brazil (1654), some of the Jews of Recife fled the Inquisition to New Amsterdam, later renamed New York. Like the English Puritans, Jews came to America in search of religious tolerance and economic opportunities; they prospered and left several moving portraits from the eighteenth century. Eventually Jews were granted civil rights in the United States of America, and then in France.

39
Catherine Mendes da Costa (1679–1756)
Portrait of the Artist's Son Abraham, n.d.
Miniature
The Jewish Museum, London

3.
Human Expressionism in the Early Twentieth Century

Liberty, equality

In France, Jewish emancipation began after "religious rationalism" emerged at the end of the eighteenth century. The philosopher and economist Isaac de Pinto, who was probably born in Bordeaux but lived mostly in the Netherlands, replied to Voltaire's anti-Semitic article in the *Philosophical Dictionary* with an *Apology for the Jewish Nation* (1762), in which he wrote that Voltaire "owed the truth to the Jews and to his century."

New conspiracy theories singled out "occult" groups such as the Freemasons, who were supposedly manipulated by the Jews. Later, the clergy and the aristocracy accused the revolutionaries of selling confiscated properties in order to pay the Jews to whom the government was in debt.[213] The French revolutionary model constructed a

national identity through a centralized education system; the Jewish problem should have dissolved in the process, but this failed to happen.[214]

Instead, by entering the open society Jews became competitors, and anti-Semitism increasingly thrived on social and economic arguments. Racial theory developed in several European countries in parallel.[215] In France, illustrious rationalists like Auguste Taine or Ernest Renan considered Aryans, as opposed to Semites, a "superior branch of the

41
Edouard Brandon (1831–1897)
The Talmudist David de Jahacob Lopez Cardozo, 1867
Oil on canvas, 8½ × 18½ in. (21.5 × 46.5 cm)
Musée du Louvre, Paris

human species."[216] The notion of a Jewish art that preceded Greek civilization was inconceivable for most scholars of the period.[217] Yet in 1853 the Galerie Judaïque opened at the Louvre, following the Judaic archaeological studies led by the French consul in Jerusalem, Félix de Saulcy. The first volume of a monumental *History of the Jews* by Heinrich Graetz was published in the same year.[218]

Jewish art gained visibility when the composer Isaac Strauss, who was Napoleon III's favorite conductor, presented his ritual objects at the 1887 World's Fair. A frequent traveler, Strauss had gathered an impressive collection, which was later acquired by Baroness Nathanael de Rothschild and deposited at the Musée de Cluny.[219] The founding of a Jewish museum in the nineteenth century was a militant act, driven by a desire to acknowledge the Jewish heritage and promote a positive image to non-Jews.[220] The French artists Edouard Brandon (plate 41) and Edouard Moyse pursued similar objectives, harmonizing their desire for integration with Jewish values, to which they gave a universal dimension in their paintings. Around that time, Jewish museums were established in Vienna and Frankfurt as well.[221]

The French suffered a terrible humiliation in the Franco-Prussian War (1870–71); the result was perpetual animosity toward anyone German, especially the Rothschilds. To make matters worse, new financial scandals involving Jews were inflamed by the Dreyfus Affair in 1894, which dragged on until 1905. Like the Dreyfus family, many Jews wanted to acquire the ways of the French aristocracy. This prompted young Jewish men to follow their gentile friends in choosing military careers, which caused major friction.[222]

Writers and artists often became anarchists. Among them, Camille Pissarro held an "elder statesman" role as an adviser to the younger Impressionists. He was born in the Virgin Islands, but his father was from Bordeaux. Although his parents were observant Jews, Pissarro regarded all religions, including Judaism, as obsolete with respect to "modern philosophy, which is absolutely social, anti-

authoritarian and anti-mystical."[223] Less than a century after emancipation, French Jews were playing complex identity games, and Pissarro was no exception.[224]

He found his first diasporic reflection in the African people of the Caribbean and drew inspiration from Latin Americans of mixed blood, the *mestizos*. Pissarro later suffered the destruction of 1,500 works of art in the German invasion of France, while he found refuge in England. His paintings often represent rural scenes, and from his letters we know that peasant life held a special appeal for him. The Belgian writer Emile Verhaeren paid tribute to the "social value" of Pissarro's work at a conference where

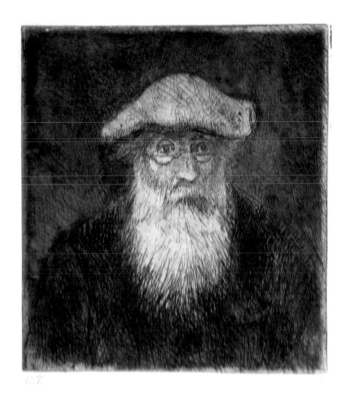

42
Camille Pissarro (1830–1903)
Self-portrait, 1890
Etching, 7¼ × 7 in. (18.5 × 17.7 cm)
Musée Pissarro, Pontoise, France

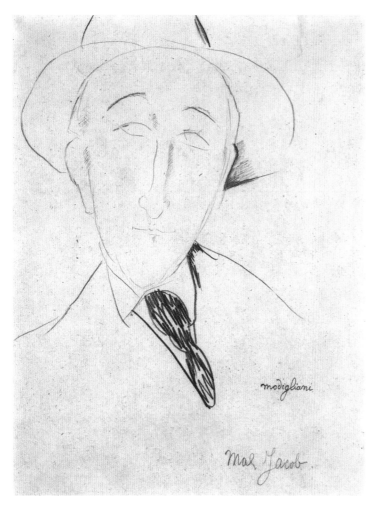

43
Amedeo Modigliani (1884–1920)
Portrait of Max Jacob, 1915
Pencil on paper, 11⅝ × 8⅞ in. (29.5 × 22.5 cm)
Private collection

Henri van de Velde, the champion of Art Nouveau, advocated "art for all."[225] Pissarro himself, however, remained distant from such considerations.

His many years painting the countryside gave him ample opportunity to explore all facets of Impressionism, and he was the main organizer of the eight group exhibitions of the Impressionists between 1874 and 1886. Pissarro collaborated with Cézanne for fifteen years, nurtured the skills of Gauguin, and promoted the work of Seurat and many others, including the young Matisse. He convinced Dr. Gachet, who lived nearby at Auvers-sur-Oise, to host Van Gogh.[226] Remaining independent in his aesthetic choices, Pissarro respected both the artistic and the human individuality of everyone.

As he aged, Pissarro came to suffer from an eye condition that made it difficult to paint outdoors; his problem was thrown into relief by a racial theory claiming that Jews were particularly subject to "weakness of the eye." By then producing work in the Neo-Impressionist pointillist style, Pissarro contested the characterization of "our diseased eyes" and agreed with the Jewish writer Bernard Lazare that "race is fiction."[227] Jews were haunted by the fear that their external aspect betrayed their origins, so it is interesting that Pissarro often turned to self-portraiture at this time, creating a series of works that defy categorization. They reinforce the stereotype, which he despised, of a biblical prophet with a long, flowing white beard, endowed with a personality strengthened over a lifetime (plates 10, 42, 44).

Marcel Proust began writing *Remembrance of Things Past* in 1905, in the wake of the Dreyfus Affair. When *Swann's Way* appeared in 1913, many readers perceived in it a Jewish imprint, since Proust's mother was related to Jewish personalities Adolphe Crémieux and Henri Bergson.[228]

Swann at first refuses to sign a petition in support of Dreyfus, fearing that he might be considered as "blindly following his race." He asserts his patriotism by showing off his medals. Swann discusses the generation of Jews who, like Proust, were born out of mixed marriages; he quotes examples such as King Ahasuerus and Esther, or Moses and Zipporah, comparing the latter to his own fiancée Odette.

Proust replaced the traditional novel structure with a "kaleidoscope," which was better suited to describe the multiple facets of his characters. He did not envision the total assimilation of the Jews: in Swann's final home-

coming, he notes that old age has accentuated his racial profile as well as his moral loneliness and solidarity with fellow Jews, forgotten long ago but recalled in the wake of his fatal illness, as well as by anti-Semitic propaganda and the Dreyfus Affair.[229]

Hannah Arendt explained that in Proust's day, Jewishness was viewed simultaneously as a negative physical trait and a mysterious privilege with "racial predestination."[230] Proust made it clear that, paradoxically, more than ever, Jewish origins played a determining role in the daily life of assimilated Jews, placing their Jewishness at the heart of their concerns. The poet, novelist, playwright, art critic, and painter Max Jacob, who had been traumatized by his childhood feelings of separateness as a Jew in Catholic Brittany, hoped to atone for his homosexuality by being baptized in 1914 (plate 43). He died in the Drancy camp in 1944. Like Proust, Jacob embodied two "fashionable vices," Jewishness and homosexuality, which were treated similarly. As Western values collapsed, society transformed crime into vice, creating a world of fatality that suppressed responsibility.[231]

Race and romance

In the nineteenth century, *Mitteleuropa* (Central Europe) encompassed Berlin, Frankfurt, Vienna, Budapest, Prague, Lemberg (then in Galicia, now Lvov in the Ukraine), and Tchernowitz (in Bukovina). The German language defined the culture of the entire area. Moses Mendelssohn, who published his annotated German translation of the Torah, *Bi'ur*, in 1783 (printed in Hebrew characters), initiated the process of assimilation. Within one generation, Hebrew and Yiddish became obsolete in the region's major cities.

Gotthold Lessing's prophetic *Nathan the Wise* (1779), projecting the enlightened Jew before such a character existed in real life, struck a deep chord with the Jewish bourgeoisie. Johann Gottfried von Herder considered the protagonist

to be a "new specimen of humanity," more intensely human and more prone to integrate.[232] Arendt described how it was easier for a Jewish intellectual to live in the aura of celebrities than to become famous himself; Jews excelled in auxiliary roles such as literary critic, impresario, and so on.[233] In the salon of Rahel Varnhagen (Levin), one could easily meet a Hohenzollern prince, a powerful industrialist, a scientist like Alexander von Humboldt, or a romantic writer like Friedrich Schlegel.

Jews had no choice but to convert, and many baptized their children to give them a better chance in life.[234] The assimilation process included the adoption of the gentile dress code: *Yekke*, from *Jacke*, "vest" in German, was the ironic Yiddish word used by Polish Jews, who were proud of their orthodox attire, to describe the German Jews. Heine was one of the few to believe in the possibility of sustaining a Judeo-German identity, but his tragic tone betrays the fact that he was cornered into such an impasse.

Moritz Oppenheim was a symbol of German-Jewish symbiosis: storytelling paintings, by Jews for Jews, appealed to the emerging bourgeoisie and helped acculturated city Jews connect with their traditions. By way of contrast, Isidor Kaufmann, who grew up in a Romanian corner of the empire, traveled extensively in the shtetls.[235] As Ashkenazic culture changed, the fear of its disappearance grew, but most wealthy Jews still wanted to be "more German than Germans."

Several of them aimed for recognition by building art collections,[236] including Marcus Kappel, Franz and Robert von Mendelssohn, Alfred Breit, and Oscar Hudchinsky. Edouard Arnold offered the Villa Maximi in Rome to the Prussian government; Max Böhm and Rudolf Mosse owned the largest collections of nineteenth-century German painting; Paul Davidson gathered a most prestigious collection of old-master prints; H. H. Meyer gave 60,000 prints to the Bremen Kunsthalle; Leopold Sonnemann donated his collection of French art to the Städelsches Kunstinstitut in Frankfurt; and Jacques Simon gave his to the

Kaiser Friedrich Museum. (Later, Ismar Littman, Leo Lewin, and Max Silberberg would gather impressive modernist collections in Breslau.)

Arendt described two categories of Jews: on one hand, the wealthy conformists, like Bismarck's bankers, Bleichröder or the Rothschilds; on the other, the pariahs who revolted against the establishment, like Heine, who were popular with the intelligentsia.[237] Those in the latter category were deeply hurt by politicians who lavished Jewish bankers with privileges while intellectuals were left to starve. Discrimination persisted; it was impossible for most Jews to attain careers in the administration, army, judiciary, or higher education system.

Bruno Bauer crafted the evil image of the modern Jew, and his text had profound ideological repercussions because of the response that Karl Marx—then twenty-seven years old—made to it in his book *The Jewish Question* (1843). When Marxism became revered as if it were a science, his arguments laid the foundation of leftist anti-Semitism. Who is the secular God of the Jews? Money! Marx used such clichés.

The term "anti-Semitism" was coined by Wilhelm Marr in 1879. The unification of Germany in 1870 had heralded the rise of the cult of the hero: Bismarck in politics, Adolf von Menzel in painting. Wagner considered Felix Mendelssohn—the grandson of Moses Mendelssohn—and Heinrich Heine to be living proof that composers and poets of Jewish origin were constitutionally unable to contribute to German culture. "The sensory capacity for sight belonging to the Jews was never such as to allow them to produce visual artists. To the best of my knowledge, we know nothing of a single Jewish architect or sculptor in our own times. As for painters of Jewish origin, I must leave it to the experts in the field to judge whether they have created anything real in their art. It is most probable, however, that these artists are no different in attitude toward their visual art than the modern Jewish composers are toward music."[238]

45
Max Liebermann (1847–1935)
The Twelve-year-old Jesus in the Temple (study), c. 1879
Black chalk drawing, 17⅛ × 12 in. (43.4 × 30.4 cm)
Staatliche Museen zu Berlin

Anti-Semitism as a political factor appeared simultaneously in France, Germany, and Austria; moreover, the different parties quickly joined forces as a supranational organization despite their nationalistic slogans.[239] The painter Max Liebermann had to confront the art scene in

that context. He had grown up in the family house in Berlin, located directly to the right of the Brandenburg Gate. Walther Rathenau, an industrialist and major political figure, was his father's cousin.

In 1878, Liebermann went to Munich, where he painted *The Twelve-year-old Jesus in the Temple*, of which the original is known only from a preparatory drawing (plate 45). It caused an outrage because Jesus was depicted as a barefoot boy with dark hair and a disheveled garment, gesticulating in a conversation with orthodox Jews.[240] The crown prince of Bavaria objected to Jesus being painted as a Jew, by a Jew, and the matter was even discussed before the Bavarian parliament!

Returning to Berlin, Liebermann found his cosmopolitan attitude at odds with the conservative culture promoted by the newly unified nation. In contrast with established art, his fluid technique, melding Realism with Impressionism, conveyed the intensity of human activity; he shared the French taste for humble subjects, peasants and rural landscapes. Jewish dealers, the Cassirers, supported the Berlin Secession art movement, of which Liebermann was the founder and first president.

In 1920, Liebermann was unanimously elected president of the Prussian Academy of the Arts, which would have been unthinkable for a Jew under the kaiser. Nevertheless, in the 1930s his work would be considered "Degenerate Art." Although Liebermann developed an even more humanistic approach in his late paintings, he was made out to be an "Oriental" character. At the same time, complaining about the intrusion of foreign art into German galleries, protesters associated him with the hated French.

In 1933, Liebermann wrote to Hayyim Bialik, "Like a horrible nightmare, the abrogation of equal rights weighs upon us all, but especially upon those Jews who, like me, had surrendered themselves to the dream of assimilation. . . . As difficult as it has been for me, I have awakened from the dream that I dreamt my whole life long."[241] In 1942, the Nazis, who had confiscated his summer villa, used it to house the guests of the infamous Wannsee Conference, where the "Final Solution" was planned.

In the catalogue of the Max Liebermann retrospective at the Jewish Museum in New York in 2006, the ambivalence with which he approached his identity and the way this influenced his aesthetic choices are addressed: "Might this sensibility have contributed to the artist's disregard for the phenomenological recording of a more autonomous embodiment of vision (as explored by Cézanne)?"[242]

The Germans saw the Dutch painter Jozef Israëls as a major influence on Liebermann (plate 46). At the time, Holland was more popular with German artists than France. Liebermann's familiarity with Dutch artists was reflected in his focus on figural genre scenes. Israëls, the "Nestor" of the famous School of The Hague, was considered the "Second Rembrandt" for his ability to capture emotion, in a style similar to that of Gustave Courbet.[243]

Israëls moved to Amsterdam, of which he said, "I lived a few houses away from where Rembrandt worked for so many years. I viewed the picturesque masses, the bustle, the warm-blooded faces of the Jewish men with their gray beards, the women with their reddish hair, the carts full of fish and fruits and other wares, the air—everything was Rembrandt . . . Rembrandtesque."[244]

Israëls revealed a humanistic concern for Jewish subjects as well as for street people, depicting loneliness, bereavement, and death. *Self-portrait with Saul and David in the Background* (1908) is his last major painting. By invoking Jewish heroes, which he had rarely done before, Israëls confirmed his loyalty to his two cultures, even though he proclaimed, "I am not a Jewish artist, nor do I want to be. I am a Dutch artist."[245] In 1911, Israëls was given a state funeral.

46
Jozef Israëls (1824–1911)
Father and Son, n.d.
Charcoal and pencil on paper, 9¼ × 6⅞ in. (23.5 × 17.5 cm)
Private collection

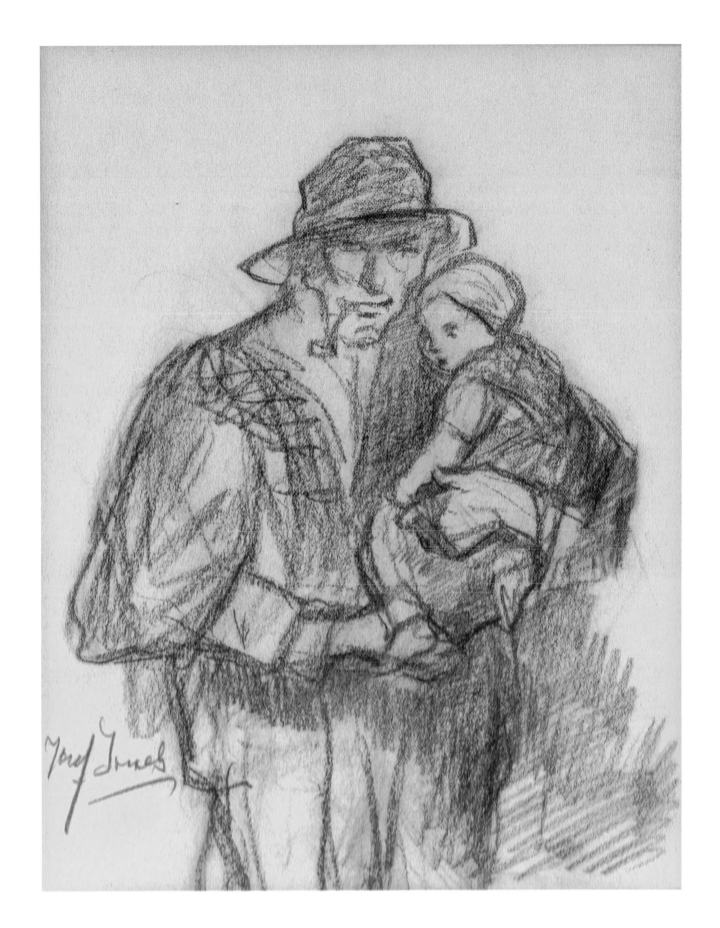

His family visited the Salon de Paris and spent summers at the North Sea shore, together with Liebermann. Israëls used to say of Itje (Isaac), his *wunderkind*, then six years old, that "with the aid of the Lord he would be a better colorist than his father." Isaac became a famous painter indeed, inspired by Zola and Van Gogh in his early studies of miners and peasants.[246] When he turned to modernism with the motto *l'art pour l'art* ("art for art's sake"), his mother Aleida consulted a psychiatrist.[247]

Kulturwissenschaft, the "science of culture"

In Germany, art historians were not concerned with Jewish topics, even though one quarter of them were of Jewish origin; this preference might be explained by their absolute desire to assimilate.[248] Students who hardly knew where the synagogue was took pride in attending the *Humanistisches Gymnasium*. They defined themselves as *Kulturwissenschaftler*, "scientists of culture." Their favorite subject was the development of Kantian philosophy as revitalized by the neo-Kantians, most prominently Hermann Cohen and his pupil Ernst Cassirer. The Jewish art historian Erwin Panofsky applied Kant's philosophy to the field of art history.

One leading cultural historian, Aby Warburg, was particularly interested in the "psychology of style," which he viewed as an ethical question.[249] He founded the famous Warburg Bibliothek in Hamburg, where documents were classified by subject, in a struggle "over the right to one's own voice and the freedom to choose who one wanted to be. . . . I am a Jew by birth, a Hamburger at heart, and a Florentine of the soul."[250] Creating an environment that would actualize his patched-together identity, he hoped to develop a science of culture aimed at understanding the "historical Other."

In his final years, Warburg worked feverishly to produce a picture atlas called *Mnemosyne*. The objective was to present a lexicon of universal symbols through a panorama of photographs affixed on screens with wooden frames: this encyclopedic work would inspire R. B. Kitaj's "Pantheon of Diasporists."[251] Western society was expected to evolve in the direction of progress, but Warburg still included several menacing images. When Hitler came to power five years after Warburg's death, his team of scholars fled with six hundred cartons of books. They established the Warburg Institute in London with an initial collection of 60,000 volumes and 20,000 photographs.

Warburg's research shows structural parallels with Freud's.[252] Cultural science and psychoanalysis shared the stigma of belonging to the Jewish minority. Moreover, while rationalists advocated the study of the laws of nature—of which man is but a part—psychoanalysts held on to the right to diagnose archaic elements buried deep inside the modern individual. As such, it was a humiliating discipline that laid waste to the belief that people are the masters of their own destiny. But for Freud, discussing hidden compulsions only boosted the capacity to resist them.

A relationship between Judaism and psychoanalysis runs through Freud's entire oeuvre, and he repeatedly expressed anxiety lest his movement be regarded as a "Jewish national affair."[253] In this context, Yosef Yerushalmi offers a provocative reading of *Moses and Monotheism*: the preoccupation with the "return of the repressed" is attributed to the aging Freud's alarming feeling of resemblance to his father, which he wards off by identifying with an Egyptian Moses.[254] Much has been written about the many gaps between Freud's private Jewishness and his public life: despite his periodic frictions with the Jewish community, his six children married within the Jewish faith.[255]

In 1926, Freud said, "My language is German. My culture, my achievements are German. I considered myself German intellectually, until I noticed the growth of anti-Semitic prejudice in Germany and Austria. Since that time, I prefer to call myself a Jew."[256] One might conclude, on a somber note, that humans would have no difficulty in

exterminating one another to the last—but nothing could stop Jewish optimism.

Autoemancipation

Moses Mendelssohn's *Bi'ur* and, later, Leon Pinsker's *Auto-emancipation* (1882) were decisive books concerning Jewish identity. With Theodor Herzl, the question migrated from private circles to the international scene. In 1901, at the Fifth Zionist Congress in Basel, Martin Buber made a plea for refashioning the Jewish soul through art, arguing that aesthetics had been overlooked in the past: "The excess in soul power that we possessed at all times expressed itself in the exile merely in an indescribably one-sided spiritual activity.... We were robbed of that from which every people takes, again and again, joyous fresh energy—the ability to behold a beautiful landscape and beautiful people."[257]

Buber attempted to define the nature of "national Jewish art" by commenting on the works of more than twenty artists, identifying their "Jewish character" in expression and form. He called upon the congress to recognize "the peculiar appropriation of light and shadow, the play of the atmosphere around objects, the integration of individual items into the surrounding environment...."[258] In 1901, Buber organized an exhibition of forty-eight works by Jewish artists, featuring Alfred Nossig, Lesser Ury, Ephraim Moses Lilien, Hermann Struck, Jehudo Epstein, and Jozef Israëls. It was the first of its kind.

In 1903, Buber edited *Jüdische Künstler*, an illustrated volume of essays on Jewish artists. The *Ausstellung Jüdische Künstler unserer Zeit* (Exhibition of Jewish Artists of Our Time) in Berlin showcased 150 paintings and sculptures in an effort to promote Buber's theory that there was a common denominator in the work of Jewish artists. But no unified concept emerged. Moreover, the works were at odds with the modernistic atmosphere in Berlin, where Jewry showed little interest in the exhibit.

Buber was trained as an art historian by Aloïs Riegl,

who was attached to the notion, inherited from Herder, of *Volksgeist*, the "spirit of the people," a sort of collective unconscious. Non-Jewish art historians, like Heinrich Wölfflin, considered the history of form to be determined by "national traits." It is hardly surprising, then, that Jewish scholars, led by Buber, claimed their own history of art.[259] Jewish nationalism was partly inspired by the German example, since these scholars' training was rooted in Christian erudition.

Paradoxically, Jewish writers rediscovered their own culture through German Neo-Romanticism: in a way, their assimilation became the starting point of their dissimilation. One of the most significant aspects of their romantic reinterpretation was the importance of messianism; aspiring to a future transcending all reality, past or present, they proclaimed messianism to be the essence of Judaism.[260]

In Poland: *Lign in dr'erd und bakn begl,* "Six feet under baking bagels"

For the Jewish community in Eastern Europe, the Enlightenment gathered force toward the end of the nineteenth century. The division of Europe into two zones, nation-states in the West and a multinational empire in the East, corresponded to the division between the so-called *Westjuden* and *Ostjuden*. The Jews who lived in nation-states considered themselves to be part of a country while adhering to modern Judaism. In the Russian empire, however, most viewed themselves as orthodox Jewish people, hardly affected by Western modernity.[261]

In the empire, Jews were accused of dominating the economy and interfering with national interests. The social and economic underdevelopment of the region largely contributed to a separatism of which the most obvious symptom was a deep attachment to Yiddish. Literature progressively left the shtetl for the city—a major step toward secularization.[262] With his Yiddish stories, Sholem

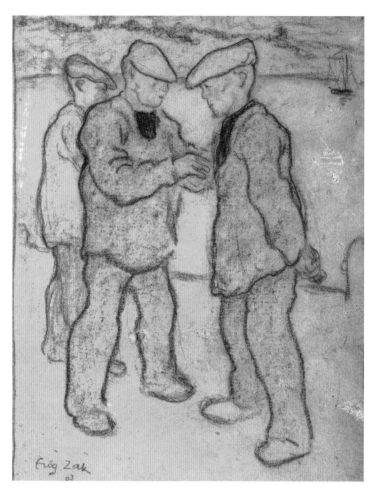

47 (above)
Eugène Zak (1884–1926)
Fishermen in Brittany, 1907
Charcoal and pastel on cardboard, 11⅜ × 9 in. (29 × 23 cm)
Private collection

48 (opposite)
Eugène Zak (1884–1926)
Sitting Shepherd, 1920
Oil on canvas, 57½ × 45 in. (146 × 114 cm)
Musée du Petit Palais, Geneva

Aleichem (Rabinowitz), the author of *Tevye the Dairyman*, which became the musical *Fiddler on the Roof*, was a household name. Achad Ha'am (Asher Ginzberg) and Hayyim Bialik modernized Hebrew literature. Synthetic Hebrew,

which would cement the emerging Zionist movement, was the brainchild of Eliezer Ben-Yehuda.[263]

After the partition of Poland in 1793, Russia inherited a large number of Jews. Five million of them then lived in the Russian empire, but not in Russia proper. They were assigned to the so-called Pale of Settlement (see the maps on the last page of this volume), which extended from the Baltic Sea to the Black Sea, excluding Moscow, St. Petersburg, and other major cities. Jews were thus confined to Lithuania, Belarus, the Ukraine, Bessarabia, Poland, and the Crimea. A massive migration took place inside *Yiddishland* toward the big cities, as well as outward, from Lithuania to southern Poland and ultimately to the West.

Poland had been a safe place in the Middle Ages, when Casimir the Great granted rights to the Jews who survived the Crusades. In the sixteenth century, regional councils, whose main purpose was tax collection, appeared among the large Jewish population of Poland and Lithuania. These organizations managed many other aspects of Jewish life and offered some protection. But the Golden Age of Polish Jewry suffered a serious setback when the Cossacks killed one hundred thousand of them in 1648–49.

In the former Polish state—split between Russia, Prussia, and Austria—cultural life was concentrated mainly in Galicia; attached to the Austro-Hungarian Empire, it enjoyed some autonomy. Born in Galicia, Maurycy Gottlieb was a German-speaking Pole as well as a proud Jew who sought acceptance as a history painter. In Vienna, he discovered the work of Jan Matejko, who acknowledged the contribution of the Krakow Jews in *The Welcome of the Jews by King Casimir* (1889).

For Gottlieb, the issue of reconciliation was essential: "How deeply I wish to eradicate all the prejudices against my people . . . and bring peace between the Poles and the Jews, for the history of both peoples is a chronicle of grief and anguish!"[264] In *Christ Preaching at Capernaum* (1878–79), inspired by Rembrandt, Gottlieb expressed his hope for a harmonious society. This prodigy saw his role as a moral

guide through art, but he died at twenty-three, and in the turmoil of national movements his universalism could not survive.[265]

An independent Poland emerged again at the end of World War I. According to the first Polish census in 1921, there were three million Jews in the country, representing 10 percent of the population. In the 1930s, some 250 Jewish journals were published regularly in Poland alone,[266] and a battle raged between the new adherents of Hebrew and those who still favored Yiddish, which remained dominant.

The Polish art scene was awakening. Warsaw—formerly in Russia—was now the capital of Poland, with a university and an art school where Wojciech Gerson taught drawing. Krakow was the cultural center of Galicia, with the Jagiel-

lonian University and the School of Fine Arts, led by Josef Pankiewicz, who promoted Impressionism and sent his students to Paris,[267] where many joined the Nabi group ("prophet" in Hebrew). The Pole Thadeus Natanson founded *La Revue blanche* in Brussels in 1891, as a forum for Parisian writers like Proust and Bergson.

With Gauguin as leader, Symbolism emerged as a broad artistic movement whose main proponents settled in Brittany, searching for the primitive roots of art. The British, and then the Americans and the Scandinavians, flocked in. The Polish, too, joined this "artist-tourist" wave. First came the Jewish Symbolists Leon Hirszenberg and Leon Kaufman.[268] Pankiewicz encouraged Moise Kisling and Simon Mondzain to go to Paris, and like many others, they traveled to Brittany. Eugène Zak visited Brittany for the first time in 1905. He was highly cultured and developed an independent style, "adding feel to color and line, and humanity to painting" (plates 47, 48).[269]

Mela Muter explained that among the models she painted in Brittany, the first one was an old peasant whose face bore the traces of suffering. While "she examined this crying face, her own heart was weeping. That feeling was the essence of her work."[270] In 1901, she had arrived in Paris, where the dealer Ambroise Vollard became interested in her art. She was in close contact with Romain Rolland and Diego Rivera; Rainer Maria Rilke dedicated poems to her. Three months before she died, the Hammer Gallery in New York organized a solo show of her work.[271]

The catalogue of the 2004 exhibition *Les artistes Polonais en Bretagne* (Polish Artists in Brittany) at the Musée d'Orsay states that "none of these painters [who were mostly Jewish] were interested in traditional folklore. They preferred to paint people at work, rather than represent them in

49
Henryk Berlewi (1894–1967)
Portrait of a Man, 1927
Pencil on paper, 10¼ × 8¼ in. (26 × 21 cm)
Private collection

their festive attire. . . . Far from the Parisian concern with style (Neo-Impressionism, Fauvism, or even Cubism), they explored highly personal paths. Some made powerful works (like Mela Muter's, which are close to Expressionism)."[272]

Around World War I, the Formists, a significant group of mostly Jewish artists with leftist tendencies, appeared in the industrial city of Lodz.[273] They used expressionism as "a system for articulating their Polish-Jewish identity."[274] Many of them settled later in Berlin or Paris and became a link between Western modernism and Polish art.[275]

Meanwhile, back in Lodz, a new artistic milieu arose around Henryk Berlewi, cofounder of the Society of Jewish Artists in Poland, and the poet-painter Moshe Broderson, who formed the artistic and literary group Yung Yiddish (1917–21). The artists had close ties with the avant-garde in Moscow, New York, Paris, and Berlin, where Berlewi met the group Der Sturm. He returned to Poland as the promoter of Mechanofaktura, an abstract movement with Constructivist tendencies.[276]

In 1926, Berlewi returned to figurative art for a thirty-year period; in Belgium he drew portraits of political and literary figures (plate 49). He resumed his abstract research in 1957, encouraged by Denise René, who organized a show in Paris, *Cinquante ans de peinture abstraite en Pologne* (Half a Century of Abstract Painting in Poland). Berlewi said that he and Lissitzky were among the few artists who sacrificed their love for Jewish life on the "Constructivist altar."[277]

In Russia: *Zolst krenken in Nakhes,* "You should suffer in the midst of pleasure"

In Russia, the atmosphere had changed radically in 1881, when Alexander II, the czar who gave the Jews relative cultural and administrative freedom, was murdered. Anti-Semitism reached a climax under his successor Nicholas II, with the publication of *The Protocols of the Learned Elders of Zion* in 1905. After the Kishinev massacre, which in itself

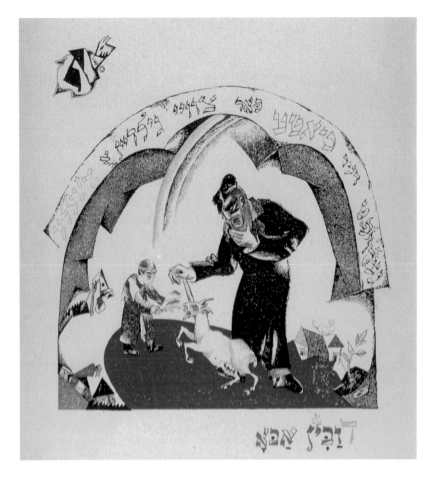

50
El Lissitzky (1890–1941)
Father Bought a Kid for Two Zuzim, Had Gadya Suite, 1919
Color lithograph on paper, 10¼ × 10 in. (27.3 × 25.4 cm)
The Jewish Museum, New York; gift of Leonard and Phyllis Greenberg, 1986

resulted in more deaths than all the pogroms of the 1880s, Jewish self-defense groups were put in place: Bund, the spearhead of the revolution in Jewish circles, was founded in 1897. New massacres followed when a Kiev Jew, Beilis, was accused of ritual murder. Nevertheless, the Russification of the Jews was in progress.

Yet even as they adopted the Russian language and substituted Tolstoy for the Talmud, Jews could not become Russian by nationality. The empire and later the Soviet Union were multinational states, dominated politically by the Russians, who made a clear distinction between true Russians and their underlings: Jews, Georgians, Lithuanians, and so on. (Indeed, in the provinces the Jews had

little contact with Russian nationals other than the administration and the military.) This was radically different not only from France or Germany, but also from neighboring areas such as Poland, where Jews were considered Frenchmen, Germans, or Poles.[278]

Among the reasons driving Jews to leave Russia was the *numerus clausus* imposed in 1898, limiting their numbers from 5 to 10 percent in higher education across the empire, and to just 3 percent in Moscow and St. Petersburg—where access to the academy of art was forbidden altogether. The Revolution raised immense hopes, however, with its abolition of some 150 discriminatory rules.

Russia's artistic emancipation began in 1870, when the Society of Traveling Art Exhibitions, the *Peredvizhniki* or "Wanderers," brought realist art to a broad public. During a brief period, artists established a symbolic reappropriation of their Jewishness.[279]

Some Jewish painters achieved fame by reinterpreting the Russian spirit. This was the case for Isaak Levitan and Leonid Pasternak (father of Boris). The World of Art group, *Mir iskusstva* (1890), was open to Art Nouveau, of which Leon Bakst (Rosenberg), the chief designer of Diaghilev's Russian ballet, was a proponent. Others synthesized Jewish tradition with Russian culture: the success of Yehuda Pen's Jewish genre scenes allowed him to open an art school in Vitebsk in 1897, the only one in the Pale of Settlement.[280] Many of his students became famous, including Marc Chagall, El Lissitzky, and Abel Pann (Pfeffermann).[281]

A Jewish ethnography also developed: the Jewish Historical and Ethnographic Society undertook a two-year expedition (1912–14) to document life in the Pale of Settlement. This survey was underwritten by Baron Horace Günzberg and led by Semyon Ansky (Rappoport), author of the famous Yiddish play *Dybbuk*.[282]

In Petrograd, the Jewish Society for the Encouragement of the Arts supported young artists who could freely portray Tolstoy or Bialik without denying or emphasizing their Jewishness. Lissitzky served the Revolution and Jewish nationalism without a conflict of loyalties (plate 50); as an engineer, expert in mathematics, his later artistic search for infinity was perhaps related to Jewish metaphysical symbolism.[283] Meanwhile, Natan Altman—Lenin's portraitist, dubbed the "David of the Russian Revolution"—designed costumes and sets for the *Dybbuk*.[284] Many, including the uncompromising brothers Natan (Antoine) and Nahum Pevsner (Naum Gabo), embraced new art forms as the Revolution transferred Jewish nationalism to messianic internationalism.[285]

The Kultur-Lige (1918–32), established in Kiev, with branches in Warsaw, Vilnius, Moscow, and New York, continued to revive Jewish folk imagery.[286] But as early as 1918, most Jewish organizations, including the Bund, were declared illegal, and the abrupt political changes put an end to the idea of a Jewish art. Throughout the 1920s, urbanization continued as hundreds of thousands of Jews moved to large cities. Their culture fell into a progressive decline even as acculturated Jewish artists ascended to the top rungs of Soviet culture. The realist Isaac Brodsky became president of the All-Russian Academy of Arts, where official portraiture was a prominent genre. A complacent Socialist Realism would dominate all art for several decades.

That Leonid Pasternak returned again and again in his writings to the issue of Jewish art and literature, and to the Jewishness of Rembrandt (!), attests to existential problems.[287] "Russia's Silver Age would lose much of its allure if the Jewish names of Pasternak, Mandelshtam, Bakst, Chagall, and El Lissitzky were subtracted from its constellation."[288]

In 1939, the State Museum of Ethnography in Leningrad organized the exhibition *Jews in Tsarist Russia and the USSR*. This proved to be the last official show devoted to Jewish

51
Alexander Tyshler (1898–1980)
D.R. N2, from the Birthday series, 1973
Oil on canvas, 25¼ × 22¾ in. (64 × 58 cm)
Courtesy of MacDougall Auctions, London

culture. The "Jewish" passport, which at first merely iden-
tified a distinct nationality, became a mark of discrimina-
tion.[289] Although the Jews were the most educated and
successful minority in the USSR, and roughly 25 percent
of the Bolshevik government was of Jewish origin, Stalin's
purges did not spare anyone who was even vaguely sus-
pected of antigovernment activity.

The horror of the Holocaust, with the murder of ap-
proximately one million Soviet Jews, did not slow their
elimination from positions of influence. Fortunately, Stalin
died in 1953. The Jewish antifascist committee, formed ear-
lier to enlist international support for the Soviet war effort,
was led by the famous actor and stage director Solomon
Mikhoels (Vovsi), who promoted Jewish culture until well
into the 1940s; such tendencies survived much longer in
Yiddish theater than in literature. Mikhoels was murdered
in the 1950s.[290]

Artists were perceived as less of a threat than writers.
For Jewish artists, avant-garde art, even at its height, never
supplanted mainstream figurative art. Aspects of Impres-
sionism, Symbolism, Post-Impressionism, Expressionism,
Cubism, and Futurism may be detected in early paint-
ings by Robert Falk, Solomon Nikritin (plate 40), David
Shterenberg, and Alexander Tyshler (plate 51), yet these
artists worked predominantly in a figurative mode.[291]

But the return to figurative art did not entail a return to
Jewish themes, even though Jews constituted a high pro-
portion of the "subversive" artists. Their work, later de-
scribed as Critical Figuration,[292] was inspired instead by a
desire to restore the artist's role in society as a philosopher
and prophet. Such painting represented a reaction against
the impersonal, anti-psychological, dehumanizing side of
the regime: humanistic art became a form of resistance.[293]

Tyshler, whose overt Jewishness made him the most
persecuted member of the group, was the one who saved
Chagall's State Jewish Theater murals. Every founding fig-
ure of the new Russian art scene would pay homage to
Falk, Nikritin, and Tyshler, who symbolized the existential

paradigm of the "eternal Jew in the ghetto." Their widows
organized private shows in the 1960s, long before *Perestroi-
ka*.[294] The universalist perspective of these artists, their
readiness to identify with others, lent them a special posi-
tion in Soviet art. Their Jewish identity, then, manifested
itself not so much in an ethnic or confessional way as in an
ethical and political one.[295]

"Rembrandt loved the East End"[296]

A massive exodus away from the tsarist empire started in
the 1880s. Many Jews went to the United States, until an
immigration quota system was introduced there in 1924.
Others settled in England, which had hitherto been un-
aware of the masses of poor Jews; the Portuguese who had
arrived in the seventeenth century were prosperous. Cath-
erine Mendes da Costa is the first known Jewish woman art-
ist, and her miniatures can still be seen in London (plate 39).

In the eighteenth century, the painter Johann Zoffany
came to London from Bohemia, but his Jewishness is not
certain, as publicizing his origins would have harmed his
career. Solomon Alexander Hart was elected a full mem-
ber of the Royal Academy in 1840; a friend introduced Hart
to his children as follows: "Mr. Hart, who we have just
elected academician, is a Jew, and the Jews crucified our
Savior, but he is a very good man for all that, and we shall
see something more of him now."[297]

Sixty-six years later, another Jewish painter, Solomon
J. Solomon, was similarly honored. He said, "We know
that the reproduction of natural forms, more particularly
human forms, was forbidden to the Jews. Art in such con-
ditions could not flourish. All design is based on natural

52
David Bomberg (1890–1957)
Theatre Ghetto, 1919–20
Oil on canvas, 30 × 25 in. (76.2 × 63.5 cm)
Ben Uri Gallery, The London Jewish Museum of Art

form and the key to the highest inspiration and appreciation is the knowledge of the human form."[298]

The Solomon family (unrelated to Solomon J. Solomon) produced three artists who left a mark on the nineteenth century: Abraham, Rebecca, and the notorious Simeon, who exhibited early on at the Royal Academy and developed ties with the Pre-Raphaelites, but ended up destitute.

Of Simeon's watercolor *Sappho and Erinna in a Garden* (1864), the Tate Britain catalogue says, "This is the earliest lesbian image, painted by a homosexual disciple of Rossetti, who was shunned by his earlier friends after conviction for gross indecency in 1873. Simeon Solomon exulted in his bohemian life-style, refusing financial assistance from wealthy Jewish relatives. His art was ambiguous, provocative, and decadent."[299]

David Solomon (also unrelated to the above) became Lord Mayor of London in 1855, and the novelist Benjamin Disraeli, who was baptized, served twice as prime minister. The abolition of slavery found a favorable echo in naturalistic theory. (Darwinism was popular, as its principle of natural selection became synonymous with "British hereditary superiority."[300]) Well-to-do Jewish families who were perfectly integrated were naturally supportive of the empire's ideology.[301]

However, the Jewish refugees who flooded London developed a cultural life of their own; in particular, their messianism reinforced the burgeoning labor movement. In the East End, the Whitechapel Library and the Whitechapel Gallery opened in 1901, while the Jewish Education Aid Society provided financial help to students. In 1906, an exhibition that gave pride of place to Jewish artists was held in London: intended to promote goodwill between the Jews of East and West, as well as between Jews and gentiles, it attracted 150,000 visitors. The Ben Uri Society for the advancement of art was founded in 1915.

Yiddish theater by amateurs, clowns, singers, and acrobats had its roots in the *Purimspieler,* which originally enacted the story of Esther, who saved the Jewish people.

Boxing and music halls became the chief forms of Saturday-night entertainment among the Jewish working class. In London, Tolstoy was staged in Yiddish before English (plate 52).[302]

With the exception of the Royal Academy and the Slade School of Fine Art at University College, art was taught in technical schools. The Royal Academy observed a strict delineation between the fine artist and the craftsman, as much to preserve a social distinction as an aesthetic one.[303] Renowned for his mordant wit, Walter Richard Sickert, a painter of German origin influenced by Whistler and Degas, moved the center of gravity from mid-London to Camden Town, where a group was officially launched in 1911.[304] Much of Sickert's realist subject matter was then pioneering; John Ruskin's followers referred to it as "slum art." Camille Pissarro's son Lucien, who had lived in London since the 1890s, played a significant role in this group.

Euston, King's Cross, and St. Pancras stations, along with their new lines cutting through the housing district, created a low-rent area encompassing London University and the British Museum, which appealed to students at the Slade School of Fine Art, south of Bloomsbury.[305] That loose circle of artists and intellectuals, connected by their Cambridge education and their liberal politics, became highly influential: Virginia Woolf, as a novelist and feminist; John Maynard Keynes, as a political economist; and Roger Fry, as the critic who brought Gertrude Stein's and David-Henry Kahnweiler's art to London.

The press's verdict on Fry's show *Manet and the Post-Impressionists* was that "the Art-Quake of 1910 has erupted."[306] Dominated by Cézanne, Gauguin, and Van Gogh, it drew 25,000 visitors and introduced the British public, who had barely come to terms with Impressionism, to Post-Impressionism.

Several noteworthy Slade students were Jewish, including Mark (Max) Gertler, Jacob Kramer, and David Bomberg, the fifth child of eleven in his family, who grew up in

Whitechapel. From an early age, Bomberg practiced drawing at the Victoria and Albert Museum. He was very close to his mother, who saw that he got all he needed—frames, canvases, and paints. John Singer Sargent singled him out while he was training at the British Museum.

Bomberg studied under the direction of Sickert, and after graduating, boldly experimented with abstract forms. He traveled to Paris with Jacob Epstein (plate 53), an American sculptor based in London, in order to organize the Jewish section of the Whitechapel exhibition *Twentieth Century Art: A Review of Modern Art Movements* (1914). Bomberg developed a style that gave expressive force to his subject. The caption for *The Mud Bath* (1914), which is on permanent exhibit at the Tate Britain, reads, "The way in which Bomberg reduces the human figure to a series of geometric shapes may reflect his fascination which he shared with the Futurists and the Vorticists. The scene is based on steam baths near Bomberg's home in East London, which were used by the local Jewish population and that also had religious associations. . . ."[107]

While Bomberg never gave up the human aspect of his work, after he traveled to Jerusalem he became more interested in "landscapes [that] often contain a spiritual tone and a sense of pathos with a touch of European Expressionism.'" His self-portraits clearly express a love for Rembrandt. Bomberg thus went through several phases after quickly abandoning his early formal experiments in the Vorticist style.[108] (The Vorticist group, founded by Wyndham Lewis in 1913, conceived of the "vortex," the rise of "drastic winds," as "England's mission"; like the Italian Futurists, the Vorticists were fiercely nationalistic.[109])

At the time, Gertler, another "Whitechapel boy," was considered one of Britain's leading painters. A child prodigy from the East End slums, he entered the Slade as a teenager, carried off many of its prizes, and left with a reputation as "the genius of the place." Gertler was so famous that when the news of his death came out in 1939, it was splashed across the front page of most newspapers.[110]

53
Jacob Epstein (1880–1959)
Oriel Ross, 1931, cast 1949
Bronze, 26 × 15¼ × 13¼ in. (66 × 40 × 33.7 cm)
Norton Museum of Art, West Palm Beach, Florida;
bequest of R. H. Norton

In London's Jewish quarters, the language remained Yiddish; when Gertler visited Montparnasse, he noted that most artists there communicated in Yiddish as well.[111] Gertler spoke Yiddish all his life with his mother, Golda. "I went out and saw more unfortunate artists," Gertler wrote to his lover Dora Carrington. "I looked at them talking art, Ancient art, Modern art, Impressionism, Post Impressionism, Neo Impressionism, Cubists, Spottists, Futurists, Cave dwelling, Wyndham Lewis, Duncan Grant, Roger Fry! It was like entering the tower of Babel, and I

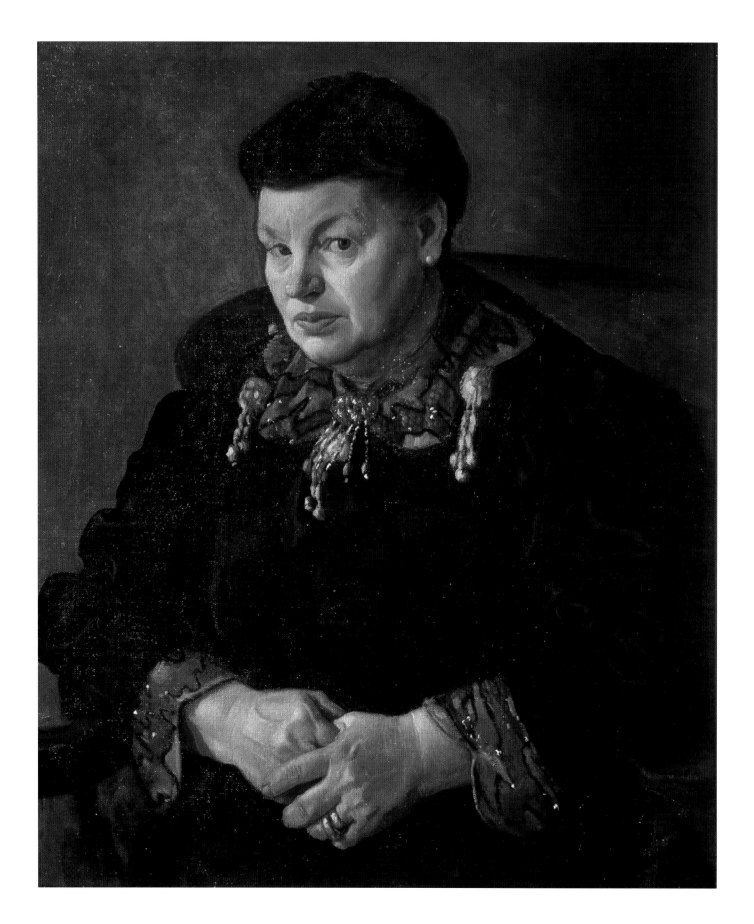

walked home disgusted with them all and glad to find Golda waiting up with a nice roll that she knows I like, and a cup of hot coffee. Dear mother, the same mother of all my life, twenty years. You, dear mother . . . are the only modern artist."[312] *The Artist's Mother*, one of Gertler's best-loved paintings, was prominently displayed at the New English Art Club in 1911, where it gained unanimous praise (plate 54).[313]

In a recent biography, Sarah MacDougall describes how Gertler fascinated his contemporaries. He became the sculptor of D. H. Lawrence's *Women in Love*, the Byronic hero of Aldous Huxley's *Crome Yellow*, and the egotistical writer of Katherine Mansfield's *Je ne parle pas français*. Vanessa Bell, Roger Fry, and Henry Moore admired Gertler. Yet despite his apparent ease in society, he felt his Jewishness and working-class background to be insuperable barriers.[314]

Where Gertler grew up, children were adept at stealing vegetables, and tuberculosis was endemic. There were over two hundred *haidarim*—Jewish schools consisting of a crowded room with just a table.[315] Parents encouraged their children to learn English to throw off the "enemy alien" label. Racial tension led to segregation in public schools, where Jewish pupils spoke English in class and Yiddish in the courtyard.

Gertler began early, drawing in chalk on the pavement outside his home. His parents were very proud of his talent, even though the profession of artist was virtually unknown to them.[316] In his early days at the Slade, he did not speak to anyone, because he was embarrassed by his accent.[317] By the time he finished school, he was known as an exceptional draftsman. Gertler established a strict rou-

tine that he followed for the rest of his life: from 10 A.M. to 1 P.M. he painted, from 2 P.M. to 4 P.M. he drew, and from 5 P.M. to 8:30 P.M. he continued painting.[318] His early pictures depict Jewish people or native peasants, including many matriarchal figures, in a primitive pictorial language that vacillates between love and terror, beauty and ugliness.[319] In the show that Bomberg organized, seven out of the fifty-three works in the Jewish section were Gertler's.

During World War I, he painted a major piece called *Merry-go-round* (1916). It was a vision of cultural disintegration as well as an expression of Gertler's discontent with his "circular" relationship with Carrington. She was the sounding board for his ideas, and his letters were full of alternating enthusiasm and despondency.[320] The only interest that *Merry-go-round* attracted was from D. H. Lawrence, who was concerned that it would raise an outcry because Gertler was a conscientious objector.

"It would take a Jew to paint this picture. It would need your national history to get you here, without disintegrating you first. You are twenty-five, and have painted this picture—I tell you, it takes three thousand years to get where this picture is,"[321] Lawrence wrote, warning Gertler about the dangers of showing this work when it might be seen as "hunlike."[322] (Critics also referred to Cubist-looking art as "cabbalistic.") The painting was never shown again during Gertler's lifetime, and he abandoned formal experimentation after this single effort.[323]

Gertler made self-portraits at significant moments of his life, or when he had little money available to pay models.[324] Jewish men and women were associated with the expression of suffering, which he depicted in a tradition handed down from Rembrandt.[325] In the 1930s, Bloomsbury was in decline, while modernism was on its way in. Although Gertler's art was considered not to be novel enough, Fry admired him until the end of his life, and through Henry Moore, Gertler met Herbert Read, the new promoter of modernism. Gertler reinvented himself with the desire to be thought of as a classical artist inspired by

Cézanne and Renoir, albeit beset with anxiety. His debt to Paris is obvious, and an added expressionist tension contributes to the vividness of his work.[326]

Gertler was connected with Bertrand Russell, T. S. Eliot, and Lytton Strachey. Though he had acquired the trappings of "the aristocracy"—clothes, culture, and recognition—inside he remained "a child of the ghetto."[327] His letters reveal a deep ambivalence toward his experience of assimilation and the ways in which he negotiated identities. He impressed Woolf with "his fanatical devotion to his art," but a large part of their conversation was about Jews, Judaism, the relation of Jews to other people, their differences, their faults and virtues, and so on.[328] Gertler committed suicide at the age of forty-seven.

Another figure, Jacob Kramer, arrived in England at the age of eight and also entered the Slade with assistance from the Jewish Education Aid Society. Unlike Bomberg or Gertler, Kramer did not experiment with Cubism, nor did he join the Bloomsbury circle. His early drawings reflect a lifelong interest in portraiture, again with Rembrandt as a role model.[329] In his correspondence with Herbert Read, Kramer wrote, "The degree of expression in a work of art is the measure of its greatness—a spiritual discernment is more essential than the reproduction of the obvious. It is my endeavor to create a purely spiritual form."[330] Forging his own values, Kramer was an early existentialist who strongly believed in freedom of choice.[331]

In the 1930s, the group Unit One, abstract in orientation, embraced Surrealist tendencies as well. Ben Nicholson and his wife Barbara Hepworth founded the St. Ives group, which also emphasized abstraction, at the outbreak of the war.[332] When the Ben Uri Society later published a catalogue of the works of Jewish modern artists who worked in Britain, their distance from abstraction was evident: sixty-three out of the seventy-six works presented in the catalogue dealt with the human figure.[333] Among the many other Jewish painters with expressionist tendencies in London, one should mention Alfred (Aaron) Wolmark

and Josef Herman.[334] When Herman held his first exhibition, Kenneth Clark, then director of the National Gallery, said, "You are a very talented painter but my advice to you is to go back to Europe. . . . We English have a great sense of nature but not of humanity. British artists in this exhibition are more emotionally detached and pursue modernist paths."[335] Meanwhile, Henry Moore became a major source of inspiration.

Between the two world wars, many families changed their names to escape identification with the enemy: for example, Auerbach became Arbour, Hallestein became Halsted, Levis became Lewis, and Meyer became Merrick.[336] While working for the War Artists Advisory Committee, Bomberg proposed a radical set of measures to tackle the prejudice faced by Jewish artists, but the committee rejected all his suggestions. He pointed out that "the Jewish artists are starving, none of us can work, most of us receive one form of charity or another."[337]

Weimar: from one war to the next

The Englishman Houston Stewart Chamberlain propagated a German anti-Semitism that combined Christianity, Neo-Romanticism, and nationalism, and whose focal point was the Bayreuth Circle. This worried German Jews but did not deter their faith in assimilation; they envisioned their future as a straight line toward full integration. After World War I, in which Jews served loyally in the German army, the Weimar Republic went through fifteen governments in the seventeen years of its existence.[338]

During that period, there were barely half a million Jews for seventy million Germans—representing 0.9 percent of the population and rapidly diminishing through assimilation. At that time, anti-Semitism crystallized around the leftist social movements, whose preeminent Jewish leaders—Rosa Luxemburg, Kurt Eisner, and Gustav Landauer—were murdered. In 1922, Walther Rathenau, who hoped to become the German Disraeli, was killed too.

The rapid modernization process, of which the Jews were perceived as promoters, exacerbated German hate. Still, many Jews did not believe that Hitler would become chancellor, or that he would implement his theories. From 1920 to 1932, Max Liebermann presided over the Prussian Academy of Arts; Einstein received the Nobel Prize in 1920. Ernst Cassirer became rector of Hamburg University in 1929, and Freud received the Goethe Award in 1930. Jews were especially present in German culture, with stage directors like Max Reinhardt (Goldmann), movie directors like Fritz Lang and Ernst Lubitsch, and composers like Arnold Schoenberg and Kurt Weill.[339]

Germany was the center of European culture, and Jewish writers considered this a guarantee of integration.[340] Major newspapers like the *Frankfurter Zeitung*, the *Berliner Illustrierte Zeitung*, the *Berliner Tageblatt*, and the *Vossische Zeitung* were founded by Jews.[341] Jewish theater critics were numerous. These protagonists on the literary stage contributed to German culture as Germans, much more than as Jews.

The pacifist writer Stefan Zweig believed Jewish destiny to be synonymous with humanistic universalism. The playwright Arthur Schnitzler developed his sensitive and subtle style of psychological writing in reaction to anti-Semitism. Another famous writer was Joseph Roth. Historical novels were fashionable too—for example, Lion Feuchtwanger's *Jud Süss*—as was Else Lasker-Schüler's poetry.

Franz Kafka, raised in a Germanized Czech family, formed the Prague Circle with his friends Max Brod, Oskar Baum, and Felix Weltsch. Kafka's works are universal parables. All these authors' search for identity became a source of literary wealth as they expressed the diffraction, and finally the impossibility, of any Jewish identity whatsoever.[342] The German-Jewish symbiosis proposed earlier by Hermann Cohen had become untenable for the new generation, which turned to existential introspection.[343]

The language was central to German culture, and the Jews were its best pupils. They knew their classics by

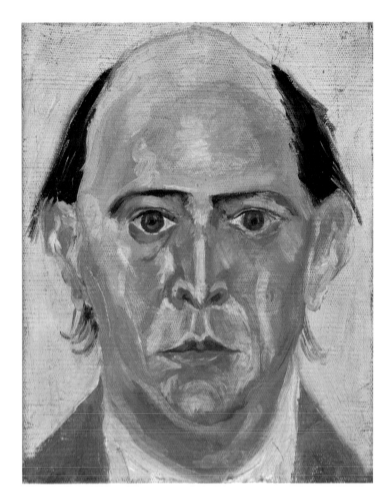

55
Arnold Schoenberg (1874–1951)
Self-portrait, c. 1910
Tempera on canvas, 11⅝ × 9⅛ in. (29.5 × 23.3 cm)
Arnold Schoenberg Center, Vienna

heart and fought until the bitter end for *Aufklärung* ideals. Their literary activity became a desperate attempt to represent through fiction a goal unattainable in real life. One third of the so-called "Expressionist" writers were of Jewish origin, generating a literary movement referred to as "Expres sionismus" (a disparaging pun on "Zionism").

A few Jewish artists also briefly participated in German Expressionist painting. Schoenberg became a composer

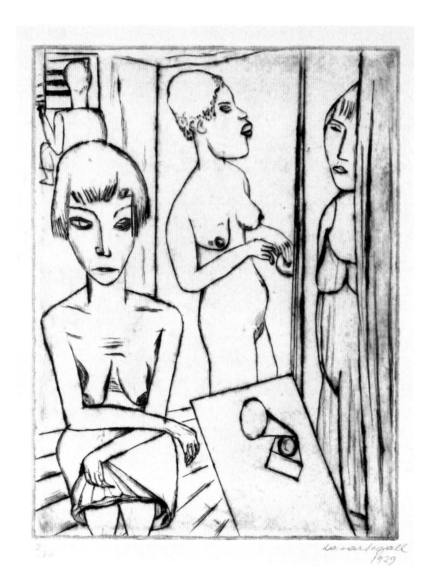

56
Lasar Segall (1891–1957)
Mango: Women with Phonograph, 1929
Drypoint, 11 × 8½ in. (27.6 × 21.6 cm)
Musée d'Art et d'Histoire du Judaisme, Paris;
gift of Mrs. Lucy Citti Ferreira

after experiments in visual art (plate 55); Jankel Adler (plate 57), who developed a messianic style of his own, moved to Britain; Lasar Segall left for Brazil, where he became famous (plates 15, 21, 56); and Ludwig Meidner developed a personal

brand of prophetic Expressionism. It was said that Meidner was the "most expressionist of the Expressionists"—but this applies only to a limited part of his work (plate 58).[344]

Violent Expressionism

The term "Expressionism" usually refers to an art movement that emerged in Germany in the early twentieth century and lasted until 1915. Catherine Soussloff explains how Richard Gerstl, Oskar Kokoschka, and Egon Schiele were Expressionist precursors in Vienna, where the links between the psyche and physical expressions were being analyzed, and art historians were debating the radical turn in portraiture.[345]

There was, however, a broader concept born around 1830 with Herder's *Volkseele,* the "soul of the people," and Hegel's *Phenomenology of Spirit.*[346] In 1908, Wilhelm Worringer published *Abstraction and Empathy,* in which, anticipating abstract art, he defined "abstraction" as a spiritual agoraphobia that drives the artist to build an imaginary defense out of geometric elements. At the opposite end, romantic empathy—*Einfühlung* in German—meant a projection toward the world. Worringer explained that Nordic men, eager for spirituality, feel "a veil between nature and themselves, and therefore aspire to an abstract art form."[347]

The word "Expressionism" was first used in 1905 by Jean-Pierre Lebenstajn in *Toll.*[348] It reappeared in 1911, when Paul Cassirer called Edvard Munch's work "Expressionism" to differentiate it from Impressionism.[349] That same year, Worringer used the word in *Der Sturm* to describe Cézanne, Van Gogh, and Matisse's paintings. In the catalogue of a Berlin Secession exhibition, it refers to Cubist and Fauvist paintings. Even the Italian Futurists are dubbed "Expressionists" in Herwarth Walden's publication *Expressionismus die Kunstwende* of 1918.[350]

Regardless of the confusion, five years earlier Walden had described the Blaue Reiter group as the symbol of German Expressionism, implicitly situating its style

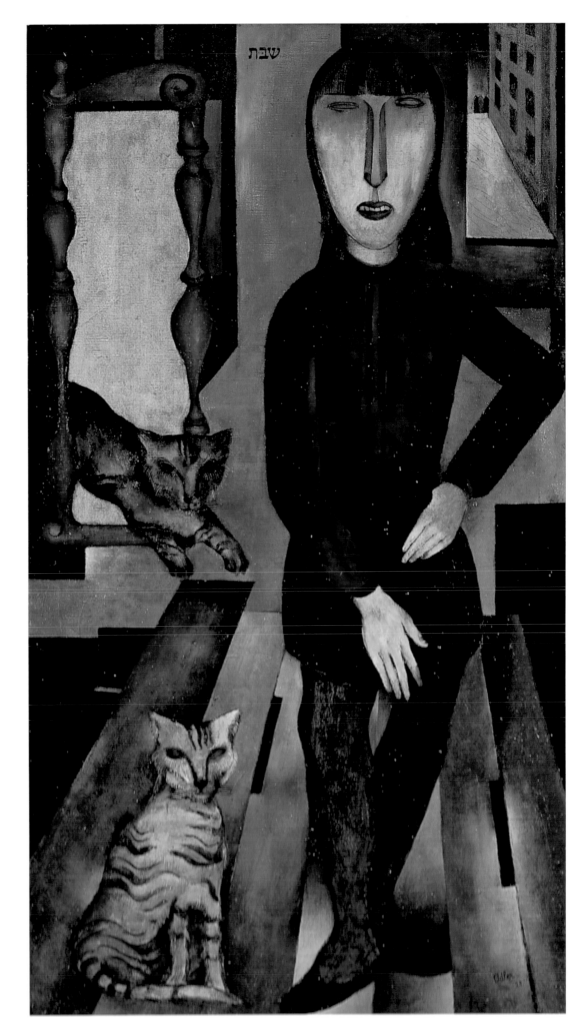

57
Jankel Adler (1895–1949)
Angelika, 1924
Oil on canvas, 41¾ × 23⅝ in. (106 × 60 cm)
Von der Heydt Museum, Wuppertal,
Germany

58 (*above*)
Ludwig Meidner (1884–1966)
Self-portrait, 1916
Published in *Im Nacken das Sternemeer*
(The Sea of Stars at My Back), Leipzig, 1918
Jüdisches Museum der Stadt Frankfurt am Main

59 (*opposite*)
Felix Nussbaum (1904–1944)
Evening, Self-portrait with Felka Platek, 1942
Oil on canvas, 34¼ × 28¼ in. (87 × 72 cm)
Felix Nussbaum Haus, Osnabrück, Germany;
collection of the Niedersächsische Sparkassenstiftung

within German culture. Their art interpreted the "angst" inspired by the decomposition of the subjective identity, fostered by Friedrich Nietzsche, who advocated freedom from bourgeois mediocrity. First in Dresden and then in Berlin, the art movements Die Brucke (a phrase from Nietzsche's *Zarathustra*) and Der Blaue Reiter envisioned a new world order. The Expressionist painters raised German romantic self-consciousness to a level of ecstasy through a metaphysical quest. An aesthetic of evil and ugliness progressively invaded the art scene, where masks and fetishes abounded.

Except for Ludwig Meidner and Conrad Felixmuller, few artists escaped the fascination with a "purified world."[351] Munich had a favorable "artistic karma": Kandinsky founded Der Blaue Reiter there in 1911, and ten years later, the heart of Expressionism and occultism became the center of National Socialism. Jean Clair explains how German Expressionism evolved into an irrational mystique detached from reality, and how aesthetic currents led directly to fascism:[352] "Expressionism is bound to violence, not only through its aggressive shapes and colors. The process itself is violent, in its immediacy and brutality."[353]

Schoenberg, who participated in Der Blaue Reiter, was later exposed to anti-Semitic tendencies at the Bauhaus. He was fascinated by the idea of a "total art" that embraced both the musical and visual aspects of a stage production. After a series of hallucinatory self-portraits (1906–12), he abandoned painting forever.[354] Schoenberg fled Austria in 1933 as a Lutheran, and ostensibly reconverted to Judaism in a Reform synagogue in Paris, with Chagall as witness.

Meidner, who met Modigliani in Paris in 1906, shared his love of the old masters; he was one of the few admitted to Modigliani's studio. Meidner later settled in Berlin, where he founded the short-lived Jewish artists' group Die Pathetiker in 1911.[355] He returned to his Jewish roots in 1923, proclaiming that in the end, "art will die but religion will live."[356]

60
Zygmund Schreter (1886–1977)
Portrait of a Man, 1940–45
Oil on cardboard, 34 × 27⅛ in. (89 × 69 cm)
Private collection

He once wrote, "I myself am a representative—or rather a victim—of that brand of Expressionism from the eastern Elbe that presents itself in the coarse manner of a stable boy, but that is now on the lookout for more civilized domains. . . . Do not be afraid of the human countenance, which is a pale reflection of heavenly magnificence, but even more a bloody battlefield. Draw the wrinkled brow, the root of the nose, the eyes close together. Like a burrowing animal, dig deep into the inexplicable depths of your subject's pupils and the whites of his eyes and do not let your pen rest until you have wed his soul with yours in an impassioned embrace. . . ."[357]

When he met his wife Else, a painter and model, Meidner led a bohemian life in a spartan studio. In 1935, he accepted a teaching position at a Jewish school, Yavneh, in Cologne, where their son David was a pupil. Their decision to move to London was inspired by the *Kindertransporte* organized by the school's director, Erich Klibansky, in 1938, after *Kristallnacht.*[358] This "children's transport" brought 130 pupils from the school to safety in England, and several thousand more from all over Germany. The Meidners followed a few weeks before the war broke out.

In England, Else worked as a servant, and Ludwig was interned as an "enemy alien." He spent some eighteen months in various camps, where he met intellectuals and artists and began to paint again.[359] The lack of recognition he met with as an artist forced Meidner to return to Germany after the war. Although he had little interest in the trends of the 1960s, his highly colored portraits bear a resemblance to those of Alex Katz (plate 107).[360]

After World War I, Germany had moved back to a form of classicism fostered by *Die Neue Sachlichkeit,* "The New Objectivity," an exhibition in Mannheim in 1925, in which painters explored social themes and Italian metaphysical art. Unlike any other artist in the show, Felix Nussbaum expressed a wide range of moods in his work, which recalled that of Giorgio de Chirico and James Ensor. His sense of fear culminated in the prescient apocalyptic works that he created in the months preceding his deportation in 1944, in the last convoy from Belgium (plate 59).

61
Jules Pascin (1885–1930)
Portrait of Jeanine (Warnod), 1924
Oil on canvas, 36¼ × 28¾ in. (92 × 73 cm)
Private collection

Expressionism served as a laboratory of identity for Jewish art collectors. Dealers like J. B. Neumann, Galka Scheyer, and Curt Valentin moved to the United States, where they introduced German art. For the former generation, patronage had been part of a strategy of assimilation. Collecting German art was for Jews in the United States an attempt to overcome their past; they drew comfort from advocating for German art as an expression of a broader human spirit.[361]

In their harsh representations of patrons and dealers, many of them Jewish, Expressionist portraits symbolized an ambivalent quest for identity.[362] In the early twentieth century, Germany could claim exceptional personalities among its Jewish dealers: Paul Cassirer, the first to exhibit French Impressionists; Herwarth Walden, founder of *Der Sturm*, who promoted Expressionism, as did Alfred Flechtheim. The champion of Cubism, Daniel-Henry Kahnweiler, settled in France.

A shtetl in Paris

Back then, after a visit to the galleries in Berlin or Munich, one continued the journey to Paris. After the Dreyfus Affair, France was considered a haven of freedom; there was a saying, *azoy gliklich wi a yid in Paris* (as happy as a Jew in Paris). La Ruche (founded in 1902), the building where many found refuge, was the archetype of artists' housing—and had an academy and a theater. Several such compounds were founded all over Paris at the end of the nineteenth century: Cité Falguière, Cité Fleurie, Villa des Arts, Cité des Fusains, and Cité du Maine.[363]

Jeanine Warnod describes La Ruche as "the Villa Medici of misery," where her father André became the artists' champion (plate 61).[364] In his *Petites nouvelles des lettres et des arts* published in *Comoedia*, André Warnod wrote about their work and life, which could be summarized in one word: *survival*. They had no choice: it was either create or go back to the countries they had left. The

painter Pinchus Kremegne wrote, "Modi [Modigliani] saved us often. He just had to sketch a portrait of someone sitting at another table, and that paid for all the drinks."[365]

In his memoirs, the artist Jacques Chapiro recounts a moving evening with Vera Dobrinsky, daughter of a founder of the Bund and wife of an artist. Vera suffered at La Ruche for over twenty years: with her martyr's face, sad eyes, and a low voice, she described how she lived in a dirty studio infested with roaches after arriving from the Ukraine: "My husband uplifted me by showing Soutine and Modigliani's findings."[366] Isaac Dobrinsky painted numerous portraits of his wife (plate 62). In 1942, they hid in Brittany together with Hersch Fenster, a friend of many painters. After the war, Serge and Rachel Pludermacher established a home for deportees' children, where two hundred found refuge. Dobrinsky made many portraits of these children.[367]

The critic Emile Szittya recalled, "Around la Ruche, each house, slum, bistro, factory, each animal, each resident, smelled of death [because of the nearby slaughterhouse]. The neighborhood was full of strangers. There, Soutine found another ghetto; like Kremegne, he wanted to forget his homeland, but La Ruche and Montparnasse were, after all, just an extension."[368] The artists shared models and mistresses: "I sit nude in three languages," recounted one.[369]

Nadine Nieszawer explained how the Yiddish art magazine *Makhmadim*, "hidden beauty," was designed at La Ruche in 1912. A work of art in itself, it was composed by hand from drawings, photographs, and collages on colored paper. *Makhmadim* was sold by artists, who laughed at how dealers who could not read Yiddish displayed it with the back cover facing out. Only four issues were produced.[370]

Roger Allard had already referred to the "école de Paris," with a lowercase "e," in 1923, but the term made its "official" debut in *État de l'art vivant*, written by Warnod in 1925. He criticized the government's policy of relegating non-French artists to the Musée des Écoles Étrangères at

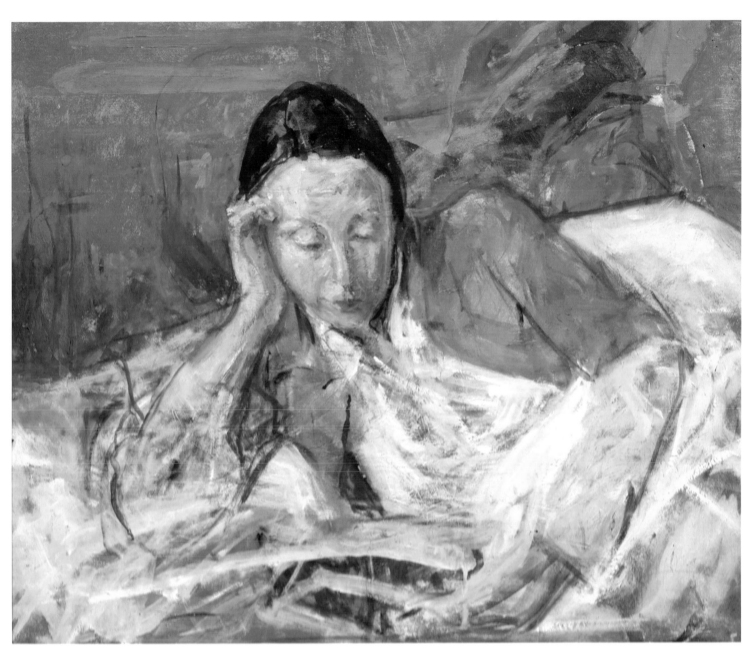

62
Isaac Dobrinsky (1891–1973)
The Reader (The Artist's Wife), c. 1940
Oil on cardboard, 20½ × 25¼ in (52 × 64 cm)
Private collection

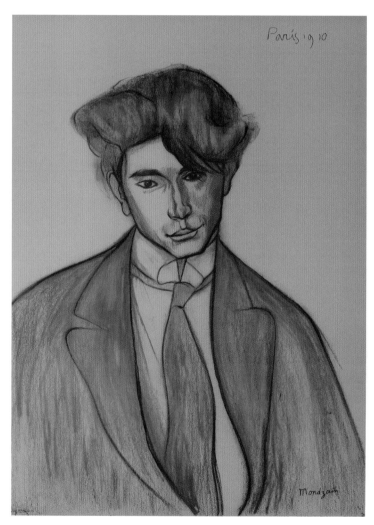

63
Marevna (1892–1984)
Friends, c. 1930
Portrait of the artist's daughter
Ink on paper, 9⅞ × 8⅝ in. (25 × 22 cm)
Private collection

64
Simon Mondzain (1888–1979)
Portrait of Ossip Zadkine, 1910
Lithograph, 29½ × 21⅝ in. (75 × 55 cm)
Private collection

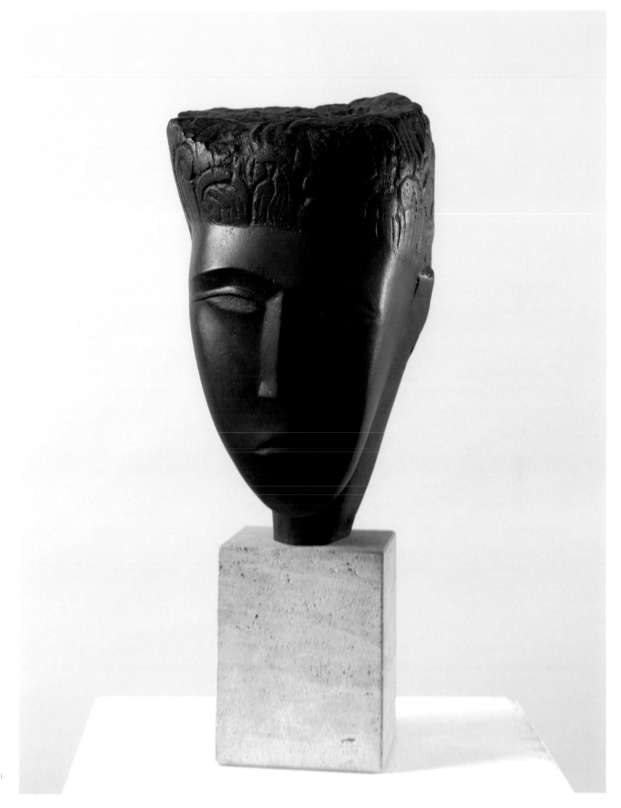

65
Ossip Zadkine (1890–1967)
Head of a Man, 1919
Bronze
14⅛ × 8¼ × 7 in (45 × 21 × 18 cm)
Musée Zadkine, Paris

the Jeu de Paume in order to provide more space for "specifically French artists" at the Musée du Luxembourg.

In a stroke of marketing genius, the "e" became an "E" when Warnod baptized the École de Paris, "of which we can confirm the power to attract artists from all over the world."[371] The critic Florent Fels (Felsenberg) wrote in *Le Roman de l'art vivant* in 1959, "This École de Paris has produced a genuine miracle: painters of Jewish descent realized that the human figure was necessary to express beauty and pathos, a milestone in the history of aesthetics for the people of Israel."[372]

The presence of Ilya Ehrenburg, Lenin, and Trotsky among the artists was notable. The latter was a real art connoisseur, often seen with Diego Rivera, whose then-girlfriend, Maria Rosanonovitz Vorobieff, the daughter of a Jewish actress, was traveling all over Europe. In Capri, she met Maxim Gorky (Peshkov), who nicknamed her Marevna, "Daughter of the Sea." In 1919, she met Rivera, with whom she had a daughter, Marika, frequently portrayed in her work (plate 63).[373]

The catalogue of the exhibition *Marevna et les Montparnos* (1985) described how "people were her main source of inspiration: Soutine, Ehrenburg, and Zadkine, a true 'portrait gallery' gathered around her and Marika. Her personal style, combining Cubism and Neo-Impressionism with humanism, indicates a disdain for fashion."[374]

Several sculptors arrived in the early 1900s: Elie Nadelman, Chana Orloff, Maurice Lipsi, Josef Csàky, Jacques Lipchitz, and Ossip Zadkine (plate 65), whose portrait was drawn by Simon Mondzain (plate 64). Zadkine, who obtained a scholarship to study art in Paris, talked sadly about La Ruche, where he remained for one miserable year. When Marevna saw him again in the 1960s, Zadkine told her that "he wanted to revive Jewish art."[375]

In the early twentieth century, after exploring Primitivism, sculptors tended to combine Expressionism with Cubism. Many left Cubism behind because it could not express the ideas that stirred them.[376] Otto Freundlich,

whose family had converted, followed an unusual path by turning to abstraction without the standard Cubist detour, after having explored Expressionism (plate 66). A sculptor as well as a painter, Freundlich opened a singular path in "constructed art."

The human figure dominates his *Homage to Colored People* of 1935, the studies for which show the progression from a schematized body to the quasi-geometric dynamic elements of the final composition.[377] Sadly enough, Freundlich is mainly remembered for the Expressionist sculpture *The New Man* (1912), which was reproduced on the cover of the catalogue of the infamous traveling exhibition *Entartete Kunst* (Degenerate Art, 1937–41) (plate 67). As soon as they came to power, the Nazis took control of all creative activities, pretending that avant-garde work was the product of "Bolsheviks, Jews, and the mentally impaired."

A significant part of Freundlich's oeuvre, including this sculpture, was deliberately destroyed. When World War II broke out, Freundlich, as a German national residing in France, was arrested by the French authorities. They released him, but in 1943 he was turned in while hiding in the Pyrenees and deported to Majdanek. He died upon arrival at the concentration camp of Sobibor.

Jews who arrived in France in the early 1900s fell in love with their adopted country and asked for French citizenship as soon as they could. Many served in the French army in World War I, though Freundlich, Walter Bondy, and Rudolf Levy were forced to leave the country. Levy then joined the German army; Leopold Gottlieb, Maurycy's youngest brother, joined the Polish army; and Chagall and Mané-Katz returned to Russia. Of those who joined the French army, Mondzain served until July 1918,

66
Otto Freundlich (1878–1943)
Head (Self-portrait), 1923
Gouache on paper, 28¾ × 23¼ in. (73 × 59 cm)
Private collection, Hamburg

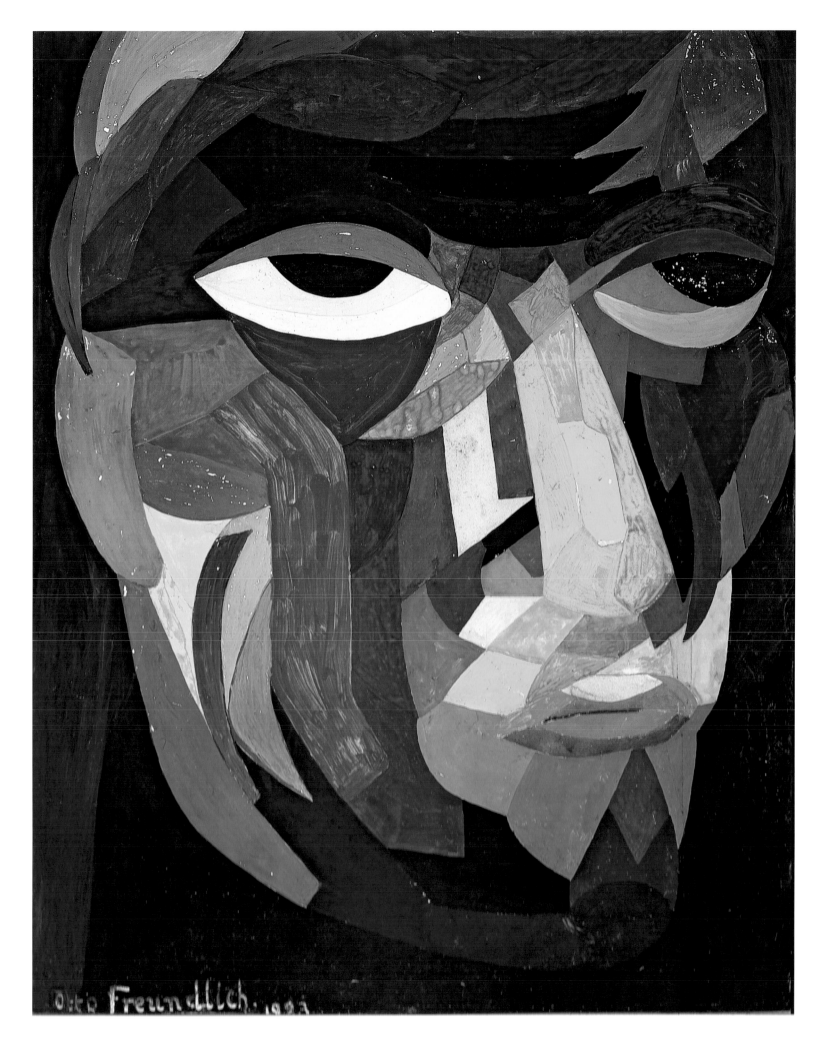

Otto Freundlich. 1937

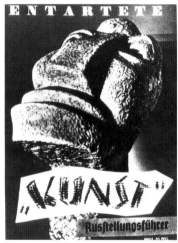

Expres-sionismus

Nadine Nieszawer's *Les Peintres Juifs à Paris* (Jewish Painters in Paris), published in 2000, offers a panorama of scores of artists who lived in Montparnasse. Nieszawer describes how many borrowed aspects of Expressionism, "searching for simplification without completely adhering to avant-garde movements. Most kept a safe distance from formal speculation and favored human expression: Abraham Mintchine, Michel Kikoïne [plates 27, 31, 70], Georges Kars (Karpeles) [plate 68], Pinchus Kremegne [plate 69], Henri Epstein, Adolph Feder, Sigmund Menkes, and Mela Muter."[378] Zygmund Schreter (plate 60) could be added to this list, as could Arbit Blatas, who painted numerous portraits of his fellow painters.[379]

On the theme of Expressionism, Yves Kobry wrote of Soutine, Pascin, Modigliani, and Chagall that "existential anxiety and intrinsic dissatisfaction, the ambiguous attitude of the uprooted, pessimism and love of life, painful irony and self-derision, unconditional faith in man and the refusal of formalism, [are] so many spiritual attitudes which, taken separately, do not suffice to define a cultural identity and might apply to numerous artists, neither Jewish nor Expressionist. It is the conjunction, the confluence of all these elements that define the contours of specifically Jewish painting."[380]

Sophie Krebs points out that an "expressive" or "expressionistic" style was frequently identified as the mark of the Jewish artists of the École de Paris. That characterization, in her opinion, deserves further scrutiny: there were also non-Jewish expressive artists in France—Rouault, for example—using rich matter, distorted shapes, and thick and tormented strokes.[381]

67
Otto Freundlich (1878–1943)
The New Man, 1912
Presumably destroyed 1939–40; previously in the collection of the Museum für Kunst und Gewerbe, Hamburg
This sculpture was featured on the cover of the catalogue of the exhibition *Degenerate Art*. The other photographs shown here were also used in Nazi propaganda of the 1930s.

Marcoussis was decorated, and Kisling, who was wounded and suffered from tuberculosis, was discharged in 1915. Modigliani and Soutine, unable to serve because of their poor health, volunteered as aid workers.

68
Georges Kars (1882–1945)
Young Woman with a Rose, 1920
Oil on canvas, 39⅜ × 32 in. (100 × 81 cm)
Musée du Petit Palais, Geneva

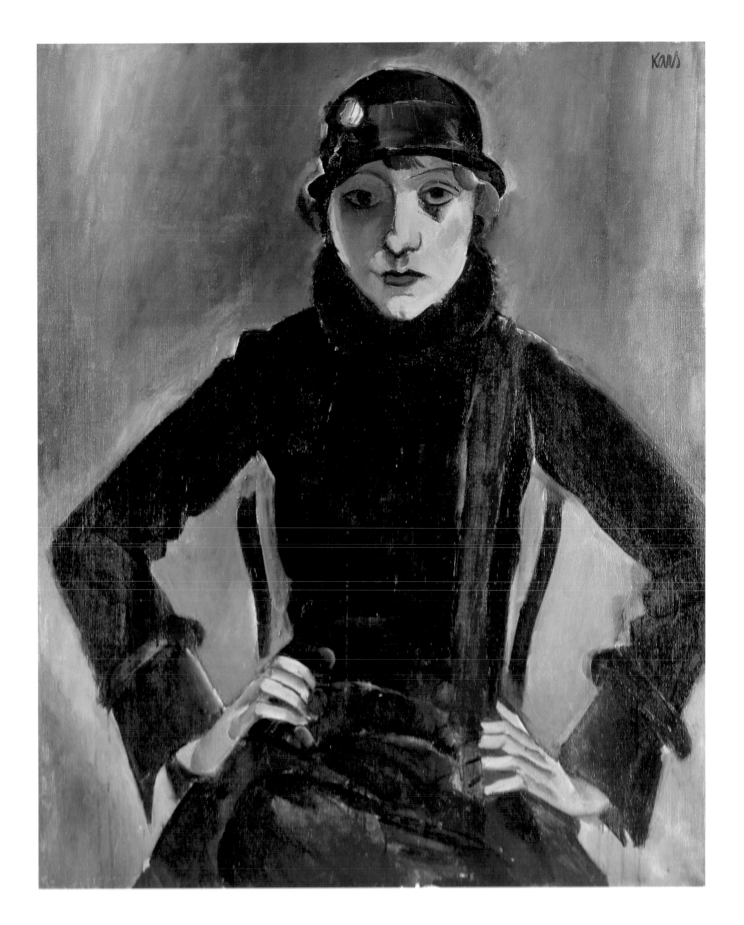

In 1912, the "Expressionist trio," Soutine, Kikoïne, and Kremegne, friends and former students at the Minsk Academy of Art, settled at La Ruche. Kremegne, who crossed the German border illegally, recalled that "the train journey in a fourth-class wagon seemed endless. I arrived in Paris with my new address scribbled on a piece of paper. Knowing only villages and small towns, to me Paris seemed immense! After many adventures, the train, the subway . . . I finally reached my new home: La Ruche."[382] Kremegne worked nights at the slaughterhouse. He was dubbed "Soutine's double," and once talked Soutine out of committing suicide.[383]

Kikoïne, jovial at work, was described as follows: "Imagine an angry man, covering with thick and quick, colorful and bright brushstrokes, something dark and hardly visible, as an exploding protest against undefined fear—the vision of a painter triumphant over anxiety, misery, ugliness, war atrocities, rampant cruelty, and the proximity of death—as an affirmation of life against all odds. Nothing could modify his good mood, his spontaneous smile, and his eternal optimism" (plate 70).[384]

Kikoïne's son Yankel, who was born at La Ruche in 1920, described his childhood as the most beautiful part of his life: "We stuck together and we couldn't care less about the misery."[385] He continued, "Should we therefore qualify my father's work as happy? I don't think so. Despite the apparent joy, I see the evacuation of anything that could interfere with life; how could one forget all he went through, and especially the fact that he was Jewish!"[386]

Michel Kikoïne's graphic vision, first and foremost in black and white, is specific to these Jewish artists haunted by the memory of pale faces studying the Talmud. "Kikoïne had to be attracted by Rembrandt, like every Jewish painter who had seen these old, wise faces his grandfather was one of these rabbis who studied in a mystical atmosphere. . . . The *café* [many artists socialized at the Dôme] was like a synagogue, a Talmudic place for Jews coming from the ghettos."[387]

70 (*above*)
Michel Kikoïne (1892–1968)
Self-portrait, 1948
Lead pencil on paper, 13 × 9⅞ in. (33 × 25 cm)
Private collection

69 (*opposite*)
Pinchus Kremegne (1890–1981)
Portrait of a Woman, c. 1925
Oil on canvas, 32 × 23⅝ in. (81 × 60 cm)
Private collection

71
Jules Pascin (1885–1930)
Portrait of a Woman, c. 1905
Ink on paper, 8 × 6¼ in. (20.5 × 16 cm)
Private collection

artists,[389] and Jules Pascin (Pincas), who arrived with a strong reputation as a draftsman (plate 71). Born in Bulgaria to a wealthy Sephardic family, Pascin, "the Jewish Toulouse-Lautrec," was notorious for his wild parties.

Pascin, a friend of Max Weber, became known in New York through the Armory Show of 1913. Back in Paris in the 1920s, he lived in the same building as Kisling and the dealer Leopold Zborowski. The opening of the famous Galerie Loeb was celebrated in 1927 with an exhibition of Pascin's work, while Flechtheim organized a Pascin show in Düsseldorf and commissioned a portrait from him.[390]

Although Jewish artists produced mainly "Parisian art," this did not mean that being Jewish was irrelevant to their work; it did matter, since the French resented the sudden appearance of so many Jews on the art scene—Montparnasse and Jews became synonymous. In Paris, many dealers were Jewish: the Bernheims, the Wildensteins, the Rosenbergs, Berthe Weill, and Adolphe Basler, who dealt in the works of several Dôme artists. The circle of patrons was heavily Jewish as well. A number of critics were Jewish: Louis Vauxcelles (Louis Meyer), Florent Fels, and Waldemar George.[391]

The artists immediately found strong support from poets and writers: Max Jacob, Blaise Cendrars, Guillaume Apollinaire, Maurice Raynal, André Salmon, Gustave Kahn, and André Warnod covered the arts for major magazines.[392] Basler was, with Zborowski, one of the leading merchants who introduced modern painting to the prestigious Right Bank galleries. Basler became a dealer in order to survive and worked for a time with Bernheim Jeune. He "discovered" Kisling and was his critical advocate until the late 1920s, when he began to view the artist as a flatterer.

The non-Jewish foreigners who gathered at the Dôme included Balthus's father, the writer Eric Klossowski. Balthus's Jewish mother, Elisabeth Dorothea Spiro, painted under the name of Baladine—she was the daughter of a Breslau synagogue *khazzan,* or cantor.[388] Among the Jewish regulars at the Dôme were the painters Isaac Grünewald, who became one of Sweden's most famous

72
Moise Kisling (1891–1953)
Portrait of Adolphe Basler, 1912
Oil on canvas, 10⅝ × 10⅝ in. (27 × 27 cm)
Private collection

Basler wrote his first art reviews in 1900 for a Polish newspaper, and then contributed to *La Plume*. He published in *Cicerone* in Germany, *La Revue blanche* in Brussels, and *Le Mercure de France*. When he was involved in polemics about Jewish art in 1925, Basler famously replied that he did not believe in such a concept. Asked to respond to the anti-Semitic critic Fritz Vanderpyl, Basler argued in favor of assimilation. He rescued the art of Modigliani, Eugène Zak, Mondzain, and Kisling from the stigma of ethnicity, emphasizing their direct debt to French painting.[393]

In a similar vein, Fels wrote, "Kisling is close to the pupils of Ingres, Chagall gives youth to La Fontaine's characters, Modigliani resuscitates Botticelli's blue by painting Parisian girls, Soutine meets Rouault, and Pascin adapts Fragonard's elegance to the postwar taste. They rejuvenate French tradition, defined as the combination of simplicity, clarity, and a sense of measure."[394]

Vauxcelles drew a fine distinction between the foreign artists who served in the French Army, and the opportunistic newcomers: "I do not want to upset the undeniably talented Kisling, Marcoussis, Pascin, Zadkine, or Lipchitz. . . . But, it is essential that they carefully study proportions if they aim at forming a recognized group."

Despite the frustration that Basler vented, Romy Golan considers that he wrote "one of the most intelligent pieces to deal with the issue of Jewish art in the twentieth century."[395] Basler (who despised "Jewish expressionism") authored several reviews on this subject, denouncing the École de Paris as "stylistic Esperanto," while the critic Wilhelm Uhde saw in this Diaspora instead "a way to transmit universal values."[396]

Asked why he sounded almost anti-Semitic at times, Basler, who wanted to be perceived as an independent French (rather than a Jewish) critic, replied, "How susceptible you are! Don't I have the right to be surprised by artists from Russia or Lithuania who will soon produce a form of painting corresponding to Yiddish literature, whose talented authors, translated into French, are be-

coming popular? I am not like those who go to synagogue, nor am I a convert like Max Jacob, but I do not blush, and I even have a lot of fun when I see our many brethren from the Lithuanian ghettos surprise civilized Westerners with unexpected sensations."[397]

Basler considered that "Paris, thanks to the painters who came from every corner of the universe, had become the true seat of the Society of Nations. Painting is the language that will unite all people regardless of creed and color. And we see flocking to La Rotonde and Le Dôme all the Expressionists [one could also read "Expres-sionists"] from Vitebsk or Smolensk."[398]

Kenneth Silver explained that although Jewish artists did not paint Jewish subjects, and even though anti-Semites were fulminating, Jewish self-consciousness was at its peak.[399] Starting in 1928, Le Triangle published a series of small monographs entitled Les Artistes Juifs (Jewish Artists). Basler contributed to these publications despite his ambivalence about the subject. The series included volumes on Indenbaum by Basler; Epstein and Kremegne by Waldemar George; Kars, Kisling, and Terechkovitch by Florent Fels; Léopold-Lévy by André Salmon; Loutchansky by André Levinson; Menkes by Tériade; Pascin by Georges Charensol; and Zak by Maximilien Gauthier. The last monograph, on Mané-Katz, was written in 1933. Then the lights went out.

Memories of the École de Paris are recollected in two major Yiddish anthologies: Hersch Fenster's *Our Martyred Artists* (1951), and Chil Aronson's *Scenes and Faces of Montparnasse* (1963). These books, as well as numerous interviews by Nieszawer, form the basis of her *Peintres Juifs à Paris*, whose preface by Claude Lanzmann reminds us that "one hundred and fifty-one painters, famous or unknown, young or old, beginners or masters, are presented in this book. Sixty-four of them (that is, more than forty-two percent) perished, asphyxiated in gas chambers in Poland, where they came from."[400]

Aronson arrived in Paris in 1929 and opened a gallery on

the Left Bank. He wrote in Yiddish on Italian and Jewish art, and published in Polish and American journals as well. He studied the motives that drew Jewish artists away from the Book, into visual experience.[401] Not all of them were great artists; many were just honest practitioners.

The "duty of remembrance" (*devoir de mémoire*) is admirably accomplished by Fenster, too. He taught Yiddish, English, and French to Bundist families; organized free meals for those who returned from concentration camps; and transformed his apartment into a cultural center. His imposing book, with a preface by Chagall, contains the biography of every artist who died after being deported from France; Fenster financed this tribute himself. History, however, mainly remembers the most famous artists: Soutine, Chagall, and Modigliani.

A genius around every corner

Modigliani arrived in Paris in 1906, attired in a corduroy suit with a red scarf and a brimmed hat, proud of his Italian and Sephardic roots, and his leftist upbringing in Livorno. Ferdinand de Medici had developed Livorno by granting rights to the *marranos* fleeing the Inquisition (1593), and the city prided itself on being the only one in Italy without a ghetto.

The Jews of Italy had first been emancipated after the arrival of Napoleon's troops. His defeat led to a reversal of this policy and the reestablishment of the ghettos, but the emancipation process was set in motion again before the unification of the provinces.

The Jewish artists Levi d'Ancona and Serafino de Tivoli were among the founders of an influential group, the Macchiaioli, whose name, derived from the word for "patch" or "spot," referred to their spontaneous style, which contrasted with classical painting.[402] This group had strong ties with the Risorgimento, Italy's unification movement (1848–70), whose first leader, Daniele Manin, was of Jewish descent.

The Jews of Livorno had a cultural history of their own. Their academies, which reached their zenith in the nineteenth century, were a model of the religious, political, and social integration that was advocated by the prominent local rabbi Elia Benamozegh. Sephardic humanism dovetailed with Risorgimento philosophy.[403] Modigliani's egalitarian vision was inculcated in his childhood, as his daughter Jane explained: "The practice of passionate Talmudic discussion was still very much alive in the family." Modigliani's mind was shaped by social concerns, as well as by the heroes glorified by his mother: Uriel da Costa, Spinoza, and Moses Mendelssohn.[404]

Modigliani's biography reveals a willful and dignified artist who reconciled poor health and bad finances with an aristocratic intellectualism. He referred to himself as a patriarchal Jew who passionately confronted anti-Semitism, and once remarked, "I'm Jewish, you know. . . . I had never thought about it. . . . It's true. In Italy there is no Jewish question."[405] Modigliani became familiar with Ashkenazic Judaism thanks to Lipchitz. It is no coincidence that one of the first of Modigliani's paintings to be shown in Paris was *The Jewess* (1908).[406]

Marc Restellini identifies signs of Modigliani's Jewish roots in a respectful portrait of Soutine "sitting without expression, hands on his knees. . . . Modigliani, who was not considered good at painting hands, represents them here, surprisingly, with great 'finesse.' Careful observation indicates a specific opening between the left middle and ring fingers, a sign that symbolizes the blessing by a Cohen."[407]

The catalogue of the 2004 exhibition *Modigliani: Beyond the Myth* takes into consideration "the traits that set Modigliani apart in the context of his Jewish heritage, such as a virtually exclusive pursuit of portraiture and the refusal to associate with a particular art movement. . . . The scrutiny with which the artist confronted identity and individualism, his portraiture, originate from his Sephardic understanding of the indelibility of his Jewishness, regardless

73 (*above*)
Amedeo Modigliani (1884–1920)
Portrait of Kisling, 1916
Pencil on parchment paper, 16¼ × 10⅛ in. (41.3 × 25.7 cm)
Private collection

74 (*opposite*)
Amedeo Modigliani (1884–1920)
Portrait of Hanka Zborowska, 1917
Oil on canvas, 18¼ × 15¼ in. (46.5 × 38.5 cm)
Private collection

of acculturation: specifically, an understanding of 'Otherness' drawn from his identification with the Diaspora."[408] Portraiture allowed Modigliani to examine identity against a wide array of cultural types (plates 14, 43).[409]

In 1916, he painted *Seated Nude*, a pivotal work that recontextualizes an Expressionist subject in the light of Italian Judeo-Christian idealism.[410] It hardly comes as a surprise that Jewish painters in Italy, namely Levi d'Ancona and Modigliani, would break the taboo of the nude. Modigliani painted some of his most beautiful nudes in the apartment of Zborowski, who persuaded Berthe Weill to give Modigliani his first (and only) solo show in 1917. Considered obscene, it was immediately closed by the police.[411]

Zborowski's wife Hanka explained, "In a few hours he usually finalized a mid-size painting."[412] One of the earliest of a dozen portraits of Hanka reflects on her cool beauty in a strict composition without decor or accessories (plate 74). The portrayal of her features goes beyond a simple likeness to reveal her character. "What are we to make of a portraitist whose scrutiny of the individual gradually becomes so stylized, as to produce a succession of seemingly indifferent faces echoed in his stone Caryatids?" And yet, "For all their anonymity, his prototype portraits always retain something of the sitter: a delicate balancing act between the specific and the generic (with some caricatured elements), the mask and the face, the endemic and the particular."[413]

By what *tour de force* did the Futurists manage to claim Modigliani for their patriotic cause?[414] He was also assimilated into the Byzantine and the Sienese schools. Italian art reviews did not mention Modigliani's Jewishness until 1927, when the press ran an excerpt in Italian of Adolphe Basler's book *La Peinture . . . religion nouvelle* (Painting, the New Religion), in which he referred to Modigliani as a "Jew from Livorno."[415]

Modigliani was a role model for Jewish artists, who saw him as an important figurative link to the Greco-Roman and Italian roots of Western art.[416] He had a deep sense of

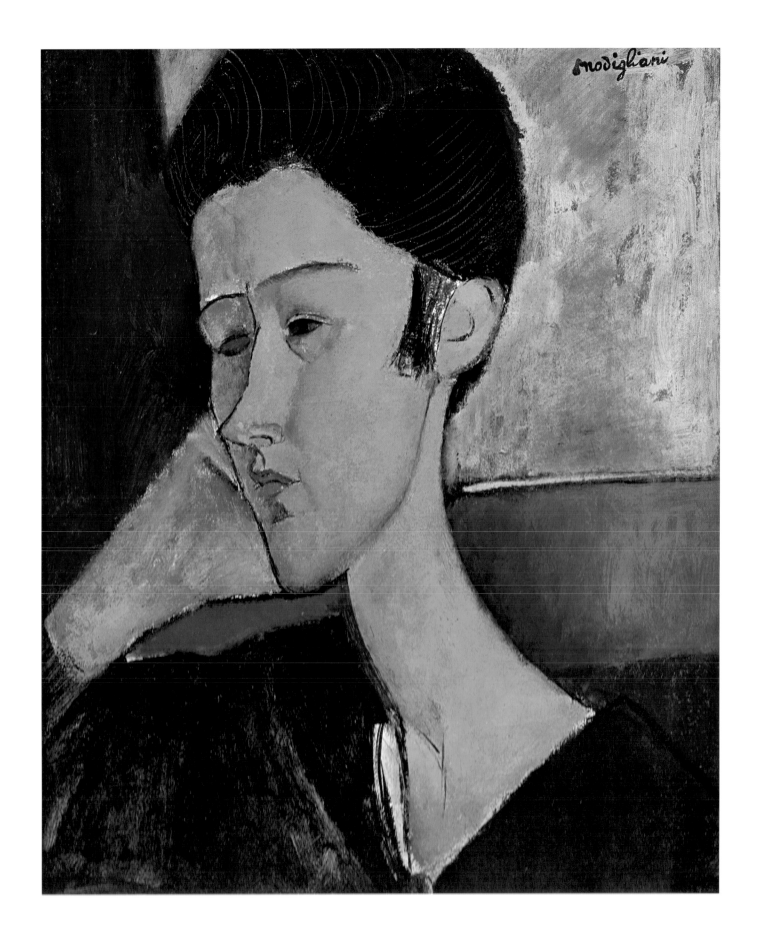

artistic and personal responsibility, and numerous supporters. When Modigliani died in the winter of 1920, Kisling and another friend attempted to make a death mask. Unfortunately, it broke, so they asked Lipchitz to put the pieces together; he made twelve plaster casts from the mask, which were distributed among Modigliani's friends.[417]

Moise Kisling arrived in Paris in 1910 and, like many others, met painters such as Picasso and Modigliani through the poets, mainly Salmon and Jacob. Kisling constantly helped "Modi" by sharing his studio and giving him paints and canvases (plate 73).[418] His son Jean explained that "Kisling was never short on money. . . . He supported his family from the age of nineteen, selling his paintings."[419] Modigliani made three oils and numerous drawings of Kisling, who was initially influenced by Cubism, as his portrait of Adolphe Basler (1912) indicates (plate 72). Kisling met Zborowski and became very successful: Arletty, Colette, and Jean Cocteau commissioned portraits. Matisse considered Kisling to be one of the best portrait painters of his time.[420]

The elegant and articulate Modigliani became the "patron saint" of Soutine, a young *misérable* from Smilowitch, after Lipchitz introduced them in 1915. Modigliani asked Zborowski to promote Soutine, then shy and depressive, who felt that his protector "represented the Italian genius. In the evening, when the New Socrates dispensed wisdom to his friends, he [Chaim] only dared to follow him from a distance."[421]

Three years after Modigliani's death, the dealer Paul Guillaume introduced Albert Barnes to Zborowski. Barnes bought several dozen paintings by Soutine, who became instantly famous.[422] But his art was not unanimously praised. Pascin believed that "there is a genius like that in every ghetto." Basler considered Soutine's work nothing but *Schmiermalerei*, "gloomy impasto, muddy material, greasy sweepings" representing the most revolting aspects of ghetto life. Critics stressed the "foreign nature" of Soutine's art: according to Waldemar George, he "judaized"

painting, while for Basler he "infected French art in order to better eliminate it."

Chaim Soutine was the tenth of eleven children in a modest family. In the shtetl, the social hierarchy was subtle but tangible, and he wished to liberate himself from his painful experience of it. As a child, Soutine sketched on scraps of paper; for this, his family taunted him because "a Jew must not paint." One day Soutine asked a pious Jew to sit for a portrait, whereupon the man's friends fiercely thrashed the boy. Soutine's mother filed a complaint, and as compensation he was given twenty-five rubles, which he and Kikoïne used to set off for Minsk to become artists. In Paris, Soutine spoke Yiddish and some gibberish that was meant to be Russian.

Because visual experience was impugned in his youth, violating the shibboleths became the basis of Soutine's art.[423] His servants (plate 75), his Christian choirboys and communicants, and even his whirling fowl are all psychological scapegoats.[424] With one exception, Soutine stayed away from the nude, but when he painted uniforms he worked impasto as if it was living flesh.[425]

Restellini stresses that Soutine's expressionism is totally different from German or Austrian Expressionism—with no political message, no revolt: "Soutine's oeuvre is timeless, like Modigliani's."[426] Soutine identified with another foreigner in France, Van Gogh, who was also attentive to the deeper characteristics of people.[427] Soutine found prototypes for his distortions in El Greco and Velázquez, but he did not hide the individual character of his sitters, who always retained their personality even as they became "types."[428]

Portraiture, with its single focus, was a perfect vehicle for Soutine. Its restricted compositional format enabled him to express his deep emotional response to the subject with maximum intensity. Soutine's fusion of form and matter was fundamental to his portraits as well as to his still lifes and landscapes, which are strongly anthropomorphic.

He has been stereotyped as isolated from society and

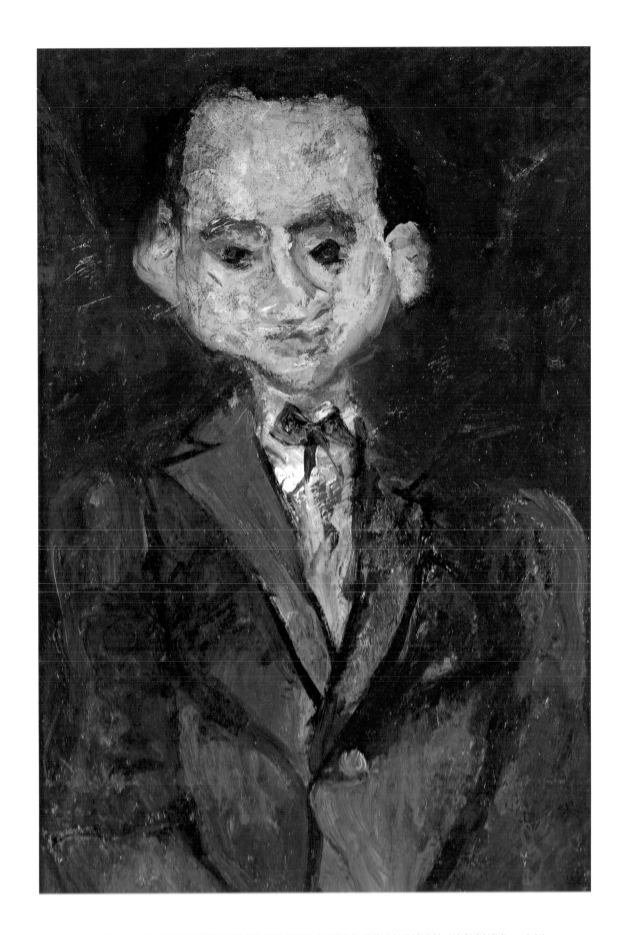

75
Chaim Soutine (1893–1943)
The Floor Waiter, c. 1922–28
Oil on canvas
21½ × 15 in. (54.5 × 38.1 cm)
Private collection

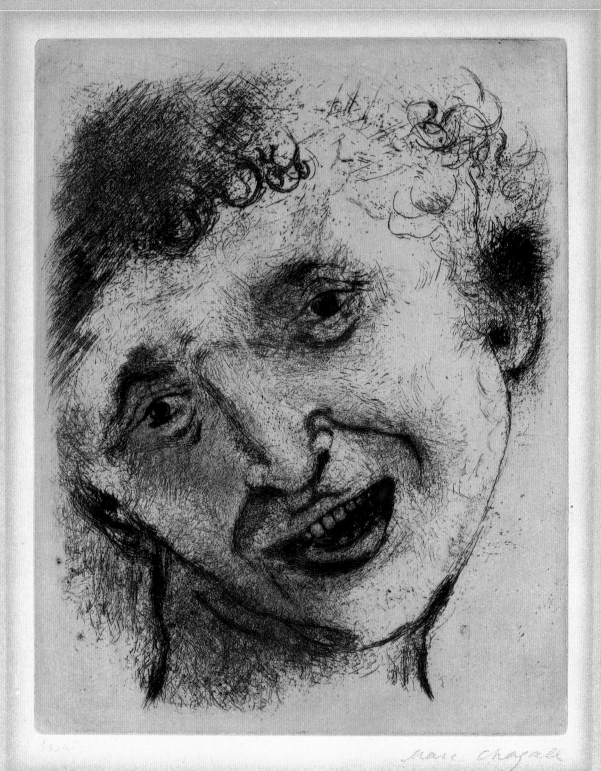

from any art tradition. "In Soutine, the suffering Jew and the *peintre-maudit* conspire against the disinterested artist who wants nothing better than to be a classic, and in the process they turn him into a classic of another sort altogether—a classic of Expressionism, where the tradition of the Old Masters he venerates is swamped by the pressures of extreme emotion."[429]

Like most Jewish painters in the 1930s, Soutine sought recognition as a *French* painter, and tailored his work accordingly.[430] Esti Dunow and Maurice Tuchman note in their *catalogue raisonné* that "the country homes painted on or around the estate of his patrons, the Castaings, were symbols of a way of life, culture, and status to which he aspired. Support from the Castaings represented broader acceptance and favor from the French upper class."

The figures in Soutine's late paintings look increasingly passive: faces and gestures become cool and distant. In his late landscapes, small children symbolize innocence despite the surrounding threatening forces. Soutine must have felt quite vulnerable in occupied France.[431] As a registered Jew, he was forced to flee from one sanctuary to another. Soutine knew hunger and attributed enormous importance to food, but eating could cause him severe pain; he died in 1943 from a ruptured stomach ulcer, after much time had been lost in moving him to a Paris clinic.

Despite his admiration of Rembrandt, Soutine painted only three self-portraits. However, he applied the techniques of portraiture to other genres. This recalls a remark by Matisse: "The only saying of Rembrandt that we know is, 'I have never painted anything but portraits.'"[432] If a portrait aims to capture the soul of the sitter, then we can call every image that Soutine painted a "portrait."

Basler, who despised weepy art, commented, "Never

two without a third. How not to associate another Jew with Pascin and Modigliani? The third one is Chagall. And we could easily find seven more to form a synagogue according to the ritual [a *minyan*]. We could even get one hundred or more if I didn't fear provoking a pogrom against the painters of my race."[433]

Being an artist, Chagall naturally tended to romanticize his story.[434] "But a word as fantastic, as literary, as out of this world as 'artist'—yes, perhaps I had heard it, but in my town no one ever pronounced it."[435] His first paintings were like a condensed Yiddish narrative, associating words and colors. The flying figures play on the expression *gehen iber die heiser*, "going over the houses," which refers to a beggar going from door to door. The *luftmensch*, one who literally walks on air, was the common symbol for the villager living in complete misery, jokingly ignoring reality, sharing the precariousness of his position with the acrobat, and the capacity to mock his shortcomings with the clown.[436] "Rembrandt alone could have fathomed the thoughts of the old grandfather, butcher, tradesman, and cantor, while his son played the violin before the window, before the dirty panes, covered with raindrops and finger marks," Chagall wrote.[437]

"Each setback to the army was an excuse for its chief, the Grand Duke Nicholas, to blame the Jews. 'Get them all out in twenty-four hours. Or have them shot. Or both at once.' The army was advancing, and as they advanced, the Jewish population retreated *en masse*, abandoning cities and villages. I longed to put them down on my canvases, to get them out of harm's way."[438] As one scholar put it, "Chagall made sure that later generations would know the names of his parents, sisters, uncles, grandfather, and grandmother, because his universe could not exist without them."[439]

"Mother directs my painting. . . . My mother, a simple, illiterate yet energetic woman, died at forty-five years of age. I cannot express in a concise way what a genius she was. She passed away, but the value of her innate talent

lives on through me. She corrected my work and her opinion was decisive for me."[440]

Bakst, who arranged for Chagall's training to be financed with a monthly stipend of thirty rubles, let the young artist work on his set designs for Diaghilev's celebrated Ballets Russes.[441] In 1912, Chagall settled at La Ruche, where he got in touch with Cendrars, Salmon, Jacob, and Apollinaire. The latter defined Chagall's work: "I do not mean old Realism, or Romantic Symbolism. This is not mythology or some fantasy . . . but then what is it, my God? Apollinaire sits, blushes, smiles and whispers the word 'Supernatural.'"[442]

In Paris, Chagall addressed his alienation by bridging Hasidic motifs with modern life. He painted a great many self-portraits, which reveal his struggle for identity; everything in his work becomes autobiographical.[443] Art is the product of his subjectivity. Choosing his own themes, Chagall embraced a messianic position with a "duty towards the viewer."[444] "Art is mostly a state of mind; the soul of every creature is sacred. . . ."[445] With eternal colors, Chagall gave life, until the very end of his own long life, to an unconditional faith in humankind.[446] To remain a "painter of happiness" in a nihilistic century was an act of daring (plate 13).

Chagall learned to write Hebrew before Cyrillic, and this structured his art. His compositions float like Hebrew characters in a Hasidic universe, where heaven and earth, men and animals, are part of a coherent system. The divine and the angels appear in ever-changing shapes: there is no fixed convention for the "supernatural." The biblical stories come alive in easily readable scenes, through expressive shapes and colors (plate 23).

Apollinaire arranged for Herwarth Walden, the champion of Expressionism, to visit Chagall's studio in Paris.[447] Impressed, the dealer offered him a solo exhibition at his Berlin gallery, Der Sturm, in 1914. There Chagall met the poet Bialik and painters Jankel Adler, Ludwig Meidner, and George Grosz.[448] But in the summer of that year, his longing for Bella Rosenfeld, his wife-to-be, made him return to Russia for what was expected to be a short visit.

Trapped there by World War I, Chagall worked for the Yiddish theater, and when the curtain rose, the stage formed a magic visual whole. Chagall's murals, which he considered his masterpieces, display exuberant motifs conveying a multitude of feelings. He left Russia in 1922, and his set designs were later hidden. They turned up in 1950, in the storeroom of the Moscow State Tretyakov Gallery, where, after being shown in 1973 (when Chagall finally saw them again, and signed them), they remained inaccessible to the public until the Soviet Union fell apart in 1989.

In describing his collaboration with Chagall, the actor Solomon Mikhoels provided some idea of the artist's expressionist tendencies (plate 76): "On the day of the premiere, Chagall came to my dressing room, laid out his paints, and started to work. He divided my face in halves. One part he colored green, the other yellow (as one says yellow and green are an expression of revulsion). He raised my right eyebrow two centimeters higher than the left one. He extended the creases around my nose and mouth over the whole face. These lines expressed the tragic character of Menachem Mendel. . . . I looked into the mirror convincing myself that the make-up created the dynamism and expression of the character. The artist continued to work with great intensity. Suddenly his fingers stopped as if uncertain. Something disturbed him. He put his finger to my eye, removed it again, stepped back, looked at me with a sorrowful expression and said, 'Oh Solomon, Solomon, if only you didn't have a right eye, we could do such marvelous things.'"[449]

In postwar France, the shift away from individualism to the *grande tradition* reintroduced an art of order, in which portraiture became a favorite subject. Chagall finished his memoirs, which he had begun in 1915–16. The first edition of *Ma Vie (My Life)*, translated by Bella, was published in 1931. Two pages before the end, he writes, "I am sure that Rembrandt loves me."

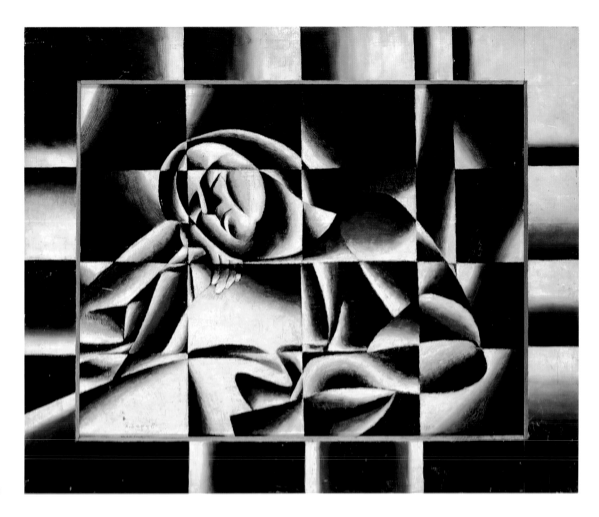

77
Arthur Segal (1875–1944)
Sleeping Woman, 1925
Oil on linen, 31⅛ × 38¼ in.
(79.1 × 98.2 cm)
Musée du Petit Palais, Geneva

For Chagall, abstraction reflected the absence of God, who guides the artist's brush. He never totally adhered to radical modernism, although early on he dabbled with Cubism, mixing Christian icons and Jewish themes. "Personally, I do not believe that a scientific bent is a good thing for art," he wrote.[450] He was not really a Cubist, an Expressionist, or a Futurist, nor even a Surrealist, but an independent painter creating a singular art from the very beginning.

"Isms" and "isms"

In 1920, Kasimir Malevich and El Lissitzky were both on Chagall's teaching staff at the Art Academy of Vitebsk.

When they chose abstraction, Chagall felt betrayed and left for Moscow. To Lissitzky, the Russian Revolution proved the ultimate triumph over the forces of destruction. Jean Clair explains how Constructivism, like most avant gardes in the twentieth century, lasted less than a decade—none was able to set the foundation of a perennial style.[451]

Cubism persisted for a decade and a half, though its influence was felt long afterward in fields as diverse as collage and mixed media, and spread to several countries, as can be seen, for example, in the work of Arthur Segal, a Romanian Jewish painter who spent most of his life in Germany and Switzerland, after being trained in Austria and France (plates 77, 78).

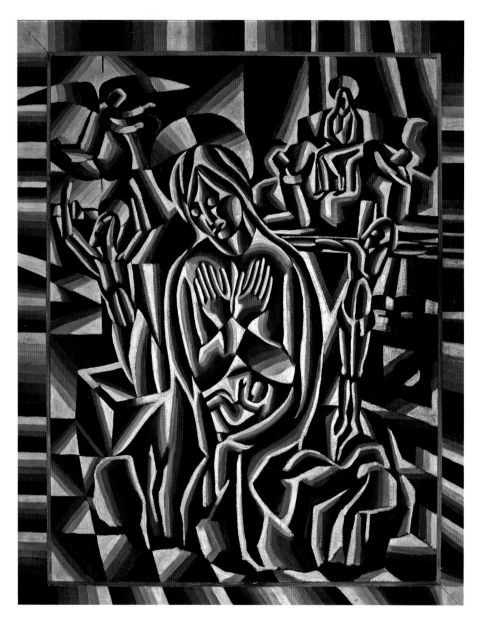

78
Arthur Segal (1875–1944)
Maria, c. 1921
Oil on canvas with artist-painted frame
63 × 49¾ in. (160 × 126 cm)
Private collection, North Salem, New York

In Paris, several Jewish painters engaged in Cubist experiments, namely Alice Halicka, Marcoussis, Henri Hayden (Haydenwurzel) (plate 79), and Léopold Survage (Stürzwage). There is a classical decorative dimension in the work of Survage, who maintained a link with dance. Hayden collaborated with the group of musicians known as Les Six: its leader, Darius Milhaud, was from an old Jewish family of Provence. The *Figaro littéraire* compared Hayden's *Musicians Trio* of 1919—acquired by the Musée d'Art Moderne de la Ville de Paris—to Picasso's *Trio*, painted shortly thereafter, and similar in composition and dimensions: "One notices how much more Hayden's *Trio*, while submitting his style to the fashionable angular sys-tem, respects the sitter's face and hands, when comparing it to the Spaniard's *Trio*."[452] In 1953, Hayden became resolutely figurative.[453]

Halicka abandoned Cubism in 1921, resuming her ties with the Post-Impressionist school in Poland, where she painted daily life in Kazimierz, Krakow's Jewish quarter.[454] She married Marcoussis, so called by Apollinaire after the name of a French village. Tériade said that "the natural racial need to give expression to his paintings, and the fight to introduce feelings into a harmonious but rigorous framework, led Marcoussis to introduce poetry into Cubist compression."[455]

Most Jewish painters who explored Cubist tendencies

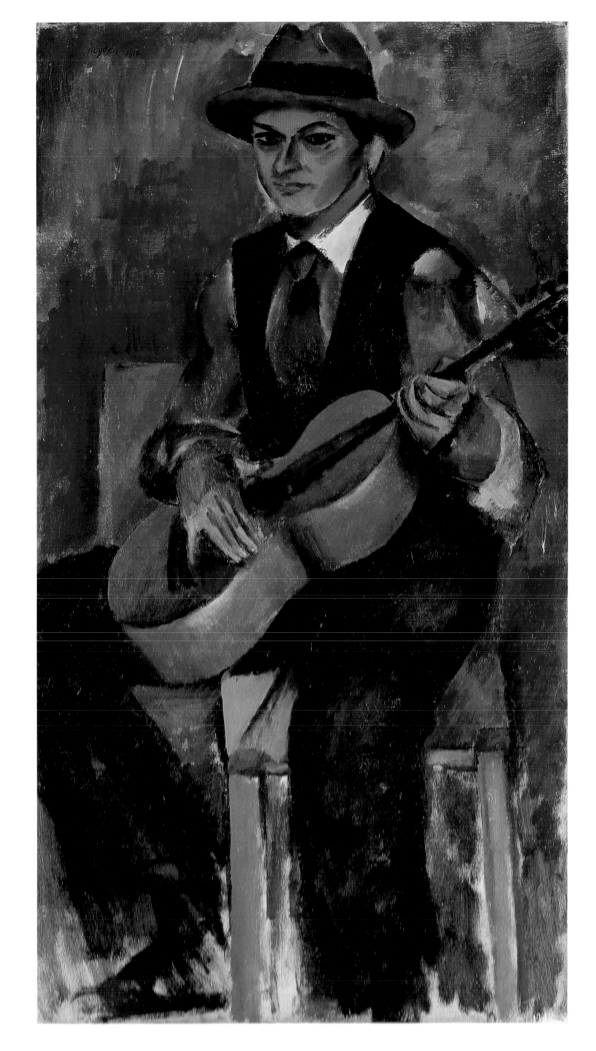

79
Henri Hayden (1883–1970)
Portrait of Kisling, 1914
Oil on canvas, 31 × 17³⁄₄ in. (81 × 45 cm)
Musée du Petit Palais, Geneva

While the majority of Jewish painters in Paris stuck to the human figure after the Shoah, some, like Philippe Hosiasson, Leon Zack (plate 4), and Felicia Pacanowska, rejected it.[456] Pacanowska offered "either strange Abstract Cubist compositions, or alternatively, more figurative subjects always with a poetic tone. The internal conflict between her great love for humans, their soul, flesh and bones, and painting according to pure plastic rules, gives Pacanowska a special status as an artist" (plate 80).[457] She received the Modigliani Drawing Award in Livorno; the Bibliothèque Nationale de France and the Musée National d'Art Moderne in Paris acquired several of her works.

In an ultimate stroke of optimism, Otto Freundlich wrote in 1936, "Today, the goal of worldwide Socialism, the concept of unity (that reaches beyond one's personal life), can be expressed by forces beyond birth and death, which are still at work. . . . The figurative opens up to action; the non-figurative now gains vital force. . . . Two worlds separated, until now, are uniting."[458] As one can read in the catalogue of the 1993 exhibition *Otto Freundlich et ses amis* (Otto Freundlich and His Friends) at the Musée de Pontoise, Ernst, Braque, Kandinsky, Mondrian, and Max Jacob all answered his call.[459]

The Parisian eye

While painters had flocked to Montparnasse in the 1910s, photographers arrived in the 1920s, driven by the availability of cheap reproduction techniques and a fast-growing illustrated press with a new business: *photo reportage*. At the first and only *Salon Independent de la photographie* in 1928, nearly all the exhibitors were foreigners: Man Ray, Brassaï (Gyula Halász), André Kertész, Berenice Abbott, Germaine Krull, Paul Outerbridge, George Hoyningen-Huene, Ilse Bing, Elie Lotar, and the lesser-known Aram Alban, Ergy Landau, and François Kollar. Dora Maar, Rogi André (Rosa Klein), and Lee Miller came to Paris later. Several of these photographers had started their careers as painters.

80
Felicia Pacanowska (1907–2002)
Violin Players (Fragments of the Orchestra), 1955
Oil on canvas, 39⅜ × 31 in. (100 × 81 cm)
Private collection

did so with moderation. Sonia Delaunay (Terk-Stern) was an exception. As a renowned portrait painter, she moved on the edges of the Dôme group, where she met her first husband, Wilhelm Uhde. She later married Robert Delaunay, and together they turned toward a version of Cubism that Apollinaire dubbed "Orphism." Later, Léonce Rosenberg and Paul Guillaume promoted a tempered and decorative form of Cubism in the context of the figurative trend of the 1920s.

Photographers celebrated their feeling of freedom with picturesque images of Paris. One would search in vain for any reference to an "École de Paris in photography" in either French or international publications, except for the catalogue of Brassaï's exhibition at the Bibliothèque Nationale de France in 1963, in which "photographers honoring the École de Paris" are mentioned.[460] It was not until 2006 that an exhibition at the same venue would honor these photographers with an appropriate title, *La photographie humaniste* (Humanist Photography).

Warnod noticed that "based on the numerous photos of the homeless taken by Krull, Kertèsz, and Brassaï, they represented the ideal Parisian figure in the eyes of the photographers, who like street people endlessly explored the city's diversity; although privileged, they saw in these solitary but free individuals sister souls on whom they projected their dreams of freedom and independence. Social expeditions in day and night life, scenes of workers, employees, *petit bourgeois*, the suffering and joy of castoffs were their favorite themes" (plate 81).[461]

The advent of Nazism generated a new wave of immigrant photographers: Robert Capa (Friedmann), Chim (David Seymour), Gisèle Freund, Herbert List, and Erwin Blumenfeld. Like those who had arrived earlier, most of them were Jewish. They turned Paris into the uncontested center of photography in the 1930s.[462]

That period was also one of the darkest in French history. After the stock market crash, the government limited immigration. Under the Laval laws, implemented in 1935, all foreign needle and garment workers—ten thousand of whom were Jews—had to obtain work permits from anti-Semitic associations. Those coming from the Reich did not realize the extent of the crisis in France, where established Jews feared competition from newcomers, and where recently naturalized residents could be instantly deprived of all their rights.

The press once again adopted the hateful language of the Dreyfus period, which had never truly been forgotten.

81
André Kertész (1894–1985)
Du Dubon Dubonnet (On the Boulevards), 1934
Gelatin silver print, 13⁵⁄₈ × 9⁷⁄₈ in. (34.6 × 25.1 cm)
Norton Museum of Art, West Palm Beach, Florida, gift of Baroness Jeane von Oppenheim

Although this did not prevent the election of Léon Blum as Président du Conseil in 1936, the new slogan became "better Hitler than Blum."[463]

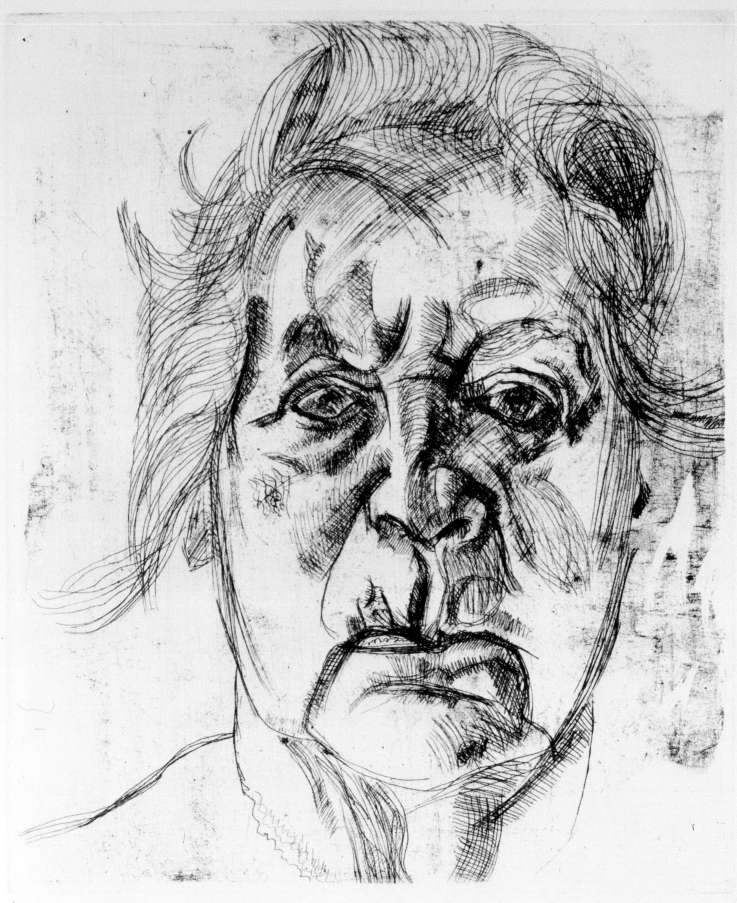

4.
The Human Figure after the Holocaust

82
Lucian Freud (b. 1922)
The Painter's Mother, 1982
Intaglio print on paper, 7 × 6 in. (17.8 × 15.2 cm)
Tate Gallery, London

Danse Macabre . . .

In 1940, the Vichy regime revoked the emancipation of the French Jews, granted 150 years earlier. With measures that were even more discriminatory than the Nuremberg Laws, France became an easy catch for the Nazi invaders: Hitler's propaganda used an all-too-familiar language.[464]

The great change in man's attitude toward death had started between the end of Symbolism and the beginning of Surrealism. Traditional religions declined, and people found a substitute in spiritualism. The priests' prerogatives were taken over by the intellectuals, who replaced religious structures with aesthetic ones.[465] Ruled through a series of rituals orchestrated first by André Breton, and later by Georges Bataille's even stricter dissident movement, Surrealism displayed all the features of an occult group.[466]

In France, Breton had witnessed the disaster of World War I and the concomitant collapse of Western values; meanwhile, in Zurich, Dada first inaugurated the cult of violence that emerged from the ensuing feeling of decadence. "Surrealism and the psychological approach led into that quagmire of the so-called automatic practices of art—the biomorphic, fecal, the natal and other absurdities."[467] That there was no distinction between good and evil in this art is shown by André Masson's

83
Alexandre Fasini (1892–1942)
Couple, 1920
Oil on canvas, 18⅛ × 15 in. (46 × 38 cm)
Private collection

Massacres or Antonin Artaud's Theatre of Cruelty, in which heroic mythology was projected like Nazi propaganda.[468] As late as 1947, Artaud openly expressed hatred for "a spiritual world derived from Judaism."

The Surrealists based their manifesto (1924) on that of Marx and Engels (1848). In *Surréalisme en tant que symptome* (Surrealism as a Symptom), Jean Clair describes Surrealism's development from a small esoteric group to a mass movement. Hannah Arendt analyzed the striking resemblance between secret societies and totalitarian regimes in the way their rituals introduce idolatry as a powerful organizational factor.[469] When Breton and his movement started to serve communism, the despotic nature of the Soviet regime was already common knowledge in Parisian circles.[470]

Surrealism pretended to be inspired by Freud's psychoanalysis, but he distanced himself immediately from that trend. Freud explored the subconscious as a scientist, while Breton, also a physician and a former student of Jean-Martin Charcot, favored esoteric experiments over rational investigation.[471] Freud considered the sublimation of passion, as opposed to its liberation, to be the basis of a civilized society.

Surrealism was the only radical art movement to gain broad popularity. Clair attributes this to the fact that, unlike other avant-garde groups, the Surrealists did not believe in progress. As opposed to most countries, where psychoanalysis was supervised by the medical profession, in France its success was due to the literary milieu where Georges Bernanos, Robert Brasillach, Paul Léautaud, Pierre Drieu de la Rochelle, Maurice Blanchot, Marcel Jouhandeau, Jean Giraudoux, Paul Morand, and Louis-Ferdinand Céline all echoed anti-Jewish attitudes. The latter believed that the Jews interfered with political harmony in Europe and provoked all the wars, and he called for them to be massacred.[472]

Arendt observed that many intellectuals, "in order to nourish their anti-humanist, anti-liberal and anti-cultural instincts, in a brilliant and spiritual apology for violence, power and cruelty, choose to read the more sophisticated Marquis de Sade over Gobineau or Chamberlain—that was just as negative."[473] Most artists were drawn to Surrealism before turning their backs on it (some sooner, some later):[474] Giorgio de Chirico, Max Ernst, Marcel Duchamp, René Magritte, Joan Miró, Alberto Giacometti, and Balthus. It is not simply fortuitous that two Jews, Pierre Klossowski (Balthus's brother) and Walter Benjamin, were the first to be alarmed when Bataille started to manipulate fascist concepts, more or less consciously.[475]

There were Jewish painters among the Surrealists, such as Alexandre Fasini (Feinsilber) (plate 83), Victor Brauner, and Grégoire Michonze, but they tended to maintain their independence. Michonze created timeless work: "My subjects have no subject and their only aim is poetry" (plate 84).[476] Brauner was antidogmatic and oscillated between desperation and delight: "The game of his life was a perpetual search for another image, aiming at a new design of man's soul and body, according to a concept of life resulting from the harmonization of human passions."[477]

During the war, Brauner stayed near Marseille, from where he hoped to escape with Breton, Duchamp, Ernst, Arendt, and Wilfredo Lam. A young American journalist, Varian Fry, managed to help 2,500 artists and intellectuals flee to the United States within thirteen months, but Brauner did not receive a visa.[478] In 1949, he painfully broke with the Surrealist group.

. . . as far as Mexico

In Mexico, Breton and Trotsky often met with Diego Rivera and Frida Kahlo, who fascinated the Surrealists. Her self-portrait *The Frame* (c. 1937–38), exhibited in the show entitled *Mexico* organized by Breton in 1935, was the first modern Mexican painting purchased by the Louvre.[479] Yet the Surrealists exasperated Kahlo, who wrote, "You have no idea how these people are whores. They make me sick.

84
Grégoire Michonze (1902–1982)
Artist in a Village, 1955
Tempera on cardboard, 10⅝ × 13⅜ in. (27 × 34 cm)
Private collection

They are so fucking *intellectual* and so rotten that I can no longer stand them."[480]

At age twenty-two, she married Rivera, who was twenty-four years her senior; their stormy relationship would be marked by mutual infidelities, divorce, and remarriage. Of his origins, Rivera, a proud mestizo, said, "My mother transmitted to me the features of three races: white, red, and black." (His father was of Judeo-Portuguese, Spanish, and Russian ancestry.)[481] During a party at the residence of Henry Ford, a notorious anti-Semite, Kahlo publicly asked, "Mr. Ford, are you Jewish?"[482] Another incident also took place in Detroit, at a hotel where Jews were not

85
Frida Kahlo (1907–1954)
Self-portrait, 1938
Oil on metal panel, 4¾ × 2¾ in. (12 × 7 cm)
Private collection. Previously in the collection of André Breton

admitted: Rivera and Kahlo loudly declared that they had "Jewish blood," forcing the manager to change the discriminatory rules.[483]

In the strict sense, Kahlo was not Jewish, since her mother was a Mexican Catholic. However, while her feelings toward her mother were ambivalent, she adored her father and was his favorite as well.[484] She described him as if he were a "Jewish mother" and recalled in her diary, "My childhood was marvelous, because although my father

was a sick man . . . he was an immense example for me of tenderness, hard work (photographer as well as painter), and above all, he understood all my problems."[485]

Wilhelm Kahlo—who never integrated into Mexican society—constructed a private world filled with European music, literature, and philosophy.[486] He nurtured his daughter's craving for culture after she was crippled at an early age by polio and later by an accident. Frida was a compulsive reader of German philosophy, of Proust and Henri Bergson, as well as books on artists such as Dürer and Botticelli. The themes of her own art were influenced by this cultural confrontation; they go beyond a simple autobiography to reveal her existential quest (plate 85). Rivera wrote in the 1950s that Kahlo "was the first woman in the history of art to have adopted with absolute and ruthless sincerity and, one could say, with impassive cruelty, the general and specific themes which concern women exclusively."[487]

She took immigration as a subject, inspired by *City of Palaces*, a book of Yiddish poems by Isaac Berliner that Rivera translated into Spanish and illustrated.[488] In 1936, Kahlo painted a small work called *My Grandparents, My Parents, and I*, in which she told the story of her origins (plate 86). She represented herself as a three-year-old, and based her parents' portrait on their wedding photo. Kahlo symbolized her Mexican maternal grandparents by the earth and her paternal grandparents, who remained in Germany, by the ocean.

Kahlo's seemingly naive depiction of her family had profound meaning, as Gannit Ankori explains in her dissertation.[489] Her decision to base her painting on her genealogical chart must be placed in the context of the Nuremberg Laws, according to which Kahlo certainly was Jewish. By 1936, Nazi-oriented manuals on how to conduct genealogical research were distributed in the German School of Mexico, where her teachers joined the Nazi party. Kahlo used genealogy for the opposite purpose as the Nazis, namely to demonstrate her pride in her "impure blood."[490]

86
Frida Kahlo (1907–1954)
My Grandparents, My Parents, and I (Family Tree), 1936
Oil and tempera on zinc, 12¹⁄₈ × 13⁵⁄₈ in. (30.7 × 34.5 cm)
The Museum of Modern Art, New York, gift of Allan Roos, M.D., and B. Mathieu Roos

She subscribed to Mexican publications by German-Jewish authors. Among her books one finds a rare copy of a Spanish translation of Judah Halevi's twelfth-century *Poemas Sagrados y Profanos*. Her library reflects her deep interest in history—pre-Columbian, colonial, revolutionary, and contemporary—as well as many other genres, including fiction and biography. Two volumes of Alfonso Toro's *La Famiglia Carvajal* provide an account of the Jews' ordeal during the Inquisition.[491]

For her painting *Moses*, Kahlo received the second prize at the annual exhibition of the Palacio de Bellas Artes, in 1946. Freud's book *Moses and Monotheism*, which one of her patrons had given her, inspired the theme of the painting, in which a face resembling Rivera's is portrayed with an "eye" on the forehead. Shortly before her death, Kahlo wrote in her journal that as a dedicated communist she rejected all religions. "Discovering at the end of her life the full sense of her German first name, *Friede* meaning peace, she changed its spelling to Frida without an 'e.'"[492]

German existentialism and fear of freedom

Until the rise of Hitler, Central Europe's cultural cachet was far superior to that of France or England. In German-speaking countries, a new generation of philosophers had appeared, with Hermann Cohen as the mentor who inspired the Jewish intellectual revival. The reputation of the Marburg School, where he taught before 1914, reverberated as far as Moscow, from where a young Boris Pasternak traveled to attend Cohen's lectures. During a short-lived Golden Age, Jewish culture shared the matrix of German humanism, in which two poles could be distinguished: that of the religious utopists like Martin Buber, Franz Rosenzweig, Rudolf Kayser, Gershom Scholem, and Hans Kohn, who asserted their Jewish identity on national, cultural, and religious grounds; and that of the secular, free-spirited Jews like Gustav Landauer, Ernst Bloch, Erich Fromm, Georg Lukács, and Manès Sperber.[493]

The Frankfurt School was the name given in the 1960s to the intellectuals who had met in that city in the 1920s, and who aimed at an interdisciplinary fusion of psychology, sociology, economics, political theory, art, literature, and philosophy.[494] Their investigation of the "culture industry" later became known as critical theory. They explained the association between the repressive evolution of society and anti-Semitism largely in terms of the psycho-sociological factors relating to the "refusal of freedom." Within this framework, Herbert Marcuse explained how paternal figures were progressively replaced by administrations.

Theodor (Wiesengrund) Adorno confronted the implications of his Jewish paternal heritage after the Holocaust in order to explain his ultimate messianism, first secularized in Marxism, and later displaced into the realm of aesthetics. He considered Auschwitz to be the culmination of a civilizational process whose reoccurrence can be prevented only by "vigorous action against blind acceptance of collective interest."[495]

All the above-mentioned philosophers of German-Jewish descent refused to bow to disenchantment: bearers of an ethical mission, they considered it their job to fix the world.[496]

The writers of the École de Paris

The German existentialists, as well as Jean-Paul Sartre, inspired an entire generation of Parisian intellectuals, led by Emmanuel Levinas. The philosophers' École de Paris believed that the Shoah induced a responsibility toward humanity: instead of dissolving Judaism into a universal abstraction, its specificity had to be at the heart of human destiny.[497] After France inherited the philosophical tradition that had deserted Germany, a current emerged in the 1960s and 1970s known as The Unpronounceable (L'Imprononçable), whose "nomad literature" offered a new myth: that of the writer as a Jew, and of Jewish writing as the essence of existence.[498] Its leader, Edmond Jabès,

wrote, "In a sense, I am now living out the historical Jewish condition. The book has become my true place . . . practically my only place. The condition of being a writer has little by little become almost the same for me as the condition of being a Jew."[499]

Twenty years earlier, in his *Writings on the Jewish Question*, Sartre found little difference between a democrat and an anti-Semite. One wants to destroy the man, which leaves him as a Jew, a pariah, an untouchable; the other wants to destroy the Jew, which leaves just a man, as an abstract universal being.[500] Artists pursued their own existentialist quests. Balthus and Giacometti explored the human figure, as both were interested in "inter-subjective reality." Sartre compared Giacometti to a magician and shared his existential preoccupation with realism in painting—namely, the idea that the viewer must invest the image with life.[501] Giacometti chased the image to the verge of disappearance; his hallucinations evoke the first appearance, the original vision of a human.[502]

Psychoanalysts like Jacques Lacan explored related issues.[503] Maurice Merleau-Ponty published *Phenomenology of Perception* (1945); Sartre wrote essays on Giacometti (1948 and 1954); André Malraux conceived *The Imaginary Museum* (1947); Skira published Bataille's thoughts on the recently discovered paintings of Lascaux, which he viewed as fundamental representations of visible reality (1955).[504]

Giacometti was plagued by the feeling that the more he looked, the more a screen appeared between him and reality; he worked tirelessly from a live model. No version is definitive, just as no encounter, with any place or person, can ever be definitive. Nothing can be captured by perpetuating the transient.

The critic David Sylvester explained that Giacometti belonged to a place apart: Val Bregaglia, where he was raised and to which he returned throughout his life. This village in Switzerland was just a few minutes away from the Italian border. The Bregaglians, who numbered about two thousand at the time, had been Italian Protestants since

1529. Their pastors were defrocked priests from Piedmont. Giacometti thus came from Protestants on both sides of his family, and he had a particularly devout mother, who familiarized her sons with the main lesson of the Bible: the transiency of human existence.[505]

For some thirty years, Giacometti's sculpture was restricted almost exclusively to three themes: the bust of a man, a walking man, and a standing woman.[506] There is much in this that reminded Sylvester of the Jewish philosopher Ludwig Wittgenstein: ". . . a similar consuming dedication to an activity, a similar refusal to take for granted accepted assumptions about the purpose and possibilities of that activity. There is a similar feeling that this activity is not a means of producing works of philosophy or works of art, but a search that can never lead to a solution."[507]

A close friend of Giacometti, Avigdor Arikha, worked in Paris. According to the catalogue of his drawings donated to the British Museum (2005), "Arikha has produced some of the most remarkable images on paper since the death of Giacometti."[508] Arikha chose to observe the familiar, yet distant human face in his studio; his nonalignment with modern movements also set him close to Giacometti. Both established studios in Paris in the 1940s and 1950s, and were in contact with existentialist circles. After having worked in modernist idioms, Surrealism for Giacometti and abstraction for Arikha, both had to overcome a visual crisis.

In the 1960s, when Arikha's art was abstract, like that of most Parisian painters, he decided to take a radical turn. Between 1965 and 1973, he confined himself solely to drawing, as "a way of re-learning how to paint."[509] From then on, Arikha's drawing has moved hand in hand with his painting. By what graphic means can one describe a world whose reality no longer seems fixed? That has been the issue for Arikha. "What intrigues us most in drawing today is the spectacle of the eye and brain struggling to agree."[510] Arikha has drawn in order to see, as a writer writes in order to think.[511] The motif is to be executed entirely from life, in one session, without revisions; restraint is necessary

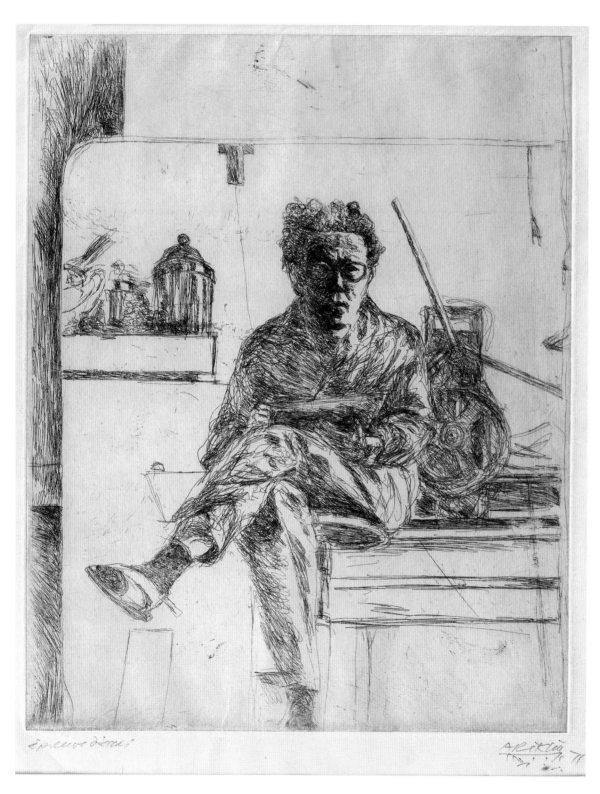

épreuve d'essai

ARIKA 71

87
Avigdor Arikha (b. 1929)
Self-portrait with Mirror and Press, 1971
Etching on Hosho paper,
11⅜ × 9¼ in. (29 × 23.5 cm)
Private collection

to the expression of emotional intensity. The sense of presence is strongest in his self-portraits, such as *Self-portrait with Mirror and Press* (plate 87). Following a break of twenty-seven years, Arikha suddenly discovered "an urge to print again."[512]

Arikha has experienced many upheavals in his life: born in Romania to German-speaking parents, he survived the Holocaust thanks to the drawings that he made as a thirteen-year-old, which secured his release from the concentration camps in 1943. Soon after, he went to live on a kibbutz near Jerusalem and got his artistic training at the Bezalel School of Arts and Crafts. Later, in Paris, the terrible circumstances of his early life gave him the instinct to find a personal voice.[513] Arikha's themes are significant: family, friends, and streets that he knew well or that he learned to know, as if he wished to reinforce their existence. He registers life as "a sort of seismic trace."[514]

Besides being a painter, Arikha is a formidable art historian, curator, and writer on artists like Poussin and Ingres. He has been saturated with culture; books and learning have sustained him throughout his life. Fluent in English, French, Italian, and Hebrew, on top of German, he is a true scholar versed in literature and philosophy. In its elliptical intensity, Arikha's work resembles his friend Samuel Beckett's writing: spiritual and minimalist.[515] It arouses deep feelings with a small amount of information. Arikha believes that abstraction at first rejuvenated Western art, as it made its constituent elements more visible: line, shape, color, and their reciprocal relationships.[516] But even as an abstract painter, Arikha did not lose the deep rooted empathy for humanity that runs through all his work.[517]

The School of London

After Giacometti's London show in 1955, his influence extended to a group of young artists: "Existentialism gave our endeavors a certain glamour, so we clung to the idea. We painted with Giacometti in mind. . . . His con-

stant dissatisfaction with his achievements also struck a chord."[518] During the decade that followed World War II, the arrival in Britain of large, energetic abstract canvases presented a major challenge. The debates on visual culture were as intense as they had been before the war—only John Berger and David Sylvester replaced Herbert Read and Anthony Blunt.[519]

Abstract and realist artists replayed old debates about elitism when pop art emerged in *This Is Tomorrow* (1956), an exhibition at the Whitechapel Art Gallery. Artists deconstructed the language of everyday culture: mass-produced, low-cost, witty, and aimed at youth. Yet this was also the time when, in London, a group of painters were rejuvenating the human figure.

In 1976, David Hockney and his friend R. B. Kitaj co-organized the exhibition *The Human Clay* at a bastion of modernism, the Hayward Gallery; it was a seminal event in English art. Both artists were figurative, narrative, literary, often autobiographical, even confessional, and they engaged with modernist painting as well as with the old masters.[520]

The show was intended as a rearguard action against abstract and conceptual art, which Hockney and Kitaj saw as a cul-de-sac. It emphasized the need for a return to drawing skills and was an apologia for what from then on would be called the School of London, a term invoking the École de Paris, with its legendary dissenters. Its roots are to be found in Stanley Spencer and David Bomberg, to whom Frank Auerbach, Leon Kossoff, and Lucian Freud freely acknowledged their debt.

The artists of the School of London chose to revisit the "grand tradition" of realist painting at a time when it was considered *passé*. "The last great wave of Paris based figurative artists, Balthus and Giacometti, both from other cultures, were the School of London's immediate forebears. Not only have the London painters been formed by the European tradition, they are the manifest continuation of it."[521]

Helen Lessore organized their first exhibitions at her Beaux Arts Gallery in the 1950s.[522] Because of their links with European tradition and the relative isolation of London from the United States, these painters were better informed about the art of the Continent than about modernism in America. Moreover, Paris had special meaning for them: Freud, who hardly traveled, visited Paris, and so did Kitaj. Kossoff, like the others, had an affinity for French classical painters like Poussin.[523]

In London, the Colony Room, the French Pub, and Wheeler's restaurant were the places where their legend crystallized.[524] The city provided a background for the artists, whose vision of London was as crucial to them as that of postwar Paris had been to Sartre.[525] Auerbach pointed out that "there may have been a stronger personal engagement with London than with any other place. Here, the artists really felt a need to leave a trace of their physical presence."[526]

To resuscitate the human figure was the deepest wish of these Diaspora painters, who found satisfaction in their relative isolation from the art trends and got used, early on, to going against the tide.[527] Except for Francis Bacon, an Irish Catholic who produced violent forms, most artists of this group firmly believed in the importance of drawing from live models in the studio.[528] "Over and over Lucian Freud draws the contours of his characters without erasing the preceding ones. . . . His hesitation reminds one of a conversation where a word which contradicts a previous word remains as if it were floating in the air."[529]

An obsessive fascination with the figure, a subject through which the most profound feelings about human existence are conveyed, has linked these artists throughout their careers. A long list of portraits illustrates their mutual admiration: Auerbach by Freud, Freud by Bacon, Kossoff by Kitaj, Kitaj by Auerbach, and so on. Not only their work but, in most cases, their lives have been interrelated, as these portraits so eloquently suggest.[530] The "Beaux Arts Quartet" (Auerbach, Freud, Bacon, and Kitaj)

contributed to a special review on *Modern Art in Britain* that highlighted their specificities: they share one main feature—individualism.[531]

Auerbach has written that these scholarly artists read with an analytical immediacy that allows them to judge a book as quickly as a painting: "All the painters I know, Lucian Freud or Leon Kossoff, or anyone who proved to have developed a high level of artistic creativity, has read a lot." Their ability to grasp the subject is derived from their habit of plundering culture, referring constantly to the past in their paintings.[532] Among them towers Lucian Freud, born in Berlin, the son of Ernst Freud, an architect who painted and was the younger son of Sigmund Freud.

As a Jew, Lucian was ineligible for the Hitler Youth; thus life under the shadow of Nazism prepared him, as nothing else, for an adult obsession with solitude and unpredictable movement.[533] It is tempting to relate Freud's early work to that of Otto Dix and Christian Schad, but he was only ten when his family left Germany in 1933. His grandmother had, however, taken him to the Charlottenburg Palace, where he saw the Rembrandts, though the art that stimulated young Freud, such as Dürer's prints, was more graphic.[534]

In his early paintings, "[New] Objectivity was followed by a touch of Surrealism (De Chirico) with a yen for organic things and a touch of mannerism."[535] In 1946, Freud met Balthus, his reference for French painting. Later, Freud saw the work of Hals, Goya, Courbet, and Ingres.[536] Herbert Read dubbed Freud "the Ingres of Existentialism," which shows in the portraits of Kitty, Freud's first wife, a daughter of Sir Jacob Epstein (plate 88).[537] Freud's portraits painted in the 1950s, in what is now considered his most gentle style, were then considered shocking.

William Feaver has explained how Freud wanted his colors to be as "Londony" as possible.[538] Freud's London is as specific and minutely detailed as the figures in his paintings. His images of London are like nudes of places that he

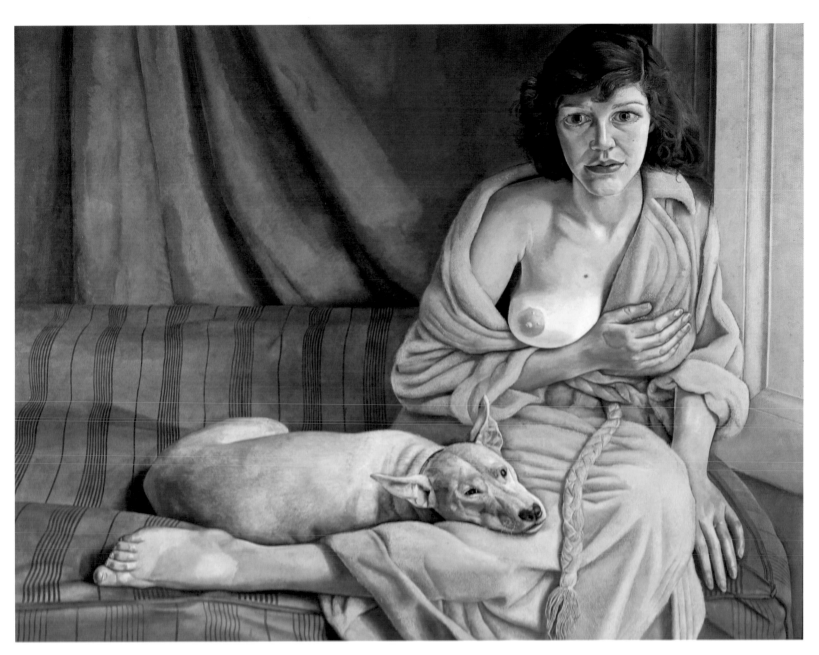

88
Lucian Freud (b. 1922)
Girl with a White Dog, 1950–51
Oil on canvas, 30 × 40 in (76.2 × 101.6 cm)
Tate Gallery, London

89
Frank Auerbach (b. 1931)
Rimbaud, 1975–76
Oil on canvas, 42½ × 42½ in. (107.9 × 107.9 cm)
Tate Gallery, London

son being naked in front of me that invokes consideration. You could even call it chivalry on my part."[544] While preserving respect, Freud wants the body to carry the expressive force that the face would otherwise, so he plays down facial expression and avoids the direct gaze. He has stated that "the painting is the person"[545] and "I want paint to work as flesh."[546]

Freud will "clinically" scrutinize the body twenty, fifty, or one hundred times.[547] His models until late in life were the people in his immediate surroundings (plate 82). "My work is purely autobiographical." Freud's aim has been presence. For him, the main difference between a painted and a photographic portrait is simply "the degree to which feelings can enter into the transaction from both sides. Photography can do this to a tiny extent, painting to an unlimited degree."[548] Freud's paintings have what Sir Ernst Gombrich calls "the pattern of living expression. . . . The consummate artist conjures up the image of a human being that will live on the richness of its emotional texture when the sitter and his vanities have long been forgotten."[549]

While Frank Auerbach creates clear shapes (plate 89), Leon Kossoff's forms are more fluid, as for example in the portrait of his brother Philip (plate 90).[550] These artists, too, find their motifs in a small circle.[551] Auerbach was born in Germany in 1931. Sent to England by his parents along with other children in 1939, he never saw them again. In London, he was considered a prodigy. He portrayed mainly female models in a style that displayed expressionistic tendencies, which his work has retained throughout his career. He attended Bomberg's classes and encouraged Kossoff to join.

The latter spent his first twelve years in streets full of immigrants. "Coming to Bomberg's class was like coming home."[552] The Holocaust, the advent of atomic weapons, and the Cold War strengthened his sense of apprehension.[553] Kossoff scrapes and repaints his canvases in order to represent the visual chaos in which humans are cut off

knows perfectly.[539] As a boy, his grandmother took him to the countryside, where he developed his lifelong love of horses.[540] "I am really interested in people as animals. Part of my liking to work from them naked is for that reason—because I can see more," Freud has said.[541] "My grandfather was adamant that to be an analyst you had to be a fully qualified medical doctor, and whenever he examined any of his patients he gave them a complete and thorough examination. That seems to me right and proper."[542]

Freud needs an immediate presence to keep him on the *qui vive*.[543] "I'm never inhibited by working from life. On the contrary I feel freer. There is something about a per-

90
Leon Kossoff (b. 1926)
Philip II (portrait of the artist's brother), 1962
Oil on wood panel, 56½ × 40½ in. (143.5 × 77.6 cm)
Private collection

91
R. B. Kitaj (1932–2007)
Self-portrait, 1997
Oil on canvas, 16 × 12 in. (40.6 × 30.5 cm)
Private collection

from their purpose. Because of alienation, meaning can only be found through individual action. The image has the last word, and it is a function of existential empathy. It represents human art after the dehumanization of art.

Klaus Kertess has learned from his interviews with Kossoff that while he "continuously paints the same people and places, for him nothing is ever the same."[554] "Rejecting time and again ideas that are possible to preconceive, making new images, destroying images that lie, and discarding images that are dead," Kossoff's portraits stress his awareness of a shared human condition.[555] "The fabric of my work through the last forty years has been dependent on those people who so patiently sat for me, each one uniquely transforming my space by their presence."[556]

The influence of Rembrandt and Soutine shows in the turbulence of Auerbach and Kossoff's colors, which are applied solidly, with close tonality; following Kossoff's preparatory drawings for the painting, a few colors emerge that seem to glow in the dusk.[557] Sometimes the motif is swallowed by the energetic impasto brushwork. Urban landscapes complement his involvement with the human figure. "The pictures are about specific places, changing seasons, and special times. But they are mostly about the human figure passing through the streets, transforming the space by its presence."[558]

In Kossoff's work, there is a constant interaction between unrelenting doubt and surging energy. In the catalogue of his retrospective at the Louisiana Museum in Denmark, the following question was asked: "Where is [Kossoff] in relationship to his oeuvre? The answer is that, like Giacometti, Kossoff is present in the extreme in his work, and yet wholly absent. Present, inasmuch as there is a biographical presence, he simply paints his world, great or small; absent, inasmuch as this world is wrenched free of its origin and quite simply becomes the universe."[559]

With its well-argued defense of the figurative, *The Human Clay* challenged the hegemony of abstract and conceptual art.[560] Kitaj wrote, "My exhibition was littered with ideas."[561] Born in Cleveland to a father who left when he was one year old, and a Jewish mother who then married Walter Kitaj, a Viennese doctor, he had little con-

tact with traditional Judaism as a young man. Instead, he read Kafka, Borges, Pound, Joyce, and Eliot.[562] When Kitaj first went to Europe, he visited Paris and Vienna. He later shipped off to South America, and then to New York, where he met the art critic Harold Rosenberg, the painter Raphael Soyer, and the philosopher Hannah Arendt.[563]

In 1983, Kitaj married Sandra Fisher in London's oldest and most beautiful synagogue, Bevis Marks, with David Hockney as best man and a *minyan* including Frank Auerbach, Leon Kossoff, and Lucian Freud.[564] His work then took an autobiographical turn,[565] and in 1989 he wrote his *First Diasporist Manifesto*. As a "Diasporist," he placed himself in a long line of rabbis who spiritualized exile: his works, which often feature complex narratives, form an unfolding commentary, a *midrash* (exegesis) in paint—a sort of secular responsa.[566]

Kitaj's literariness transposed his erotic desires to the realm of culture.[567] He drew upon poetry, history, and books—anything at hand.[568] "For me books are what trees are for landscape painters."[569] His art was grounded in Surrealism, Symbolism, and Abstract Expressionism.[570] The influence of collage and of Warburg's approach to iconography can also be detected in his work.[571]

In the catalogue of the 1990 exhibition *From Kitaj to Chagall* at the Barbican, Kitaj stated, "Whenever I have the energy, I aim to consider the Jewish question in art (which a lot of people think is a bad idea). . . . I aim to be as unlike my neighbor as possible. I aim to renew the depiction of the human face and form if I can."[572] The investigation of identity was Kitaj's lifelong preoccupation.[573]

Many of his portraits depict generic "types" as opposed to specific individuals; even his self-portraits seem stereotyped (plate 91). At the same time, the paintings in the series that includes *The Orientalist* (1976–77) and *The Hispanist* (1977–78), among others, depict the sitters accurately, in an attempt to resolve the tension between type and individual.[574] When asked what he tried to capture in a portrait, Kitaj replied, "I intend to captivate some onlookers, which hap-

pens too rarely I suppose. I like the (Jewish) idea that the face of the Other elicits responsibility for the Other. Face to face to face."[575]

Kitaj was the first American elected to the Royal Academy in London, after Benjamin West in the eighteenth century and John Singer Sargent in the nineteenth. However, his exegetical zeal eventually upset the London art scene, and in 1997 he returned permanently to the United States.

Social Expressionism

Identifying themselves with the city of New York, Jews participated in a specific vision of America.[576] Like London painters, or Paris photographers, writers in New York often reflected on their Jewish childhood. *The Melting Pot*, a play by the Englishman Israel Zangwill, whose assimilationist view rested on a revised version of *Nathan the Wise*, was first presented in Washington, D.C., in 1907.[577] The so-called Jewish qualities of ambition, hard work, and civic and community engagement were precisely those that shaped the American mentality.

Successful immigrants started significant collections. Hadji Ephraim Benguiat's ritual objects were presented at the World's Columbian Exhibition in Chicago in 1893. Cyrus Adler founded the Jewish Museum in New York, which began as a gallery of the Jewish Theological Seminary, then became The Museum of Jewish Ceremonial Objects, and finally, in 1947, settled, under its present name, in a building donated by Frieda Warburg. (Its major acquisition, made in 1925 with the help of Felix Warburg, was Benguiat's collection, which was previously deposited at the Smithsonian.)[578]

But for most Jews, social life was defined by exclusion from major sections of society, such as employment at banks, at insurance companies, or in public service, and membership in social or sports clubs. As a result, young people extended strong support to socialism and communism. Jews were employed mainly in the garment industry,

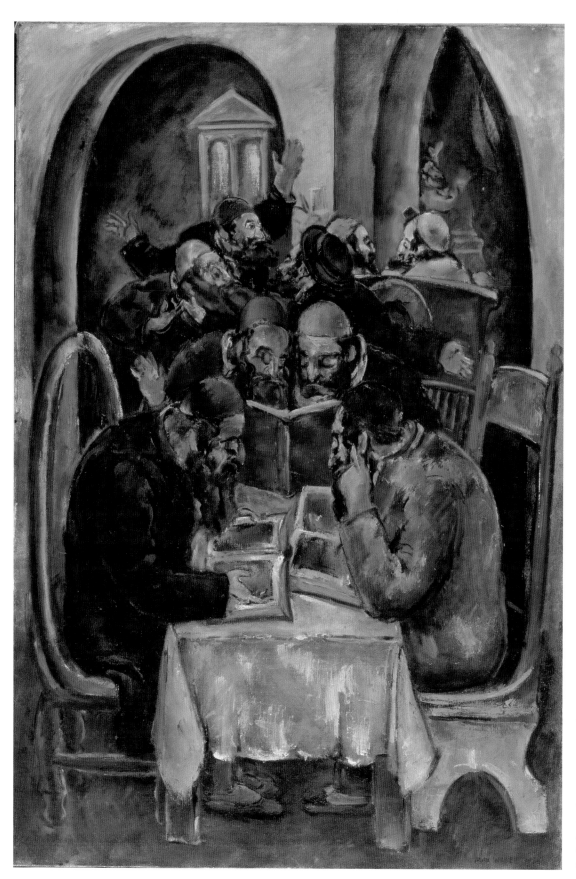

92 (*left*)
Max Weber (1881–1961)
The Talmudists, 1934
Oil on canvas
50 × 34 in. (127 × 86.7 cm)
The Jewish Museum,
New York; gift of Mrs. Nathan Miller

93 (*opposite*)
Mark Rothko (1903–1970)
Self-portrait, 1936
Oil on canvas, 32¼ × 25¾ in. (81.9 × 65.4 cm)
Christopher Rothko

94
Chaim Gross (1904–1991)
Young Performers, 1959
Cast bronze, 46 × 43 × 14 in. (117 × 109 × 36 cm)
Private collection, North Salem, New York

The Society of American Artists was to the National Academy of Design what the New English Art Club was to the Royal Academy of Arts. In the "city of opportunities," as Alfred Stieglitz dubbed New York, Max Weber synthesized elements of Cubism with chromatic abstraction and expressionism. With Arthur Dove, Georgia O'Keeffe, John Marin, and others, Weber exhibited at the 291 Gallery, where the first American modernists found refuge from hostile critics and an indifferent public. The Armory Show (1913), where Fauvism and Cubism were presented in New York for the first time, provoked a shock wave comparable to that of Roger Fry's exhibition in London.

During the 1920s, the Jewish Educational Alliance offered help to the newly arrived. The People's Art Guild had a strong socialist orientation: in order to bring art to the general public, within the three years of its existence it arranged some sixty exhibitions in coffeehouses, restaurants, community centers, libraries, and playhouses.[580] The avant-garde Yiddish journal *Schriftn*, edited by David Ignatoff, reproduced art by Max Weber (plate 92), Benjamin Kopman, Jennings Tofel, Abbo Ostrowsky, Ben Ben, Chaim Gross (plate 94), Louis Ryback, Abraham Walkowitz, and many others.

When the financial crisis started in 1929, the Brooklyn Jewish Center employed Mark Rothko (Rothkowitz), stage director Moss Hart, and opera singer Richard Tucker. During the Great Depression, realism, regional and urban, emerged *en force*. An equitable social order was the goal of many painters, such as Ben Shahn, William Gropper, Jack Levine, the Soyer brothers—Raphael, Moses, and Isaac—and even the young Rothko (plate 93),

whose hundreds of thousands of workers turned New York into a bastion of syndicalism. Raised in a tight family framework, they aspired to freedom in a sophisticated city where the music industry contributed to a general feeling of optimism.

One can establish parallels between the London and New York art scenes of that time.[579] The roles of Walter Sickert and Robert Henri, as both teachers and trendsetters, were comparable. The realists of the Ashcan School, such as John Sloan and George Bellows, were chronicling city life; Edward Hopper developed a new "American Scene"; and the regionalists—Thomas Hart Benton, Grant Wood, and John Steuart Curry—pushed the frontiers of realism westward.

95
Raphael Soyer (1899–1987)
Self-portrait with Model, c. 1945
Oil on canvas, 20 × 16 in. (50.8 × 40 cm)
Private collection

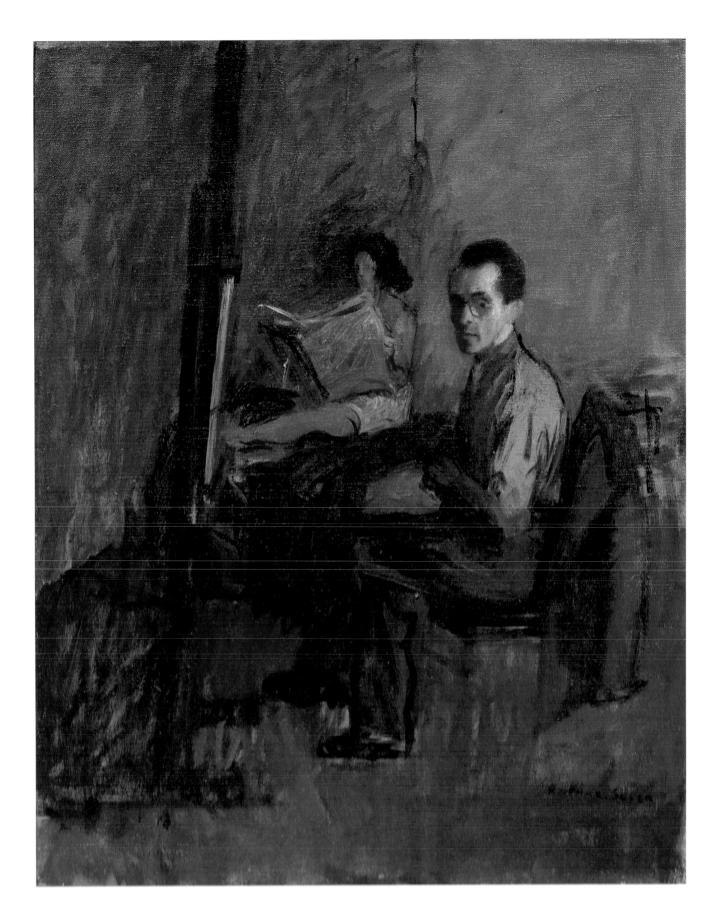

as well as of sculptors like Seymour Lipton, William Zorach, Leonard Baskin, Chaim Gross, and George Segal (plate 102).[581]

They used narrative qualities in their art to create an emotional bond with the working classes. Of the numerous artists discussed by Bram Dijkstra in his masterpiece *American Expressionism*, the overwhelming majority were Jews who had come from Eastern Europe as children.[582] Among the gentiles, most were immigrants, or first-generation Americans of Italian, Spanish, and Japanese descent. The African-American descendants of (forced) immigrants made their own contribution to this important art movement, in which, for the first time in American history, artists of northern-European ancestry were distinctly in the minority.[583]

The art critic Royal Cortissoz, the arbiter of American taste for over fifty years, described the expressionist tendencies of the immigrant artists as "crude, crotchety, tasteless, abounding in arrogant assertion, making a fetich [sic] of ugliness and, above all else, rife in ignorance of the technical amenities. These movements have been promoted by types not yet fitted for their first papers in esthetic naturalization—the makers of true Ellis Island art."[584]

In 1931, President Herbert Hoover instructed the State Department to strictly adhere to the provisions of the Immigration Act, because of the likelihood of new arrivals remaining unemployed: as a result, immigration dropped from 242,000 in 1931 to 35,000 in the following year.[585] Isolationist policies, antilabor agitation, and the revival of the Ku Klux Klan—which boasted a membership of six million—radicalized large sections of the Jewish community. Unabashed anti-Semitism was then a common strain of thought in American life.

In the depths of the Great Depression, the Public Works of Art Project was established under the aegis of the Treasury Department. Most of the artist-workers on the payroll of the WPA (Works Progress Administration) received between thirty and forty dollars a week, just enough for art supplies and food.[586] But the war was the perfect excuse to end this initiative. In 1944, a headline in *Life* magazine declared the "End of WPA Art: canvases which cost the government 35,000,000 dollars are sold for junk." Thousands of paintings were auctioned, de-stretched, and lumped in dirty bundles. "The prevalent idea was that the WPA was dominated by Communists." The conservatives, who gained control during the war, associated expressionist art with "Jewish Bolshevism, the source of all America's troubles."[587]

After World War II, with the ascendancy of Abstract Expressionism, the tendency grew to treat the art of the 1930s as a unified movement dominated by "American Scene" painting—of which ghetto-bred art was just a subdivision, a sort of urban regionalism.[588] The unifying feature of these Jewish artists' work was identified as "specifically humanistic Expressionism," recognizable by its "deep preoccupation with spiritual and psychological values and its use of organic rather than angular distortions."[589]

A major representative of this trend was Raphael Soyer, who arrived in the United States as a teenager, already dedicated to becoming an artist. Because he and his two brothers were raised in the ghettos, it was predictable that they would emerge as urban realists in the late 1920s. Raphael's early paintings describe immigration, acculturation, and universalism. Although the Soyers retained little of their parents' orthodoxy, the prophets still took pride of place in their pantheon.

In her recent biography of Raphael Soyer, Samantha Baskind explains how he "has been labeled the quintessential Jewish American artist when, in fact, he actively sought to dispel the idea that his art was related to his Jewish identity."[590] This sort of consciousness, waning and waxing, stemmed from a strong desire to overcome Jewish parochialism. Like most artists, Soyer's ambivalence reflected his fear that "ethnicity" would interfere with his career.

His last words in *Self-revealment: A Memoir* indicate how autobiographical his art was: "[I made] all these portraits

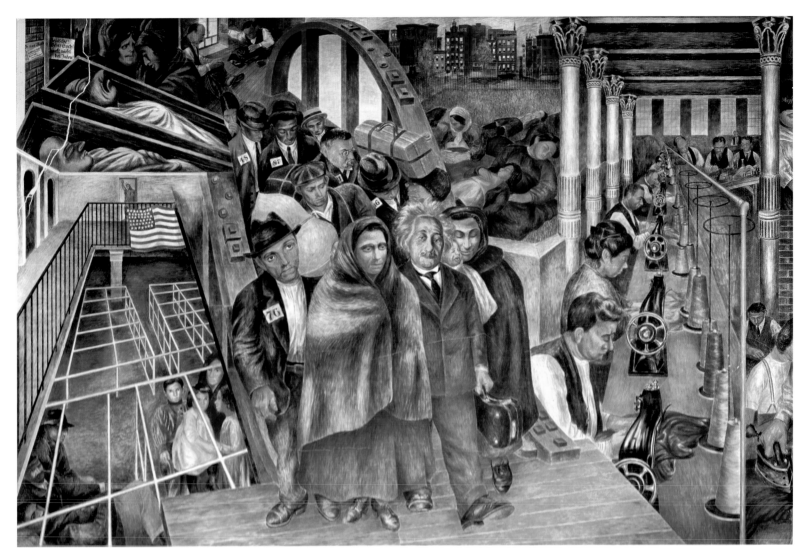

96
Ben Shahn (1898–1969)
Albert Einstein among other immigrants
Detail of the *Roosevelt Mural*, 1937–38
Jersey Homestead Community Center, New Jersey

of myself, my parents, the members of my family; the pictures of the artists with whom I came in contact; the city I have known and its people. . . ." Soyer's idol was Rembrandt, but he revered Degas, Corot, and Eakins as well, because of their expressions of humanity.[391] Soyer also had an affinity with Pascin, who, like himself, transformed the studio picture from an exercise in formal organization into a metaphor for the human condition. With time, Soyer's work became increasingly confined, yet "within this narrow, self-imposed frame, he managed to capture a broad spectrum of life."

In his eulogy for the artist, Milton Brown said that "it was almost as if the world, after it learned that Raphael was always in his studio, dropped in to visit: among them, artist friends, musicians or people with musical instruments, neighborhood derelicts and students, hippie kids, beatnik celebrities and the flower people, would be dancers, young actresses and models, in all shapes and sizes,

97
Jack Levine (b. 1915)
The Passing Scene, 1941
Oil on composition board
48 × 29¾ in. (121.9 × 75.6 cm)
The Museum of Modern Art,
New York

nubile or pregnant and in various stages of undress. His studies encapsulate splintered fragments of time painted with the intimation of truth" (plate 95).[592]

Soyer was considered one of the finest portrait painters of his time, but throughout his life, he was in conflict with his Otherness. To understand how he negotiated his shifting identities, one must examine his self-portraits, as well as his genre and street scenes. One of his main subjects, the homeless, indicates that he was driven by *tikkun olam*, the Jewish belief in social justice.[593]

Ben Shahn also fits the classical description of the self-educated worker-intellectual, schooled in both the Talmud and Marxism, committed to a universal vision of culture. He was the first of five children in an orthodox family. "In Brooklyn, it was best not to walk through certain sections, since there was always the danger of being attacked and of having one's books taken away and thrown down the sewer."[594] This seemed somehow even more threatening than the anti-Semitism he experienced in Vilkomir, Lithuania, before his family came to the United States.

Early on, Shahn assisted Diego Rivera on a Rockefeller Center mural featuring the likeness of Lenin, which was destroyed in 1933. Shahn was active in several federally financed projects; when officials selected him to paint a mural for the Jersey Homesteads in 1936, the result was one of his most open expressions of the American Jewish experience. This housing development, sponsored by the Resettlement Administration, was founded primarily for Jewish garment workers; Shahn moved there himself in 1939. In his mural, Shahn created a narrative montage of immigrants coming off a ship, mixing anonymous arrivals with portraits of friends and historical figures who had actually arrived at different times and from different countries. The work contains one of the few images of the president to emerge from the federal mural program; in fact, the Homesteads compound was later renamed Roosevelt, New Jersey. Shahn's mother is also portrayed (plate 96).[595] The murals address the competing voices of the Jewish community: the conflicts between Socialists and Communists, between Zionists and Jews opposed to a Jewish state, and between the organizers of the Homesteads and the labor movement, who feared that the new community would weaken the unions.[596]

In the 1940s, disillusioned with partisan ideologies and the limits of realistic representation, Shahn dealt less explicitly with social issues in his work, and instead used biblical and mythological allegory to express universal concerns.[597] In doing so, he moved from the experience of an immigrant to that of an American artist. Shahn's evolving style, which paralleled his changing identity, was symptomatic of the experience of an entire generation. During and after World War II, most American artists engaged with this principal crisis of their life, and as a result, their art moved toward the universal. Shahn's move away from topical subject matter and toward the symbolic interpretation of themes like destruction and renewal in the face of catastrophic upheaval paralleled that of expressionists like Abraham Rattner and Hyman Bloom, or that of Mark Rothko and Barnett Newman (who would later become Abstract Expressionists).[598]

"Shahn's later art stood somewhere between the abstract and the figurative, borrowing from one its material riches of color, shape, and texture and its preference for inner organization, and from the other its focus on man as the most interesting object on earth."[599] In some of Shahn's work, texts and symbols are fused in the form of biblical lessons for the contemporary world. He loved the symbolism of Hebrew characters and may even have thought about it in kabbalistic terms. By the time of his posthumous retrospective at the Jewish Museum in New York (1976), Shahn was among the most widely collected artists in the country.[600] His themes of birth, life, death, and regeneration also characterize much of Hyman Bloom's postwar work, where "the bodies are emblems in which the process of decay symbolizes the corruption of society and of the human spirit."[601]

Jack Levine, another major figure who began to paint more scenes from the Bible in the 1940s, is known mostly for his caustic satirical depictions of corrupt politicians and cops and other manifestations of social injustice (plate 97). Born in 1915, he was the youngest of the eight children of Lithuanian immigrants Mary and Samuel Levine. He fondly recalled, "My mother always let me keep my pencils, crayons and papers in the oven of the coal stove in the kitchen during the hot summer months while she cooked on a gas range. When the weather grew cold, I was moved to the icebox. Milk and other spoilables were then kept outside on the window ledge and the stove came into play. As summer came on again, I was shifted again. And so, my mother and I dodged each other in the kitchen, and so the seasons passed."[602]

Levine loved the old masters, especially Rembrandt, Goya, El Greco, and Velázquez. The rise of abstraction in the 1950s caused him great consternation: "As Spinoza said: If the triangle could speak, it would say the world is a triangle. It's more than that. I think the whole thing [abstraction] is stupid. It is part of the downfall of our time."[603]

Despite the tremendous pressure from the abstract art world, a number of Jewish artists, like Levine, Shahn, Bloom, William Gropper (plate 98), Chaim Gross, George Segal, and the three Soyer brothers, remained fiercely representational.[604]

American denial

In the 1940s, there were scores of Jewish artists in New York, which was home to almost two million Jews. There was even an informal group of Jewish artists who called themselves The Ten, but one cannot say that there was a Jewish art scene.[605] The *Art Digest* noted the arrival of European artists, including Marc Chagall, Mané-Katz, Moise Kisling, Jacques Lipchitz (plate 99), Eugen Spiro (Balthus's uncle), and Ossip Zadkine, as well as Americans returning home, like Abraham Rattner and Man Ray.

In America, they found anti-Semitism barely less vitriolic than in Europe: according to a poll taken in 1938, a majority of Americans believed the persecution of German Jews to be entirely their own fault.[606] The *New York Herald-Tribune* reported as early as 1941 that nothing less than "total extermination" was underway. In 1943, newspapers stated that one million had already been murdered and that the Warsaw Ghetto had been wiped out.[607] During the war years, no moderately informed person could plead ignorance of what was taking place. Most artists played down Jewish suffering, as they wished "to be universal in feeling and wanted to avoid 'ethnic self-pity.'"[608] "When I try to discuss the Holocaust with either Jews or non-Jews, the conversation is often deflected by a discussion of the genocide, or mass-killing of other groups," observed Matthew Baigell, who believes that "whatever else it may mean, it is a form of denial, an inability to deal with the plan for the total eradication of the Jews."[609]

As the scale of the horror became apparent, artists reacted in various ways. The Holocaust did not cause mature artists to change their style, although Rattner, Shahn, and Gropper explored more Jewish themes in their late careers; others replaced their old imagery with scenes of liberation and return.[610] Rattner wrote, "As Hitler's voice grew louder and louder I felt at odds with esthetics and pure art. I had to express something with my art . . . escape from my emotional entanglement with the suffering of my fellow men. . . . His voice took me back to my childhood and I found no way to ignore these feelings. . . ."[611] Barnett Newman felt that "during the war it became nonsensical to get involved in painting men playing violins or cellos or flowers. . . ."[612]

The young artists at that time rejected regionalism, Social Realism, and all styles derived from mass culture or from faith in progress. The presence of Surrealist painters in New York opened new avenues to them; automatism had a particular appeal. The influence of Nietzsche and Jung—even though Jung was an apologist for racist ideas,

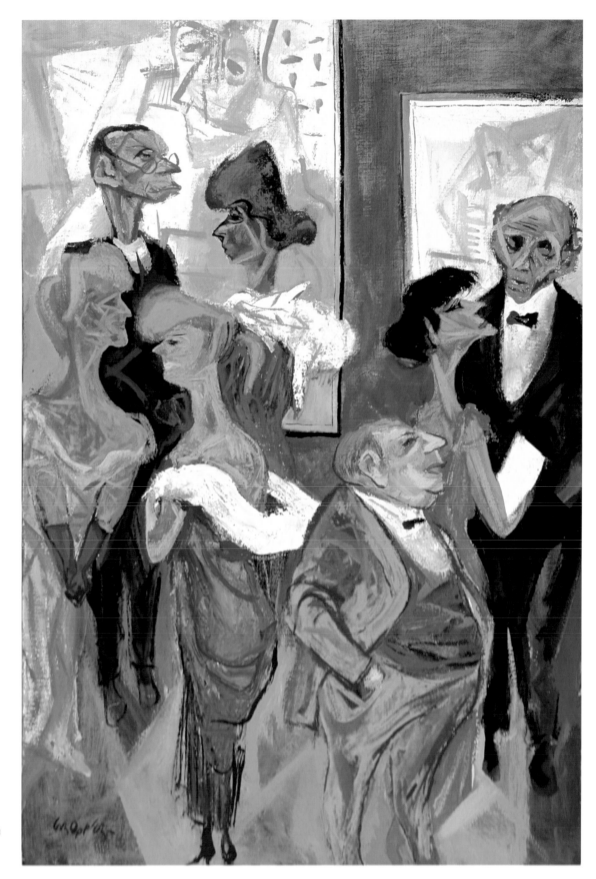

98
William Gropper (1897–1977)
Art Opening, c. 1959
Oil on canvas
32 × 22 in. (81.3 × 55.9 cm)
Norton Museum of Art, West
Palm Beach, Florida; gift of
Mr. Paul M. Kaminsky

as Jewish artists in America were aware—provided a way to reconnect with the human race: archetypes belonged to all. Rothko said, "Perhaps the artist is a prophet. . . . The truth is therefore that the modern artist has a spiritual kinship with the emotions of these archaic forms and the myths which they represent."[613]

Rothko and Gottlieb no longer cultivated sufficient ties with Judaism to derive an art from traditional Jewish sources; instead, they found in other cultures the surrogate images that allowed them to grapple with the immeasurable destruction. Abstract Expressionism, once thought to epitomize the quest for new forms, may be seen as an inventive mode of coming to terms with the Depression and the two world wars. However, Ziva Amishai-Maisels and Baigell feel that the crisis in subject matter was motivated more than anything else by what happened to European Jewry.[614]

Adorno claimed that because abstract art is nonfigurative, it satisfies the old prohibition against the graven image, offering a mode of aesthetic representation that avoids what both Auschwitz and the Hebrew Bible expressly forbid.[615] Rothko's work has been interpreted in terms of withdrawal from the world. Some view him as the "last rabbi of modern art," and Newman as a "modern-day kabbalist." These Abstract Expressionists developed their mature style also in response to events that shattered their paradigms.[616] The Holocaust was an overwhelming experience that Rothko really could not talk about. "The large rectangular forms in his mature works are, perhaps, inspired by open graves that he saw in photographs."[617]

The postwar world required an art that reflected on the uncertainties of the nuclear arms race. There was a growing sentiment that the United States needed an art commensurate to its new status as world leader. Now, for the first time in history, Jewish artists would make a significant and lasting contribution to a radical change in Western art. The late 1950s also marked the corporate takeover of American art. New buyers consisted less of passionate collectors like Albert Barnes or Duncan Phillips than the CEOs of major corporations.[618] No matter how much critics might prattle on about the significance of "nonobjective" painting, no CEO who hung a Pollock drip painting in his office was likely to find himself suspected of un-American activities. Champions of abstraction called American Expressionism a "socially conscious" art and labeled it as "Social Realism," a term that was awfully close to the "Socialist Realism" of the Soviets.[619]

America needed a "higher art" that denied the significance of content by making the *act* of painting its legitimate subject matter. Abstraction was championed by Clement Greenberg, known for his formalist insistence on the purity of the medium. In his way, he expressed a desire to achieve a better place in a better world, a desire that was perhaps remotely rooted in the prophets but played out in the secular arena.[620]

Art historian Margaret Olin has suggested that Greenberg and Rosenberg's denial of the subjective was part of an "assimilationist tactic," a means to negotiate identity in the context of nationalism, racism, and anti-Semitism, which were then still intertwined in the art historical inquiry.[621] Later, Greenberg openly viewed modern art from a Jewish point of view, while Rosenberg, who did not really believe in the concept of Jewish art, argued nevertheless that anxiety about identity is the most serious theme of Jewish life and modern art.[622]

Clinging to the human

The salient feature of the 1970s was a return to the figurative. If Pollock pioneered the way into abstraction, one of

99
Jacques Lipchitz (1891–1973)
Variation on the Theme of the Rape of Europa VII, 1969–72
Bronze, height: 9.1 in. (23.2 cm)
Patrice Trigano, Paris

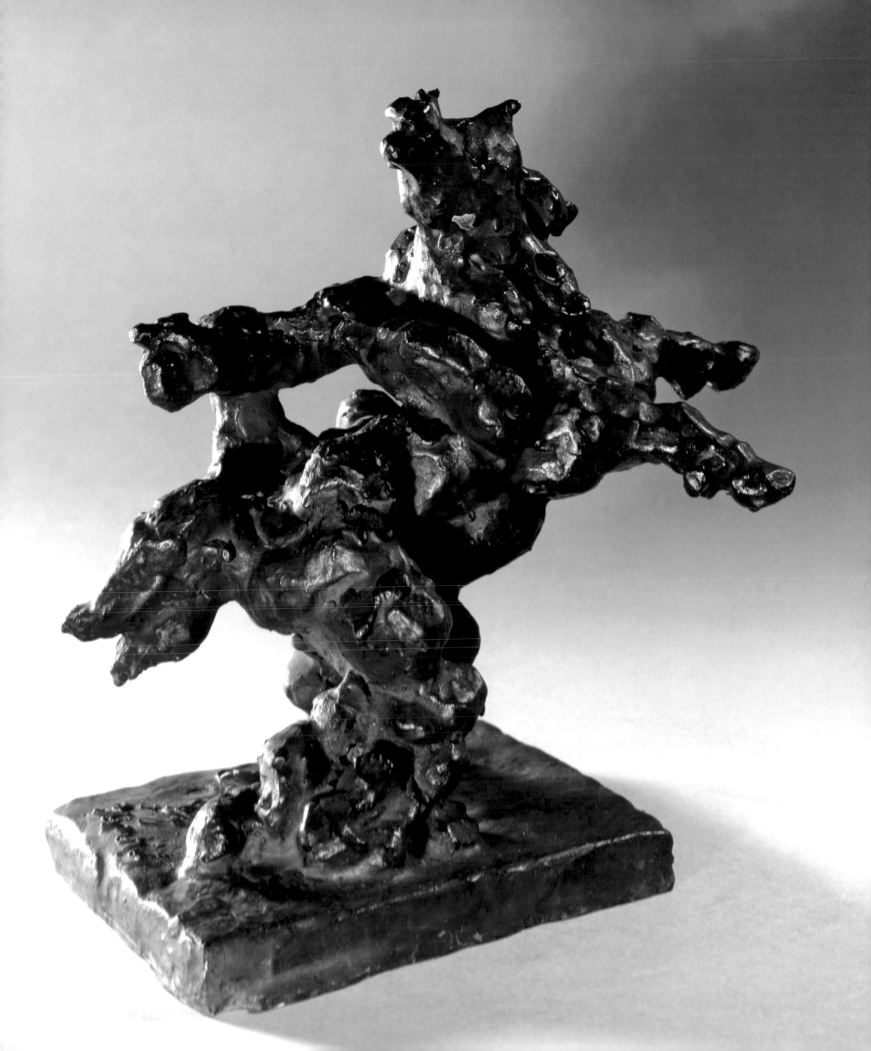

100
Philip Guston (1913–1980)
The Painter, 1980
Lithograph, 32 × 42½ in. (81 × 108 cm)
Private collection

his closest high-school friends, Philip Guston, was most suited to lead the way out. The youngest of seven children, Guston was born into "one of the better Jewish ghettos, but a ghetto nonetheless." His parents left Russia looking for a good life, which they didn't find in Mon-

treal. After his father's suicide, Guston's mother Rachel was left to support the family while nurturing her son's drawing skills. Guston's political instincts developed as quickly as his artistic interests.[623] Initially his work was close to that of Shahn's, and since he grew up in Southern

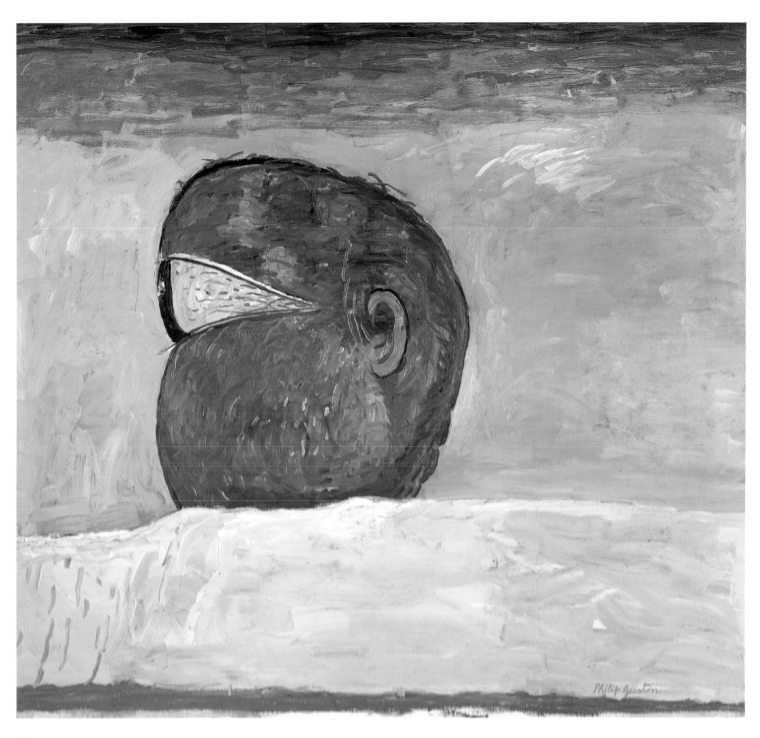

101
Philip Guston (1913–1980)
Head, 1975
Oil on canvas, 69⅛ × 74⅛ in. (176 × 189 cm)
Edward and Agnes Lee

California, he also counted the Mexican muralists among his role models.

Guston himself made some public murals early in his career, but soon abandoned this medium in favor of easel painting. He painted Klansmen as embodiments of evil and later became familiar with Max Beckmann's depictions of the dark face of humanity. Parting with allegorical figuration, Guston then made abstract work for sixteen years, before returning to social critique at the height of the Vietnam War. His late work often featured disembodied limbs and still-life objects, seemingly strewn all over the canvas but actually deliberately juxtaposed. Guston was attracted to art built on solid forms, like that of Paolo Uccello, Piero della Francesca, Cézanne, and Léger.[624]

He was also passionately engaged with art history: "In Rembrandt the plane of art is removed. It is not a painting, but a real person—a substitute, a golem. He is really the only painter in the world!"[625] Guston, a high-school dropout, was among the most erudite painters of his generation. He read Vladimir Mayakovsky, Isaac Babel, Pasternak, Kafka, Camus, Rilke, Nathanael West (Weinberg), T. S. Eliot, and his friend Philip Roth.[626]

When Guston married Musa McKim in 1937, he changed his name from Goldstein to appease her parents, but he later admitted to feeling awful about this: "There is a deeper existential level to any name change." In fact, Guston's name change was emblematic of his protean career: masks fascinated him, as they had two of his favorite painters—Max Beckmann and James Ensor. Guston was obsessed with images of facial concealment. In addition to hooded figures, he repeatedly painted partially shielded faces. Guston spent a lifetime involved in cycles of masquerade and self-disclosure: he wanted to be a shaman and spoke of creating "golems," of "being a maker of worlds, not merely a respectable art practitioner" (plates 100, 101).[627]

Explaining why he had risked his already developed career in the 1960s by abandoning his elegant abstract style for raucous figuration, Guston said, "I got sick and tired

of all that purity! . . . I wanted to tell stories!"[628] In fact, the German painter Georg Baselitz observed that Guston's works back in the 1950s were "not that abstract," but rather a "distortion of the abstract, full of concrete forms."[629] Leo Steinberg saw surrogate figures in Guston's abstractions, "hauled up from unspeakable depths of privacy. It is as if the hollow of man's body—scarred and stained with sin and hunger, pain and nicotine—were flattened like an unrolled cylinder and clothes-pinned to the sky."[630]

Guston's abstract forms seemed to be weighted down by gravity, but supported by deep reds and blacks. He gradually repopulated the painterly field with new shapes, moving toward greater density. In 1957, Guston had already provoked a discussion about whether form should be divided into strict categories of figuration or abstraction, proclaiming that Soutine was *the* most abstract painter.[631] Guston saw the extreme malleability of Soutine's beef carcasses—constructed with dripping red, blue, and whitish brushstrokes—as exemplary of the way he had pushed at the boundaries of shape and color.

Guston concluded, "I don't know what non-objective art is. There is no such thing as non-objective art. Everything has an object. Everything has a figure. The question is what kind?"[632] Guston was proud of what Willem de Kooning, another independent-minded artist, told him after he saw Guston's first major exhibition of figurative paintings: "You know, Philip, what your real subject is? It's freedom!"[633] Meanwhile, most abstract artists feared that the rise of conceptual and pop art would end their hegemony.

From Pop . . .

Various techniques, such as photography as a form of painting, contributed to a renewal of pictorial realism, especially through pop art. Alex Katz, Philip Pearlstein, Larry Rivers, Jim Dine, and Roy Lichtenstein all kept the object at the center of their work. Katz has described his

102.
George Segal (1924–2000)
Man Leaving a Bus, 1967
Plaster, metal, glass, chrome, and rubber
88¹⁄₂ × 39 × 33¹⁄₂ in (225 × 99.1 × 85.1 cm)
Private collection, North Salem, New York

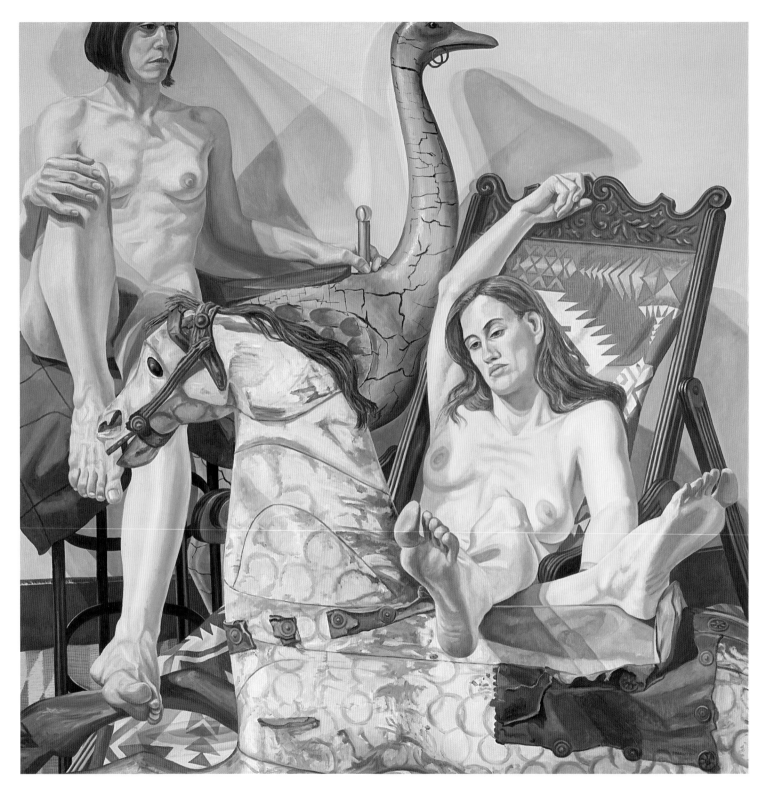

103
Philip Pearlstein (b. 1924)
Two Models with Hobby Horse and Carousel Ostrich, 2002
Oil on linen, 60 × 60 in. (152.5 × 152.5 cm)
Galerie Daniel Templon, Paris

larger-than-life portraits, which approach abstraction, as "documents of Pop's influence on the surroundings" (plate 107). Pearlstein has used the term "hard realism" to define his paintings, which seek to balance intellectual detachment with personal expression (plate 103). In paintings that alternated between irreverence and respect for high culture, Rivers revisited elements of abstraction, employing blocks of color and representing some figures in a linear shorthand. Bathrobes were part of the eclectic iconography that Dine has recycled throughout his oeuvre as stand-ins for self-portraits.

Leon Golub, who violently scraped and rubbed paint onto the canvas, may be characterized as a Neo-Expressionist; through his work, which protested against armed conflicts, he maintained a dialogue with his wife Nancy Spero, also a celebrated artist. Golub was one of the earliest Jewish artists to paint figures engaged in retaliatory activities, although the South African artist William Kentridge, whose Jewish-Russian parents were involved in the anti-Apartheid movement as lawyers, expresses similar feelings of revolt.

Expressive figurative art blossomed in the United States with painters such as Susan Rothenberg and sculptors like Jonathan Borofsky.[614] In Latin America, José Gurvich and his followers also pursued the figurative. Contemporary artists such as the Israelis Ra'anan Levy (plate 16) and Ofer Lellouche (plate 104), or the Belgian Serge Strosberg (plates 17, 106), keep the human figure at the heart of their work.

Julian Schnabel, who has painted portraits on a surface of broken plates, has written that what he is really interested in is "taking things that are already there, like fragments of the world, and reorganizing those fragments." During his childhood, Schnabel's family moved near the violent Mexican border: "I am both an urban dweller and a small town delinquent. My understanding of things is informed both by the insulation of the ethnic European community and by the cultural conditioning of a Jew in

Brooklyn. My role is that of a witness and participant in an inventory of small-town tragedies."[635] Can it be totally fortuitous that the above-mentioned Jewish artists are the main actors in the figurative revival?

. . . to Sots

Russia's break with the West lasted nearly thirty years, during which time underground art thrived. In 1957, contemporary Western art made a rare appearance at the World Festival of Youth and Students in Moscow. Jewish poets and artists gradually came to light, even though the atmosphere was openly anti-Semitic; many of the younger ones tended to romanticize their isolation. The only authorized exhibition of "unofficial painters" was organized by Oskar Rabin in 1974; it was crushed by bulldozers after a mere two hours, while Western journalists watched in disbelief.

Pop art had a major influence on the cultural awakening of the Soviet Union: in the early 1970s, certain of the "unofficial" artists began to use the icons of propaganda and the kitschy style of official Socialist Realism to mock the regime's myths. Vitaly Komar and Alexander Melamid, who began their long collaboration in 1972,[636] coined the name of this new style—Sots Art—from the first syllable of "Socialist Realism" and the last syllable of "pop art."[637] However, Sots Art differs from Western pop art in that it finds nothing to celebrate in Socialist Realism, while pop art takes an ambivalent delight in the consumer culture that it restages.

The economic crisis of the 1970s forced the Soviets to seek Western aid, which was tied to the right of the Jews to leave the country. A number of Sots artists subsequently emigrated to New York, notably Komar and Melamid, Grisha Bruskin, and Ilya Kabakov. The latter, who was one of the first artists to criticize the Soviet system's disregard for human dignity, reconstitutes life in the Soviet Union through installations (plate 105).

104
Ofer Lellouche (b. 1947)
Head for Meina, 2008–9
Concrete, height: 14 ft. (5 m)
Study for a monumental sculpture commemorating the massacre of
fifty-four Jewish citizens of Meina, Italy, in September 1943
Collection of the artist

„Мы здесь живем" 1995. *И. Кабаков 95 г.*

105
Ilya Kabakov (b. 1933)
We Live Here, 1995
Preparatory drawing for an installation at the upper forum of the Centre Georges Pompidou
Colored chalks, black ink, and gouache on paper, 8¼ × 11¾ in. (21 × 29.7 cm)
Centre Georges Pompidou, Paris

Others, like Kabakov's friend Erik Bulatov, settled in Paris. Bulatov had been born in the Urals, where his father, an economist who loved art, was a member of the Communist Party. His Yiddish-speaking mother had left Poland at fifteen to join the Russian Revolution. During the Moscow Trials of the late 1930s, Bulatov's father was sought by the secret police; he died at war in 1943 and was later rehabilitated.

Bulatov conveys feeling of alienation through the tension between words and images. His work thus has formal connections to that of El Lissitzky. It may be significant as well that Bulatov began his career as an illustrator of children's books. (Since Russian culture was mostly literary, many artists found a niche in book illustration.)

Nothing remains of *Yiddishland*, and humanism has not surfaced in Russia so far, yet the human figure reappeared early in the art of Bulatov. He has built a complex figurative oeuvre at the crossroads of pop, conceptual, and narrative art,[638] in which one critic has discerned "the emergence of a positive view of humanity that rejects all false images. We could compare Bulatov to Spinoza, as he built a philosophical system to answer the questions: 'Why are people so profoundly irrational? Why do they honor their own enslavement? Are painters philosophers, too?'"[639]

106
Serge Strosberg (b. 1966)
The Human Condition, 2007
Oil and tempera on linen
37⅜ × 35⅜ in. (95 × 90 cm)
Nicolas Lefevre

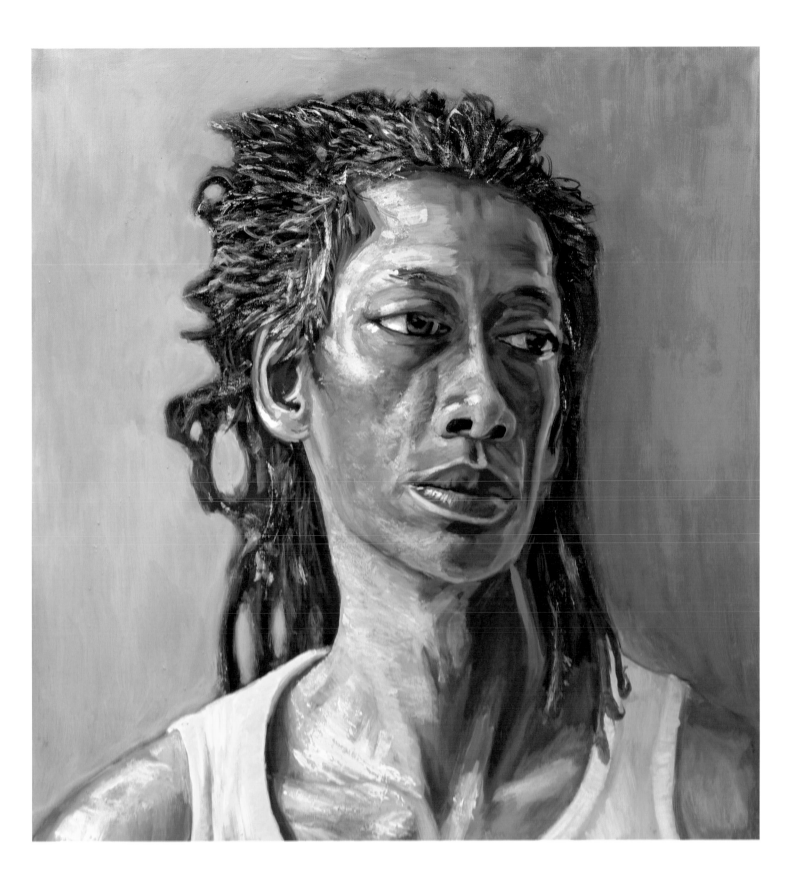

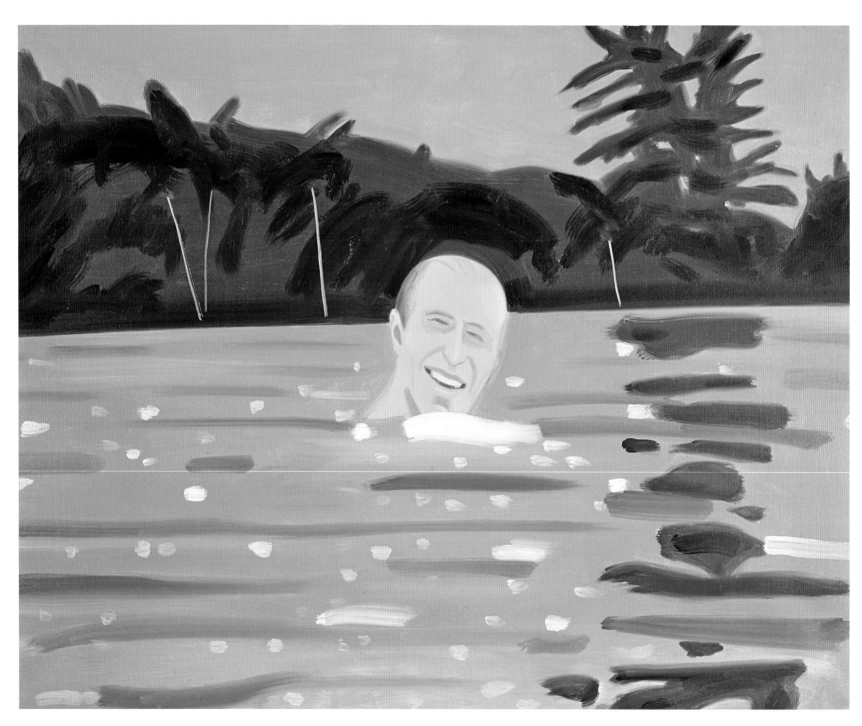

107
Alex Katz (b. 1927)
Self-portrait, 1991
Oil on canvas, 60 × 80 in. (152.4 × 203.2 cm)
Private collection, Austria
Courtesy Galerie Thaddaeus Ropac, Paris and Salzburg

Epilogue

Thirty years ago, Avram Kamp indicated that the importance of the Jewish experience in the realm of art had not been sufficiently appraised.[640] Since then, numerous studies have been published. Obviously, Jewish art, with its four-thousand-year history, cannot be reduced to a single category any more than Italian or German art can. There is a great diversity and discontinuity in its style and subject matter, depending on function, patronage, location, and historical period.

Until the Enlightenment, art was mainly created to sustain Judaism. After this came an attempt to bridge tradition with secular art. Throughout much of the twentieth century, numerous Jewish artists showed a special attachment to the human figure. Their work, described variously as Neo-Humanism, Expressionismus, Formism, Human Clay, Critical Figuration, or Social Expressionism, projected the depth of their souls with expressive charge. They explored every psychological facet of the human species, from the specific to the generic, and from the intimate to the universal. Their "Human Expressionism" constitutes an ethical, if not an aesthetic, art movement. The comment that "Modigliani searched for an ideal form that melded classicism with an expressionist or modernist sensibility"[641] could be applied equally well to most of the other artists discussed in this book.

As new monographs and retrospective shows appear, we will be able to specify how and why each of these artists expressed the freedom of Paris, the moods of London, and the realities of New York through the human figure.

The Holocaust influenced Jewish artists in various ways: in Paris, while some abandoned the figurative, others embraced it; in postwar London, human figuration became almost a symbol of survival; and in New York, the Shoah contributed significantly to the emergence of Abstract Expressionism. Such differences invite further investigation.

Research should also be carried out on photography, to highlight its potential similarities with painting and sculpture. The reasons why some non-Jewish artists have chosen the human figure as their favorite subject deserve to be examined as well. In short, this book generates many further questions.

In recent decades, artists of Jewish descent have developed complex identities and engaged in all aspects of contemporary art.[642] Jews can now also choose between multiple forms of Judaism. There is a price to be paid for a diffracted identity: potential disappearance. But, as Yosef Yerushalmi explains, Jewishness and its values can be transmitted independently of Judaism: the former will carry on even if the latter comes to an end. Let us give the final word to an artist, Kitaj: "The face of the Other elicits responsibility for the Other."[643]

Notes

Foreword

1. Jacques Lassaigne, *Cent chefs-d'œuvre des peintres de l'École de Paris* (Paris: Galerie Charpentier, 1947), 18.

2. James Hyman et al., *Making Waves: Masterpieces of Modern British Art* (London: Ben Uri Gallery, 2003), 5–7.

3. Saul Raskin, "The Future of Jewish Art," *Dos Neie Land*, September 1911, quoted in Avram Kampf, *Jewish Experience in the Art of the Twentieth Century* (South Hadley, MA: Bergin & Garvey, 1984), 51.

4. Arthur Cohen, "From Eastern Europe to Paris and Beyond," in *The Circle of Montparnasse: Jewish Artists in Paris, 1905–1945*, ed. Kenneth Silver and Romy Golan (New York: Universe Books, 1985), 64.

Introduction

5. Exodus 20:4; Deuteronomy 5:8; Elisheva Revel Neher, "Seeing the Voice: Configuring the Non Figurable in Early Medieval Jewish Art," in Bracha Yaniv, ed., *Ars Judaica* (Ramat Gan, Israel: Bar Ilan Journal of Jewish Art, 2006), 2:7–24.

6. Exodus 15:2; Exodus 35:31–35.

7. Arnold Schwartzman, *Graven Images: Graphic Motifs of the Jewish Grave Stone* (New York: Harry N. Abrams, 1993), 12.

8. Fred Skolnick, ed., *Encyclopedia Judaica* (Detroit: Macmillan Reference USA 2007), 4:521.

9. El Lissitzky, *Journal* (Berlin: Skify, 1922).

10. Katrin Kogman-Appel, "Picture Bibles and the Re-written Bible: The Place of Moses dal Castellazzo in Early Modern Book History," in Yaniv, ed., *Ars Judaica* (2006), 2:35–52.

11. Schwartzman, *Graven Images*, 12.

12. Ibid.

13. Margaret Olin, "From Bezal'el to Max Liebermann: Jewish Art in Nineteenth-Century Art-Historical Texts," in *Jewish Identity in Modern Art History*, ed. Catherine M. Soussloff (Berkeley, CA: University of California Press, 1999), 19–40.

14. *Emmanuel Kant: Œuvres philosophiques*, La Pléiade, 3:207, 521, quoted in Raphaël Draï, *Identité juive, Identité humaine* (Paris: A. Colin, 1995), 261–68.

15. Kalman P. Bland, "Anti Semitism and Aniconism: The Germanophone Requiem for Jewish Visual Art," *Jewish Identity*, ed. Soussloff, 41–59.

16. Heinrich Heine, *Geständnisse, Heinrich Heine*, quoted in Bland, "Anti Semitism and Aniconism," 44–45.

17. Sigmund Freud, *Der Mann Moses und die monotheistische Religion: Drei Abhandlungen* (Amsterdam: Allert de Lange, 1939), quoted in Yosef Yerushalmi, *Freud's Moses: Judaism Terminable and Interminable* (New Haven, CT: Yale University Press, 1991),

200–10; Bland, "Anti-Semitism and Aniconism," 51–52.

18. Meyer Schapiro, "Chagall's Illustrations for the Bible," in *Modern Art: 19th and 20th Centuries* (New York: G. Braziller, 1978), quoted in Donald Kuspit, "Meyer Schapiro's Jewish Unconsciousness," in *Jewish Identity*, ed. Soussloff, 200–17.

19. Marc Chagall, "Eygns," in *Vitebsk amol*, ed. Gregor Aronson (New York: Waldon Press, 1956), 441–44, quoted in Lucy Dawidowicz, *The Golden Tradition: Jewish Life and Thought in Eastern Europe* (New York: Holt, Rinehart and Winston, 1967), 331–32.

20. Gabrielle Sed-Rajna, *L'Art juif* (Paris: Citadelles et Mazenod, 1995), 114–26.

21. Avigdor Poseq, "Toward a Semiotic Approach to Jewish Art," in Yaniv, ed., *Ars Judaica* (2005), 1:27–50.

22. Susan Tumarkin Goodman, "Reshaping Jewish Identity in Art," in *The Emergence of Jewish Artists in Nineteenth Century Europe*, ed. Susan Tumarkin Goodman (London: Merrell, 2001), 15–29.

23. Exposition Internationale Universelle of 1900, *Catalogue général officiel*, 529, No. 95, quoted in Gabriel P. Weisberg, "Jewish Naturalist Painters: Understanding and Competing in the Mainstream," in *Emergence of Jewish Artists*, ed. Goodman, 144.

24. Martin Buber, address at the Fifth Zionist Congress, quoted in Basel, "Von

Jüdischer Kunst, Die Jüdische Bewegung" in Martin Buber, *Die Jüdische Bewegung* (Berlin: Jüdischer Verlag, 1916), 60.

25. Dominique Jarrassé, *Existe-t-il un art juif?* (Paris: Biro, 2006), 105–12.

26. Ibid., 79.

27. Monica Bohm-Duchen, "Jewish Art or Jewish Artists: A Problem of Definition," in *Jewish Artists. The Ben Uri Collection*, ed. Walter Schwab and Julia Weiner (London: Lund Humphries Publishers, 1994), 12–15; Harold Rosenberg, "Is There a Jewish Art?" *Commentary*, July 1966, 42/1:57–60; Joseph Gutmann, "Is There a Jewish Art?" in Clare Moore, ed., *The Visual Dimension: Aspects of Jewish Art* (Boulder, CO: Westview Press, 1993), 1–19; Jarrassé, *Existe-t-il un art juif?*

28. *L'École de Paris, 1904–1929, La part de l'Autre, Musée d'Art moderne de la Ville de Paris* (Paris: Paris Musées, 2001), 23.

29. *L'École de Paris Boulogne: Exposition* (Paris: Musée municipal de Boulogne Billancourt, 1988), 8.

30. Mason Klein, "Modigliani against the Grain," in *Modigliani: Beyond the Myth*, ed. Mason Klein (New York: The Jewish Museum, New Haven, CT: Yale University Press, 2004), 2.

31. Valentine Marcadé et al., "La peinture russe à Paris entre les deux guerres mondiales," in *Paris Russe 1910–1960* (Bordeaux: Palace Editions, 2003), 16–17.

32. Bram Dijkstra, *American Expressionism, Art, and Social Change, 1920–1950* (New York: Harry N. Abrams, 2003), 45.

33. John I. H. Baur, *Revolution and Tradition in Modern American Art* (Cambridge, MA: Harvard University Press, 1951), quoted in Dijkstra, *American Expressionism*, 44.

34. Andrew Lambirth, *Kitaj* (London: PWP Contemporary Art, 2004), 71.

35. Raphael Soyer, AAA 867/611.

36. Georg Simmel, *Die Ästhetische Bedeutung, des Gesichtes*, quoted in Jean Clair, *De Immundo: Apophatisme et apocatastase dans l'art d'aujourd'hui*, (Paris: Galilée, 2004), 113.

37. Richard Brilliant, *Portraiture* (London: Reaktion Books, 1991), 171.

38. Goodman, ed., *Emergence of Jewish Artists*, 22–25.

39. Camille Bourniquel, *Kikoïne et ses amis* (Paris: Couvent des Cordeliers, 1993).

40. Itzhak Goldberg, "Le visage hanté," in *Soutine* (Paris: Pinacothèque de Paris, 2007), 228; Tamar Garb, "Making and Masking: Modigliani and the Problem of Portraiture," in Klein, *Modigliani*, 43–53; Tim Hyman, Interview with R. B. Kitaj in "A return to London," *London Magazine*, February 1980, 24.

1. The Jewish Experience

41. Morris Kertzer, *What Is a Jew?* (New York: Touchstone, Simon & Schuster, 1996), 7–28. Melvin Konner, *The Jewish Body* (New York: Nextbook Schocken, 2009), 225–43.

42. Alasdair MacIntyre, *Against the Self—Images of the Age: Essays on Ideology and Philosophy* (New York: Schocken Books, 1971), 12–13, quoted in Jonathan Sacks, *Radical Then, Radical Now: The Legacy of the World's Oldest Religion* (London: HarperCollins, 2000), 215.

43. Hannah Arendt, *The Origins of Totalitarianism* (New York: Harcourt, Brace & World Inc., 1966), 64.

44. Clement Greenberg, "Self-Hatred and Jewish Chauvinism: Some Reflections on 'Positive Jewishness,'" *Commentary*, November 1950, in *The Collected Essays and Criticism* (Chicago: Chicago University Press, 1995), 3:45–58; Thierry de Duve, "Les silences de la doctrine," in *Clement Greenberg entre les lignes* (Paris: Éditions Dis voir, 1996), 40.

45. Sacks, *Radical Then, Radical Now*, 204.

46. Nicholas Mirzoeff, "Inside/Out: Jewishness Imagines Emancipation," in *The Emergence of Jewish Artists in Nineteenth-Century Europe*, ed. Susan Tumarkin Goodman (London: Merrell, 2001), 41–47.

47. Larry Silver, "Between Tradition and Acculturation: Jewish Painters in Nineteenth Century Europe," in *Emergence of Jewish Artists*, ed. Goodman, 137.

48. R. B. Kitaj, Conference at the Oxford Synagogue, November 25, 1983, in "R. B. Kitaj, Jewish Art—Indictment and Defence/A Personal Testimony," *Jewish Chronicle* (London: November 30, 1984), 42–46; Marco Livingstone, *Kitaj* (London: Phaidon Press, 1994), 29.

49. Fred Skolnick, ed., *Encyclopedia Judaica* (Detroit: Macmillan Reference USA: 2007), 13:871; Michael Novak, *Tell Me Why* (Oxford: Lion Publishing, 1999), 91.

50. Donald Kuspit, "The Abandoned Nude: Natan Nuchi's Paintings," in Donald Kuspit, *Natan Nuchi* (New York: Klarfeld Perry Gallery, 1992).

51. Michael Auping, *Philip Guston Retrospective* (New York: Thames and Hudson, 2003), 58.

52. Blaise Pascal, *Pensées*, trans. A. J. Krailsheimer (London: Penguin, Harmondsworth, 1968), 171, 176–77.

53. Arendt, *The Origins*, 23.

54. Amos 3:2, in Yosef Yerushalmi, *Freud's Moses: Judaism Terminable and Interminable* (New Haven, CT: Yale University Press, 1991), 85.

55. Milton Himmelfarb, *The Jews of Modernity* (New York: Basic Books, 1973), 359; Erich Auerbach, *Mimesis: The Representation of Reality in Western Literature* (Princeton, NJ: Princeton University Press, 1971), 3–23.

56. Kertzer, *What Is a Jew?* 107–12.

57. Ibid.

58. Yosef Yerushalmi, *Zakhor, Jewish History and Jewish Memory* (Seattle: University of Washington Press, 1996), 15.

59. Kertzer, *What Is a Jew?* 35–46; Yerushalmi, *Zakhor*, 55.

60. Joseph Karo, *Shulhan 'Arukh*, quoted in Yerushalmi, *Zakhor*, 69.

61. Yerushalmi, *Zakhor*, 11.

62. Ben Shahn, *Love and Joy about Letters* (New York: Grossman Publishers, 1963), 5.

63. Arthur Cohen, "From Eastern Europe to Paris and Beyond," in *The Circle of Montparnasse: Jewish Artists in Paris, 1905–1945*, ed. Kenneth Silver and Romy Golan (New York: Universe Books, 1985), 66.

64. Ronald Brooks Kitaj, *First Diasporist Manifesto* (New York: Thames and Hudson, 1989), 11.

65. Leon Wieseltier, "Glosses On and For, Kitaj, R. B.," in R. B. Kitaj, *How to Reach 67 in Jewish Art: 100 Pictures* (New York: Marlborough Gallery, 2000).

66. Julia Kristeva, *Etrangers à nous-mêmes* (Paris: Fayard, 1988), 1–37.

67. Shmuel Trigano, *Le Temps de l'exil* (Paris: Payot, 2000), 19.

68. Nathalie Hazan-Brunet, "Vas vers toi, le paysage de l'exil, 1922–1930," in *Chagall connu et inconnu* (Paris: Réunion des musées nationaux, 2003), 73–79; Mel Gussow and Charles McGrath, "Saul Bellow, 89, Master of American Novel," *New York Times*, April 7, 2005.

69. Raphaël Draï, *Identité juive, Identité humaine* (Paris: A. Colin, 1995), 48.

70. Bernard Berenson, *Sunset and Twilight: From the Diaries of 1947–1958* (London: H. Hamilton, 1964), October 29, 1953, 323.

71. Michael Wex, *Born to Kvetch: Yiddish Language and Culture in All Its Modes* (New York: St Martin's Press, 2005), 7, 21, 62, 131, 153.

72. Heschel Abraham J., "The Eastern European Era in Jewish History," *Yivo Annual of Jewish Social Science* (New York: Yiddish Scientific Institute, 1946), 1.

73. Sacks, *Radical Then, Radical Now*, 168.

74. Ibid., 55.

75. Jean Michel Foray, "Chagall et les modernes," in *Chagall connu et inconnu*, 52.

76. Mark Zborowski and Elizabeth Herzog, *Life Is with People: The Jewish Little Town of Eastern Europe* (New York: International Universities Press, 1952).

77. Deuteronomy 8:3.

78. Tamar Garb, "Making and Masking: Modigliani and the Problem of Portraiture," in *Modigliani: Beyond the Myth*, ed. Mason Klein (New York: The Jewish Museum, New Haven, CT: Yale University Press, 2004), 52.

79. Sholem Aleichem, *Motl Peyse dem Khazns* (Buenos Aires: Cui, 1957), vol. 4, chap. 17, 153–54.

80. Klein, ed., *Modigliani*, 5; Emily Braun, "The Faces of Modigliani," in *Modigliani*, ed. Klein, 39.

81. Zborowski and Herzog, *Life Is with People*, 316–17.

82. Ibid., 312–13.

83. "Madeleine Castaing Reminisces about Chaim Soutine," *Arts*, Paris, December 1984, 59/4:73.

84. Avigdor Poseq, *Soutine: His Jewish Modality* (Brighton, UK: Book Guild, 2001), 82, quoted in Maurice Tuchman, ed., *Chaim Soutine (1893–1943): Catalogue Raisonné* (Cologne: Taschen, 1993), 515.

85. Nadine Nieszawer, Mary Boyé, and Paul Fogel, *Peintres juifs à Paris, 1905–1939: École de Paris* (Paris: Denoël, 2000), 25.

86. Kertzer, *What Is a Jew?* 233.

87. Sacks, *Radical Then, Radical Now*, 38.

88. Draï, *Identité juive, Identité humaine*, 89–98.

89. Amos Funkenstein et al., *The Sociology of Ignorance* (Tel Aviv: Matkal/Ketsin hinukh rashi/Gale Tsahal, Misrad ha-bitahan, 1987), quoted in Albert Bilgrey "Intellectuals and Jews" (lecture), April 6, 1989.

90. Sacks, *Radical Then, Radical Now*, 127–28.

91. *Encyclopedia Britannica* (1995), 2:1041.

92. Paul Johnson, *A History of the Jews* (London: Weidenfeld & Nicolson, 1987), 341.

93. Sacks, *Radical Then, Radical Now*, 128–30.

94. Talmud of Babylon, Horayot 13a; Talmud of Jerusalem, Horayot 3:5.

95. Beryl Smalley, *The Study of the Bible in the Middle Ages* (Oxford: Blackwell, 1952), 78.

96. Maimonides, *Misneh Torah* 1:6, 10.

97. Sacks, *Radical Then, Radical Now*, 162.

98. Kertzer, *What Is a Jew?* 47–50.

99. Daniel Bell, *Richard Hofstadter Project*, Columbia University Oral History Research Office, April 1972, 25–29, quoted in Matthew Baigell, *Jewish Artists in New York: The Holocaust Years* (New Brunswick, NJ: Rutgers University Press, 2002), 34.

100. Talmud of Babylon, Shabbat 31a, quoted in Sacks, *Radical Then, Radical Now*, 20–21.

101. Kertzer, *What Is a Jew?* 49, 154–56.

102. Ibid., 257–60.

103. Ibid.

104. Anselmo Buci, "Ricordi d'Artisti: Modigliani," *L'Ambrosiano*, May 27, 1931.

105. Kertzer, *What Is a Jew?* 57–58, 71–72.

106. Draï, *Identité juive, Identité humaine*, 80–85.

107. Kertzer, *What Is a Jew?* 246–49.

108. Ibid., 169.

109. Ibid., 170; Deuteronomy 6:7.

110. Kertzer, *What Is a Jew?* 149–52.

111. Braun, "Faces," in *Modigliani*, ed. Klein, 25.

112. Silver and Golan, *Circle of Montparnasse*, 49.

113. William Feaver, *Lucian Freud* (London: Tate Gallery, 2002), 31.

114. Kertzer, *What Is a Jew?* 87–90; Draï, *Identité juive, Identité humaine*, 98–107.

115. Bernard Josephs, "Shabbat cholent: the Ultimate Slow Food," *The Jewish Chronicle*, London, March 12, 2009.

116. Howe Irving and Eliezer Greenberg, eds., *A Treasury of Yiddish Stories* (New York: Viking, 1954), 11.

117. Leviticus 1; Deuteronomy 14.

118. *Soutine* (Paris: Pinacothèque de Paris, 2007), 16.

119. Tuchman, ed., *Soutine*, 342–45.

120. Kertzer, *What Is a Jew?* 208–28.

121. Exodus 29:23.

122. Sacks, *Radical Then, Radical Now*, 131.

123. *Misnah Pessahim* 10:5.

124. Susan Chevlowe, "A Bull in a China Shop: An Introduction to Ben Shahn," in *Common Man, Mythic Vision: The Paintings of Ben Shahn*, ed. Susan Chevlowe (Princeton, NJ: Princeton University Press, 1998), 9.

125. Yerushalmi, *Zakhor*, 42–44.

126. Commentary of Genesis 49:2, in Draï, *Identité juive, Identité humaine*, 97–98, and in Sacks, *Radical Then, Radical Now*, 94.

127. Exodus 22:21, Genesis 12:1.

128. Leviticus 19; *Torat Kohanim* 34; Kedoshim 19.

129. Exodus 12:49.

130. Kristeva, *Etrangers à nous-mêmes*, 95–111.

131. Donald Phillip Verene, ed., *Symbol, Myth, and Culture: Essays and Lectures of Ernst Cassirer, 1935–1945* (New Haven, CT: Yale University Press, 1979), 241.

132. Foray, "Chagall et les modernes," 55.

133. Genesis 32:25–29.

134. Genesis 29:35.

135. Kertzer, *What Is a Jew?* 243.

136. Judy Chicago, *Through the Flower: My Struggle as a Woman Artist* (Garden City, NY: Doubleday, 1975), 63; Milly Heyd, "Hidden Traces: Jewish Artists' Universal and Particular Identities," in *The Hidden Trace: Jewish Paths through Modernity*, ed. Martin R. Deppner (Bramsche: Rasch, 2008), 74–97.

137. Sacks, *Radical Then, Radical Now*, 70–80.

138. Marcel Proust, *À la Recherche du temps perdu* (Paris: La Pleiade, 1925), 23.

139. Klein, ed., *Modigliani*, 7–8.

140. Maimonides, *Mishne Torah*, Hilchot Teshuvah, 9:2.

141. Elie Barnavi and Saul Friedländer, eds., *Les Juifs et le XXe siècle: Dictionnarie critique* (Paris: Calmann-Lévy, 2000), 260–70.

142. Sigmund Freud, *Civilization and its Discontents* (New York: W.W. Norton & Company, 1961); Yerushalmi, *Freud's Moses*, 16.

143. Dennis B. Klein, *Jewish Origins of the Psychoanlyctic Movement* (New York: Praeger, 1981), 69–102, 155–65.

144. Philip Rieff, *Freud, The Mind of the Moralist* (New York: Viking Press, 1959), 258, quoted in Yerushalmi, *Freud's Moses*, 9–10.

2. The Human Figure before the Enlightenment

145. Bruce Feiler, *Walking the Bible: A Journey by Land through the Five Books of Moses* (New York: Morrow, 2001).

146. Hannah Arendt, *The Origins of Totalitarianism* (New York: Harcourt, Brace & World Inc., 1966), 8.

147. Max Weber, *Ancient Judaism* (New York: The Free Press, 1952).

148. Genesis 1:26–27.

149. Genesis 3:16–19.

150. Morris Kertzer, *What Is a Jew?* (New York: Touchstone, Simon & Schuster, 1996), 147–49. Melvin Konner, *The Jewish Body* (New York: Nextbook Schocken, 2009), 48–60.

151. Ilana Reiss-Schimmel, "Sigmund Freud," in *Les Juifs et le XXe siècle: Dictionnaire critique*, ed. Elie Barnavi and Saul Friedländer (Paris: Calmann-Lévy, 2000), 582.

152. Ilana Reiss-Schimmel, "La psychanalyse," in *Les Juifs et le XXe siècle*, ed. Barnavi and Friedländer, 190–205.

153. Genesis 8:12.

154. Raphaël Draï, *Identité juive, Identité humaine* (Paris: A. Colin, 1995), 59.

155. Genesis 12:1.

156. Draï, *Identité juive, Identité humaine*, 75.

157. Jonathan Sacks, *Radical Then, Radical Now: The Legacy of the World's Oldest Religion* (London: HarperCollins, 2000), 49–50.

158. Ibid., 109.

159. Exodus 3:14.

160. Exodus 25:11–13; 25:20; 26:30.

161. Yerushalmi, *Freud's Moses: Judaism Terminable and Interminable* (New Haven, CT: Yale University Press, 1991), 3–5.

162. Ibid., 230–35.

163. Sigmund Freud, *Der Mann Moses und die monotheistische Religion: Drei Abhandlungen* (Amsterdam: Allert de Lange, 1939), 200–10, quoted in Freud, *Moses and Monotheism* (New York: Knopf, 1939), 144–52.

164. Sigmund Freud, *The Diary of Sigmund Freud, 1929–1939: A Record of the Final Decade* (London: Hogarth Press, 1992), 230.

165. James Breasted, *The Dawn of Conscience* (London: Charles Scribner's Sons, 1933), 22, 145, 349, quoted in William Feaver, *Lucian Freud* (London: Tate Gallery, 2002), 13.

166. Sacks, *Radical Then, Radical Now*, 110.

167. I Chronicles 22:8.

168. I Kings 11.

169. Ezekiel 20:32.

170. Pirke Abot 1:14.

171. Lee I. Levine, "Figural Art in Ancient Judaism," in Bracha Yaniv ed., *Ars Judaica* (Ramat Gan, Israel: Bar-Ilan Journal of Jewish Art, 2005), 1:9–26.

172. Flavius Josephus, *Antiquities*, XII, Jos, Anr: 115ff.

173. Sacks, *Radical Then, Radical Now*, 140–43.

174. Draï, *Identité juive, Identité humaine*, 41.

175. Kertzer, *What Is a Jew?* 192–96.

176. Gabrielle Sed-Rajna, ed., *L'Art juif* (Paris: Citadelles et Mazenod, 1995), 114–26.

177. Mary Stephanos, "The Jewish Community at Dura-Europos: Portrait of a People," *Janus*, May 2001, www.janus.umd.edu/May 2001.

178. Fred Skolnick, ed., *Encyclopedia Judaica* (Detroit: Macmillan Reference USA: 2007), 3:521.

179. Ibid.

180. Mira Friedman, "The Meaning of the Zodiac in Synagogues in the Land of Israel during the Byzantine Period," in Yaniv, ed., *Ars Judaica* (2005), 1:51–62.

181. Ibid.

182. Avigdor Poseq, "Toward a Semiotic Approach to Jewish Art," in Yaniv, ed., *Ars Judaica* (2005), 1:27–50.

183. *Encyclopedia Judaica* (2007), 3:521; Zeev Weiss, "Reconstructing and

Deconstructing Jewish Art: Between Rome and Byzantium," in Yaniv, ed., *Ars Judaica* (2007), 3:7–18.

184. Julia Kristeva, *Etrangers à nous-mêmes* (Paris: Fayard, 1988), 117–22.

185. Elisheva Revel-Neher, "Seeing the Voice: Configuring the Non-Figurable in Early Medieval Jewish Art," in Yaniv, ed., *Ars Judaica* (2006), 2:7–24.

186. *Encyclopedia Judaica* (2007), 13:1558–64.

187. Ziva Amishai-Maisels, "Menasseh Ben Israel and the 'Wandering Jew,'" in Yaniv, ed., *Ars Judaica* (2006), 2:59–82.

188. Katrin Kogman-Appel, "Picture Bibles and the Re-written Bible: The Place of Moses dal Castellazzo in Early Modern Book History," in Yaniv, ed., *Ars Judaica* (2006), 2:35–52.

189. Sed Rajna, *L'Art juif*, preface.

190. Draï, *Identité juive, Identité humaine*, 223–42.

191. Eugène Delacroix, *Journal, 1822–1863* (Paris: Plon, 1966).

192. Carlos Fuentes, "Voices," in Frédéric Brenner, *Diaspora* (Paris: Éditions De La Martinière, 2003), 21.

193. Yosef Yerushalmi, *Zakhor, Jewish History and Jewish Memory* (Seattle: University of Washington Press, 1996), 57–75.

194. Ingram, in Dawson W. Carr, *Velázquez* (London: National Gallery, 2006), 69–85.

195. Abrabanel, Commentary on Ezekiel 20:32.

196. Yerushalmi, *Zakhor*, 74.

197. *Encyclopedia Judaica*, 8:1381–1400.

198. Benjamin Raba, "Un Portugais se penche sur son passé," in *Hommage à Georges Vajda, Etudes d'histoire et de pensée juive*, ed. Gérard Nahon and Charles Touati (Louvain: Peeters, 1980), 505–29.

199. Michel de Montaigne, *Essais* (Paris: La Pléiade), vol. 3, chap. 2: 782.

200. Steven Nadler, *Rembrandt's Jews* (Chicago: University of Chicago Press, 2003), 60–61.

201. Ibid., 90–93, 97.

202. Ibid., 116.

203. Ibid., 65.

204. Ibid., 76.

205. Simon Shama, *Rembrandt's Eyes* (New York: Alfred A. Knopf, 1999), 465–56.

206. Nadler, *Rembrandt's Jews*, 82.

207. Ibid., 86.

208. Ibid.

209. Amishai Maisels, "Menasseh Ben Israel and the 'Wandering Jew,'" 59–82.

210. Nadler, *Rembrandt's Jews*, 128–42.

211. Sharman Kadish, "Sha'ar ha Shamayim: London's Bevis Marks Synagogue and the Sephardi Architectural Heritage," in Yaniv, ed., *Ars Judaica* (2007), 3:41–52.

212. Nadler, *Rembrandt's Jews*, 194–97.

3. Human Expressionism in the Early Twentieth Century

213. Hannah Arendt, *The Origins of Totalitarianism* (New York: Harcourt, Brace & World Inc., 1966), 46.

214. Abbé Grégoire, *Motion en faveur des Juifs* (Paris: E. D. H. I. S., 1789), 7:38.

215. Arendt, *The Origins*, 158.

216. Ibid., 174.

217. Dominique Jarrassé, *Existe-t-il un art juif?* (Paris: Biro, 2006), 33.

218. Ibid., 27–38.

219. Ibid., 43–46.

220. Ibid., 39–42.

221. Ibid., 22.

222. Arendt, *The Origins*, 100–106.

223. Ralph E. Shikes and Paula Harper, *Pissarro, His Life and Work* (New York: Horizon Press, 1980), 221, 226–41.

224. Nicholas Mirzoeff, "Pissarro's Passage: The Sensation of Caribbean Jewishness in Diaspora," in *Diaspora and Visual Culture: Representing Africans and Jews* (London: Routledge, 2000), 57–75; Mirzoeff, "Inside/Out: Jewishness Imagines Emancipation," in *The Emergence of Jewish Artists in Nineteenth Century Europe*, ed. Susan Tumarkin Goodman (London: Merrell, 2001), 43, 180.

225. Henri Van de Velde, Conference at the 8th Salon des XX in Brussels, on February 19, 1891 (Brussels: Editions de l'Avenir Social, 1900).

226. Christophe Duvivier, ed., *Camille Pissarro et les peintres de la vallée de l'Oise* (Paris: Somogy Editions d'Art, 2003).

227. Mirzoeff, "Pissarro's Passage," 57–75; "Inside/Out," 46.

228. David Mendelson, "Marcel Proust," in *Les Juifs et le XXe siècle: Dictionnaire critique*, ed. Elie Barnavi and Saul Friedländer (Paris: Calmann-Lévy, 2000), 661–70.

229. Marcel Proust, "Sodome et Gomorrhe," in *À la Recherche du temps perdu* (Paris: La Pléiade, 1925), vol. 2, chap. 3: 1524.

230. Arendt, *The Origins*, 79–88.

231. Siegfried E. Van Praag, "Marcel Proust, témoin du judaïsme déjudaïsé," *Revue juive de Genève*, 1937/48:338–47, quoted in Arendt, *The Origins*, 74.

232. Arendt, Ibid., 56–60.

233. Ibid., 279–82.

234. Ibid., 60.

235. Susan Tumarkin Goodman, "Reshaping Jewish Identity in Art," in *Emergence of Jewish Artists*, ed. Goodman, 15–30.

236. Adrian M. Darmon, *Autour de l'art juif* (Paris: Carnot, 2003), 21; Keith Holz, "Whose Art? Whose History? The Modernist Art Collections of Breslau Jewry, Then and Now," *The First Congress of Jewish Art in Poland,*

Kazimierz on the Vistula, October 27–29, 2008.

237. Karl Krauss, quoted in Arendt, *The Origins*, 68.

238. Richard Wagner, "Das Judenthum in der Musik," in *Gesammelte Schriften und Dichtungen* (Leipzig: W. Fritzsch, 1887–88).

239. Arendt, *The Origins*, 41.

240. Chana Schutz et al., "Max Liebermann: German Painter and Berlin Jew," in *Max Liebermann: From Realism to Impressionism*, ed. Barbara C. Gilbert (Los Angeles: Skirball Cultural Center, 2005), 153–54.

241. Max Liebermann, letter to Hayim Bialik, 1933, in Schütz et al., "Max Liebermann," 161–62; Dizengoff Archives, M. H. H. D. I II 14, History Museum of Tel Aviv.

242. Mason Klein, "Gentleman's Agreement: Belief and Disillusionment in the Art of Max Liebermann," in *Max Liebermann*, ed. Gilbert, 172.

243. Saskia de Bodt, "Isaac Israels en zijn vader Jozef," in *Isaac Israels: Hollands impressionist* (Rotterdam: Scriptum Art, 1999), 34–37.

244. Ibid.

245. Israel Cohen, "Two Interviews: Josef Israels and Max Nordau," *New Era*, March–April 1905, 358–63.

246. Jeroen Kapelle, "Isaac Lazarus Israels, Amsterdam 1865–Den Haag 1934," in De Bodt, *Isaac Israels*, 10–33.

247. A. Israels-Schaap, letter of December 12, 1988 to

Albert Verwey, Amsterdam University: Albert Verwey Archives.

248. Karen Michels, "Art History, German Jewish Identity and the Emigration of Iconology," in *Jewish Identity in Modern Art History*, ed. Catherine Soussloff (Berkeley CA: University of California Press, 1999), 167–79.

249. Charlotte Schoell-Glass, "Aby Warburg, Forced Identity and 'Cultural Science,'" in *Jewish Identity*, ed. Soussloff, 218–30.

250. Gertrud Bing, Conference at Hambur g Kunsthalle in 1958, in Schoell-Glass, "Aby Warburg."

251. Leon Wieseltier, "Glosses On and For, Kitaj, R. B.," in R. B. Kitaj, *How to Reach 67 in Jewish Art: 100 Pictures* (New York: Marlborough Gallery, 2000).

252. Schoell-Glass, "Aby Warburg."

253. Ilana Reiss-Schimmel, "La psychanalyse," 191–205, and "Sigmund Freud," 579–88, in *Les Juifs et le XXe siècle*, ed. Barnavi and Freidländer.

254. Yosef Yerushalmi, *Freud's Moses: Judaism Terminable and Interminable* (New Haven, CT: Yale University Press, 1991), 57–69.

255. Ibid., 39–41.

256. George Vierek, *Glimpses of the Great* (London: Duckworth, 1930), 30.

257. Martin Buber, "In Quest for the Jewish Style in the Era of the Russian Revolution," *Journal of Jewish Art*, Chicago, 1978, 5:48–75, quoted in *The First Buber: Youthful Zionist*

Writings of Martin Buber (Syracuse, NY: Syracuse University Press, 1999), 48, 55, and in Avram Kampf, *Jewish Experience in the Art of the Twentieth Century* (South Hadley, MA: Bergin & Garvey, 1984), 203.

258. Richard I. Cohen, "Exhibiting Nineteenth-Century Artists of Jewish Origin in the Twentieth Century: Identity, Politics, and Culture," in *Emergence of Jewish Artists*, ed. Goodman, 153–62.

259. Jarrassé, *Existe-t-il un art juif?* 65.

260. Pierre Bouretz, *Témoins du futur, philosophie et messianisme* (Paris: Gallimard, 2003).

261. Ezra Mendelsohn, "Intégration et citoyenneté: l'Europe des ethnies," in *Les Juifs et le XXe siècle*, ed. Barnavi and Freidländer, 335–47.

262. Israël Bartal, "Littérature profane en Europe de l'Est," in *Les Juifs et le XXe siècle*, ed. Barnavi and Freidländer, 133–40.

263. Menachem Brinker, "Culture hébraïque, la réinvention de l'hébreu," in *Les Juifs et le XXe siècle*, ed. Barnavi and Freidländer, 47–60.

264. Nehama Guralnik, *In the Flower of Youth: Maurycy Gottlieb, 1856–1879* (Tel Aviv: Tel Aviv Museum of Art: Dvir Publishers, 1991).

265. Larry Silver, "Jewish Identity in Art and History. Mauricy Gottlieb as Early Jewish Artist," in *Jewish Identity*, ed. Soussloff, 87–113.

266. Mendelsohn, "Integration et citoyenneté," 334–47.

267. Barbara Brus-Malinowska et al. *Peintres Polonais en Bretagne (1890–1939)* (Quimper: Musée départemental Breton; Editions Palantines, 2004), 12, 27.

268. Ibid., 21.

269. Maximilien Gauthier, *Eugène Zak* (Paris: Editions "Le Triangle," 1933), 7, 16, 20, quoted in Nadine Nieszawer, Mary Boyé, and Paul Fogel, *Peintres juifs à Paris, 1905–1939: École de Paris* (Paris: Denoël, 2000), 347.

270. B. Nawrocki, *Mela Muter, sa peinture et ses modèles* (Warsaw: National Museum, 1994), quoted in Brus-Malinowska et al., *Peintres Polonais en Bretagne*, 23.

271. Nieszawer, Boyé, and Fogel, *Peintres juifs à Paris*, 265–67.

272. Denis Delouche, "Les artistes polonais a la découverte de la Bretagne: une vision originale," in Brus-Malinowska et al., *Peintres Polonais en Bretagne*, 130–31, 137.

273. Natasza Styrna, *Jewish Artists in Krakow, 1873–1939* (Krakow: Historical Museum, 2008), 18–31.

274. Malgorzata Stolarska-Fronia, "Jewish Expressionism: A Quest for Cultural Space," Jewish Artists and Central-Eastern Europe—Nineteenth Century to WWII, First Congress of Jewish Art in Poland.

275. Styrna, *Jewish Artists in Krakow*, 25.

276. Henryk Berlewi, "Mechanofaktura," (Warsaw, March 1924), in *Précurseurs de l'art abstrait en Pologne: Kazimierz Malewicz, Katarzyna Kobro, Wladylaw Strzeminski, Henryk Berlewi, Henryk Stazewski* (Paris: Galerie Denise René, 1957), 19–22.

277. Nieszawer, Boyé, and Fogel, *Peintres juifs à Paris*, 64.

278. Michael Stanislawski, "The Jew and Russian Culture and Politics," in *Emergence of Jewish Artists*, ed. Goodman, 16–27.

279. Ziva Amishai-Maisels, "The Jewish Awakening: A Search for National Identity," in *Russian Jewish Artists in a Century of Change, 1890–1990*, ed. Susan Tumarkin Goodman (New York: Prestel, 1995), 54–70.

280. Susan Tumarkin Goodman, "Alienation and Adaptation of Jewish Artists in Russia," in *Russian Jewish Artists*, ed. Goodman, 28–39.

281. Goodman, "Chagall's Paradise Lost: The Russian Years," in *Marc Chagall: Early Works from Russian Collections* (New York: The Jewish Museum; London: Third Millennium Publishing, 2001), 19.

282. Ibid., 27.

283. Igor Dukhan, "El Lissitzky Jewish as Universal: From Jewish Style to Pangeometry," in Yaniv, ed., *Ars Judaica* (2007), 54–72.

284. Stanislawski, "The Jew and Russian Culture and Politics," 19.

285. Alexandra Shatskikh, "Jewish Artists in the Russian Avant-Garde," in *Russian Jewish Artists*, ed. Goodman, 71–80.

286. Eugeny Kotlyar, "Bezalel (1906–1932) vs Kultur-Lige (1918–1932): Approaches to Jewish Folk Imagery Revival." First Congress of Jewish Art in Poland.

287. Leonid Pasternak, *Rembrandt, i evreistvo v ego tvorchestve* (Berlin: Saltzmann, 1923), quoted in John E. Bolt, "Jewish Artists and the Russian Silver Age," in *Russian Jewish Artists*, ed. Goodman, 44.

288. Bolt, ibid., 40–52; Stanislawski, "The Jew and Russian Culture and Politics," 21.

289. Benjamin Pinkus, *The Jews of the Soviet Union: The History of a National Minority* (Cambridge University Press, 1988); R. Ainsztein, "Soviet Jewry in the Second World War," in *The Jews in Soviet Russia since 1917*, ed. Lionel Kochan (New York: Oxford University Press, 1972).

290. Kampf, *Jewish Experience*, 36–43.

291. Goodman, "Alienation and Adaptation of Jewish Artists in Russia," 32.

292. *L'Avant garde Russe* (Paris: Fondation Dina Vierny Musée Maillol, RMN, 2008).

293. Shatskikh, "Jewish Artists in the Russian Avant-Garde," 77.

294. Goodman, "Alienation and Adaptation of Jewish Artists in Russia," 35.

295. Shatskikh, "Jewish Artists in the Russian Avant-Garde," 79.

296. Jacob Epstein, "Let there be sculpture," *Readers Union*, London, 1942, 8.

297. *Jewish Quarterly Review*, July, 1901.

298. Monica Bohm-Duchen, *Ben Uri Collection* (London: Lund and Humphries, 1990), 8.

299. Richard Humphreys, *The Tate Britain Companion to British Art* (London: Tate Publishing 2001), 144.

300. Arendt, *The Origins*, 170–84.

301. Todd M. Endelman, *The Jews of Britain, 1656–2000* (Berkeley, CA: University of California Press, 2002), 170.

302. Sarah MacDougall, *Mark Gertler* (London: John Murray, 2002), 16.

303. Humphreys, *Tate Britain Companion*, 166.

304. Ibid., 166, 170.

305. Ibid., 166, 175.

306. MacDougall, *Mark Gertler*, 50.

307. Richard Cork, *David Bomberg* (New Haven, CT: Yale University Press, 1987), 79–80.

308. Ibid., 7, 10, 40–43, 50–51, 64, 110, 117, 128.

309. Humphreys, *Tate Britain Companion*, 17.

310. Roger Fry, "The Goupil Gallery," *New Statesman*, London, February 12, 1921, 561.

311. Mark Gertler, letter to Dorothy Brett, March 29, 1920, Austin, TX: University of Texas.

312. Mark Gertler, letter to Dora Carrington, in *Mark Gertler: Selected Letters*, ed. Noel Carrington (London: Rupert Hart-Davis, 1965), 47.

313. MacDougall, *Mark Gertler*, 56.

314. MacDougall, *Mark Gertler*, preface.

315. Endelman, *Jews of Britain*, 146.

316. MacDougall, *Mark Gertler*, 18.

317. Ibid., 34.

318. Ibid., 39.

319. Ibid., 37.

320. Juliet Steyn, "Mythical Edges of Assimilation," in *Mark Gertler: Paintings & Drawings* (London: Camden Arts Centre, 1992), 12–13; MacDougall, *Mark Gertler*, 72.

321. D. H. Lawrence, letter to Mark Gertler, October 9, 1916.

322. Humphreys, *Tate Britain Companion*, 185.

323. MacDougall, *Mark Gertler*, 138–92.

324. Ibid., 165.

325. Steyn, "Mythical Edges of Assimilation," 14–15.

326. Andrew Causey, "A Certain Gipsy Gaudiness," in *Mark Gertler: Paintings and Drawings*, 23, 33.

327. MacDougall, *Mark Gertler*, 261.

328. Mark Gertler, letter to Mary Hutchinson, June 24, 1918, Austin, TX: University of Texas.

329. Frances Spalding, in *Jacob Kramer Reassessed* (London: Ben Uri Society, 1984), 4.

330. Ibid., 4.

331. Joshua Walsh, "Unity of Arts," in *Jacob Kramer Reassessed*, 10.

332. Humphreys, *Tate Britain Companion*, 194–97.

333. *The Ben Uri Society: From Art Society to Museum and the Influence of Anglo-Jewish Artists on the Modern British Movement* (London: Ben Uri, 2001), 78–86.

334. Sarah MacDougall, "From Warsaw to Whitechapel," First Congress of Jewish Art in Poland.

335. James Hyman, *Making Waves: Masterpieces of Modern British Art* (London: Ben Uri Gallery, 2003), 5; Monica Bohm-Duchen, *The Art and Life of Jozef Herman* (London: Lund Humphries, 2009).

336. Endelman, *Jews of Britain*, 184.

337. David Bomberg, letter to Jacob Kramer, quoted in MacDougall, *Mark Gertler*, 312.

338. Dominique Bourel, "Weimar," in *Les Juifs et le XXe siècle*, ed. Barnavi and Freidländer, 459–68.

339. Ibid.

340. Delphine Bechtel, "Littérateurs de langue allemande," in *Les Juifs et le XXe siècle*, ed. Barnavi and Freidländer, 118–31.

341. Jacques Ehrenfreund, *Mémoire juive et nationalité allemande: Les Juifs Berlinois à la Belle Epoque* (Paris: Presses Universitaires de France, 2000), 55.

342. Bechtel, "Littérateurs," in *Les Juifs et le XXe siècle*, ed. Barnavi and Freidländer, 127–28.

343. Marc de Launay, "Symbiose judéo-allemande," in *Les Juifs et le XXe siècle*, ed. Barnavi and Freidländer, 426–37.

344. Norbert Wolf, *Expressionnisme* (Cologne: Taschen, 2004), 72.

345. Catherine M. Soussloff, *The Subject in Art: Portraiture and the Birth of the Modern* (Durham, NC: Duke University Press, 2006), 15, 27, 42–46, 62.

346. Wolf, *Expressionnisme*, 6.

347. Ibid.

348. Jean-Pierre Lebenstajn, in *Figures du Moderne: L'expressionnisme en Allemagne, 1905–1914* (Paris: Paris-Musées, 1992)

349. Jean Clair, *Du surréalisme considéré dans ses rapports au totalitarisme et aux tables tournantes: Contribution à histoire de l'insensé* (Paris: Mille et une nuits, 2003), 85.

350. Ibid., 86.

351. Ibid., 84–110.

352. Ibid., 59.

353. Ibid., 103.

354. Wolf, *Expressionnisme*, 92; Milly Heyd, "Arnold Schoenberg's Self-Portraits between 'Iconism' and 'Anti-Iconism': The Jewish-Christian Struggle," in Yaniv, ed., *Ars Judaica* (2005), 1:133–46.

355. Erik Riedel, in *Ludwig und Else Meidner* (Frankfurt am Main: Jüdisches Museum Frankfurt am Main, 2002), 12.

356. Ludwig Meidner, in *Ludwig und Else Meidner*, 12.

357. Ibid., 15–16.

358. *Ludwig und Else Meidner*, 18.

359. Ibid., 20.

360. Ibid., 22.

361. Robin Reisenfeld, "German Expressionist Art and Modern Jewish Identity," *Jewish Identity*, ed. Soussloff, 114–34.

362. Ibid.

363. Pierre-Gilles Kern, "La genèse de la Ruche," in *La Ruche: Cité d'artistes au regard tendre, 1902–2002* (Paris: Musée du Montparnasse, 2002), 14.

364. Jeanine Warnod, "Comment j'ai connu les artistes de la Ruche," in *La Ruche*, 30.

365. Jeanine Warnod, "Les premières années à la Ruche," in *Kikoïne: Les Pionniers de l'école de Paris* (Paris: Editions de l'Albaron, 1992), 72.

366. Jeanine Warnod, "Comment j'ai connu les artistes de la Ruche," 48.

367. Nieszawer, Boyé, and Fogel, *Peintres juifs à Paris*, 101.

368. Emile Szittya, *Soutine et son temps* (Paris, Bibliothèque des arts, 1955), 24.

369. Jean Robiquet, *L'Information*, February 14, 1922.

370. Dominique Paulvé, *La Ruche: Un siècle d'art à Paris* (Paris: Gründ, 2002), 72–73.

371. André Warnod, *L'Avenir du Dauphiné*, January 4 and 27, 1925, *Comœdia*, quoted in *Chagall connu et inconnu* (Paris: Réunion des musées nationaux, 2003), 21–35.

372. Florent Fels, *Le Roman de l'art vivant* (Paris: Fayard, 1959), 55–56.

373. *Marevna et les Monparnos: Musée Bourdelle* (Paris: Musée de la ville de Paris, 1985).

374. Nieszawer, Boyé, and Fogel, *Peintres juifs à Paris*, 234.

375. Marevna Vorobëv, *Life with the Painters of La Ruche* (London: n.p., 1972), 36.

376. Kenneth Silver and Romy Golan, eds., *The Circle of Montparnasse: Jewish Artists in Paris, 1905–1945* (New York: Universe Books, 1985).

377. Christophe Duvivier, *Otto Freundlich et ses amis* (Pontoise: Musée de Pontoise, 1993), 17–22.

378. Nieszawer, Boyé, and Fogel, *Peintres juifs à Paris*, 24.

379. Arbit Blatas, "Montparnasse, capitale de la Lituanie des Arts," in *Arbit Blatas: Portraits de Montparnasse* (Paris: Somogy, 1998); Emmanuel Bréon, *L'École de Paris-Boulogne* (Paris: Musée municipal de Boulogne-Billancourt, 1988).

380. Yves Kobry, in Nieszawer, Boyé, and Fogel, *Peintres juifs à Paris*, 24.

381. Sophie Krebs, personal communication.

382. Pinchus Krémègne, in Paulvé, *La Ruche*, 75.

383. Maurice Tuchman,"Chaim Soutine (1893–1944). Life and Work," in *Chaim Soutine (1893–1943): Catalogue Raisonné*, ed. Maurice Tuchman (Cologne: Taschen, 1993), 16.

384. Lydie Lachenal, "Le sourire du peintre," in *Kikoïne: Les Pionniers*, 86.

385. Michel Kikoïne, in Jeanine Warnod, "Comment j'ai connu les artistes de la Ruche," 46.

386. Jean-Pierre Raynaud, "Michel Kikoïne, héraut de la peinture," in *Kikoïne: Les Pionniers*, 124.

387. Arbit Blatas, "Montparnasse, capitale de la Lituanie des Arts," 33.

388. Silver and Golan, eds., *Circle of Montparnasse*, 15.

389. Ibid., 16.

390. Nieszawer, Boyé, and Fogel, *Peintres juifs à Paris*, 280–83.

391. Silver and Golan, eds., *Circle of Montparnasse*, 17.

392. Jacqueline Gojard, "Au rendez-vous des poètes," in *L'École de Paris, 1904–1929, La part de l'Autre, Musée d'Art moderne de la Ville de Paris* (Paris: Paris Musées), 116.

393. Fritz Vanderpyl, "Existe-t-il une peinture juive?" *Mercure de France*, July 15, 1925, 486–96; Adolphe Basler, "Existe-t-il une peinture juive?" *Mercure de France*, November 15, 1925, 111–18.

394. Fels, *Roman de l'art vivant*, 55–56.

395. Romy Golan, "École Française versus École de Paris," in *The*

Circle of Montparnasse, ed. Silver and Golan.

396. Adolphe Basler, *Le Cafard après la fête* (Paris: J. Budry, 1929), 13, quoted in Golan, "École Française versus École de Paris," 85.

397. Adolphe Basler, *La Peinture: Religion nouvelle* (Paris: Le Libraire de France, 1926), 73.

398. Ibid., 16.

399. Silver and Golan, eds., *Circle of Montparnasse*, 49.

400. Claude Lanzmann, in Nieszawer, Boyé, and Fogel, *Peintres juifs à Paris*, preface.

401. Nieszawer, Boyé, and Fogel, *Peintres juifs à Paris*, 28–30.

402. Vivian B. Mann ed., *Gardens and Ghettos: The Art of Jewish Life in Italy* (Berkeley, CA: University of California Press, 1989).

403. Klein, *Modigliani: Beyond the Myth* (New York: The Jewish Museum: New Haven, CT: Yale University Press, 2004), 4, 232–34.

404. Ibid., 5.

405. Anselmo Bucci, "Ricordi d'Artisti: Modigliani," May 17, 1931.

406. Klein, *Modigliani*, 2; Emily Braun, "The Faces of Modigliani," in Klein, *Modigliani*, 25.

407. Marc Restellini, "Modigliani, 'L'Ange au visage grave,'" (Paris: Musée du Luxembourg, Seuil 2002), 40, 53, 54.

408. Klein, *Modigliani*, 9.

409. Ibid., 4–5, 7.

410. Ibid., 17.

411. Griselda Pollock, "Modigliani and the Bodies of Art," in Klein, *Modigliani*, 55–73.

412. Francis Carco, *L'Ami des peintres* (Paris: Gallimard, 1953), 41.

413. Tamar Garb, "Making and Masking," in Klein, *Modigliani*, 43–53.

414. Braun, "The Faces of Modigliani," 27, 35.

415. Ibid., 29.

416. Silver and Golan, eds., *The Circle of Montparnasse*, 19–20; Maurice Berger, "Epilogue: The Modigliani Myth, Beyond the Myth," Klein, *Modigliani*, 85.

417. Jacques Lipchitz, *My Life in Sculpture* (New York: Viking Press, 1972), 18–20.

418. Warnod, "Comment j'ai connu les artistes de la Ruche," 84; Restellini, "Modigliani, 'L'Ange au visage grave,'" 216.

419. Warnod, "Comment j'ai connu les artistes de la Ruche," 84.

420. Henri Matisse, *La Terre retrouvée*, May 15, 1951.

421. Christian Parisot, "Modigliani et la Ruche," *La Ruche*, 74.

422. *Soutine* (Paris: Pinacothèque de Paris, 2007), 14.

423. Tuchman, ed., *Chaim Soutine*, 14.

424. Ibid., 27–40.

425. Tuchman, ed., *Chaim Soutine*, 22.

426. *Soutine*, back cover.

427. Vincent Van Gogh, letter B 15F on August 1882, in *Correspondance* (Paris: Gallimard/Grasset, 1960).

428. Tuchman, ed., *Chaim Soutine*, 18, 20.

429. Kramer Hilton, "Soutine and the Problem of Expressionism," in *The Age of the Avant-Garde: An Art Chronicle of 1956–1972* (New York: Farrar, Straus and Giroux, 1973), 230; Esti Dunow, in Tuchman, ed., *Chaim Soutine*, 65.

430. Tuchman, ed., *Chaim Soutine*, 102.

431. Ibid., 103.

432. Tuchman, ed., *Chaim Soutine*, 517.

433. Basler, *Peinture*, 18.

434. Monica Bohm-Duchen, "La quête d'un art juif dans la Russie révolutionnaire," in *Chagall, connu et inconnu*.

435. Chagall Marc, *My Life* (New York: Orion Press, 1960), 53.

436. Ibid., 34.

437. Ibid., 87.

438. Ibid., 134.

439. Ziva Amishai-Maisels, "Chagall's Jewish In-Jokes," *Journal of Jewish Art*, 5 (1978): 80–81; Mirjam Rajner, "The Wandering Jew, Chagall's Jew in Bright Red," in Yaniv, ed., *Ars Judaica* (2008), 61–80.

440. Marc Chagall, autobiographical notes, department of manuscripts, Tretiakov Gallery, f. 31, No. 2074, in *Marc Chagall: Les*

Années russes, 1907–1922 (Paris: Paris-Musées, 1995), 246.

441. Obolenskaïa, "À l'école Zvantseva," L. Bakst ed., department of manuscripts, Tretiakov Gallery, 1906–1910, f. 5, No. 75 P. 17, in Jakov Bruk, "Marc Chagall, 1887–1922," in *Chagall connu et inconnu*, 22.

442. Warnod, "Comment j'ai connu les artistes de la Ruche," 36.

443. Jacky Wullschlager, *Chagall: Life, Art, Exile* (London: Penguin Books, 2008); Jean-Michel Foray, in *Chagall connu et inconnu*, 51–55.

444. Jean-Louis Prat, "Les couleurs de la poésie," in *Chagall connu et inconnu*, 15–16.

445. Warnod, "Comment j'ai connu les artistes de la Ruche," 36.

446. Franz Meyer, *Marc Chagall: Life and Work* (New York: Harry N. Abrams, 1964), 246.

447. Susan Tumarkin Goodman, ed., *Marc Chagall: Early Works from Russian Collections* (New York: The Jewish Museum; London: Third Millenium, 2001), 34.

448. Meret Meyer Graber, "Marc Chagall, 1922–1985," in *Chagall connu et inconnu*, 31.

449. Joseph Schein, "À propos du théâtre juif de Moscou," in Kampf, *Jewish Experience*, 43.

450. Chagall, *My Life*, 247.

451. Clair, *Du surréalisme*, 199.

452. Claude Roger-Marx, *Le Figaro littéraire*, March 20, 1968.

453. Nieszawer, Boyé, and Fogel, *Peintres juifs à Paris*, 156.

454. Ibid., 152.

455. Jean Cassou, *Marcoussis* (Paris: Gallimard, 1930), quoted in Nieszawer, Boyé, and Fogel, *Peintres juifs à Paris*, 230–32.

456. Nieszawer, Boyé, and Fogel, *Peintres juifs à Paris*, 24.

457. Pierre Mornand, *Art graphique français contemporain*, quoted in Nieszawer, Boyé, and Fogel, *Peintres juifs à Paris*, 274.

458. Otto Freundlich, *Le Mur* (1936), quoted in Duvivier, *Otto Freundlich*, 136–37.

459. Ibid., 113.

460. Herbert Moldering, "Nouvelles Images," in *L'École de Paris, 1904–1929: La part de l'Autre* (Paris: Paris-Musées, 2000), 71, 74.

461. André Warnod, *Visages de Paris* (Paris: Firmin-Didot et Cie, 1930), 267–72.

462. Moldering, "Nouvelles Images," 83.

463. Saul Friedländer, "Antisémitisme(s) moderne(s)," in *Les Juifs et le XXe siècle*, ed. Barnavi and Freidländer, 19–35.

4. The Human Figure after the Holocaust

464. Michael R. Marrus and Robert O. Paxton, *Vichy, France and the Jews* (New York: Basic Books, 1981), 54.

465. Carl Einstein, *Die Fabrikation der Fiktionen* (Hamburg: Pencker, Rohwolt, Reinbeck, 1973), quoted in Jean Clair, *Du surréalisme considéré dans ses rapports au totalitarisme et aux tables tournantes: Contribution à histoire de l'insensé* (Paris: Mille et une nuits, 2003), 51.

466. Clair, *Du surréalisme*, 19–20.

467. Ben Shahn, *Shape of Content* (Cambridge, MA: Harvard University Press, 1957), 43.

468. Clair, *De Immundo: Apophatisme et apocatastase dans l'art d'aujourd'hui* (Paris: Galilée, 2004), 55.

469. Clair, *Du surréalisme*, 20.

470. Ibid., 21.

471. Ibid., 40.

472. Saul Friedländer, "Antisémitisme(s) moderne(s)," in *Les Juifs et le XXe siècle: Dictionnaire critique*, ed. Elie Barnavi and Saul Friedländer (Paris: Calmann-Lévy, 2000), 28; Louis-Ferdinand Céline, *L'École des cadavres, 1938–1940*, quoted in Hannah Arendt, *Les Origines du totalitarisme* (Paris: Quarto Gallimard, 2002), 277.

473. Clair, *Du surréalisme*, 177.

474. David Sylvester, *Looking at Giacometti* (London: Chatto & Windus, 1994), 44.

475. Clair, *Du surréalisme*, 136.

476. Grégoire Michonze, letter to Peter Stone (1959), in *Grégoire Michonze, 1902–1982: Naturaliste surréel* (Paris: Terre des Peintres, 1997), 90–99, in Nadine Nieszawer, Mary Boyé, and Paul Fogel, *Peintres juifs à Paris, 1905–1939: École de Paris* (Paris: Denoël, 2000), 247–48.

477. Alain Jouffroy, *Victor Brauner* (Paris: Fall Edition, 1996), 67.

478. Nieszawer, *Paris–Marseille, La mission de Varian Fry, 1940* (Paris: Musée du Montparnasse, 2003), 36–37; *Varian Fry, Marseille, 1940–1941* (Paris: Halle St Pierre, 2008).

479. Andrea Kettenmann, *Frida Kahlo, 1907–1954: Souffrance et passion* (Cologne: Taschen, 2002), 31.

480. Hayden Herrera, *Frida, A Biography of Frida Kahlo* (New York: Harper & Row, 1983), 250.

481. Diego Rivera, *My Art, My Life: An Autobiography* (New York: Dover Publications, 1991); Christina Burrus, "Diego Rivera," in *Diego Rivera, Frida Kahlo: Regards croisés* (Paris: Fondation Dina Vierny-Musée Maillol; RMN, 1998), 19.

482. Herrera, *Frida, A Biography*, 135.

483. Burrus, "Frida Kahlo," in *Diego Rivera, Frida Kahlo*, 37.

484. Ibid.

485. Herrera, *Frida, A Biography*, 30.

486. Ibid.

487. Ibid., 38; Raquel Tibol, *Frida Kahlo: Una Vida Abierta* (Mexico: Editorial Oasis, 1983), 96.

488. Gannit Ankori, "The Hidden Frida: Covert Jewish Elements in the Art of Frida Kahlo," dissertation, in *The Hidden Frida* (New York: The Jewish Museum, 2005).

489. Ibid.

490. Ibid.

491. Ibid.

492. Burrus, "Frida Kahlo," 42.

493. Michael Löwy, "Mittel-europa," in *Les Juifs et le XXe siècle*, ed. Barnavi and Friedländer, 406.

494. Moshé Zuckermann, "L'école de Francfort," in *Les Juifs et le XXe siècle*, ed. Barnavi and Friedländer, 61–76.

495. Lisa Saltzman, "To Figure or Not to Figure," in *Jewish Identity in Modern Art History*, ed. Catherine M. Soussloff (Berkeley, CA: University of California Press, 1999), 67–84.

496. Pierre Bouretz, *Témoins du futur: Philosophie et messianisme* (Paris: Gallimard, 2003).

497. Emmanuel Levinas, "La réalité et son ombre," *Les Temps modernes*, November 1948; *Éthique comme philosophie première* (Paris: Payot & Rivages, 1998), 67–109; Jacob Meskin, "The Other in Levinas and Derrida: Society, Philosophy, Judaism," in *The Other in Jewish Thought and History: Constructions of Jewish Culture and Identity*, ed. Laurence Silberstein and Robert Cohn (New York: New York University Press, 1994), 402–22.

498. Shmuel Trigano, *L'Idéal démocratique à l'épreuve de la Shoa* (Paris: O. Jacob, 1999), 101, 109–14.

499. Edmond Jabès, *Ground Work: Selected Poems and Essays, 1970–1979* (London: Faber and Faber, 1990), 184, 194; George Steiner, "A Kind of Survivor,"

in *Language and Silence: Essays on Language, Literature, and the Inhuman* (New York: Atheneum, 1967), 151.

500. Jean-Paul Sartre, *Réflexions sur la question juive* (Paris: Gallimard, 1968); *L'existentialisme est un humanisme* (Paris: Gallimard, Folio Essais, 1996).

501. Jean-Paul Sartre, *L'Imaginaire* (Paris: Gallimard, 1986), 15–17.

502. Sylvester, *Looking at Giacometti*, 27.

503. Catherine M. Soussloff, *The Subject in Art: Portraiture and the Birth of the Modern* (Durham, NC: Duke University Press, 2006), 12, 51, 119.

504. Brendan Prendeville, *Realism in 20th Century Painting* (New York: Thames & Hudson, 2000), 126–27.

505. Sylvester, *Looking at Giacometti*, 88–89.

506. Ibid., 76.

507. Ibid., 11.

508. Robert Hughes, "Feedback from Life, Drawings and Paintings," in Duncan Thomson and Stephen Coppel, *Avigdor Arikha: From Life: Drawings and Prints, 1965–2005* (London: The British Museum Press, 2006), 10.

509. Thomson, "The Drawings," in Thomson and Coppel, *Avigdor Arikha*, 16.

510. Hughes, *Avigdor Arikha: Inks, Drawings and Etchings* (London: Marlborough Fine Art, 1974).

511. Hughes, "Feedback from Life, Drawings and Paintings," 10.

512. Coppel, "The Prints," in Thomson and Coppel, *Avigdor Arikha*, 30.

513. Neil MacGregor, in Thomson and Coppel, *Avigdor Arikha*, preface.

514. Coppel, "The Prints," 23.

515. Mary Blume, "Beckett's refuge: story of a friendship," *International Herald Tribune*, February 27, 2004.

516. Ibid.

517. Thomson, "The Drawings," 16.

518. Michael Peppiatt, "L'École de Londres," in *L'École de Londres, De Bacon à Bevan* (Paris: Fondation Dina Vierny-Musée Maillol, RMN, 1998), 19.

519. Richard Humphreys, *The Tate Britain Companion to British Art* (London: Tate Publishing, 2001), 216.

520. Ibid., 234–35.

521. Michael Peppiatt, "L'École de Londres," 15–30.

522. Dina Vierny, ibid., 9.

523. Peppiatt, "L'École de Londres," 15–29.

524. Bertrand Lorquin, "De l'École de Londres à la figuration contemporaine," in *L'École de Londres, De Bacon à Bevan*, 11–13.

525. Peppiatt, "L'École de Londres," 19.

526. Frank Auerbach, *Art International*, Autumn 1987.

527. Peppiatt, "L'École de Londres," 19.

528. Ibid., 25. Humphreys, *Tate Britain Companion*, 211.

529. Craig Hartley, *Lucian Freud, Recent Etchings, 1995–1999* (London: Marlborough Graphics, 2002), 42, quoted in Frédéric Brenner, "Voices," in *Diaspora: Homelands in Exile* (New York: Harper Collins, 2003), 34.

530. Peppiatt, "L'École de Londres," 17.

531. Ibid.; Peppiatt, "Modern Art in Britain," *Cambridge Opinion* 37, January 1964.

532. Peppiatt, "L'École de Londres," 23.

533. Robert Hughes, "On Lucian Freud," in *Lucian Freud Paintings* (London: Thames and Hudson, 1989), 9.

534. William Feaver, *Lucian Freud* (London: Tate Publishing, 2002), 15.

535. Hughes, "On Lucian Freud," 11–14.

536. Feaver, *Lucian Freud*, 29.

537. Humphreys, *Tate Britain Companion*, 216.

538. Feaver, *Lucian Freud*, 32.

539. Peppiatt, "L'École de Londres," 22.

540. Hughes, "On Lucian Freud," 9.

541. Feaver, interview of Lucian Freud, *Third Ear*, BBC Radio 3, December 10, 1991.

542. Interviews of Lucian Freud, *Observer Review*, December 6, 1992; Feaver, *Lucian Freud*, 40.

543. Feaver, *Lucian Freud*, 48.

544. Ibid., 15.

545. Ibid., 33.

546. Lawrence Gowing, *Lucian Freud* (New York: Thames and Hudson, 1982), 91, quoted in Peppiatt, "L'École de Londres," 28.

547. Jean Clair, "Lucian Freud: Le nu en peinture," in *Eloge du visible : Fondements imaginaires de la science* (Paris: Gallimard, 1996).

548. Feaver, *Lucian Freud*, 35; Hughes, "On Lucian Freud," 18, 20.

549. E. H. Gombrich, "Portrait Painting and Portrait Photography," *Apropos*, 5, London, 1945: 6.

550. David Sylvester, "Against the Odds," in *Leon Kossoff: Recent Paintings; British Pavilion XLVI Venice Biennale* (London: British Council, 1995), 18.

551. Andrea Rose, in *Leon Kossoff: Recent Paintings*, preface.

552. Richard Cork, *David Bomberg* (New Haven, CT: Yale University Press, 1987), 286.

553. Paul Moorhouse, *Leon Kossoff* (London: Tate Gallery, 1996), 9–10.

554. Klaus Kertess, *Leon Kossoff* (New York: Mitchell-Innes & Nash; London: Anneli Juda Fine Art, 2000), 9–13.

555. Leon Kossoff, *The Paintings of Frank Auerbach* (London: Hayward Gallery, 1978).

556. Moorhouse, *Leon Kossoff*, 36.

557. Rudi Fuchs, in *Leon Kossoff: Recent Paintings*, 22.

558. Moorhouse, *Leon Kossoff*, 9.

559. Poul Erik Tojner, *Kossoff: Selected Paintings, 1956–2000* (Humleback, Denmark: Louisiana Museum of Modern Art, 2005), 4–5.

560. Andrew Lambirth, *Kitaj* (London: PWP Contemporary Art, 2004), 39.

561. Ronald Brooks Kitaj, *First Diasporist Manifesto* (London: Thames and Hudson, 1989), 39.

562. Lambirth, *Kitaj*, 15

563. Ibid., 7–11

564. Ibid., 31.

565. Lambirth, *Kitaj*, 54.

566. Kitaj, *First Diasporist Manifesto*, 30–31.

567. Lambirth, *Kitaj*, 19.

568. Ibid., 27.

569. Ibid., 40.

570. Ibid., 15, 17.

571. Ibid., 15.

572. Ibid., 58.

573. Marco Livingstone, *Kitaj*, (London: Phaidon Press, 1994), 54.

574. Ibid., 33.

575. Lambirth, *Kitaj*, 77.

576. David Biale, "Intégration et citoyenneté: le modèle américain," in *Les Juifs et le XXe siècle*, ed. Barnavi and Friedländer, 360–75.

577. Deborah Dash Moore, "New York," in *Les Juifs et le XXe siècle*, ed. Barnavi and Friedländer, 411–25.

578. Dominique Jarrassé, *Existe-t-il un art juif?* (Paris: Biro, 2006), 48.

579. Prendeville, *Realism in 20th Century Painting*, 37–38.

580. Avram Kampf, *Jewish Experience in the Art of the Twentieth Century* (South Hadley, MA; Bergin & Garvey, 1984), 61–63.

581. Ibid., 62.

582. Bram Dijkstra, *American Expressionism, Art, and Social Change, 1920–1950* (New York: Harry N. Abrams, 2003), 12.

583. Ibid., 13.

584. Ibid., 18.

585. Diana L. Linden, "Ben Shahn's New Deal Murals," in *Common Man, Mythic Vision: The Paintings of Ben Shahn*, ed. Susan Chevlowe (Princeton, NJ: Princeton University Press, 1998), 56.

586. Dijkstra, *American Expressionism*, 17.

587. Ibid., 15.

588. Ibid., 22.

589. Ibid., 44–45.

590. Samantha Baskind, *Raphael Soyer and the Search for Modern Jewish Art* (Chapel Hill, NC: University of North Carolina Press, 2004), 1–16.

591. Ibid., 43, 118.

592. Milton W. Brown, *Raphael Soyer* (New York: Forum Gallery, 1989).

593. Baskind, *Raphael Soyer*, 82, 109.

594. Dijkstra, *American Expressionism*, 19.

595. Linden, "Ben Shahn's New Deal Murals," 48.

596. Ibid., 37–65.

597. Stephen Polcari, "Ben Shahn and Postwar American Art," in *Common Man, Mythic Vision*, ed. Chevlowe, 68–109.

598. Joan Rosenbaum, in *Common Man, Mythic Vision*, ed. Chevlowe, foreword.

599. Bernarda Bryson Shahn, *Ben Shahn* (New York: Harry N. Abrams, 1972), 15.

600. Harold Rosenberg, "The Art World: Ben Shahn," *New Yorker*, December 13, 1976, 156.

601. Polcari, "Ben Shahn and Postwar American Art," 87–92.

602. Samanta Baskind, "Midrash and the Jewish American Experience in Jack Levine's 'Planning Solomon's Temple,'" in Yaniv, ed., *Ars Judaica* (2007), 3:73–90.

603. Jack Levine, "My Early Boyhood," in *Paintings by Jack Levine—Sculptures by David von Schlegell: Paintings and Sculpture by Americans of Our Times* (Ogunquit, 1964), quoted in Baskind, "Midrash and the Jewish American Experience," 78.

604. Piri Halasz, "Figuration in the '40s, the Other Expressionism," *Art in America*, December 1982, 145, quoted in Baskind, *Raphael Soyer*, 112.

605. Matthew Baigell, *Jewish Artists in New York: The Holocaust Years* (New Brunswick, NJ: Rutgers University Press, 2002), 16.

606. Ibid., 4.

607. Ibid., 75.

608. Ibid., 52.

609. Ibid., 50–53.

610. Ibid., 53.

611. Abraham Rattner, Archives, AAA, roll N 681/568.

612. Harold Rosenberg, *Barnett Newman* (New York: Harry Abrams, 1977), 27.

613. Mark Rothko, projects of letters to M. Jewell, Archives AAA, roll 3134; 2–5. Dore Ashton, *About Rothko* (New York: Da Capo Press, 1977).

614. Baigell, *Jewish Artists in New York*, 2–12, 152–60.

615. Lisa Saltzman, "To Figure, or Not to Figure," 67–84.

616. Baigell, *Jewish Artists in New York*, 98–151.

617. Ibid., 102.

618. Dijkstra, *American Expressionism*, 25–30.

619. Ibid., 37–39.

620. Louis Kaplan, "Reframing the Self Criticism: Clement Greenberg's 'Modernist Painting' in Light of Jewish Identity," *Jewish Identity*, ed. Soussloff, 180–200.

621. Margaret Olin, "C[lement] Hardesh G[reenberg] and Company: Formal Criticism and Jewish Identity," in *Too Jewish? Challenging Traditional Identities*, ed. Norman Kleeblatt (New York: The Jewish Museum; New Brunswick, NJ: Rutgers University Press, 1996), 39–59.

622. Harold Rosenberg, "Is There a Jewish Art?" *Commentary*, vol. 42, July 1966, in *Discovering the Present: Three Decades in Art, Culture and Politics* (Chicago: Chicago University Press, 1973), 123, and in Donald Kuspit, "Meyer Schapiro's Jewish Unconscious," in *Jewish Identity*, ed. Soussloff, 200–17; Meyer Schapiro, "Chagall's Illustrations for the Bible" (1956), in *Modern Art: Nineteenth and Twentieth Centuries, Selected Papers* (New York: George Braziller, 1972), 2:133.

623. Michael Auping, *Philip Guston Retrospective* (New York: Thames and Hudson, 2003), 14.

624. Ibid., 21.

625. Ibid., 95.

626. Ibid., 83–92.

627. Ibid., 60.

628. Musa Mayer, *Night Studio: A Memoir of Philip Guston* (London: Thames and Hudson, 1991), 153.

629. Ibid., 45.

630. Leo Steinberg, "Fritz Glarner and Philip Guston," in *Other Criteria: Confrontation with Twentieth-Century Art* (New York: Oxford University Press, 1972), 282.

631. Auping, *Philip Guston Retrospective*, 47.

632. Ibid., 51.

633. Mayer, *Night Studio*, 157.

634. Auping, *Philip Guston Retrospective*, 22.

635. Julian Schnabel, *C.V.J.: Nicknames of Maitre D's & Other Excerpts from Life* (New York: Random House, 1987), 54.

636. Anthony Julius, *Idolizing Pictures: Idolatry, Iconoclasm, and Jewish Art* (London: Thames and Hudson, 2000), 58–77.

637. Margarita Tupitsyn, *Sots Art* (New York: New Museum of Contemporary Art, 1986).

638. Bertrand Lorquin, in Dina Vierny, *Erik Boulatov* (Paris: Fondation Dina Vierny-Musée Maillol, RMN, 1999), 100.

639. Lorquin, in Vierny, *Erik Boulatov*, 23.

Epilogue

640. Avram Kampf, *Jewish Experience in the Art of the Twentieth Century* (South Hadley, MA: Bergin & Garvey, 1984).

641. Mason Klein, "Modigliani against the Grain," in *Modigliani: Beyond the Myth*, ed. Mason Klein (New York: The Jewish Museum; New Haven, CT: Yale University Press, 2004), 2.

642. Norman Kleeblatt, ed., *Too Jewish? Challenging Traditional Identities* (New York: The Jewish Museum; New Brunswick, NJ: Rutgers University Press, 1996).

643. Andrew Lambirth, *Kitaj* (London: PWP Contemporary Art, 2004), 77.

Chronology

c. 2000–1750 BCE
Time of the Patriarchs: Abraham
and Sarah, Isaac and Rebekah,
Jacob (Israel) and his wives Leah
and Rachel, and their children
who gave their names to the
Twelve Tribes.

c. 1250 BCE
Exodus from Egypt and conquest
of Canaan by Joshua

c. 1000 BCE
First kings of Israel, Saul
and David

970–928 BCE
King Solomon and the
construction of the First Temple

c. 928 BCE
Splitting of the kingdom into
Israel and Judea

c. 800 BCE
First Prophets

722 BCE
Destruction of the Kingdom of
Israel by the Assyrians

586 BCE
Destruction of the Kingdom of
Judea, and the First Temple, by
the Babylonians

536 BCE
Return from exile in Babylon

516 BCE
Inauguration of the
Second Temple

c. 450 BCE
Compilation of the Torah

167 BCE
Maccabee uprising

70 CE
Destruction of the Second
Temple and massive deportations
by the Romans

135 CE
Uprising led by Bar Kokhba

c. 200–550 CE
Compilation of the Talmud

622–c. 700 CE
Destruction of the Jewish
communities in the Arabian
Peninsula and enactment of the
Omar Covenant

c. 800 CE
Development of the
Ashkenazi culture

c. 1090–1200
Massacre of the German Jews
during the Crusades

1290
Expulsion of the Jews
from England

1295
Compilation of the Zohar, the
fundamental text of Kabbalah

1306
Expulsion of the Jews from France

1492
Expulsion of the Jews from Spain

1555
Establishment of the ghetto
in Rome

1565
Unification of Sephardic and
Ashkenazic religious practices

1597
Establishment of the Jewish
Portuguese community
in Amsterdam

1648–49
Pogroms in the Ukraine
and Poland

1654
First Jewish settlers in
North America

1790
Beginning of the emancipation of
the Jews in Germany and France

1843
Founding of B'nai B'rith

1860
Founding of the Alliance
Israelite Universelle

1881–1917
Massive exodus of Jews from
Russia due to pogroms

1894
Dreyfus Affair

1897
First Zionist Congress
Founding of the Bund

1910
First Kibbutz

1940–44
Shoah

1943
Uprisings in the Warsaw ghetto
and at the Treblinka and Sobibor
death camps

1948
Founding of the State of Israel

1950–60
Massive exodus of Jews from the
Muslim countries

1960–70
Massive exodus of Jews from the
Soviet Union

1980, 1991
Exodus of the Ethiopian Jews
to Israel

Glossary

ASHKENAZIM: Jews from Central and Eastern Europe

BAR MITZVAH; *fem.* BAT MITZVAH: ceremony marking the passage to adulthood

BAT: daughter

BEN: son

BET: house

BRIT: covenant

CONVERSO: convert, in Spanish

DYBBUK: demon, in Yiddish

GENIZA: place where ritual books and objects no longer in use are stored

GOLEM: legendary creature brought to life from clay

GOLES: exile

HAD GADYA: song ending the Passover ritual

HAGGADAH: book of the Passover ritual, commemorating the Exodus from Egypt

HALAKHAH: the body of Jewish law derived from an ever evolving commentary on the Talmud

HANUKKAH: Feast of Lights commemorating the Maccabees' victory in 167 BCE

HASIDIM: ultra Orthodox Jews following an eighteenth century mystical interpretation of Judaism

HASKALAH: Jewish emancipation movement in Germany during the eighteenth century

HAZAN: cantor

HEDER: room or school, in Yiddish

KABBALAH: influential tradition of Jewish mysticism

KETUBAH: religious marriage document

KIDDUSH: benediction

KOSHER: food prepared according to the dietary laws

KVETCH: complaint or protest, in Yiddish

L'CHAIM: traditional toast "to life," in Yiddish

LUFTMENSCH: "air man" in Yiddish, denoting an impractical dreamer

MARRANO: "pig" in Spanish, denoting a *converso* who continued to practice Judaism in secret

MATZAH: unleavened bread eaten during Passover to recollect that the Hebrews had to flee before their bread rose

MEKHUTN; *fem.* MEKHUTENESTE: Yiddish term for the parent of one's son- or daughter-in-law

MEZUZAH: ritual object affixed to a house's doorpost

MIDRASH: collection of rabbinical commentary on the Bible

MIKVAH: ritual bath

MILAH: circumcision, symbolizing the Covenant

MINYAN: quorum of ten required for public worship

MITZVAH; *pl.* MITZVOTH: commandment; also, a good deed

MOSHIACH: messiah

PESSAH: Passover, Feast of Freedom, commemorating the deliverance from bondage in Egypt

PURIM: festival celebrating Queen Esther's deliverance of the Persian Jews from a plot to murder them

ROSH HASHANAH: Jewish New Year

SEPHARDIM: Jews who trace their roots to Spain or Portugal

SHABBAT: weekly day of rest and peace

SHAVUOT: Festival of Weeks, celebrating the giving of the Torah and the love of learning

SHEMA: fundamental prayer affirming the monotheistic principle

SHOAH: the Holocaust

SHTETL: small town, in Yiddish

SIMHAT TORAH: Feast marking the end of the yearly cycle of the reading of the Torah, and the beginning of the new cycle

SUKKOTH: Festival of Tabernacles, or Booths, which traditionally marked the autumn harvest

TALMUD: major collection of Jewish teachings

TIKKUN OLAM: act of "repairing the world"

TORAH, *or* PENTATEUCH: first five books of the Bible; broadly speaking, the Jewish way of life

TZEDEK: charity; etymological meaning is justice

YESHIVA: religious academy

YOM KIPPUR: Day of Atonement

ZAKHOR: remember

General Bibliography

On Jewish Artists

Amishai-Maisels, Ziva. *Depiction and Interpretation: The Influence of the Holocaust on the Visual Arts*. Oxford: Pergamon Press, 1993.

Baigell, Matthew. *American Artists, Jewish Images*. Syracuse, NY: Syracuse University Press, 2006.

————. *Jewish Artists in New York: The Holocaust Years*. New Brunswick, NJ: Rutgers University Press, 2002.

Baur, John I. H. *Revolution and Tradition in Modern American Art*. Cambridge, MA: Harvard University Press, 1951.

Brus-Malinowska, Barbara, et al. *Peintres Polonais en Bretagne (1890–1939)*. Quimper: Musée départemental Breton; Editions Palantines, 2004.

Clair, Jean. *De Immundo: Apophatisme et apocatastase dans l'art d'aujourd'hui*. Paris: Galilée, 2004.

————. *Du surréalisme considéré dans ses rapports au totalitarisme et aux tables tournantes: Contribution à histoire de l'insensé*. Paris: Mille et une nuits, 2003.

Deppner, Martin Roman, ed. *The Hidden Trace: Jewish Paths through Modernity*. Bramsche: Rasch, 2008.

Dijkstra, Bram. *American Expressionism, Art, and Social Change, 1920–1950*. New York: Harry N. Abrams, 2003.

L'École de Londres, De Bacon à Bevan. Paris: Fondation Dina Vierny-Musée Maillol, RMN, 1998.

L'École de Paris, 1904–1929, La part de l'Autre, Musée d'Art moderne de la Ville de Paris. Paris: Paris-Musées, 2000.

Goodman, Susan Tumarkin, ed. *The Emergence of Jewish Artists in Nineteenth-Century Europe*. London: Merrell, 2001.

————. *Russian Jewish Artists in a Century of Change, 1890–1990*. New York: Prestel, 1995.

Jarrassé, Dominique. *Existe-t-il un art juif?* Paris: Biro, 2006.

Kampf, Avram. *Chagall to Kitaj: Jewish Experience in 20th Century Art*. London: Lund & Humphries, 1990.

————. *Jewish Experience in the Art of the Twentieth Century*. South Hadley, MA: Bergin & Garvey, 1984.

Kleeblatt, Norman, ed. *Too Jewish? Challenging Traditional Identities*. New York: The Jewish Museum; New Brunswick, NJ: Rutgers University Press, 1996.

Nieszawer, Nadine, Mary Boyé, and Paul Fogel. *Peintres juifs à Paris, 1905–1939: École de Paris*. Paris: Denoël, 2000.

Sed-Rajna, Gabrielle. *L'Art juif*. Paris: Citadelles et Mazenod, 1995.

Silver, Kenneth, and Romy Golan, eds. *The Circle of Montparnasse: Jewish Artists in Paris, 1905–1945*. New York: Universe Books, 1985.

Soussloff, Catherine M., ed. *Jewish Identity in Modern Art History*. Berkeley: University of California Press, 1999.

Sylvester, David. *Looking at Giacometti*. London: Chatto & Windus, 1994.

Van Voolen, Edward. *My Grandparents, My Parents and I: Jewish Art and Culture*. New York: Prestel, 2006.

Yaniv, Bracha, ed. *Ars Judaica*. Vols. 1–5. Ramat Gan, Israel: The Bar-Ilan Journal of Jewish Art, 2005–8.

On Judaism

Arendt, Hannah. *The Origins of Totalitarianism*. New York: Harcourt, Brace & World Inc., 1966.

Barnavi, Elie, ed. *Histoire universelle des juifs: De la genèse à la fin du XXe siècle*. Paris: Hachette, 1992.

Barnavi, Elie, and Saul Friedländer, eds. *Les Juifs et le XXe siècle: Dictionnaire critique*. Paris: Calmann-Lévy, 2000.

Draï, Raphaël. *Identité juive, Identité humaine*. Paris: A. Colin, 1995.

Gilman, Sander. *The Jew's Body*. New York: Routledge, 1991.

Hadas-Lebel, Mieille. *Rome, la Judée et les Juifs*. Paris: A. et J. Picard, 2009.

Johnson, Paul. *A History of the Jews*. New York: Harper & Row, 1987.

Kertzer, Morris. *What is a Jew?* New York: Touchstone, Simon & Shuster, 1996.

Konner, Melvin. *The Jewish Body*. New York: Nextbook Schocken, 2009.

Kristeva, Julia. *Strangers to Ourselves*. Translated by Leon S. Roudiez. New York: Columbia University Press, 1994.

Nadler, Steven. *Rembrandt's Jews*. Chicago: University of Chicago Press, 2003.

Sacks, Jonathan. *Radical Then, Radical Now: The Legacy of the World's Oldest Religion*. London: HarperCollins, 2000.

Skolnik, Fred, ed. *Encyclopedia Judaica*, 22 vols. Detroit: Macmillan Reference USA, 2007.

Wex, Michael. *Born to Kvetch: Yiddish Language and Culture in All Its Modes*. New York: St. Martin's Press, 2005.

Wigoder, Geoffrey, et al. *Encyclopedia Judaica*, CD-ROM. Jerusalem: Judaica Multimedia, 1997.

Yerushalmi, Yosef Hayim. *Freud's Moses: Judaism Terminable and Interminable*. New Haven, CT: Yale University Press, 1991.

————. *Zakhor, Jewish History and Jewish Memory*. Seattle: University of Washington Press, 1982.

Artist Biographies and Bibliographies

ADLER, JANKEL

(b. 1895 Poland, d. 1949 Great Britain)

Adler, who began as an Expressionist in Germany and acted as an artistic link between that country and England, combined Hasidic themes with formal experiments in his later work.

Entartete Kunst: Geschichte und Gegenwart einer Ausstellung. Oldenburg: Bibliothek- und Informationssystem der Universität Oldenburg, 1992.

Jankel Adler. Jerusalem: The Israel Museum, 1969.

Jankel Adler, 1895–1949. Cologne: Dumont, 1985.

ARIKHA, AVIGDOR

(b. 1929 Romania, lives in France)

Initially an abstract painter, Arikha later focused on the human figure, drawing and painting exclusively from live models. Although he is based in Paris, he is closely associated with the School of London.

Miessner, Marie-Cécile. *Avigdor Arikha: Gravure sur le vif.* Paris: Bibliothèque nationale, 2008.

Schwarz, Arturo. *Love at First Sight: The Vera, Silvia, and Arturo Schwarz Collection of Israeli Art.* Jerusalem: The Israel Museum, 2001.

Thomson, Duncan, and Stephen Coppel. *Avigdor Arikha: From Life; Drawings and Prints, 1965–2006.* London: British Museum, 2006.

AUERBACH, FRANK

(b. 1931 Germany, lives in Great Britain)

A pillar of the School of London, Auerbach paints mostly portraits in an expressionistic style.

Feaver, William. *Frank Auerbach.* New York: Rizzoli, 2009.

Hughes, Robert. *Frank Auerbach.* New York: Thames and Hudson, 1992.

Lampert, Catherine, Norman Rosenthal, and Isabel Carlisle. *Frank Auerbach: Paintings and Drawings, 1954–2001.* London: Royal Academy of Arts, 2001.

BAGEL, MOSES

(b. 1908 Lithuania, d. 1995 France)

Trained at the Bauhaus, Bagel maintained a lifelong interest in architectural structure. For the Sholem Aleichem Centennial in 1959, UNESCO commissioned fifteen large paintings illustrating the Yiddish poet's work from him.

Aronson, Chil. *Bilder un geshtaltn fun Monparnas.* Paris: n.p., 1963.

"Moshe Bagel." *L'Arche,* 270–71, September–October 1979.

Nieszawer, Nadine, Marie Boyé, and Paul Fogel. *Peintres juifs à Paris, 1905–1939: École de Paris.* Paris: Denoël, 2000.

BERLEWI, HENRYK

(b. 1894 Poland, d. 1967 France)

Influenced by El Lissitzky, Berlewi founded Mechanofaktura, a movement related to Constructivism, in Warsaw. He devoted most of his later career to portraiture.

Colleye, Hubert. Interview of Henryk Berlewi. Antwerp, Belgium: De Sikkel, 1937.

"Mechanofaktura (Warsaw, 1924)." In *Précurseurs de l'art abstrait en Pologne.* Paris: Galerie Denise René, 1957.

Nieszawer, Nadine, Marie Boyé, and Paul Fogel. *Peintres juifs à Paris, 1905–1939: École de Paris.* Paris: Denoël, 2000.

BLONDEL, ANDRÉ

(b. 1909 Poland, d. 1949 France)

A founding member of the Krakow Group of artists, Blondel later fled Poland for the south of France, where he participated in the École de Sète.

André Blondel: Peintures, aquarelles, dessins; juillet–septembre 1959: Palais des archevêques à Narbonne. Montpellier: Impr. C. G. Castelnau, 1959.

Blondel. Krakow: National Museum, 1968.

Nieszawer, Nadine, Marie Boyé, and Paul Fogel. *Peintres juifs à Paris, 1905–1939: École de Paris.* Paris: Denoël, 2000.

BOMBERG, DAVID

(b. 1890, d. 1957, British)

A precursor of the School of London, Bomberg briefly experimented with modernism early on. He spent most of his career painting expressionistic landscapes and people.

Cork, Richard. *David Bomberg.* New Haven, CT: Yale University Press, 1987.

David Bomberg: The Later Years. London: Whitechapel Art Gallery, 1979.

Sylvester, David. *The Discovering of a Structure: David Bomberg, 1890–1957.* London: Marlborough Gallery 1979.

BRANDON, EDOUARD

(b. 1831, d. 1897, French)

One of the first established French Jewish artists of the nineteenth century, Brandon painted several synagogue interiors, as well as scenes of Jewish family life.

Goldman, Ida Batsheva. "A Synagogue Interior by Edouard Brandon." Tel Aviv Museum of Art, *Annual Review* 1996–97, 6:62–72.

Goodman, Susan Tumarkin, ed. *The Emergence of Jewish Artists in Nineteenth-Century Europe.* London: Merrell, 2001.

Jarrassé, Dominique. *Existe-t-il un art juif?* Paris: Biro, 2006.

CHAGALL, MARC

(b. 1887 Belarus, d. 1985 France)

The Jewish artist *par excellence,* Chagall's narrative art, mainly representing human and animal figures, is a hymn to life.

Bohm-Duchen, Monica. *Chagall.* London: Phaidon Press, 1998.

Chagall connu et inconnu. Paris: Réunion des musées nationaux, 2003.

Wullschlager, Jackie. *Chagall: Life, Art, Exile.* London: Penguin Books, 2008.

DA COSTA, CATHERINE MENDES

(b. 1679, d. 1756, British)

The first female Jewish artist known by name, Catherine da Costa came from a prominent Sephardic family in London, where she became a successful miniature portrait painter.

Finestein, Israel. *Studies and Profiles in Anglo-Jewish History: From Picciotto to Bermant.* London: Vallentine Mitchell, 2008.

Graetz, Heinrich. *Geschichte der Juden von den ältesten Zeiten bis auf die Gegenwart.* Vol. 4. Leipzig: O. Leiner, 1891.

Wolf, Lucien. "Crypto-Jews under the Commonwealth." *Transactions of the Jewish Historical Society of England.* 1988.

DOBRINSKY, ISAAC

(b. 1891 Ukraine, d. 1973 France)

A longtime resident of La Ruche in Montparnasse, Dobrinsky spent most of his life painting portraits of his wife Vera and of children who lost their parents in the Holocaust.

Aronson, Chil. *Bilder un geshtaltn fun Monparnas.* Paris: n.p., 1963.

Nieszawer, Nadine, Marie Boyé, and Paul Fogel. *Peintres juifs à Paris, 1905–1939: École de Paris.* Paris: Denoël, 2000.

Warnod, Jeanine. "L'Art du portrait." *Le Figaro,* May 6, 1982.

EPSTEIN, JACOB

(b. 1880 USA, d. 1959 Great Britain)

Epstein left the United States for Britain, where he became a famous modern sculptor, paving the way for a new generation that included Henry Moore.

Cork, Richard. *Jacob Epstein.* London: Tate Gallery, 1999.

Cronshaw, Johathan. *The Sideshow and the Problems of History: Jacob Epstein's Adam (1939).* Leeds: University of Leeds, 2005.

Epstein, Jacob. *Let There be Sculpture.* New York: G. P. Putnam's Sons, 1940.

FASINI, ALEXANDRE

(b. 1892 Ukraine, d. 1942 Auschwitz, Poland)

Moving on the edges of abstraction and Surrealism, Fasini was an independent poetic artist who never lost track of the human figure.

Fenster, Hersh. *Undzere farpaynikte kinstler.* Paris: H. Fenster, 1951.

Memorial in Honour of Jewish Artists Victims of Nazism, Oscar Ghez Collection. Israel: University of Haifa, 1978.

Nieszawer, Nadine, Marie Boyé, and Paul Fogel. *Peintres juifs à Paris, 1905–1939: École de Paris.* Paris: Denoël, 2000.

FREUD, LUCIAN

(b. 1922 Germany, lives in Great Britain)

The leading artist of the School of London, Freud paints highly charged nudes, often using close acquaintances as his models.

Feaver, William. *Lucian Freud.* London: Tate Gallery, 2002.

Hughes, Robert. *Lucian Freud Paintings.* London: Thames and Hudson, 1989.

Sebastian, Smee. *Lucian Freud.* London: Taschen, 2007.

FREUNDLICH, OTTO

(b. 1878 Germany, d. 1943 Sobibor, Poland)

Freundlich, who began as an Expressionist painter and sculptor, was the inventor of Constructed Art. His sculpture *Der Neue Mensch* was on the cover of the catalogue of the Nazi traveling exhibition *Degenerate Art.*

Heusinger von Waldegg, Joachim. *Otto Freundlich 1878–1943: Monographie mit Dokumentation und Werkverzeichnis.* Cologne: Rheinland-Verlag, 1978.

Otto Freundlich 1878–1943. Pontoise: Musée Tavet-Delacour; Paris: Somogy, 2009.

Poley, Stefanie, "Skizze zu einem 'Museum des neuen Menschen' im 20ste Jahrhundert." In *Kunst im Kontext: Kunstmuseum und Kulturgeschichte.* Weimar: VDG, 1996.

GERTLER, MARK

(b. 1891, d. 1939, British)

One of the leading British artists of the early twentieth century, Gertler painted portraits in an expressive yet classical style.

Carrington, Noel, ed. *Mark Gertler: Selected Letters.* London: Rupert Hart Davis, 1965.

Davies, A. *The East-End Nobody Knows: A History, a Guide, an Explanation.* London: MacMillan, 1990.

MacDougall, Sarah. *Mark Gertler.* London: John Murray, 2002.

GROPPER, WILLIAM

(b. 1897, d. 1977, American)

A caricaturist and cartoonist as well as a painter, Gropper satirized American society in his art.

Baigell, Matthew. *Jewish Artists in New York: The Holocaust Years.* New Brunswick, NJ: Rutgers University Press, 2002.

Dijkstra, Bram. *American Expressionism, Art, and Social Change, 1920–1950.* New York: Harry N. Abrams, 2003.

Lozowick, Louis. *William Gropper.* Philadelphia: Art Alliance Press; New York: Cornwall Books, 1983.

GROSS, CHAIM

(b. 1904 Austria, d. 1991 USA)

Carving mostly in wood, Gross took the human figure as his principal subject. He served as president of the Sculptors Guild of America.

Dijkstra, Bram. *American Expressionism, Art, and Social Change, 1920–1950.* New York: Harry N. Abrams, 2003.

Goodrich, Lloyd, and John I. H. Baur. *Four American Expressionists: Doris Caesar, Chaim Gross, Karl Knaths, Abraham Rattner.* New York: Praeger, 1959.

Opitz, Glenn, ed. *Mantle Fielding's Dictionary of American Painters, Sculptors & Engravers.* Poughkeepsie, NY: Apollo Book, 1986.

GUSTON, PHILIP

(b. 1913 Canada, d. 1980 USA)

Guston, a major Abstract Expressionist painter, astonished the New York art scene when he reverted to figurative and narrative art.

Auping, Michael. *Philip Guston Retrospective.* New York: Thames and Hudson, 2003.

Feld, Ross. *Guston in Time: Remembering Philip Guston.* New York: Counterpoint, 2003.

Mayer, Musa. *Night Studio: A Memoir of Philip Guston.* New York: Knopf, 1991.

HAYDEN, HENRI

(b. 1883 Poland, d. 1970 France)

Associated with the École de Paris and inspired by Cézanne and Picasso, Hayden painted Cubist portraits, genre scenes, and landscapes. Toward the end of his life, his art became more figurative.

Cassou, Jean. *Soixante Ans de Peinture, 1908–1969.* Paris: Musée National d'Art Moderne, 1968.

Chabert, Philippe, ed. *Henri Hayden, 1883–1970.* Cherbourg: Musée Thomas Henry, 1997.

Selz, Jean. *Hayden: Avec une biographie, une bibliographie et une documentation complète sur le peintre et son oeuvre.* Geneva: P. Cailler, 1962.

ISRAËLS, JOZEF

(b. 1824, d. 1911, Dutch)

A major nineteenth century Dutch artist, Israëls depicted humble characters and genre scenes in a realistic style.

De Bodt, Saskia. "Isaac Israels en zijn vader Jozef." In *Isaac Israels, Hollands impressionist.* Scheidam: Scriptum Art, 1999.

Dekkers, Dieuwertje, ed. *Jozef Israëls, 1824–1911.* Zwolle: Waanders, 1999.

Jozef Israels: Son of the Ancient People. Amsterdam: Jewish Historical Museum, 1999.

KABAKOV, ILYA

(b. 1933 Russia, lives in USA)

An emigrant from the former Soviet Union, Kabakov creates installations evoking a dehumanized society.

Goodman, Susan Tumarkin, ed. *Russian Jewish Artists in a Century of Change, 1890–1990.* New York: Prestel, 1995.

Groys, Boris, et al. *Kabakov: Catalogue Raisonne 1957–2008.* Bielefeld, Germany: Kerber Verlag, 2009.

Storr, Robert. Interview with Ilya Kabakov. *Art in America* 83, 1 (1995): 60–69.

KAHLO, FRIDA

(b. 1907, d. 1954, Mexican)

The entirely autobiographical paintings of Kahlo, one of the first feminist artists, often form a dialogue with those of her husband, the muralist Diego Rivera.

Burrus, Christina. "Diego Rivera." In *Diego Rivera, Frida Kahlo.* Martigny, Switzerland: Fondation Pierre Gianadda, 1998.

Herrera, Hayden, et al. *Frida Kahlo.* Minneapolis: Walker Art Center, 2007.

Kahlo, Frida, et al. *The Diary of Frida Kahlo: An Intimate Self-Portrait.* New York: Harry N. Abrams, 2005.

KARS, GEORGES

(b. 1882 Czech Republic, d. 1945 Switzerland)

An artist of the École de Paris, Kars painted many expressive portraits.

Chabert, Philippe Gérard. *Georges Kars, peintures et dessins.* Troyes: Musée d'art moderne, 1983.

Johnon, Joseph. *Kars, la vie et l'oeuvre de Georges Kars.* Lyon: Imprimerie Gle. du Sud Est, 1958.

Nieszawer, Nadine, Marie Boyé, and Paul Fogel. *Peintres juifs à Paris, 1905–1939: École de Paris.* Paris: Denoël, 2000.

KATZ, ALEX

(b. 1927, American)

A figural artist associated with the pop art movement, Katz is known for his cool yet colorful paintings and prints, including many portraits of his wife and friends.

Katz, Alex. *Alex Katz: Seeing, Drawing, Making.* Vero Beach, Florida: Windsor Press, 2008.

Ratcliff, Carter, et al. *Alex Katz.* London: Phaidon Press, 2005.

Storr, Robert, et al. *Alex Katz Paints Ada.* New York: The Jewish Museum; New Haven, CT: Yale University Press, 2006.

KERTÉSZ, ANDRÉ (ANDOR)

(b. 1894 Hungary, d. 1985 USA)

Known for his groundbreaking contributions to photographic composition, Kertész is also recognized for his efforts in establishing the photo essay.

Borhan, Pierre, ed. *André Kertész: His Life and Work.* Boston: Bulfinch, 2000.

Bourcier, Noel. *André Kertész.* London: Phaidon Press, 2001.

Greenough, Sarah, Robert Gurbo, and Sarah Kennel. *André Kertész.* Princeton, NJ: Princeton University Press, 2005.

KIKOÏNE, MICHEL

(b. 1892 Belarus, d. 1968 France)

A major expressionist painter of the École de Paris, Kikoïne drew numerous self-portraits.

Kikoïne et ses amis de l'École de Paris. Paris: Couvent des Cordeliers, 1993.

Nieszawer, Nadine, Marie Boyé, and Paul Fogel. *Peintres juifs à Paris, 1905–1939: École de Paris.* Paris: Denoël, 2000.

Silver, Kenneth, and Romy Golan, eds. *The Circle of Montparnasse: Jewish Artists in Paris, 1905–1945.* New York: Universe Books, 1985.

KISLING, MOISE

(b. 1891 Poland, d. 1953 France)

One of the most famous portraitists in Montparnasse in the 1920s, Kisling painted numerous celebrities.

Kisling, Jean. *Catalogue Raisonné.* Paris: vol. 1, 1971; vol. 2, 1982; vol. 3, 1995.

Malinowsky, Jerzy, and Barbara Brus Malinowska. *W kręgu École de Paris: malarze żydowscy z Polska.* Warsaw: DiG, 2007.

Tasset, Jean Marie. *Kisling. Centenaire.* Paris: Galerie Daniel Malingue, 1991.

KITAJ, RONALD BROOKS

(b. 1932, d. 2007, American)

Closely associated with the School of London, the American Kitaj introduced Jewish themes to his complex narrative figural paintings.

Lambirth, Andrew. *Kitaj*. London: PWP Contemporary Art, 2004.

Livingstone, Marco. *Kitaj*. London: Phaidon Press, 1994.

Kitaj, R. B. *First Diasporist Manifesto*. London: Thames and Hudson, 1989.

KOSSOFF, LEON

(b. 1926, British)

An artist of the School of London, Kossoff paints mostly portraits of friends and family with thick energetic brushstrokes.

Moorhouse, Paul. *Leon Kossoff*. London: Tate Gallery, 1996.

Sylvester, David. "Against the Odds." In *Leon Kossoff: Recent Paintings: British Pavilion, XLVI Venice Biennale*. London: British Council, 1995.

Tojner, Poul Erik. *Kossoff: Selected Paintings 1956–2000*. Humleback, Denmark: Louisiana Museum of Modern Art, 2005.

KRAEMER, NATHALIE

(b. 1891 France, d. 1943 Auschwitz, Poland)

A poet and a painter of the École de Paris, Kraemer painted many family scenes inspired by Russian primitivism.

Memorial in Honour of Jewish Artists Victims of Nazism: Oscar Ghez Collection. Israel: University of Haifa, 1978.

Nieszawer, Nadine, Marie Boyé, and Paul Fogel. *Peintres juifs à Paris, 1905–1939: École de Paris*. Paris: Denoël, 2000.

Shaman, Sanford S., *Kraemer: Oscar Ghez Collection*. Israel: University of Haifa, 1999.

KREMEGNE, PINCHUS

(b. 1890 Lithuania, d. 1981 France)

As an expressionist of the École de Paris,

Kremegne painted in a style similar to that of Soutine.

Miller, Gérard, et al. *Kremegne: L'Expressionnisme sublime*. Paris: Navarin, 1990.

Nieszawer, Nadine, Marie Boyé, and Paul Fogel. *Peintres juifs à Paris, 1905–1939: École de Paris*. Paris: Denoël, 2000.

Waldemar George. *Krémègne*. Paris: Editions "Le Triangle," 1933.

LELLOUCHE, OFER

(b. 1947 Tunisia, lives in Israel)

A well-known Israeli painter and sculptor, and a prolific writer, Lellouche focuses on the human figure.

Lellouche, Ofer. *Aspects of Narcissism: Nude descending a Staircase*. Tel Aviv: Genia Schreiber University Gallery, 1994.

———. *Ofer Lellouche: Self-Portrait*. Tel Aviv: Gordon Gallery, 1980.

Schwarz, Arturo. *Love at First Sight: The Vera, Silvia, and Arturo Schwarz Collection of Israeli Art*. Jerusalem: The Israel Museum, 2001.

LEVINE, JACK

(b. 1915, American)

An American Social Realist, Levine is known for his satirical portrayals of judges, policemen, and other actors of society. He introduced Jewish subjects in his later works.

Dijkstra, Bram. *American Expressionism, Art, and Social Change, 1920–1950*. New York: Harry N. Abrams, 2003.

Frankel, Stephen Robert, ed. *Jack Levine*. New York: Rizzoli International Publications, 1989.

Jack Levine Papers. Smithsonian Archives of American Art.

LEVY, RA'ANAN

(b. 1954 Israel, lives in France)

Mostly known for his self-portraits, Levy also creates colorful still lifes.

Omer, Mordechai, and Nicolas Bréhal.

Ra'anan Levy: Oeuvres sur papier. Paris: Adam Biro, 1997.

Poetics of Space. Tel Aviv: Tel Aviv Museum, 1993.

Ra'anan Lévy. Peinture & Arts graphiques. Paris: Musée Maillol Fondation Dina Vierny, 2007.

LIEBERMANN, MAX

(b. 1847, d. 1935, German)

A founding member of the Berlin Secession at the turn of the twentieth century, Liebermann combined impressionism with realism.

Gilbert, Barbara C., ed. *Max Liebermann: From Realism to Impressionism*. Los Angeles: Skirball Cultural Center, 2005.

Goodman, Susan Tumarkin, ed. *The Emergence of Jewish Artists in Nineteenth-Century Europe*. London: Merrell, 2001.

Makele, Maria Martha. *The Munich Secession*.

LIPCHITZ, JACQUES

(b. 1891 Lithuania, d. 1973 Italy)

Associated with the Cubist sculptors, Lipchitz represented mostly mythological and humanistic subjects in a style that displayed abstract tendencies.

Lipchitz, Jacques. *My Life in Sculpture*. New York: Viking Press, 1972.

Stott, Deborah A. *Jacques Lipchitz and Cubism*. New York: Garland Publishers, 1978.

Van Bork, Bert. *Jacques Lipchitz: The Artist at Work*. New York: Crown Publishers, 1966.

LISSITZKY, EL (LAZAR MARKOVITCH LISSITZKY)

(b. 1890, d. 1941, Russian)

As an artist, designer, photographer, typographer, architect, and polemicist, Lissitzky was an important figure of the Russian avant-garde.

Band, Arnold J., ed. *Had Gadya: The Only Kid, Facsimile of 1919 Edition*. Los Angeles: Getty Research Institute, 2004.

Perloff, Nancy, and Brian Reed, eds. *Situating El Lissitzky: Vitebsk, Berlin, Moscow.* Los Angeles: Getty Research Institute, 2003.

Tupitsyn, Margarita. *El Lissitzky: Beyond the Abstract Cabinet.* New Haven, CT: Yale University Press, 1999.

MANÉ-KATZ, EMMANUEL

(b. 1894 Ukraine, d. 1962 Israel)

Depicting Jewish themes and life in the shtetl in an expressionist style, Mané-Katz was an independent figure related to the École de Paris.

École Juive de Paris. Paris: Celiv, 1995.

Mané-Katz Museum. Haifa, Israel.

Nieszawer, Nadine, Marie Boyé, and Paul Fogel. *Peintres juifs à Paris, 1905–1939: École de Paris.* Paris: Denoël, 2000.

MARCOUSSIS, LOUIS

(b. 1878 Poland, d. 1941 France)

Exploring Cubist tendencies, Marcoussis created mostly decorative still lifes.

Halicka, Alice. *Hier, Souvenirs.* Paris: Éditions du Pavois, 1946.

Lafranchis, Jean. *Marcoussis: Sa vie, son oeuvre, catalogue complet des peintures, fixés sur verre, aquarelles, dessins, gravures.* Paris: Éditions du Temps, 1961.

Nieszawer, Nadine, Marie Boyé, and Paul Fogel. *Peintres juifs à Paris, 1905–1939: École de Paris.* Paris: Denoël, 2000.

MAREVNA (VOROBËV STEBELSKA)

(b. 1892 Russia, d. 1984 Great Britain)

A friend of many artists and intellectuals, Marevna painted numerous Montparnasse personalities in a unique style combining Pointillism and Cubism.

Nieszawer, Nadine, Marie Boyé, and Paul Fogel. *Peintres juifs à Paris, 1905–1939: École de Paris.* Paris: Denoël, 2000.

Pelleix, Georges. *Marevna et les Montparnos.* Paris: Musée de la Ville de Paris, 1985.

Silver, Kenneth, and Romy Golan, eds. *The*

Circle of Montparnasse: Jewish Artists in Paris, 1905–1945. New York: Universe Books, 1985.

MEIDNER, LUDWIG

(b. 1884, d. 1966, German)

A major German Expressionist, Meidner took up apocalyptic and prophetic themes. He later produced milder, colorful portraits.

Lorquin, Bertrand, Annette Vogel, and Hans Wilderotter. *Allemagne, les années noires.* Paris: Gallimard, 2007.

Ludwig Meidner, An Expressionist Master. Ann Arbor, MI: The Museum, 1978.

Ludwig und Else Meidner. Frankfurt am Main: Jüdisches Museum Frankfurt am Main, 2002.

MICHONZE, GRÉGOIRE

(b. 1902 Russia, d. 1982 France)

Loosely associated with the Surrealist painters, Michonze painted poetic village and genre scenes.

Kikoïne et ses amis de l'École de Paris. Paris: Couvent des Cordeliers, 1993.

Maxime Alexandre vu par ses amis: Le cinquantenaire du Surréalisme. Brussels: Henry Fagne, 1975.

Nieszawer, Nadine, Marie Boyé, and Paul Fogel. *Peintres juifs à Paris, 1905–1939: École de Paris.* Paris: Denoël, 2000.

MODIGLIANI, AMEDEO

(b. 1884 Italy, d. 1920 France)

A sculptor as well as a painter, Modigliani was totally devoted to the human figure, which he often stylized.

Braun, Emily, et al. *Modigliani and His Models.* London: Royal Academy, 2006.

Camerlati, Doriana, ed. *Modigliani: The Melancholy Angel.* Milan: Skira, 2002.

Klein, Mason, ed. *Modigliani: Beyond the Myth.* New York: The Jewish Museum; New Haven, CT: Yale University Press, 2004.

MONDZAIN, SIMON

(b. 1888 Poland, d. 1979 France)

An artist of the École de Paris, Mondzain created expressive portraits. He also painted many landscapes.

Grabska, Elzbieta. *Autour de Bourdelle: Paris et les artistes Polonais, 1900–1918.* Paris: Paris-Musées, 1996.

Nieszawer, Nadine, Marie Boyé, and Paul Fogel. *Peintres juifs à Paris, 1905–1939: École de Paris.* Paris: Denoël, 2000.

Silver, Kenneth, and Romy Golan, eds. *The Circle of Montparnasse: Jewish Artists in Paris, 1905–1945.* New York: Universe Books, 1985.

NIKRITIN, SOLOMON

(b. 1898 Ukraine, d. 1965 Russia)

A leading figure of the artistic resistance to the Soviet dictatorship, Nikritin painted human beings living in an oppressive atmosphere.

L'Avant Guarde Russe. Paris: Fondation Dina Vierny-Musée Maillol, RMN, 2008.

Goodman, Susan Tumarkin, ed. *Russian Jewish Artists in a Century of Change, 1890–1990.* New York: Prestel, 1995.

The Great Utopia: The Russian and Soviet Avant Garde, 1915–1932. New York: Solomon R. Guggenheim Museum, 1992.

NUSSBAUM, FELIX

(b. 1904 Germany, d. 1944 Auschwitz, Poland)

An established painter in Germany before World War II, Nussbaum produced several haunting self portraits in the years preceding his deportation.

Amishai Maisels, Ziva. *Depiction and Interpretation: The Influence of the Holocaust on the Visual Arts.* Oxford: Pergamon Press, 1993.

Bilski, Emily. "Felix Nussbaum: A Mirror of his Time." In *Art and Exile: Felix Nussbaum, 1904–1944.* New York: The Jewish Museum, 1985.

Faster, Karl Georg. *Felix Nussbaum: Art Defamed, Art in Exile, Art in Resistance.* Translated by Eileen Martin. Woodstock, New York: The Overlook Press, 1997.

ORLOFF, CHANA

(b. 1888 Ukraine, d. 1968 Israel)

A successful figurative sculptor in Paris, Orloff made portraits of several noted personalities. The theme of the mother and child was one of her favorites.

Coutard-Salmon, G., et al. *Chana Orloff.* Paris: Shakespeare & Co., 1980.

Nieszawer, Nadine, Marie Boyé, and Paul Fogel. *Peintres juifs à Paris, 1905–1939: École de Paris.* Paris: Denoël, 2000.

Silver, Kenneth, and Romy Golan, eds. *The Circle of Montparnasse: Jewish Artists in Paris, 1905–1945.* New York: Universe Books, 1985.

PACANOWSKA, FELICIA

(b. 1907 Poland, d. 2002 Italy)

Well-known in Rome and Paris in the early twentieth century, Pacanowska painted many portraits. Her style became more abstract after the Holocaust.

Adhemar, Jean. *Art Graphique Français contemporain.* Paris : Bibliothèque Nationale de France, 1988.

Matura, Bruno et al. *Felicia Pacanowska.* Rome: Studio D'Arte Modena, 1971.

PASCIN, JULES

(b. 1885 Bulgaria, d. 1930 Paris)

A painter of Parisian nightlife, Pascin depicted mostly women; he quickly gained international recognition.

Hemin, Yves, et al. *Pascin: Catalogue Raisonné.* Paris: A. Rambert, 1984–91.

Nieszawer, Nadine, Marie Boyé, and Paul Fogel. *Peintres juifs à Paris, 1905–1939: École de Paris.* Paris: Denoël, 2000.

Pascin: Le proxénète de la peinture. Paris: Fondation Dina Vierny-Musée Maillol, RMN, 2007.

PEARLSTEIN, PHILIP

(b. 1924, American)

A figurative artist related to the pop art movement, Pearlstein paints nude figures in cold, theatrical decorative settings.

Bowman, Russell. *Philip Pearlstein: The Complete Paintings.* New York: Alpine Fine Arts Collection Ltd., 1983.

Perreault, John. *Philip Pearlstein: Drawings and Watercolors.* New York: Abrams, 1988.

Storr, Robert. *Philip Pearlstein: Since 1983.* New York: Harry N. Abrams, 2002.

PISSARRO, CAMILLE

(b. 1830 Danish Caribbean, d. 1903 France)

The "patriarch" of the Impressionists, Pissarro later painted a number of self-portraits that defy categorization.

Mirzoeff, Nicholas. "Inside/Out: Jewishness Imagines Emancipation." In *The Emergence of Jewish Artists in Nineteenth-century Europe*, edited by Susan Tumarkin Goodman. London: Merrell, 2001.

———. "Pissarro's Passage: The Sensation of Caribbean Jewishness in Diaspora." In *Diaspora and Visual Culture: Representing Africans and Jews.* London: Routledge, 2000.

Shikes, Ralph E., and Paula Harper. *Pissarro, His Life and Work.* New York: Horizon Press, 1980.

REMBRANDT VAN RIJN

(b. 1606, d. 1669, Dutch)

A friend and painter of the Jews of seventeenth-century Amsterdam, Rembrandt's portraits inspired an overwhelming number of Jewish artists throughout the twentieth century.

Mirjam, Alexander-Knotter, Jasper Hillegers, and Edward van Voolen. *De 'Joodse' Rembrandt: De mythe ontrafeld.* Zwolle: Uitgeverij Waanders; Amsterdam: Joods Historisch Museum, 2006.

Nadler, Steven. *Rembrandt's Jews.* Chicago: University of Chicago Press, 2003.

Schama, Simon. *Rembrandt's Eyes.* New York: Alfred A. Knopf, 1999.

ROTHKO, MARK

(b. 1903 Russia, d. 1970 USA)

According to recent studies, Rothko's Abstract Expressionism may have been related to the Holocaust. His prewar work was realistic, as was that of most Jewish painters of his generation.

Ashton, Dore. *About Rothko.* New York: Da Capo Press, 1996.

Baigell, Matthew. *American Artists, Jewish Images.* Syracuse, NY: Syracuse University Press, 2006.

Mark Rothko Files. Smithsonian Archives of American Art.

SCHOENBERG, ARNOLD

(b. 1874 Austria, d. 1951 USA)

Mainly known for revolutionizing contemporary music, Schoenberg started his career as a painter and produced over one hundred haunting self-portraits before becoming a composer.

Da Costa Meyer, Esther. "Schoenberg's Echo. The Composer as Painter." In *Schoenberg, Kandinsky and the Blue Rider*, edited by Fred Wasserman and Esther Da Costa Meyer. New York: The Jewish Museum; London: Scala, 2003.

Gilman, Sander. "The Jew's Body: Thoughts on Jewish Physical Differences." In *Too Jewish? Challenging Traditional Identities*, edited by Norman Kleeblatt. New York: The Jewish Museum; New Brunswick, NJ: Rutgers University Press, 1996.

Heyd, Milly. "Arnold Schoenberg's Self-Portraits between 'Iconism' and 'Anti-Iconism': The Jewish-Christian Struggle." In *Ars Judaica.* Ramat Gan, Israel: The Bar-Ilan Journal of Jewish Art, 2005.

SCHRETER, ZYGMUND

(b. 1886 Poland, d. 1977 France)

Schreter mostly painted harmonious landscapes. However, the darker portraits he produced around World War II were influenced by German Expressionism.

Aronson, Chil. *Bilder un geshtaltn fun Monparnas.* Paris: n.p., 1963.

Bréon, Emmanuel. *L'École de Paris-Boulogne.* Paris: Musée municipal de Boulogne-Billancourt, 1988.

Nieszawer, Nadine, Marie Boyé, and Paul Fogel. *Peintres juifs à Paris, 1905–1939: École de Paris.* Paris: Denoël, 2000.

SEGAL, ARTHUR

(b. 1875 Romania, d. 1944 Great Britain)

Influenced by various stylistic currents such as those of Expressionism, Cubism, and Dadaism, Segal often expressed antiwar themes.

Arthur Segal: A Collection of Drawings, 1908–1918. London: Alpine Club, 1977.

Arthur Segal: Memorial Exhibition of Oil Paintings, Woodcuts, Sculpture (1894–1944). London: Royal Society of British Artists Galleries, 1945.

SEGAL, GEORGE

(b. 1924, d. 2000, American)

Well known for his life-size cast plaster figures, Segal often addressed Jewish themes in his work.

Busch, Julia M. *A Decade of Sculpture: The 1960s.* Philadelphia: Art Alliance Press; London: Associated University Presses, 1974.

Livingstone, Marco. *George Segal: Retrospective: Sculptures, Paintings, Drawings.* Montreal Museum of Fine Arts, 1997.

Pachner, Joan, and Janis Carroll. *George Segal: Bronze.* New York: Mitchell Innes & Nash, 2003.

SEGALL, LASAR

(b. 1891 Lithuania, d. 1957 Brazil)

A German Expressionist painter, Segall fled Germany for Brazil, where he became famous. His style evolved into milder expressive figuration.

D'Alessandro, Stephanie. *Lasar Segall: Nouveaux Mondes.* Paris: Musée d'Art et

d'Histoire du Judaïsme; Societé Nouvelle Adam Biro, Musée d'art et d'histoire du Judaisme, 2000.

———. *Still More Distant Journeys: The Artistic Emigrations of Lasar Segall.* Chicago: David and Alfred Smart Museum of Art, 1997.

Nieszawer, Nadine, Marie Boyé, and Paul Fogel. *Peintres juifs à Paris, 1905–1939: École de Paris.* Paris: Denoël, 2000.

SHAHN, BEN

(b. 1898 Lithuania, d. 1969 USA)

A Social Realist, Shahn often addressed Jewish themes in his work. In his lifetime, he was one of the most-collected Jewish artists in the United States.

Amishai-Maisels, Ziva. "Ben Shahn and the Problem of Jewish Identity." *Jewish Art* 12–13 (1986–87): 304–19.

Baigell, Matthew. *American Artists, Jewish Images.* Syracuse, NY: Syracuse University Press, 2006.

Chevlowe, Susan, ed. *Common Man, Mythic Vision: The Paintings of Ben Shahn.* Princeton, NJ: Princeton University Press, 1998.

SOUTINE, CHAIM

(b. 1893 Lithuania, d. 1943 Paris)

Well known for his expressionistic portraits, Soutine also painted landscapes and still lifes with an anthropomorphic vitality.

Kleeblatt, Norman L., et al. *An Expressionist in Paris: The Paintings of Chaim Soutine.* New York: Prestel, 1998.

Soutine. Paris: Pinacothèque de Paris, 2007.

Tuchman, Maurice, ed. *Chaim Soutine (1893–1943): Catalogue Raisonné.* Cologne: Taschen, 1993.

SOYER, RAPHAEL

(b. 1899, d. 1987, American)

A Social Realist painter whose work conveys empathy, Soyer was also considered one of the best portrait painters of his time.

Baskind, Samantha. *Raphael Soyer and the*

Search for Modern Jewish Art. Chapel Hill: University of North Carolina Press, 2004.

Brown, Milton W. *Raphael Soyer.* New York: Forum Gallery, 1989.

Soyer, Raphael. *Self-Revealment: A Memoir.* New York: Maecenas Press, 1969.

STROSBERG, SERGE

(b. 1966 Belgium, lives in USA)

A well-established painter in Europe, Strosberg has recently settled in New York, where he pursues his portrait painting with deep psychological insight.

Deppner, Martin Roman, ed. *The Hidden Trace: Jewish Paths through Modernity.* Bramsche: Rasch, 2008.

Engoren, Jan. "Serge Strosberg: Of Men and Flowers." *Art of the Times,* Palm Beach, spring 2009.

Zaragovia, Veronica. "Artists gain inspiration from Judaism." *Sun Sentinel,* Florida, January 17, 2007.

TYSHLER, ALEXANDER

(b. 1898, d. 1980, Russian)

One of the most individualistic figurative painters, Tyshler created allegorical paintings often based on Jewish life.

Alexander Tyshler. Moscow: Pushkin Museum of Visual Arts, 1966.

Goodman, Susan Tumarkin, ed. *Russian Jewish Artists in a Century of Change, 1890–1990.* New York: Prestel, 1995.

Syrkina, F. *Aleksandr Grigorevich Tyshler.* Moscow: Sovetskii khudozhnik, 1966.

WEBER, MAX

(b. 1881 Poland, d. 1961 USA)

After introducing Cubism to the United States, Weber went on to explore Jewish themes.

Harnsberger, R. Scott. *Four Artists of the Stieglitz Circle: A Sourcebook on Arthur Dove, Marsden Hartley, John Marin, and Max Weber.* Art Reference Collection, No. 26. Westport, CT: Greenwood Press, 2002.

Weber, Max. *An Exhibition of Oil and Tempera Paintings, Gouaches, Pastels, Woodcuts, Lithographs and Drawings. Celebrating the Artist's 75th Birthday.* New York: The Jewish Museum, 1956.

Werner, Alfred. *Max Weber.* New York: Abrams, 1975.

ZACK, LEON

(b. 1892 Russia, d. 1980 France)

Originally a figurative painter with expressive tendencies, Zack focused on abstraction after the Shoah.

Maulpoix, Jean-Michel. *Léon Zack ou l'instinct de ciel (Le Miroir oblique).* Paris: Editions de la Différence, 1990.

Nieszawer, Nadine, Marie Boyé, and Paul Fogel. *Peintres juifs à Paris, 1905–1939: École de Paris.* Paris: Denoël, 2000.

Zack, Florent. *Léon Zack: Catalogue de l'oeuvre peint.* Paris: Les Editions de L'amateur, 1993.

ZADKINE, OSSIP

(b. 1890 Russia, d. 1967 France)

Influenced initially by Rodin and then by Cubism, Zadkine later mainly depicted expressive human and mythological figures.

Lecombre Sylvain. *Ossip Zadkine, L'oeuvre sculpté.* Paris: Paris Musées, 1994.

Ossip Zadkine. London: British Arts Council, 1961.

Prax, Valentine. *Avec Zadkine: Souvenirs De Notre Vie.* Lausanne: La Bibliothèque des Arts, 1973.

ZAK, EUGÈNE

(b. 1884 Poland, d. 1926 France)

An early member of the École de Paris, Zak depicted humble people with empathy.

Brus-Malinowska, Barbara. *Eugeniusz Zak, 1884–1926.* Warsaw: National Museum, 2004.

Brus-Malinowska, Barbara, et al. *Peintres Polonais en Bretagne (1890–1939).* Quimper: Musée départemental Breton; Editions Palantines, 2004.

Nieszawer, Nadine, Marie Boyé, and Paul Fogel. *Peintres juifs à Paris, 1905–1939: École de Paris.* Paris: Denoël, 2000.

Index of Names

Abbot, Berenice (photographer, 1898 USA–1991), 130
Abel (biblical figure), 40, 60
Abelard, Petrus (writer, 1079 Fr–1142), 42
Abrabanel, Isaac (rabbi, 1437 Sp–1508 It), 69
Abraham (biblical figure), 38, 40, 52, 60, 63
Adam (biblical figure), 58
Adler, Cyrus (scholar, 1863–1940 USA), 149
Adler, Jankel (painter, 1895 Pol–1949 GB), 100, 126; 57
Adorno, Theodor (philosopher, 1903 G–1969 USA), 140, 160
Ahasuerus (king of Persia, 7th century BCE), 52, 78
Akhenaton (Egyptian pharaoh, c. 1372–1354 BCE), 61
Akiva (rabbi, 50–135 Isr), 52, 63
Alban, Aram (photographer, 1883–1961 Fr), 130
Aleichem, Shalom (Yiddish writer, 1859 R–1916 USA), 85–86
Alexander II (Russian czar, 1818–1881), 89
Alfonso X (king of Spain, 1221–1284), 69
Allen, Woody (writer and movie director, 1936 USA–), 38
Altman, Natan (artist, 1889 R–1970 USA), 90
Ancona, Levi d' (painter, 1825 It–1884), 119, 120
Ansky (writer, 1863 Belarus–1920 Pol), 90
Apollinaire, Guillaume (writer, 1880 It–1918 Fr), 116, 126, 128, 130
Arama, Isaac (rabbi, c. 1420 Sp–1494), 69
Arendt, Hannah (philosopher, 1906 G–1975 USA), 58, 80, 81, 136, 149
Arikha, Avigdor (painter, 1929 Rom–Fr), 141–43; 87
Arletty (actress, 1898 Fr–1992), 122
Aronson, Chil (writer, 1898 Pol–1966 Fr), 118, 119

Artaud, Antonin (writer and artist, 1896 Fr–1948), 136
Auerbach, Frank (painter, 1931 G–GB), 20, 61, 143–49; 89
Augustus (Roman emperor, 63 BCE–14 CE), 37, 62
Auster, Paul (writer, 1947 USA–), 38

Babel, Isaac (writer, 1894 Ukr–1941 R), 164
Bacon, Francis (painter, 1902 Irl–1992), 144
Bagel, Moses (painter, 1908 Lit–1995 Fr), 32
Bakst, Leon (artist, 1866 R–1924 Fr), 90, 126
Balthus (painter, 1908 Fr–2001 Sw), 30, 36, 116, 136, 141–45
Bar Kokhba (political leader, ?–Isr–135 CE), 63
Barnes, Alfred (art collector, 1872 USA–1951), 122, 160
Baselitz, Georg (painter, 1938 G–), 164
Baskin, Leonard (artist, 1922 USA–2000), 154
Basler, Adolph (critic and art dealer, 1878 Pol–1949 Fr), 116, 118, 120, 122, 125; 72
Bataille, George (writer, 1897 Fr–1962), 134, 136, 141
Bauer, Bruno (philosopher, 1809 G–1882), 81
Baum, Oscar (writer, 1883 Cz–1941), 99
Baur, John I. H. (art critic, 1909 USA–1987), 30
Bayazid II (Turkish sultan, 1447?–1512), 47
Beckett, Samuel (writer, 1906 Irl–1989 Fr), 143
Beckmann, Max (painter, 1884 G–1950 USA), 164
Beilis, Menahem (1874 Ukr–1934), 89
Bell, Vanessa (painter, 1879 GB–1961), 97
Bellows, George (painter, 1882 USA–1925), 152

Ben Ben, painter (1884 R–1983 USA), 152
Ben Israel, Menasseh (1604 Port–1657 Holl), 70–72; 38
Ben-Yehuda, Eliezer (Hebrew lexicographer, 1858 Lit–1922), 86
Benamozegh, Elia (rabbi, 1822 It–1900), 119
Benguiat, Ephraïm (art collector, ?–1926 USA), 149
Benjamin (biblical figure), 40
Benjamin, Walter (writer, 1892 G–1940 Sp), 54, 136
Benton, Thomas Hart (painter, 1889 USA–1975), 152
Berenson, Bernard (art historian, 1865 Lit–1959 USA), 39
Bergson, Henri (philosopher, 1859 Fr–1941), 78, 88, 138
Berlewi, Henryk (artist, 1894 Pol–1967 Fr), 89; 49
Berlin, Isaiah (philosopher, 1909 Latvia–1997 GB), 39
Berliner, Isaac (writer, 1899 Pol–1957 Mexico), 138
Bernanos, Georges (writer, 1888 Fr–1948) 136
Bezalel (first artist, biblical period), 22, 26, 143
Bialik, Hayyim (Hebrew poet, 1873 Ukr–1934 Au), 82, 86, 90, 126
Bing, Ilse (photographer, 1899 G–1998 USA), 130
Bismarck, Otto von (statesman, 1815 G–1898), 81
Blanchot, Maurice (writer, 1907 Fr–2003), 136
Blatas, Arbit (painter, 1908 Lit–1999 USA), 112
Bleichröder, Gerson von (banker, 1822 G–1893), 81
Bloch, Ernst (philosopher, 1885 G–1977), 54, 140
Blondel, André (painter, 1909 Pol–1949 Fr), 28
Bloom, Hyman (painter, 1913 Latvia–USA), 157, 158
Blum, Leon (statesman, 1872 Fr–1950), 111

Blumenfeld, Erwin (photographer, 1897 G–1969), 131
Bomberg, David (painter, 1890 GB–1957), 20, 94–95, 97, 98, 143, 146; 52
Bondy, Walther (painter, 1883 Hgr–1940 Fr), 110
Borges, Jorge Luis (writer, 1899 Argentina–1986 Sw), 149
Borofsky, Jonathan (sculptor, 1942 USA–), 166
Botticelli, Sandro (painter, 1445 It–1510), 118, 138
Brandon, Edouard (painter, 1831 Fr–1897), 26, 77; 41
Braque, Georges (painter, 1882 Fr–1963), 130
Brasillach, Robert (writer, 1909 Fr–1945), 136
Brassaï (photographer, 1899 Hgr–1984 Fr), 130, 131
Brauner, Victor (painter, Rom 1903–1966 Fr), 136
Breton, André (writer, 1884 Fr–1968), 134–36
Brod, Max (writer, 1884 Cz–1958 Isr), 99
Broderson, Moshe (poet, 1890 Pol–1956), 89
Brodsky, Isaac (painter, 1884 R–1930), 90
Bruskin, Grisha (painter, 1945 R–USA), 167
Buber, Martin (philosopher, 1878 Au–1965 Isr), 26, 85, 140
Bulatov, Erik (painter, 1933 Ukr–Fr), 170

Caesar, Julius (Roman leader, 100–44 BCE), 47, 62
Cain (biblical figure), 40, 60
Camus, Albert (writer, 1913 Alg–1960 Fr), 164
Capa, Robert (photographer, 1913 Hgr–1954 Vietnam), 131
Cardozo, Ribeyro Jacob (artist, c. 1620–1700 Holl), 70
Carrington, Dora (artist, 1893 GB–1932), 95, 97

Casimir the Great (king of Poland, 1310–1370), 37, 86

Cassin, René (lawyer and statesman, 1887 Fr–1976), 52

Cassirer, Ernst (philosopher, 1874 Pol–1945 USA), 52, 84, 99

Cassirer, Paul (art dealer, 1871 G–1926), 82, 100, 106

Céline, Louis-Ferdinand (writer, 1894 Fr–1961), 136

Cendrars, Blaise (writer, 1887 Sw–1961 Fr), 116, 126

Cervantes, Miguel de (writer, 1547 Sp–1616), 39

Cézanne, Paul (painter, 1839 Fr–1906), 78, 82, 94, 98, 100, 164

Chagall, Marc (painter, 1887 Belarus–1985 Fr), 23, 24, 26, 36, 40, 45, 48, 52, 67, 90, 92, 102, 110, 112, 118, 119, 125–27, 150, 158; *13, 23, 36, 76*

Chamberlain, Houston (politician, 1855 GB–1927 G), 98, 136

Chapiro, Jacques (painter and writer, 1887 Belarus–1972 Fr), 106

Charcot, Martin (neurologist, 1825 Fr–1893), 136

Charensol, Georges (art critic, 1899 Fr–1995), 118

Charlemagne (Carolingian emperor, 742 G–814), 37, 65

Chicago, Judy (artist, 1939 USA–), 54

Chim (photographer, 1911 Pol–1956), 131

Clark, Kenneth (art historian, 1903 GB–1983), 98

Cocteau, Jean (poet and artist, 1889 Fr–1963), 122

Cohen, Hermann (philosopher, 1842 G–1918), 84, 99, 140

Colette, Sidonie Gabrielle (writer, 1873 Fr–1954), 122

Corinth, Lovis (painter, 1858 G–1925 Holl), 26

Corot, Camille (painter, 1796 Fr–1825), 155

Courbet, Gustave (painter, 1819 Fr–1877), 82, 144

Crémieux, Adolphe (statesman, 1796 Fr–1880), 69, 78

Cresques, Abraham (geographer, 1387 Sp–?), 69

Cresques, Judah (geographer, 1360 Sp–?), 69

Cromwell, Oliver (statesman, 1599 GB–1658), 37, 72

Csàky, Josef (sculptor, 1888 Hgr–1971 Fr), 110

Curry, John Steuart (painter, 1897 USA–1997), 152

D'Orta, Samuel (painter, c. 1650 Holl–1700), 70

Da Costa, Catherine Mendes (painter, 1678 GB–1756), 92; *39*

Da Costa, Uriel (1585 Port–1640 Holl), 72, 119

Daniel (biblical prophet), 62

David (king of Israel, c. 1010–950 BCE), 52, 54, 62, 63, 82

David, Jacques-Louis (painter, 1748 Fr–1825), 90

De Chaves, Aron (artist, c. 1650 Holl–1700), 72

De Chirico, Giorgio (painter, 1888 Greece–1978 It), 104, 136, 144,

De Hooghe, Romijn (painter, 1629 Holl–1684), 70

De Kooning, Willem (painter, 1904 Holl–1995 USA), 164

De Pinto, Isaac (philosopher and economist, 1717 Fr–1787 Holl), 76

De Salinas, Abraham Yom Tov (artist, c. 1406 Sp–?), 69

De Salinas, Bonastruc (artist, c. 1438 Sp–?), 69

Degas, Edgar (painter, 1834 Fr–1917) 94, 155

Delacroix, Eugène (painter, 1798 Fr–1863), 68

Delaunay, Robert (artist, 1885 Fr–1941), 130

Delaunay, Sonia (artist, 1885 R–1979 Fr), 130

Della Francesca, Piero (painter, 1420 It–1492), 164

Deutscher, Isaac (writer, 1907 Pol–1967 It), 36

Diaghilev, Serge de (impresario, 1872 R–1929 It), 90, 126

Diderot, Denis (philosopher, 1713 Fr–1784), 37

Dine, Jim (artist, 1935 USA–), 164, 167

Disraeli, Benjamin (statesman, 1804 GB–1880), 94, 98

Dix, Otto (painter, 1891 G–1960), 144

Dobrinsky, Isaac (painter, 1891 Ukr–1973 Fr), 106; *62*

Dove, Arthur (painter, 1880 USA–1946), 152

Dreyfus, Alfred (army officer, 1859 Fr–1935), 20, 36, 77, 78, 80, 106, 131

Drieu La Rochelle, Pierre (writer, 1893 Fr–1945), 136

Duchamp, Marcel (artist, 1887 Fr–1968), 136

Dürer, Albrecht (artist, 1471 G–1528), 138, 144

Eakins, Thomas (artist, 1844 USA–1916), 155

Ehrenburg, Ilya (writer, 1891 Ukr–1967 R), 110

Einstein, Albert (physicist, 1879 G–1955 USA), 48, 99, 155

Eisner, Kurt (politician, 1867 G–1919), 98

Elijah (biblical prophet), 63

Eliot, Thomas Stearns (writer, 1888 G–1965 GB), 98, 149, 164

Engels, Friedrich (philosopher, 1820 G–1895 GB), 136

Ensor, James (painter, 1860 Belg–1949), 104, 164

Epstein, Henri (artist, 1891 Pol–1944 Auschwitz Pol), 112, 118

Epstein, Jacob (sculptor, 1880 USA–1959), 144, 145; *53*

Ernst, Max (painter, 1891 G–1976 Fr), 130, 136

Esther (Queen of Persia, 7th century BCE), 52, 78

Ezekiel (biblical prophet, 8th century BCE), 62

Ezra (biblical prophet, 5th century BCE), 62, 68

Falk, Robert (painter, 1886 R–1958), 92

Fasini, Alexandre (painter, 1892 Ukr–1942 Auschwitz Pol), 136; *83*

Feder, Adolphe (painter, 1885 Ukr–1943 Auschwitz Pol), 112

Felixmuller, Conrad (painter, 1897 G–1977), 102

Fels, Florent (art critic, 1893 Fr–1997), 110, 116, 118

Fenster, Hersch (Yiddish writer, 1892 Pol–1964 Fr), 106, 118, 119

Fenyes, Adolph (painter, 1867 Hgr–1945), 26

Feuchtwanger, Lion (writer, 1884 G–1958 USA), 99

Flinck, Govaert (artist, 1615 Holl–1660), 70

Ford, Henry (industrialist, 1863 USA–1947), 137

Fragonard, Jean-Honoré (painter, 1732 Fr–1806), 118

Freud, Lucian (painter, 1929 G–GB), 48, 50, 143–46; *34, 82, 88*

Freud, Sigmund (psychoanalyst, 1856 Cz–1939 GB), 20, 24, 34, 48, 55, 60, 61, 84, 99, 132, 133, 136, 140, 143, 144, 146

Freund, Gisèle (photographer, 1912 G–2000 Fr), 131

Freundlich, Otto (artist, 1878 G–1943 Sobibor Pol), 110, 130; *66, 67*

Fromm, Erich (psychoanalyst, 1900 G–1980 Sw), 140

Fry, Roger (art critic, 1866 GB–1934), 94, 95, 97, 136, 152

Fry, Varian (journalist, 1908 USA–1967), 136

Fuentes, Carlos (writer, 1928 Panama–), 69

Gabo, Naum (sculptor, 1890 R–1977 USA), 90

Index of Subjects

abstract art, 30, 89, 95, 98, 100, 110, 127, 130, 141, 143, 148, 149, 152, 154, 158, 160, 164, 167
Abstract Expressionism, 54, 149, 154, 157, 160, 163, 164, 173
academies. *See* art schools, schools
Adonai (name of God), 52
aesthetics, 18, 44, 85, 102, 134, 140, 158, 160, 173
Africa, 40, 63, 66, 68, 77, 167
African-Americans, 154
afterlife, 54
agnosticism, 36
Alexandria, 52, 63
alienation, 20, 21, 38, 126, 148, 170
Alliance Israelite Universelle, 69
alphabet, Hebrew, 42
America. *See* United States
American Expressionism, 29, 30, 154, 160, 173
American Scene, 150, 152, 154
Amsterdam, 70, 72, 82
anarchism, 77
angels, 22, 51, 52, 126
aniconism, 24, 62
animals, 23, 45, 51, 52, 104, 106, 122, 126, 146
anthropology, 61
anthropomorphism, 23, 122
antiquity, 18, 22, 54, 62–63, 65
anti-Semitism, 20, 29, 36, 39, 54, 55, 65, 76, 80, 84, 89, 98, 99, 102, 118, 119, 131, 136, 137, 140, 141, 154, 157, 160, 167
Arabic culture, Jews and, 37, 66–69
Aramaic, 39, 63, 64
archaeology, 77
archetypes, Jungian, 160
architecture, 62–64, 81, 144
Ark of the Covenant, 38, 60, 63, 72
Armory Show, 116, 152
art collecting, 77, 80, 81 106, 149, 160
art critics, 20, 29, 30, 36, 49, 54, 80, 94, 96, 99, 106, 110, 116, 118, 122, 141, 149, 152, 154, 160
art dealers, 82, 88, 106, 116, 117, 122, 126

art history, 18, 23, 29, 84, 85, 100, 138, 143, 160, 164
Art Nouveau, 78, 90
art schools, 88, 90, 94, 97, 106, 127
Aryans, 76
Ashcan School, 152
Ashkenazim, 34, 39, 65, 70, 80, 119
assimilation of Jews, 34, 36, 54, 69, 78, 80, 82, 84, 98, 106, 118, 149, 160
assymetry, 40
Assyria, 38, 44
astronomy, 69
atheism, 34
Athens, p.36
Aton (Egyptian deity), 61
Aufklarung, 99
Auschwitz, 140, 160
Austria, 81, 84, 86, 102, 122, 127
Austro-Hungarian Empire, 86
autobiography, 106, 126, 138, 143, 146, 149, 154–55
auto-da-fe, 70
Autoemancipation, 85
automatism, Surrealist, 134, 158
Auvers-sur-Oise, 78
avant-gardes, 18, 92, 127, 136

Babylon, 37, 38, 62, 63, 66
Ballets Russes, 90, 126
bankers, 70, 81
baptism, 34, 80, 94
Bar mitzvah, 45
baroque ornamentation, 23
Basel, 26, 85
Bauhaus, 102
Bavaria, 54, 82
Bayreuth, 98
Beaux Arts Gallery, 144
Belarus, 86
Belgium, 77, 89, 104, 167
Ben Uri Society, 94, 98
Berlin, 26, 29, 80, 82, 85, 89, 99–103, 106, 126, 144
Berlin Secession, 82, 100
Bessarabia, 86
bet midrash, 42
Bezalel School of Arts and Crafts, 22, 29, 143

Bible, 18, 20, 21, 22, 24, 38, 40, 42, 45, 48, 52, 54, 55, 58, 60, 61–63, 66, 70, 126, 141, 157, 158, 160
Bibliothèque Nationale de France, 130, 131
biography, 20, 97, 119, 148
Bi'ur, 80, 85
Black Death, 65
Blaue Reiter, Der, 100, 102
blood, 51, 62, 69, 77, 138
Bloomsbury, 94, 97, 98
B'nai Brith, 55
Bohemia (region), 92
Bolshevism, 92, 110, 154, 171
books, 20, 34, 66, 84, 85, 138, 140, 141, 143, 144, 149
Bordeaux, 39, 70, 76, 77
Brandenburg Gate, 82
Brazil, 72, 100
Breslau, 81, 116
brit milah, 42
Britain. *See* England
British Museum, 94, 95, 141
Brittany, 80, 88, 106
Brooklyn, 153, 157, 167
Brucke, Die, 102
Budapest, 26, 80
Bukovina, 80
Bund (political party), 54, 89, 90, 106, 119
Byzantine art, 120
Byzantine Empire, 65

Cairo, 66
California, 164
calligraphy, 44
Calvinism, 70
Camden Town, 94
Caribbean, 77
Carolingian era, 65
caryatids, 29, 120
Catholicism, 69, 70, 80, 138, 144
cemeteries, 23, 66
census, Polish, 88
charity, 44
cherubim, 60
children and childhood, 21, 36, 40, 45–52, 60, 80, 106, 125
chosen people, 37
Christ, 24, 92

Christianity, 24, 45, 52, 64–66, 85, 86, 98, 122, 127
chronology, historical, 38
Cicerone (periodical), 118
circumcision, 42, 45, 60, 65, 70
civil rights, 63, 72, 82
clowns, 94, 125
coins, 51, 63
Cold War, 146
color in art, 29, 44, 51, 84, 88, 102, 104, 125, 126, 143, 144, 148, 157, 164, 167
communism, 136, 149, 154, 157
composers, 77, 81, 99
compulsion, Sigmund Freud's views on, 60, 84
concentration camps, 110, 119, 142
conceptual art, 143, 148, 164, 170
conscience, 24, 29, 55
Constructivism, 89, 127
conversion, 24, 34, 36, 39, 52, 69, 80, 118
conversos, 69, 70
Cossacks, 86
Covenant, 38, 40, 44, 51, 58
crafts, 60, 65, 66, 68, 70, 94, 142
Creation, biblical story of, 52, 58
Crimea, 86
criminality, 37
Critical Figuration, 92, 173
critical theory, 140
Crusades, the, 37, 39, 69, 86
Cubism, 18, 40, 89, 92, 95, 97, 100, 98, 106, 110, 122, 126–30, 152
Cyrillic, 126
Czechoslovakia, 99

Dada, 52, 134
dance, 42, 128
Darwinism, 94
death, 40, 42, 115, 122, 157
Declaration of Independence, United States, 52
decorative art, 21–22, 64, 65
degenerate art, 36, 110, 112
Deicide, 65
democracy, 44, 141
Denmark, 148
Depression, the Great, 51, 154, 160
Detroit, 137

Japanese-Americans, 154
Jersey Homesteads, 41, 155, 157
Jerusalem, 29, 62–66, 70, 77, 95, 143
Jeu de Paume, 110
Jewish art, 20, 22–30, 63–66
Jewish Education Aid Society, 94, 98
Jewish Educational Alliance, 152
Jewish experience, 20, 21, 32–55
Jewish Historical and Ethnographic Society, 90
Jewish museums, 77, 82, 149, 157
Jewish Paradox, 24
Jewish Question, 81, 119, 141, 149
Jewishness, 24, 55, 80, 84, 90, 92, 119, 120, 173
jihad, 37
journalism, 36, 99, 136, 167
Judea, 52, 63
Judeo-Arab culture, 66
justice, 44, 45, 70

Kabbalah, 44, 69, 97, 157, 160
Kazimierz, 128
Ketubah, 23
khazzan, 116
kibbutz, 54, 143
Kiddush, 51
Kiev, 90
Kindertransporte, 104
Kohanim, 22, 119
Koran, 66
kosher practices, 51, 70
Krakow, 26, 86, 88, 128
Kristallnacht, 104
Ku Klux Klan, 154, 164
Kultur-Lige, 90
Kulturwissenschaft, 84
kvetch, 39

L'Chaim, 40
landscape, 29, 38, 40, 82, 85, 95, 122, 125, 148, 149
language, 38, 63, 66, 69, 80, 97, 99, 106. *See also* specific languages
Lascaux, 141
Latin America, 77, 167
Latin language, 69
Laval Laws, 131

law, Jewish, 40, 42, 44, 52, 60, 61, 63, 65
Lemberg. *See* Lvov
Leningrad, 90
lesbianism, 94
Levite, 22
Leviticus, 40
life cycle, human, 39, 40, 54, 157
linguistics, 66
literature, 20, 38, 39, 66, 69, 85–86, 89, 90, 92, 118, 136, 138, 140–41, 143, 149, 164, 170
Lithuania, 39, 86, 89, 118, 157, 158
Livorno, 37, 119, 120, 130
Lodz, 89
London, 18, 20, 21, 29, 30, 45, 52, 61, 69, 84, 72, 92–98, 143–49, 152, 173
Louvre. *See* Musée du Louvre
luftmensch, 40, 125
Lutheranism, 102
Lvov, 80

Maccabees, the, 51
Macchiaioli, 119
Makhmadim (periodical), 106
manifestos, 136, 149
Mannheim, 104
manuscripts, 23, 44, 66, 68
Marburg School, 140
marranos, 69, 70, 119
marriage, 34, 45, 48, 78
Marseille, 136
Marxism, 24, 34, 36, 54, 81, 136, 140, 157
masks in art, 23, 102, 120, 164
massacres of Jews, 23, 37, 39, 65, 86, 89, 136
May 1968 movement, 54
Mecca, 66
Mechanofaktura, 89
Mediterranean, 62, 70
mekhutn, mekhuteneste, 48
Melting Pot, The, 149
memoirs. *See* autobiography
memory, 37–38, 61
Mercure de France, Le, 118
Mesopotamia, 44, 60, 63
messianism, 39, 54, 62, 63, 64, 65, 85, 90, 100, 126, 140

mestizos, 77, 137
metaphysics, 90, 102, 104
Mexico, 29, 48, 136–40, 164, 167
mezuzah, 45
Middle Ages, 18, 22–23, 26, 37, 39, 48, 65, 66, 69, 86, 63–66, 69
midrash, 42, 66, 149
mikvah, 23
military service, Jews and, 77, 81, 110–12, 118
miniature painting, 73, 92
Minsk, 115, 122
minyan, 62, 125, 149
mishpat, 44
misogyny, 48
Mitteleuropa, 80
mitzvah, 45
Mnemosyne (Warburg's picture atlas), 84
models, artist's, 20, 21, 70, 88, 97, 104, 106, 141, 144, 146, 155
modernism, 20, 29, 84, 89, 97, 98, 127, 143, 144
money, 44–45, 81, 97, 122
monotheism, 23, 34, 60, 61, 84, 140
Montparnasse, 29, 95, 106, 112, 116, 118, 130
Montreal, 162
Morocco, 22
mosaics, 22, 63, 65
Moscow, 29, 86, 89, 90, 127, 140, 167, 170
mothers, 20, 21, 34, 38, 39, 45–50, 51, 65, 70, 78, 84, 95–97, 116, 119, 122, 125, 126, 132, 137–39, 141, 148, 155, 157, 158, 162, 170
movie directors, Jewish, 99
Munich, 82, 102, 106
murals, 63–65, 155, 157, 164
Musée d'Orsay, 88
Musée de Cluny, 77
Mechanofaktura, 89
Musée des Écoles Étrangères, 106
Musée du Louvre, 70, 77, 136
Musée National d'Art Moderne, 128, 130
music, 22, 62, 66, 68, 102, 128, 138, 152, 155
mysticism, 37, 44, 58, 64
myth of origins, 58, 60
mythology, 136, 157, 167

Nabis, 88
Nabucco, 54
names, 36, 52, 54, 60, 98, 140, 164
narrative in art, 20, 26, 61, 66, 125, 143, 149, 154, 157, 170
National Academy of Design (U.S.), 152
National Gallery (UK), 98
National Socialism. *See* Nazism
nationalism, 23, 55, 81, 98, 160
Nazism, 82, 98–102, 110, 131, 134, 136, 138, 144
Neo-Expressionism, 167
Neo-Humanism, 29, 173
Neo-Impressionism, 78, 89, 95, 100, 110
Neo-Romanticism, 85, 98
Netherlands, 23, 30, 70–72, 76, 82, 83
Neue Sachlichkeit, 104
New Amsterdam, 72
New Deal, 30
New English Art Club, 97, 152
New Objectivity, 144
New York City, 20, 21, 29, 72, 88, 89, 90, 116, 149, 152, 149–60, 167, 173
newspapers, 95, 99, 118, 158
nihilism, 21, 44, 126
Nile River, 60, 63–64
Nobel Prize, 52, 69, 99
nomadism, 60, 140
North Africa, 63, 66–68
nude in art, the, 23, 58, 63–64, 106, 120, 122, 144, 146
Numbers, Book of, 40
numerus clausus, 90
Nuremberg Laws, 134, 138

occultism, 65, 76, 102, 134
old masters, 102, 125, 143, 158
Omar Covenant, 66, 69
Oriental languages, 39
Orientalism, 29, 149
orphans, education of, 42, 44
Orphism, 130
Orthodox Church, 65
Orthodox Judaism, 34, 40, 63, 80, 82, 85, 154, 157
Ostjuden, 85

Photography credits

Numbers refer to plates.

Art Resource NY: 35, 93; Association des Amis du Musée du Petit Palais/Studio Monique Bernaz, Geneva: 3, 6, 18, 29, 31, 33, 36, 48, 68, 77, 79; © Belmont Music Publishers, Los Angeles, and VBK, Vienna: 55; Ben Uri Gallery, The London Jewish Museum of Art: 52; © Beth Hatefutsoth, The Nahum Goldmann Museum of the Jewish Diaspora, Tel Aviv: 12, 37; Bildarchiv Preussischer Kulturbesitz/Art Resource NY, photo Joerg P. Anders: 45; Christian Baraja: 1, 17; CNAC/MNAM/Dist. RMN/Art Resource NY, photo Georges Meguerditchian: 15; CNAC/MNAM/Dist. RMN/Art Resource NY, photo Jean-Claude Planchet: 105; Felix-Nussbaum-Haus Osnabrück mit der Sammlung der Niedersächsischen Sparkassenstiftung: 24, 59; Galerie Daniel Templon, Paris: 103; Galerie Gimpel & Müller, Paris: 4; Galerie Thaddaeus Ropac, Paris-Salzburg: 107; Galerie Trigano, Paris: 99; Groupe Jacques Bogart, Paris: 16; photo Ivory Serra: 78, 94; © The Jewish Museum, London: 39; © The Jewish Museum New York/Art Resource NY, photo John Parnell: 8, 22, 50, 92; Jüdisches Museum Frankfurt, photo Ursula Seitz-Gray: 58; © Library of the Hebrew University of Jerusalem: 30; Musée d'Art et d'Histoire du Judaïsme, Paris (MAHJ): 21, 56; Musée Municipal de Vichy, Donation Pierre Bourut/Musées de Pontoise, Jean-Michel Rousvoal: 20; Musées de Pontoise/Jean-Pierre Levallois: front cover, 10, 42, 44; Musées de Pontoise/Jean Villain: 25, 26, 67; © The Museum of Modern Art, licensed by Scala/Art Resource NY: 86, 97; Norton Museum of Art, West Palm Beach: 9, 53, 81, 98; © Pierpont Morgan Library, New York, NY/Art Resource NY: 38; private archives: back cover, 1, 2, 7, 14, 19, 23, 27, 28, 32, 34, 43, 46, 47, 49, 60–64, 66, 69–76, 80, 83–85, 87, 90, 91, 95, 100, 102; © Réunion des Musées Nationaux/Art Resource NY, photo Herve Lewandowski: 41; Roger-Viollet/Musée Zadkine, Paris, photo Eric Emo: 65; © Scala/Art Resource NY: 5, 96; photo Steven Sloman, New York: 101; © Staats- und Universitätsbibliothek Hamburg: 11; © Tate London/Art Resource NY: 54, 82, 88, 89; © Thessaloniki Costakis Collection: 40; Von der Heydt Museum, Wuppertal: 13, 57.

The copyrights for artworks not in the public domain are held by the artists, with the exception of the following: Jankel Adler, Marc Chagall, Isaac Dobrinsky, Henri Hayden, Ilya Kabakov, Frida Kahlo, Michel Kikoïne, Moise Kisling, Pinchus Krémègne, El Lissitzky, Emmanuel Mané-Katz, Louise Marcoussis, Marevna, Gregoire Michonze, Simon Mondzain, Mark Rothko, Arnold Schoenberg, Chaim Soutine, Leon Zack, and Ossip Zadkine © 2009 Artists Rights Society (ARS), New York/ADAGP Paris; Lucian Freud © 2009 Goodman Derrick Solicitors, London; Chaim Gross © 2009 Artists Rights Society (ARS), New York; Alex Katz © the artist, licensed by VAGA, New York, NY; André Kertész © Higher Pictures; Jack Levine © the artist, licensed by VAGA, New York, NY; Felix Nussbaum © 2009 ADAGP Paris & VG Bild-Kunst, Bonn; Mark Rothko © 2009 Kate Rothko Prizel & Christopher Rothko/Artists Rights Society (ARS), New York; George Segal © The George and Helen Segal Foundation, licensed by VAGA, New York, NY; Ben Shahn © Estate of Ben Shahn, licensed by VAGA, New York, NY.

The maps on the next page were provided by Christophe Duvivier and are based on information found in the following publications: Elie Barnavi, *Histoire universelle des Juifs* (Paris: Hachette, 1993); Evyatar Friesel, *Atlas of Modern Jewish History* (New York: Oxford University Press, 1990); Martin Gilbert, *The Routledge Atlas of Jewish History* (London: Routledge, 1993).